THE SYMBOLISTS

Philippe Jullian

THE SYMBOLISTS

Phaidon

To
Derek Hill

Translated by Mary Anne Stevens

PHAIDON PRESS LIMITED
5 Cromwell Place, London SW7 2JL
Published in the United States of America by Phaidon Publishers, Inc.
and distributed by Praeger Publishers, Inc.
111 Fourth Avenue, New York, N.Y. 10003

First published 1973
© 1973 by Phaidon Press Limited
All rights reserved

Reprinted 1974, 1975

ISBN 0 7148 1590 X
Library of Congress Catalog Card Number: 72-89483

Printed in Great Britain by
W & J Mackay Limited, Chatham

Contents

Introduction

Two major exhibitions of Symbolist art were held in 1972 in Paris and London. Planned on a scale previously reserved for the Impressionist and Surrealist schools, these two exhibitions brought together a vast number of scattered and generally forgotten works of art. The first was held at the Grand Palais in February 1972 and bore the title *Belgian Painters of the Imaginary*; the Symbolist section of this exhibition was organized by Mme Legrand, Keeper of the Musée Royal d'Art Moderne in Brussels. The second exhibition, *French Symbolist Painters,* was held in June of the same year at the Hayward Gallery, London; this was organized by Mme Lacambre, a curator in the Department of Paintings at the Louvre, Alan Bowness of the Courtauld Institute, and myself, under the aegis of the Arts Council of Great Britain. Finally there was the exhibition of Lévy-Dhurmer held during the winter of 1972–3 at the Grand Palais and organized by Mme Lacambre and Mme Monnier of the Louvre.

The first exhibition of Symbolism, which was held in Turin in 1969, displayed a certain lack of cohesion. The themes of inspiration for pictorial Symbolism were similar in Milan and Vienna, Glasgow and Darmstadt, but their expression differed widely in each city; the period of time covered by this exhibition was also too large. For Symbolism, while its influence was indeed very great, really inspired original works of art in a limited period: the last decade of the nineteenth century. In this time it was closely associated with (though it must not be confused with) the atmosphere of Decadence and the emergence of *art nouveau.*

By contrast this book deals principally with French and Belgian painters, because of the unity of their intellectual background and ideals, and because of the continuous contact between Brussels and Paris in this period. The sections are defined by pictorial type (portraiture, landscape, interiors, graphic work), source of inspiration (religious or philosophical), and artistic medium (fresco, oil, pastel, drawing, lithography). This Symbolist country, limited geographically to that under the reign of Verlaine and Maeterlinck, is restricted also in its time-period. Allegorical, bizarre, even nightmare pictures had been painted since the beginning of the nineteenth century, and some of these were sources for the artists in this book; and Moreau and Puvis de Chavannes had had established reputations since the Second Empire. Yet, in the literary field, the year 1886 marks the date of the official birth of Symbolism with Moréas' famous manifesto; this was also the year in which Moreau completed his pictorial cycle, *La vie de l'humanité* ('The Life of Humanity'), Seurat exhibited *La Grande Jatte* and Gauguin went to Pont-Aven. The year 1891 is probably the most typical of the movement. By 1895 one begins to sense its waning, and by 1900, although some Symbolist ideas had an important place in the Paris Exhibition, the painters of the imaginary had generally become academic or had already been pushed into oblivion and been ridiculed. The subject of this book, therefore, embraces a period of about a dozen years.

The number of artists to be discussed in this book has also been subject to limitations. For the pale sun of Symbolism touched for a while a very diverse collection of painters: Seurat, for example, Picasso in his Blue Period, Gauguin and the School of Pont-Aven, where it shone with great effect, and Vuillard, who also had a Symbolist side to his work although one cannot include him under the banner of Symbolism.

This book is also more strictly concerned with painting than was *Dreamers of Decadence,* my previous book in this field. Whereas the first book dealt with a complete movement in the history of Western imagination, this one is limited to the history of an episode in the development of painting. For a bibliography I refer the reader to the very complete one compiled by Mme Lacambre in the catalogue of the Arts Council exhibition at the Hayward Gallery. It is indeed to Mme Lacambre that all who

are interested in these painters owe a great debt of gratitude. Through her research for this catalogue she has rescued from oblivion such artists as Edmond Aman-Jean, Lucien Lévy-Dhurmer, Ary Renan, Georges de Feure, Eugène Grasset and Armand Point, and has established them in the mainstream of the history of art.

Another important contribution has been made by Mme Francine Legrand, the Keeper at the Musée d'Art Moderne in Brussels, who has refurbished the European reputations of Fernand Khnopff, William Degouve de Nunques and Jean Delville, thus placing them once again on the level that they occupied at the end of the last century. Her catalogue for the exhibition at the Grand Palais should be placed next to the catalogue of *French Symbolist Painters*.

I am also indebted to the other contributors to the Hayward catalogue apart from Mme Lacambre: Mary Anne Stevens, who wrote the entries for works from non-French collections; M. Elie-Charles Flamand who wrote the entries for works in his own collection, especially those of Alexandre Séon; and Alan Bowness, whose introduction 'An Alternative Tradition?' has so admirably defined the position of the Symbolists within the wider context of nineteenth-century art. I have also been greatly assisted by Denys Sutton's and Ronald Pickvance's catalogue for the exhibition *Gauguin and the Pont-Aven Group*, which was organized by the Arts Council in 1967.

I should also like to remember those organizers of the first exhibitions of Symbolism: Dr Carluccio of Turin, Mario Amayo, now the Director of the New York Park Cultural Center, and Mme Dane, the Director of the Musée Galliéra in Paris, with whom I organized the exhibition *Esthètes et Magiciens* ('Aesthetes and Magicians'), held in Paris in 1970.

ACKNOWLEDGEMENTS

The publishers and author wish to thank all the owners of paintings who have kindly allowed them to be reproduced in this book. Many are private collectors who wish to remain anonymous. All other owners are noted in the captions. Acknowledgements are also due to the following for reproduction permission and/or photographic material: SPADEM, Paris, for works by Aman-Jean, Bernard, Blanche, Denis, Desvallières, Le Sidaner, Maillol, Maxence, Rochegrosse, and Sérusier; AGRACI, Paris, for Nos. 13, 27, 45, 46, 49, 58, 61, 63, 85, 112, 119, 126, 127, 135, 140, 143, 162, 163, 170, 181, 183, 184, 189, 202, 207, 211; Photo Service of the Musées Nationaux de France for Nos. 7, 16, 18, 47, 48, 60, 62, 67, 79, 88, 93, 95, 97, 100, 108, 150, 151, 152, 154, 173, 192, 193, 197, 201; ACL, Brussels, for Nos. 24, 30, 36, 52, 54, 55, 72, 73, 131, 175, 180, 188; Photo Bulloz for Nos. 34, 84, 86, 87, 89, 91, 92, 103, 105, 110; Photo Giraudon for Nos. 25, 94, 125, 136, 147; Photo Arsicaud, Tours, for No. 139; Studio Madec, Nantes, for No. 74; Fratelli Fabbri Editore, Milan, for Nos. 194 and 195; Nos. 168 and 200 were reproduced by permission of the Harvard College Library.

The pictures have been divided into three groups: general paintings, portraits and graphics. Each is arranged in roughly alphabetical order. The colour plates do not always fall in the correct alphabetical position; and the first colour section is outside the general scheme, being a group of portraits. Wherever possible we have given details of size, date and medium, but in some cases this information was not obtainable.

1. The Palace of Symbolism

The late nineteenth century saw its international exhibitions as cathedrals; every eleven years it rejoiced in grouping together under the cupolas of temporary palaces art collections which, as the century drew to its close, became increasingly diverse and profuse. Naturally official painting, both historical and allegorical, held pride of place, followed by *genre* painting, that is, portraits, landscape and anecdotal subject-matter (and it was in this latter category that the more modern schools of painting survived as best they could) while sculpture filled the central rotunda, a vast mausoleum of plaster poses and potted plants. At these aesthetic bazaars, the connoisseur was free to select his museum of the future; in 1867 he noticed that Courbet and Realism dominated the scene; in 1878 he saw the Impressionists hailed as the liberators of painting from the boredom of academic art; by 1889 he saw sunlit painting more or less established, and even if the doors of official acceptance had not been completely flung open to the Impressionists, the new *avant-garde* now appeared to rest with a school of simple, poetic painting that was opposed to the virtuosity and vulgarity of academic art. It was in the small, private galleries that the collector had to follow the development of this new school. Christened by some 'Ideist', by others 'Idealist', this school soon claimed for itself the name of 'Symbolist'—a name which was also claimed at the same date by a movement in literature.

Widely diverse in technique as well as in inspiration, the work of these young artists did not immediately display sufficient common ground to qualify as a school. Yet, 'drawing upon that common source of images which defines a style', revolting as much against naturalism as against academicism, these artists can be grouped under a common banner in much the same way as the Mannerists of the sixteenth century—a movement with which these young artists had several points in common. This new style, like Mannerism, was generally regarded as an affectation in France; it was rapidly denounced, then forgotten for more than fifty years. Indeed, it has only been in the last five or six years that the Symbolists have succeeded in claiming the attention of art historians, the speculative interest of art dealers and the admiration of the young. So many kinds of art have been assembled under its banner, so many masters at some period during their careers have flocked to its message, and so many schools, with varying degrees of justification, have been associated with its name, that one would really like to see a sort of Palace of the Arts hung only with their works in one vast exhibition. We must dream, so that these riches, now exhumed, reclaimed, even disputed, may be visualized more clearly. The sole, indisputable characteristic shared by all these artists was that they preferred the imaginary to the real, and this characteristic would clearly emerge from such an exhibition.

In 1972, the exhibitions of Belgian painters of the imaginary in Paris and of French Symbolist painters in London, already referred to, emphasized the need to limit the definition of the term 'Symbolism', and they underlined the common sources of inspiration, technique and ideal which united its Belgian and French exponents. These artists belonged to that spiritual kingdom which had seen the birth of Gothic art, of Rogier van der Weyden and of Watteau, which spreads from the Seine to the Scheldt, and has always been open to the influence of England; a country where landscapes charm rather than astonish the eye, where the climate favours seclusion; a country which is sober, pensive, mystical, encouraging flights of the imagination which can obliterate an essentially bourgeois pattern of existence. If the remarkable renaissance of literature which took place in Belgium from about 1880 onwards was fundamental to the creation of Symbolism, it was French painters such as Moreau, Puvis de Chavannes and Redon who were venerated in Brussels. The influence of the English Aesthetic Movement was felt in both capitals, which shared a common admiration for Burne-Jones. They also found a common language and a common vocabulary in the cult of Wagner. With the political frontiers out of

the way, French and Belgian artists belonged only to the kingdom which pledged allegiance to the things of the imagination, which turned back in part to the past, and which turned away completely from the rapidly advancing industrialization of the contemporary world.

Imagine a Palace of Symbolism in which this great Franco-Belgian exhibition of art is hung and for which this book will serve as a guide. In its architecture it resembles the buildings dreamed of by the young Paul Valéry: 'This is the forest of silence. . . . In it the towering growth of pillars and columns, like lilies, intertwine in the deep shadows above precious mosaic pavements. They are adorned with mysterious blossoms and carry below their abacuses the symbols of magic sculpted like fruits of the Tree of Universal Science' (*L'Ermitage*—'The Hermitage'—1890).

Passing from room to room, we can follow the different aspects of the movement during the last ten years of the nineteenth century. As we enter we shall first stop to consider examples of those works of art that fed the youthful imaginations of the principal artists shown in the exhibition, and that acted as stimulants to their vocation. Pre-Raphaelites and even Nazarenes will hang beside canvases of Chassériau, engravings by Gustave Doré and Bresdin, and reproductions of Italian and Flemish Primitives.

From this antechamber we move into a rotunda consecrated to the gods and masters of Symbolist thought. Set against wall-hangings coloured by Villiers de l'Isle Adam (1), the statues of Baudelaire and Wagner tower above a host of smaller busts: Swedenborg, Hegel, Poe, Mallarmé, Verlaine; and texts sacred to the Symbolist aesthetic are immortalized in mosaic. This mystic rotunda has side chapels and a crypt which we shall also visit in due course, as well as galleries which open from it to the left and to the right. One of these galleries is entered through a room decorated in the style of the Second Empire; it is consecrated to Gustave Moreau. The other gallery is starker and less immediately attractive and contains the work of Puvis de Chavannes. Thus, across the central rotunda Salome confronts St Genevieve, Sin confronts Faith, Imagination Contemplation, the two poles of the movement. Beyond the Moreau room we find groups of his admirers such as Khnopff and Lévy-Dhurmer and pupils such as Rouault and Ary Renan; we also meet many illustrious visitors such as Huysmans, Proust, Wilde, and, further on, the Surrealists. Beyond the Puvis de Chavannes room, we find his earnest disciples, Maurice Denis, Gauguin and the painters of Pont-Aven, and a few works of Seurat, who strayed briefly into the Symbolist country. From the pictorial point of view these later rooms are more interesting than those centred around Moreau.

Three more rooms also open off this central rotunda, each one sealed off from the next. There is the Odilon Redon room with its walls darkened by charcoal drawings, its light coming from pastels which, like stained-glass windows, flood the room with colour. And there are two other rooms in which most visitors would not bother to pause, but which were much frequented by the Symbolists: one is dedicated to Carrière, the other to Fantin-Latour.

Then, as in all international exhibitions, there will also be rooms devoted to separate categories of art: Portraits, Landscape, Religious Painting, Graphic Art, in which we should consider if there was any type of painting peculiar to the Symbolists. Our visit will end in a room hung with twentieth-century painting which, if it had been executed twenty or thirty years earlier, would have qualified as 'Symbolist'.

Before we study these galleries in detail, we must be better prepared. We shall stroll in the garden planted in the middle of the palace, where we shall find the painters themselves, the masters of the aesthetic they admired, the poets and composers by whom they were inspired; we shall listen to music; we shall read both the grandiloquent and the more intimate statements of their aesthetic leaders Péladan and Huysmans, the two critics who helped them to formulate their aspirations. We shall think back to exhibitions of the time in Paris and Brussels; we shall leaf through the reviews, both large and small; and we shall realize that painting was but one of the aspects of a movement which touched the sensibilities of an entire intellectual élite. These developments in art involved of course a good deal of self-conscious affectation, and we shall try to make a distinction between real works of art and 'art works'. Indeed, there has never been a time which has wanted more to be 'artistic', nor a period with more interchange between painters, poets and musicians—the last were indeed the most self-conscious of the three.

The mere idea of imagining such a palace of Symbolism, and the attempt to bring together the various threads developed in the exhibitions of late nineteenth-century art which have attracted so many people over the last four years, would have been inconceivable ten years ago. Whereas *art nouveau* was certainly rehabilitated by then, with Mucha, Gallé, Guimard and Gaudí all well known, the painters who had taken part in the Symbolist movement were exhibited at Knokke-le-Zoute and at Tokyo as mere curiosities. Never has a period of painting been held in such universal contempt, not even the work of Boucher during the supremacy of David. 'Scarcely had the movement of so-called French Symbolism gasped its last breath, impoverished and broken by the weight of the plastic forms of its century, than a frail flower blossomed, a glorious flower belonging to a culture which had scarcely any life left in it, and no power of revelation: this flower was Redon.' Thus wrote Elie Faure, one of the most distinguished critics of contemporary art, in 1923.

In 1961, the Museum of Modern Art in New York took the courageous step of mounting an exhibition of Moreau, Bresdin and Redon, based primarily, however, on the claims of these artists to be the precursors of Surrealism. The success of the 1960 exhibition of Gustave Moreau at the Louvre had already seemed astonishing. The general public slowly came to realize that the painting of the end of the nineteenth century meant more than just the Impressionists and the official artists of the *Salon*. Indeed, as Alan Bowness wrote in the introduction to the catalogue for the Arts Council exhibition held at the Hayward, London, in 1972: 'What one can trace, I think, is an alternative tradition of modern art—a line of succession that leads from the Romantic period (when the modern world seems to begin) directly into the preoccupations of the twentieth century. For the painters represented in this exhibition are not in fact as odd and isolated as they have been made to appear, and one of the reasons for bringing them together in this exhibition—the first time the attempt has been made—is to show how the jigsaw of French symbolist (or to use an older term now in disuse, idealist) painting fits together' (p. 14).

In the history of taste, these exhibitions of Symbolism represent the great 'revival' of our decade. This growth of interest runs parallel to a relative decline in interest in the Impressionists and the great masters of the Modern Movement such as Matisse and even Picasso. We have seen too much of their work; their commercial value on the art market has sullied their aesthetic value. They were also too prolific; one hundred facile Renoirs ultimately make us forget that the *Déjeuner des canotiers* is one of the finest paintings to be executed in the last century, just as the thousands of drawings and paper-cuttings executed by Matisse can be so easily copied that our admiration is inevitably diluted.

By no means all those people who came to the Symbolist exhibitions could be classified as admirers of Symbolism; those over thirty years old with artistic tastes formed by the successes of abstract art merely shrug their shoulders in dismissal; those over fifty who, many years ago, dispatched to the attic the paintings commissioned by their grandfathers are either annoyed or merely concede the faint praise of 'period charm', or they find these serious and often strange paintings to be nothing more than 'kitsch' and are unable to understand their significance. The lovers of 'kitsch' have certainly been provided with absurd paintings by the imitators of Symbolism, a hotch-potch in which the nostalgic past can be recaptured, with added Freudian overtones and parodies of Surrealism. However, we must not linger long over the works that fall into this category; we can leave 'kitsch' to the admirers of the 'Modern Style'. Familiarity with the Surrealist vision allows more sophisticated observers to enjoy the strange and exotic; they can see the links that run from Delville to Delvaux, recognize Dali's borrowing from Böcklin and the symbol of the birds of Max Ernst.

For the last ten years, Gustave Moreau has at last been recognized as one of the important masters of the nineteenth century, and today, art historians are busy uncovering the immense influence of Puvis de Chavannes. For the older generation there is another aspect which may have developed a taste for this period: their memories of children's books illustrated by Rackham and Dulac. For the younger generation used to comic strips, there is a natural gravitation towards narrative painting, and in so far as they have metaphysical preoccupations they will find them reflected in the themes of some of these idealist painters, and their love of psychedelic colours repeated in their palettes. And finally there is the eroticism found in many of the works of this period, the ambiguous charm of the Symbolists' idea of physical beauty which reflects unconscious fantasies and desires.

2. The Visual Sources of Symbolist Imagery

Before visiting the main rooms of the Palace of Symbolism, it is advisable to pause in the entrance hall which serves as much as a library and print room as a picture gallery. Never before had artists been brought up to such an extent on ink, ink with which the philosophers and theoreticians whose works they read so avidly were printed, ink of engravings which gave their imaginations new vision, ink in reproductions in which they found their ideal.

From the middle of the century, newspapers illustrated with wood engravings and lithographs reproducing much-revered canvases and the latest *Salon* success offered them infinitely more models than the preceding generations had ever known. Magazines like *L'Illustration* and *Le Musée des Familles* (the 'Family Museum') publicized foreign works of art with a soft spot for the Germans—picturesque and sentimental like Maurice von Schwind, mythological and idealist like Peter Cornelius. If one leafed through children's newspapers of the time such as the *Magazine d'Education et de Récréation,* or *Saint Nicholas,* one would find (as the critics of Rimbaud have in fact done) the sources of a good Symbolist iconography. Even the caricatures parodying Courbet, then Manet, then Puvis de Chavannes, made the bourgeoisie aware of the quarrels within the artistic world. The *Gazette des Beaux-Arts* kept more cultivated circles up to date on discoveries and new ideas. There we see the works which held Baudelaire's attention in his *Salons* before they were buried in provincial museums.

Today certain dreamers of the Lyons school appear to us to be halfway between the Nazarenes and Puvis de Chavannes. They appealed to a poetic public weary of romantic exercises in the picturesque. Janmot and Chenavard, even more so the lustreless Flandrin and the boring Ary Scheffer (these last two very frequently reproduced), deserve a place among the iconographic sources of the Symbolist movement. Even more than the *Salons,* the sections of foreign art at the Universal Exhibitions, the newspaper reports of which were garnished with numerous reproductions, were of lasting influence; thus the immense drawings by late Nazarenes had caught the attention of Théophile Gautier in 1855.

Towards the end of the Second Empire, the photographic reproduction industry was developed by Alinari and by Braun, the photographs ochre in colour and pasted on to thick card. In this way M. Swann was able to bring reproductions of the frescoes by Giotto at Padua to his young neighbour at Combray (Proust himself), and Grandmother, growing increasingly fond of aestheticism, wanted Marcel to get to know Venice through Turner. Probably less spoilt than Proust, the painters had to make their own collections. Leaving to the tourists the Madonnas of Raphael, the Venuses of Titian or Rubens, which Bouguereau and Cabanel had turned into stereotypes, they chose instead works which had nothing in common with the painting of the *Salons*. Like Maurice Denis, they loved Fra Angelico, and they too could have written: 'A photograph of a primitive suffices in the chaos, the tumult of life, to remind us of what our soul is and that a pure light comforts it in spite of ourselves.' The Belgians sought inspiration from Van Eyck and above all from Memling. Others, less inclined to the mystical than to the bizarre, preferred Carpaccio whom Gustave Moreau carefully copied during his visit to Venice. And everyone adored Botticelli, hanging reproductions of the *Primavera* in their bedrooms. The Gioconda and Leonardo's androgynous *St John the Baptist* had their place on those walls, while on the mantelpiece sat the cast of the late Renaissance wax head from the Lille museum or the death-mask of the *Drowned Woman of the Seine*.

The photograph, making possible exact comparisons between documents, has allowed art history to become independent of history and aesthetics. The study of civilizations was far more interesting than the chronicle of battles, and a large number of artists born after 1850 were very conscious of art history; so, starting with reproductions, Symbolism was really an art formed by museums.

For a season, the Universal Exhibitions would bring together such museums under their glass vaults; in those held in Paris, the English section was always of immense importance. Thus Théophile Gautier noticed the Pre-Raphaelites in 1867: *The Eve of Saint Agnes* by Millais and two paintings by Watts. At the exhibition of 1878, the two big Burne-Jones works *Love among the Ruins* and *Merlin and Viviane* created a sensation; these bore no relation to anything being done in France and started a craze which lasted for close on twenty years. Invited to exhibit at the *Salon* of 1889, Burne-Jones sent *King Cophetua and the Beggar Maid*. It was a triumph he repeated at the *Salon* of 1893 with *Perseus* (2).

Watts was almost as appreciated as Burne-Jones. In 1883, he had a great success at the Georges Petit gallery and at Brussels with *Hope*; his portraits of aristocratic, melancholic ladies had a strong influence on Khnopff. Watts' more philosophical bent, his moonlight tonalities, his indistinct outline, made him seem preferable by far to the Pre-Raphaelites who, with their moral preoccupations, their vibrant colours and their realistically rendered detail, could not really appeal to artists who turned their backs on Realism. The entire generation which adopted the tastes of Huysmans' hero saw Watts through the eyes of Des Esseintes (3).

Rossetti was much less liked; when Montesquiou went to London in 1884, he called him 'a bizarre Bouguereau'; on the other hand he was carried away by Whistler, whose influence on Symbolism was far greater than his friendship with Courbet and Manet would have led one to believe. His 'Symphonies' and his 'Nocturnes' enchanted Mallarmé. He was, together with Moreau, Proust's favourite artist. His portraits appeared to recall the heroines of Edgar Allan Poe; this belief stemmed less from pictorial evidence than from the rather sinister legend which Whistler had skilfully built up around his personality. One understands how in comparison Millais, having become a fashionable portrait painter, rather like Bonnat, interested no one. The strangest Pre-Raphaelite, the most Symbolist down to the minutest detail, Holman Hunt, was equally disregarded on the Continent and his famous *Light of the World* was dismissed as religious imagery. The Symbolists hardly knew anything of the work of Blake with whom they had so much in common, both having fallen under the influence of Swedenborg (4).

The influence of the Pre-Raphaelites was felt less through their paintings than through a book, *The Poems of Tennyson*, edited by Moxon and wonderfully illustrated by Rossetti and Millais. The influence on Maeterlinck stems less from the poems themselves than from the illustrations. The revival of illustrated books in the last two years of the century derives from this Tennyson, the books printed at William Morris' press, the albums of Walter Crane. These last two and the ravishing little books for children by Kate Greenaway were heralded by Huysmans as early as 1881 (5).

Generally speaking, it is the English Aesthetic Movement rather than the Pre-Raphaelites which influenced the Symbolists, a new life-style rather than a school of painting. The Continent, passing through the Industrial Revolution some fifty years after England, found valuable advice on how to escape from materialism on the other side of the Channel. Everything that one heard about the refinements practised in Chelsea enchanted Frenchmen of taste: furniture by Godwin, open-air theatricals by Lady Archibald Campbell, the Peacock Room by Whistler, Liberty prints. As the pressure of morality was much less pronounced in France than in England, the ideal of Aestheticism was not a revolt but a retreat towards an exquisite world which left hearty good living to the readers of the magazine *La Vie Parisienne* ('Paris Life') and success to the readers of Zola. If one could not write a beautiful poem or paint a beautiful picture, one could always choose materials or arrange bouquets of flowers. Aesthetic ardour smothered the anglophobia in the Symbolist circle. The ideal of a harmonious life suggested in Baudelaire's poem *L'Invitation au Voyage* seemed capable of realization in England, whose fashions were brought back by celebrated travellers: Mallarmé after 1862, Verlaine in 1872. Carrière spent a long time in London, as did Khnopff later on. People read the books by Gabriel Mourey on Swinburne, and his *Passé le Détroit* ('Beyond the Channel') is particularly important for the artistic way of life. In 1884, Paul Bourget published his *Lettre de Londres* ('London Letter'), a supplement to the book Taine had pub-

lished fifteen years earlier; Oxford held an important place in it—it was 'the town of the soul'. A year later appeared *Les Poètes Modernes de l'Angleterre* ('Modern English Poets') by Sarrazin.

This influence was even stronger in Belgium, much more dependent economically on England. That charming artist Alfred Stevens and Ensor were both of English origin. Thus England is represented in this hall of visual influences by the works of Burne-Jones and Watts, by illustrated books, and by *objets d'art*. Germany, with the exception of Böcklin, had very little pictorial influence. The initial Scandinavian share was above all literary in the period before the exhibition of 1900. From the Latin countries, where the Pre-Raphaelite influence also made itself felt side by side with a curiously baroque brand of official painting, there is nothing of importance.

Who were the French masters to whom the young artists turned for a new style which was not Impressionist? Obviously Gustave Moreau and Puvis de Chavannes, but also Chassériau, who died in 1856, and who, had he lived as long as his two contemporaries, would have been just as important for the young school. In the work of the Symbolists one finds the feminine type favoured by Chassériau: the line of Ingres decked with the melancholy which Delacroix gave to the victims of his massacres; one also finds a decorative harmony, a happy rhythm which the walls of the Cour des Comptes display in a few remaining fragments of his frescoes. With greater charm than Puvis (who worked in his studio) Chassériau created the idea of a spiritualized world; his portraits *Lacordaire* and the *Two Sisters* are of beings sent to the earth from that other world.

If Delacroix influenced Symbolism it was more through his personality and his writings than through his painting; his theory of the symbolism of colour interested both Van Gogh and Redon, each of whom copied his work. All the young Symbolists loved the green and grey woods of Corot, the drawings of Millet, but it is hard to pin down their specific influence. Perhaps these masters were too 'painterly' for these essentially literary men who had chosen painting rather than writing. On the other hand, three draughtsmen exerted a great influence: Victor Hugo, Gustave Doré and Rodolphe Bresdin.

Of all the works by Victor Hugo the poetic generation of 1880 preferred above all the *Chansons des Rues et des Bois* ('Songs of the Streets and Woods') and the late poems such as *Ce que dit la Bouche d'Ombre* ('What says the mouth of shadow'), written during a period of intense spiritualism. Quite apart from drawings done during seances, for the most part caricatures, hob-goblins and ghouls, the graphic work of Hugo is that of a visionary. Wood engravers beautifully reproduced these visions as illustrations for *Le Rhin* ('The Rhine') or *Les Travailleurs de la Mer* ('The Toilers of the Sea'). Drawn beside cursed romantic castles and storm-tossed lighthouses, ink blots become angels or skeletons, accidental stains become souls or flowers, ambiguities and metamorphoses provide prodigious leaven for the imagination: 'The magnificent imagination which flows through the drawings of Victor Hugo like the mystery in the sky' (Baudelaire).

Despite his facility and periodic vulgarities, Gustave Doré also contributed much. In the drawing-rooms of the bourgeoisie one found those heavy volumes bound in red and gold, mysterious in themselves, which were half-opened for well-behaved children. What provision for dreams! The castle of the Sleeping Beauty, crumbling under the creeper, the virgin forests of Atala, the black knights of *Orlando Furioso*, the ghost ship of the *Rime of the Ancient Mariner*. Highly regarded in England, even for his appalling paintings, Doré illustrated Coleridge, Tennyson, Poe; *The Raven* is perhaps his masterpiece because it is stripped of all picturesque qualities. Doré is as much the last of the Romantics as he is one of the first Symbolists; on his plates worked in *grisaille* the sea merges with the clouds, leaving one guessing at some fateful portent.

In complete contrast to Doré, Rodolphe Bresdin was hardly known at all. Artists sought out his lithographs because Baudelaire had liked them. Perhaps Grandville also had a certain influence with his metamorphoses, but it was to be considerably greater on the Surrealists. As for the Belgians, they were occasionally impressed by that late megalomaniac Romantic, Wirtz. The Symbolists accepted so many different sources of guidance that the list of influences could be much longer. Let us add that they were not much influenced by oriental art, that of the eighteenth century they only liked Watteau, that they ignored Venetian painters after Carpaccio, Flemish painters after Bruegel, and that they preferred the harmony of Ingres to the passion of Delacroix.

3. The Aesthetic

Any movement in art which rejects Nature and devotes itself to the Idea must have a library to serve as the purveyor of inspiration which is not received from the imagination. Such a library is at the heart of the Palace of Symbolism; a vast rotunda shielded from the direct light of day, a sanctuary and a library combined, as in the basilicas of the Ancient World. The dome is decorated with mythological figures arranged like the procession which Flaubert created to tempt St Anthony: Christ, Buddha, Isis, Adonis and other figures stand there, each with his own personal message and mysterious cult. Below this procession there is a pale frieze of muses and allegorical figures. The walls of the rotunda are covered with quotations from the prophets and immediate precursors of Symbolism rather than with paintings, and its doors are Rodin's *Gates of Hell*. In the flickering lamp-light stand the statues of Baudelaire and Wagner; these two tower above the statues of the other men who inspired the movement. Knowledge of the works of these men and their followers is essential to an understanding of the art in the rest of the exhibition.

There were many reasons for venerating Wagner. He had composed music of ecstasy, and given dream-images a concrete form: 'An absolute which is at last understood emerges from the retreating waters; it is like a mountain peak which stands isolated and glittering in all its brilliance. The vision of the future . . . a monster which cannot be' (Mallarmé). In the music-drama *Parsifal*, he had lauded the virtues of renunciation and created a model of mysticism easily adopted by the Symbolists. Most important of all, he expressed the need for Faith in the creative process, a need which Villiers de l'Isle Adam later discussed in an article in the *Revue Wagnerienne*: 'When an object is created without faith, it can never be a work of art because it lacks the vital flame which rouses, lifts, grows, warms and fortifies; instead it carries that odour of putrefaction which results from the frivolity of its creation.' The *Revue Wagnerienne*, published between 1885 and 1888, played an important part in the flowering of Symbolism. Next to literary contributions by Mallarmé and Verlaine, and lithographs by Fantin-Latour and Redon, there were articles by Schuré which suggested that Wagner had developed from a reawakening of Celtic and Germanic myths to an appreciation of oriental mysticism. Seen in this context, Wagner's Parsifal becomes a Christian Buddha and his music the means of transporting ordinary people into a world of ecstasy (6). Gods and Ecstasy were the two principal demands made by the rebels against a world dominated by Positivism and Rationalism, and these could be found in Wagner.

The appreciation of Wagner in England was slight. This fact might account for the washed-out visual interpretations given to his work by the followers of Burne-Jones. Bad paintings in the style of the German picturesque tradition are also found in the illustrations to Wagnerian operas by mediocre French and Belgian painters such as Bussière and De Groux. An exception to this general rule is found in a drawing by Delville which captures the spirit of the sublime in *Tristan and Isolde*. It was not, therefore, as the purveyor of visual images that Wagner made his contribution to the Symbolist Movement, but as the creator of a philosophy which could be appreciated by artists as different from one another as Gustave Moreau and Puvis de Chavannes.

If Wagner provided the example of a successful artist who was deified, the friend of a king, the man who was loved by several remarkable women, the composer who died at the height of his glory, Baudelaire represented a consolation for the people who could no longer fight against the century, an excuse for that quintessentially Symbolist phenomenon—the man of failure, and an example of the self-consciousness so earnestly sought after by the young artists. Although Rodin and Moreau, two of the most important artists in the Symbolist Movement, acknowledged Baudelaire as their master, the influence of this writer upon the movement as a whole was transmitted through his poems rather than

lished fifteen years earlier; Oxford held an important place in it—it was 'the town of the soul'. A year later appeared *Les Poètes Modernes de l'Angleterre* ('Modern English Poets') by Sarrazin.

This influence was even stronger in Belgium, much more dependent economically on England. That charming artist Alfred Stevens and Ensor were both of English origin. Thus England is represented in this hall of visual influences by the works of Burne-Jones and Watts, by illustrated books, and by *objets d'art*. Germany, with the exception of Böcklin, had very little pictorial influence. The initial Scandinavian share was above all literary in the period before the exhibition of 1900. From the Latin countries, where the Pre-Raphaelite influence also made itself felt side by side with a curiously baroque brand of official painting, there is nothing of importance.

Who were the French masters to whom the young artists turned for a new style which was not Impressionist? Obviously Gustave Moreau and Puvis de Chavannes, but also Chassériau, who died in 1856, and who, had he lived as long as his two contemporaries, would have been just as important for the young school. In the work of the Symbolists one finds the feminine type favoured by Chassériau: the line of Ingres decked with the melancholy which Delacroix gave to the victims of his massacres; one also finds a decorative harmony, a happy rhythm which the walls of the Cour des Comptes display in a few remaining fragments of his frescoes. With greater charm than Puvis (who worked in his studio) Chassériau created the idea of a spiritualized world; his portraits *Lacordaire* and the *Two Sisters* are of beings sent to the earth from that other world.

If Delacroix influenced Symbolism it was more through his personality and his writings than through his painting; his theory of the symbolism of colour interested both Van Gogh and Redon, each of whom copied his work. All the young Symbolists loved the green and grey woods of Corot, the drawings of Millet, but it is hard to pin down their specific influence. Perhaps these masters were too 'painterly' for these essentially literary men who had chosen painting rather than writing. On the other hand, three draughtsmen exerted a great influence: Victor Hugo, Gustave Doré and Rodolphe Bresdin.

Of all the works by Victor Hugo the poetic generation of 1880 preferred above all the *Chansons des Rues et des Bois* ('Songs of the Streets and Woods') and the late poems such as *Ce que dit la Bouche d'Ombre* ('What says the mouth of shadow'), written during a period of intense spiritualism. Quite apart from drawings done during seances, for the most part caricatures, hob-goblins and ghouls, the graphic work of Hugo is that of a visionary. Wood engravers beautifully reproduced these visions as illustrations for *Le Rhin* ('The Rhine') or *Les Travailleurs de la Mer* ('The Toilers of the Sea'). Drawn beside cursed romantic castles and storm-tossed lighthouses, ink blots become angels or skeletons, accidental stains become souls or flowers, ambiguities and metamorphoses provide prodigious leaven for the imagination: 'The magnificent imagination which flows through the drawings of Victor Hugo like the mystery in the sky' (Baudelaire).

Despite his facility and periodic vulgarities, Gustave Doré also contributed much. In the drawing-rooms of the bourgeoisie one found those heavy volumes bound in red and gold, mysterious in themselves, which were half-opened for well-behaved children. What provision for dreams! The castle of the Sleeping Beauty, crumbling under the creeper, the virgin forests of Atala, the black knights of *Orlando Furioso*, the ghost ship of the *Rime of the Ancient Mariner*. Highly regarded in England, even for his appalling paintings, Doré illustrated Coleridge, Tennyson, Poe; *The Raven* is perhaps his masterpiece because it is stripped of all picturesque qualities. Doré is as much the last of the Romantics as he is one of the first Symbolists; on his plates worked in *grisaille* the sea merges with the clouds, leaving one guessing at some fateful portent.

In complete contrast to Doré, Rodolphe Bresdin was hardly known at all. Artists sought out his lithographs because Baudelaire had liked them. Perhaps Grandville also had a certain influence with his metamorphoses, but it was to be considerably greater on the Surrealists. As for the Belgians, they were occasionally impressed by that late megalomaniac Romantic, Wirtz. The Symbolists accepted so many different sources of guidance that the list of influences could be much longer. Let us add that they were not much influenced by oriental art, that of the eighteenth century they only liked Watteau, that they ignored Venetian painters after Carpaccio, Flemish painters after Bruegel, and that they preferred the harmony of Ingres to the passion of Delacroix.

3. The Aesthetic

Any movement in art which rejects Nature and devotes itself to the Idea must have a library to serve as the purveyor of inspiration which is not received from the imagination. Such a library is at the heart of the Palace of Symbolism; a vast rotunda shielded from the direct light of day, a sanctuary and a library combined, as in the basilicas of the Ancient World. The dome is decorated with mythological figures arranged like the procession which Flaubert created to tempt St Anthony: Christ, Buddha, Isis, Adonis and other figures stand there, each with his own personal message and mysterious cult. Below this procession there is a pale frieze of muses and allegorical figures. The walls of the rotunda are covered with quotations from the prophets and immediate precursors of Symbolism rather than with paintings, and its doors are Rodin's *Gates of Hell*. In the flickering lamp-light stand the statues of Baudelaire and Wagner; these two tower above the statues of the other men who inspired the movement. Knowledge of the works of these men and their followers is essential to an understanding of the art in the rest of the exhibition.

There were many reasons for venerating Wagner. He had composed music of ecstasy, and given dream-images a concrete form: 'An absolute which is at last understood emerges from the retreating waters; it is like a mountain peak which stands isolated and glittering in all its brilliance. The vision of the future . . . a monster which cannot be' (Mallarmé). In the music-drama *Parsifal*, he had lauded the virtues of renunciation and created a model of mysticism easily adopted by the Symbolists. Most important of all, he expressed the need for Faith in the creative process, a need which Villiers de l'Isle Adam later discussed in an article in the *Revue Wagnerienne*: 'When an object is created without faith, it can never be a work of art because it lacks the vital flame which rouses, lifts, grows, warms and fortifies; instead it carries that odour of putrefaction which results from the frivolity of its creation.' The *Revue Wagnerienne*, published between 1885 and 1888, played an important part in the flowering of Symbolism. Next to literary contributions by Mallarmé and Verlaine, and lithographs by Fantin-Latour and Redon, there were articles by Schuré which suggested that Wagner had developed from a reawakening of Celtic and Germanic myths to an appreciation of oriental mysticism. Seen in this context, Wagner's Parsifal becomes a Christian Buddha and his music the means of transporting ordinary people into a world of ecstasy (6). Gods and Ecstasy were the two principal demands made by the rebels against a world dominated by Positivism and Rationalism, and these could be found in Wagner.

The appreciation of Wagner in England was slight. This fact might account for the washed-out visual interpretations given to his work by the followers of Burne-Jones. Bad paintings in the style of the German picturesque tradition are also found in the illustrations to Wagnerian operas by mediocre French and Belgian painters such as Bussière and De Groux. An exception to this general rule is found in a drawing by Delville which captures the spirit of the sublime in *Tristan and Isolde*. It was not, therefore, as the purveyor of visual images that Wagner made his contribution to the Symbolist Movement, but as the creator of a philosophy which could be appreciated by artists as different from one another as Gustave Moreau and Puvis de Chavannes.

If Wagner provided the example of a successful artist who was deified, the friend of a king, the man who was loved by several remarkable women, the composer who died at the height of his glory, Baudelaire represented a consolation for the people who could no longer fight against the century, an excuse for that quintessentially Symbolist phenomenon—the man of failure, and an example of the self-consciousness so earnestly sought after by the young artists. Although Rodin and Moreau, two of the most important artists in the Symbolist Movement, acknowledged Baudelaire as their master, the influence of this writer upon the movement as a whole was transmitted through his poems rather than

through his art criticism. His poems provided an inexhaustible supply of morbid or macabre images for all artists of the Imagination, whereas his *Salons* and even the essays on Delacroix seemed little suited to the Symbolists' taste. They regretted his admiration for Manet although they found some consolation in a phrase which he used to describe the artist of *Olympia*: 'You are merely the first artist in the progress of decadence in painting.' In the case of Courbet, the artist whom Maurice Denis was later to describe as an 'ignorant genius who utters legendary inanities', they could only comfort themselves by remembering that it was Baudelaire's discovery of Edgar Allan Poe and the supernatural which finally dimmed his admiration for the painter of the *Artist's Studio*. At the same time they eagerly noted that Baudelaire's study of Joseph de Maistre led him to accept a theocracy and renounce the misguided beliefs of the '48 Revolution. The Symbolists could also trace the influence of Swedenborg in his poems as well as in the famous definition of correspondences given in *L'Art Romantique*: '(These are) the affinities which exist between spiritual states and states in nature; those people who are aware of these correspondences become artists and their art is of value only in so far as it is capable of expressing these mysterious relationships.'

When we read Baudelaire's comments about Chenavard's immense *grisaille* decorations in the Panthéon where he states that 'there are things in this artist's mind which are not clearly revealed; they only appear through a veil of mist . . . Let us assume that Chenavard is greatly superior to all other artists; then he is not animal enough, and the other artists are not spiritual enough'; and when we meet the same reserve in his comments on a series of paintings by Janmot called *Le Poème de L'Âme* ('The Poem of the Soul') we are left with the impression that Baudelaire preferred good painting to high-flown ideas. It would be interesting to know whether Baudelaire would have appreciated the paintings of his followers, especially when one has to include among them the work of that talented but sick draughtsman Félicien Rops. This artist rescues himself from obscenity by the sheer horror of his illustrations, in which he exaggerates to the limit the most disturbing passages of the *Fleurs du Mal*.

Baudelaire's famous poem, *Les Phares* ('The Beacons'), did not manage to obtain a place for Rubens and Michelangelo in the Symbolists' museum, next to the other deities whom he mentions: Leonardo da Vinci, 'a deep and sombre mirror'; Rembrandt, 'a sad hospital of whispers . . .'; Watteau, 'this carnival'; Goya, 'a nightmare full of things unknown . . .'; and Delacroix, described at greater length in the poet's own notes as 'A blood-red lake—haunted by angels of evil; supernaturalism—a wood which is always green: green is complementary to red—a sky of affliction; the tumultuous and storm-ridden backgrounds to his paintings—the fanfares of Weber: ideas of romantic music awakened by the harmonies of his colour.' Delacroix's theory of colour symbolism as described by Baudelaire was taken up thirty years later by the critic of *L'Ermitage* when writing about Gauguin (7). In the case of the poem, *Correspondences*, it was the critic of *La Plume*, Albert Aurier, who was to write a commentary upon it. (Both these were magazines closely associated with Symbolism.) Almost every poem in *Spleen et Idéal* also contains at least one of the essential ideas of Symbolism.

Beside Baudelaire and Wagner, figures for whom there was a special cult, we find Swedenborg, Mallarmé, Verlaine and Edgar Allan Poe in the hierarchy of the prophets of Symbolism. Swedenborg, the eighteenth-century Swedish visionary philosopher, tended to be generally referred to rather than have his philosophy given practical application. Known to the French reader through a translation published in 1867 and above all through Balzac's novel *Seraphitus Seraphita*, it was again Aurier who described his influence: 'There are correspondences between the spiritual world and the natural world; things which exist in the natural world through the spiritual world are termed "representations". . . .' Aurier then goes on to distinguish two tendencies in the development of art which depend 'the one on the clairvoyance, the other on the blindness of this inner eye of man about which Swedenborg writes, the tendency towards realism and the tendency towards ideism'.

These remarks about Swedenborg suggest a parallel with Hegel's theory of the existence of a pre-ordained harmony between the Idea and the Form. The German philosopher, whose work was translated into French in 1875, was to exert a very considerable influence on Puvis de Chavannes as well as on Villiers de l'Isle Adam, who declared to Mallarmé that Hegel was one of the 'titans of the human spirit' (8).

Swedenborg and Hegel, together with Novalis, were the sources of inspiration for two French idealist philosophers much admired by the Symbolists: Hello and Schuré, author of the *Grands Initiés* (the 'Great Initiated'). From this work it was but a short step to the cult of the esoteric: 'The occult sciences constitute one of art's most important and fundamental cornerstones. Every true poet is by instinct an initiate; the reading of spell-books awakens in him the secrets of which he has always subconsciously been aware' (Charles Morice). And out of this cult grew a large number of esoteric reviews: *L'Initiation* ('The Initiation'), *Voile d'Isis* ('The Veil of Isis'), *Psyché, La Haute Science* ('The High Science'), *Cœur Illustré* ('The Illustrated Heart'); the works of Eliphas Lévy were read with great enthusiasm, and the Belgians immersed themselves in those of Louis Delbecke: *L'Harmonie Universelle* ('Universal Harmony'), *Le Fond de la Boîte de Pandore* ('The Bottom of Pandora's Box'), and the *Sphinx Evangélique* ('Evangelical Sphinx').

The ideas of Swedenborg were also adopted by Poe, who, in turn, influenced the Symbolist imagination in two ways: he originated the images of drowned people and crumbling houses reflected in stagnant pools of water, and evoked that atmosphere of suffocating vegetation and overpowering odours which can be experienced in some of the paintings by Degouve de Nunques and Lévy-Dhurmer. Although his debt to Swedenborg should be mentioned, it is the contrast between the philosopher and the poet which is important in considering the complex nature of the Symbolist Movement. As A. Orliac has pointed out in his book *La Cathédrale Symboliste* (the 'Symbolist Cathedral') (1933), we must make a distinction between white Symbolism and black Symbolism. Whereas the former originates with Swedenborg and includes Puvis, Denis and Aman-Jean, the painters of angels and flowers, the latter stems from Poe and is the source of inspiration for Moreau, Khnopff and the painters of cruel, death-ridden chimeras.

The relationship which existed between the Symbolists and Baudelaire was to a certain extent reproduced in their relationship with Mallarmé. Being closer to them in age, he was in a position to have a more immediate impact on them. They certainly looked upon his poetry as the oracles of a magician and piously presented themselves at his famous Tuesday soirées. Although Mallarmé liked Gauguin and Puvis de Chavannes, his artistic tastes really lay with Impressionism. Furthermore, the difficulties encountered in comprehending his poems and even his critical essays like the one on Beckford tended to make their emotional appeal less direct than the work of Baudelaire. In spite of this, Mallarmé did provide certain ideas which were adopted by both painters and poets: 'To describe an object is to eliminate three-quarters of the pleasure found in a poem, since poetry is the joy of gradual discovery; the dream is to suggest. That is the perfect use of the mystery which makes up a symbol.'

Verlaine was closely related to Mallarmé. Too literal to be regarded as an oracle, he was canonized instead. As M. Lethève has pointed out, the beatification of Verlaine and the mystery surrounding Rimbaud are the two most curious examples of myth-making indulged in by the Symbolists. Up to the time of the Surrealists Rimbaud was more admired for his personality than for his writings. As in the case of Lautréamont, his appeal was limited to a few, for his taste for violence and the macabre put off those who, even though they wished to escape from the world, had no desire to descend into Hell. It was in the work of Verlaine that this gentler form of escape could be found: melancholy pleasures, abandoned parks, distant waltzes, and pious paintings hung on the walls of taverns. Verlaine was the link between Decadence and Symbolism (9). He was also an indulgent teacher and easy to follow:

Car nous voulons la nuance encor	('We want nothing but suggestion
Pas de couleur, rien que la nuance!	No more colour, just suggestion!
Or la nuance seule fiance	For suggestion alone can marry
Le rêve au rêve et la flûte au cor.	The dream to another dream, the flute to the horn.')

Verlaine was the inspiration for some of Debussy's and Fauré's most beautiful music, for Maurice Denis' and Bonnard's best illustrations, and for Aman-Jean's most charming decorative compositions.

Verlaine was overshadowed, however, by a figure of even greater importance: Maeterlinck. Over a period of four or five years, this writer succeeded in captivating the heart of Europe and creating an entirely new attitude to, and style of, life (10). This position was first pointed out by M. Jean Cassou when

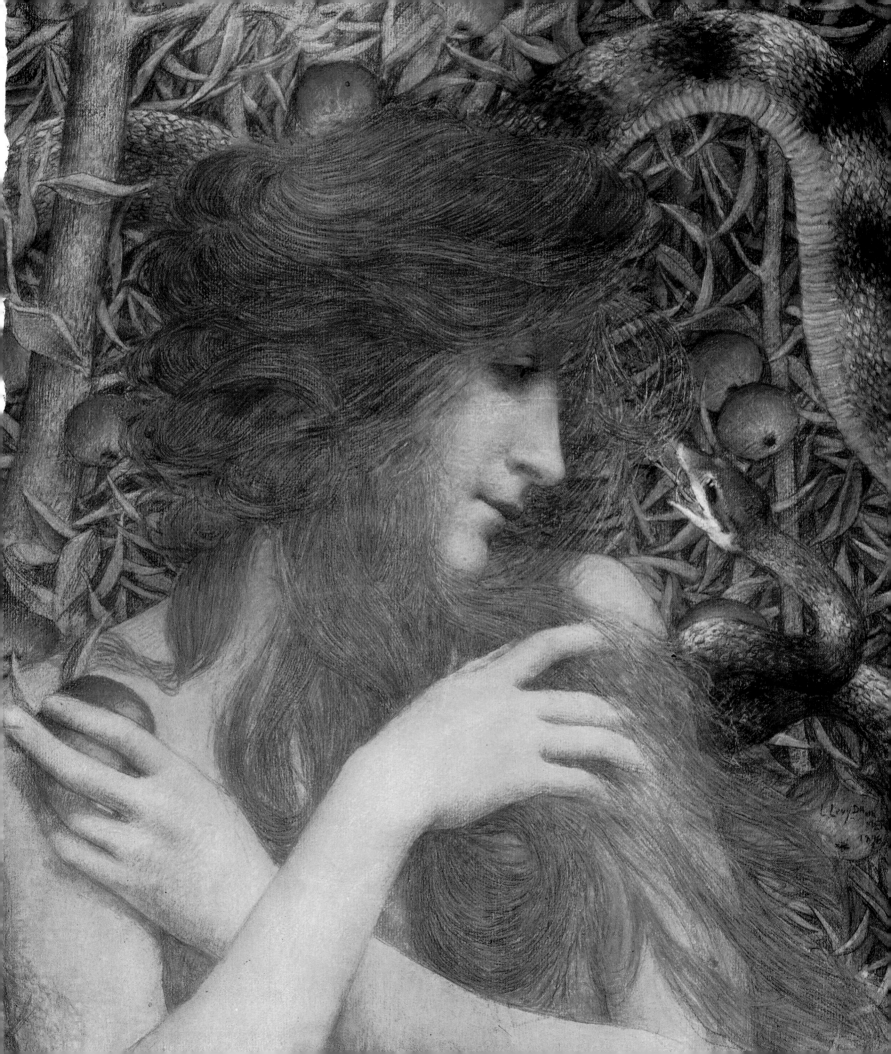

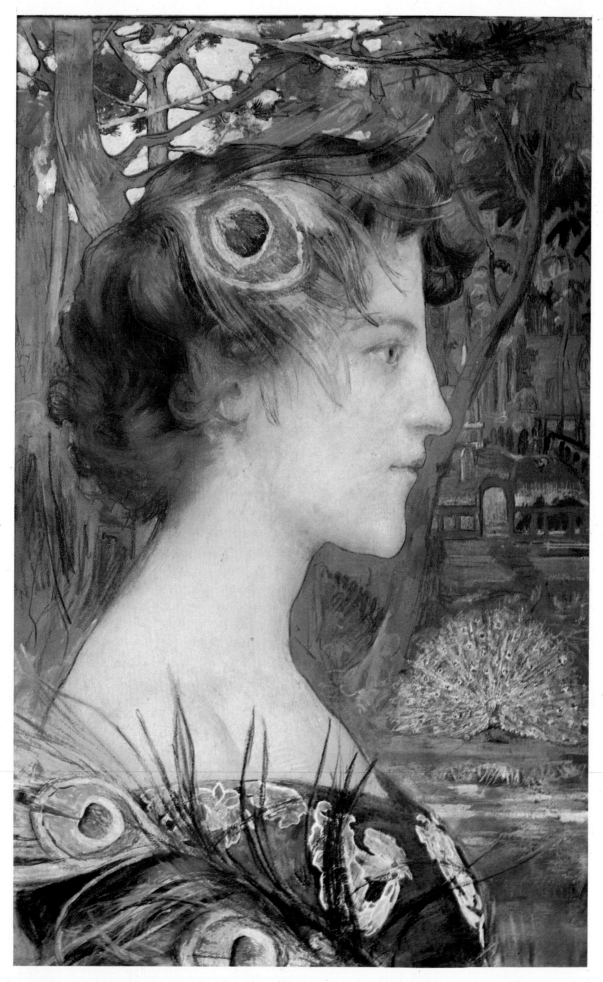

writing in 1960 in connection with the exhibition *Les Sources du XXème siècle*. In 1885, Maeterlinck had translated the work of the Flemish mystic, Ruysbroek l'Admirable. In his preface, Maeterlinck provided a definition for a completely new aesthetic, 'neo-mysticism': 'a straining towards invisible truths which is supported by a language in which the Word has been re-invested with its original and almost divine meaning'. Robust and articulate, unlike the characters of his plays, this young writer from Ghent soon attracted an artistic circle whose most distinguished members were Doudelet and Minne—the illustrators of his poems and the designers of his stage sets. With the production of his play *Princesse Maleine* at the Théâtre de l'Œuvre, Parisians applauded a 'new Shakespeare' and Octave Mirbeau told the readers of *Le Figaro* that this play was 'a wonderful, pure, immortal masterpiece'.

Oscar Wilde of course borrowed from all the writers mentioned, but above all from Maeterlinck and Verlaine; if we were less charmed by his style and his imagination, it would be easy to show how much he owed to Pater, Swinburne, Carlyle and Hegel in his essays on aesthetics. Alas, Wilde was endowed with too sharp a wit to be able to play the role of Plato in the Aesthetic Movement; an act of fate made him its Socrates. In his essays, such as the *Decay of Lying* and *The Soul of Man under Socialism*—both of which rapidly became known in France—one can find among the verbal gems and flowery emotions a collection of ideas worthy of a hand-book for the 'Perfect Symbolist' (11).

Another dandy—although clad in armour—was Maurice Barrès; the political involvements and Nietzschian superiority of this writer have tended to hide the influence of his charming youthful novels on the Symbolist generation. In them he developed an elaborate 'cult of self' based upon a pattern of life governed by Beauty; whenever a sense of duty weighed too heavily upon the somewhat unstable shoulders of this patriotic aesthete, he would take recourse to his precepts of Beauty (12).

Beside these personalities, who were crowned with spectacular and often precocious success, the figure of Villiers de l'Isle Adam may appear slight. He was regarded as a writer of significance only by a few people who were fascinated by the overwhelming failure of his life. This claim to failure gave an allure to his uneven literary output which was dedicated to art and imbued with some of the ideas which the Symbolists were later on to make their own (13).

The plight of Saint-Pôl-Roux was even more unhappy than that of Villiers. His genius was far too bizarre to be acceptable to his own time and his vision of an art cloaked in splendour was too heady for the dwellers of the Ivory Tower (14). He had to wait for the Surrealists to acquire a following. In spite of this rejection, he was a martyr to Art-for-Art's-sake and wrote that 'the resurrection of Lazarus seems to me to be the most perfect symbol of art'.

The walls of this imaginary Valhalla also bear the names of two writers of the older generation appearing like the mosaic monogram of Christ among the intertwining arabesques of Schwabe and Mucha: Balzac and Flaubert. Balzac has earned his position here both on account of his belief in the supernatural and his hope for a reinstatement of a Catholic monarchy in France, and because of his appreciation, in *Le Chef d'Œuvre Inconnu* ('The Unknown Masterpiece'), of the agonies which an artist can experience during the creative process. He inspired both Beardsley and Rodin. Flaubert's inclusion does not rest upon his reputation as the author of *Madame Bovary*, but as the creator of the mystical, exotic world so venerated by the Decadents; he was the recorder of visions in the *Tentation de St-Antoine* ('The Temptation of St Anthony'), illustrated by Redon, and the writer of the tales of *St-Julien l'Hospitalier* ('St Julian the Hospitaler') and *Herodias*, the territories of Gustave Moreau.

Although mysterious rites bathed in incense and sometimes mingled with sacrilege take place in the crypt of our basilica, Catholicism retained an attraction for some of the Symbolists. The Catholicism which they admired was not the modernistic faith outlined in Pope Leo XIII's encyclicals or its revolting artistic expressions, but the faith of men such as Léon Bloy and Barbey d'Aurévilly which rejected all accommodation with the nineteenth century. The Catholic chapel in the basilica is built in the Byzantine style with Christ portrayed as an emperor surrounded by avenging angels. It is the sanctuary of the Holy Grail, and its worshippers, like Huysmans and other recent converts, will never entirely shake off a slight odour of burning faggots. Indeed, the Symbolists' deep-seated pessimism derived not only from a rejection of the world, but also from a disgust with a form of Catholicism which itself had become materialistic.

Opposite:
2. Edgar Maxence:
Peacock profile. Before 1896.
Pastel and gouache with
silver paper, 46 × 30 cm.
Coll. M. Gérard Lévy,
Paris

4. The Setting

From the basilica of myth and magi with its suffocating atmosphere of dreams and mysterious rites, we pass into the garden at the centre of the Palace of Arts. This is like a vast cloister—full of flowers and lit by a weak light which filters through the rows of columns and the overhanging branches of trees. Ornamental pools reflect the faces of countless Narcissuses and Ophelias between the fleeting shadows cast by passing clouds. The water from these pools flows along sluggish canals through intertwining reeds like tresses of hair:

> *Les choses dans l'eau vaste échappent à leur loi*
> *Et plongent un moment dans un ciel sans durée*
> (Rodenbach)
> ('In an expanse of water, solid objects defy the laws of gravity
> And soar for one brief moment into a limitless sky').

When music ceases, the only sound to be heard is the gentle fall of water in the fountains.

The garden is like those painted by late medieval artists from the banks of the Rhine or from Northern Italy where Madonnas and courting couples stroll, far removed from the squalor of the cities and the tumult of war. It is a paradise garden with its paths well raked, with its arbours and its fountains to invite meditation upon love, a poem, a painting; it is an Ivory Tower or the courtyard of a Symbolist Palace. Pessimism and disdain for vulgar achievement have banned the words 'progress' and 'success'. Once artists have admitted a need for failure, it is of a garden like this that they dream: a fatherland for idealists, an oasis for the victims of the century, the home of an aesthetic aristocracy to which the Symbolists in their capacity as voluntary dropouts almost always aspire (15). This is also the garden where Klingsor grows the flower girls who will set out to conquer Parsifal; all women want to be flowers here, and the aesthetes, like Wagner's magician, teach them to be beautiful. Here one also finds Mélisande's well, the laurel trees of Puvis de Chavannes' 'Sacred Wood', and Burne-Jones' briar-roses. Here Gustave Moreau fashions out of ivory his allegorical figures which then turn to gold in the sunset against a background of Böcklin's cypress trees. Here reign Maurice Denis' mauve shadows, that transform his most bourgeois scenes into the visions of fairyland. Here Degouve de Nunques and Lévy-Dhurmer release their white peacocks.

The paths lead towards the frescoes of dead cities painted on the walls of the cloister: Florence and Venice, Oxford and Bruges—above all Bruges, the capital of Symbolism, with its Gothic stones reflected in the waters of the canals, the sanctuary of the Golden Fleece and the shrine of Memling's St Ursula, the city of mystery in which a canon whom Huysmans knew celebrated black masses, where Rodenbach's characters died of jealousy, a city like the partially submerged and half-forgotten town of Ys, deserted like the town shown by Khnopff in his best drawing. Venice was more the capital of aesthetes, Byzantine and exotic for Gustave Moreau, shrouded in mist for Whistler. And Florence, Ruskin's 'city of the soul', provided more inspiration for poets than for painters, with the exception of Maurice Denis, who spent some time in Fiesole. Some places that one would have expected to be popular, such as Ludwig II's castles, never appear in Symbolist paintings; they were too solid and definite and left no room for dreams.

Symbolism developed a complete language based on flowers. Some flowers were indeed banned from the garden because of their strident colours or their popularity in municipal gardens, and others, such as the dazzling sunflower, were only admitted through the good offices of Walter Crane and the English Aesthetic Movement. Lilies were ubiquitous—innocent in appearance, disturbing in their

scent, and gathered by the Primitives; Schwabe made them his hallmark. The iris, the flower of the Modern Movement, could be found in Mucha's posters, Lalique's jewellery, Lorrain's poems—in which it was dyed black and became a phallic symbol. Orchids, which were found so frequently on Gallé's vases and in the corsages of Proust's Odette, were of little interest to the painters. The blue hydrangeas growing around the fountains dear to Robert de Montesquiou were painted by Helleu and Le Sidaner. Towards the end of the Symbolist Movement, violets became the flowers of Lesbos for Renée Vivien. Dead roses which were so loved by Poe and Verlaine withered at the feet of a statue of a sphinx. Dead leaves which covered the paths in October, the month of Decadence, formed patterns as in a tapestry by William Morris; they were burnt by the girls in Millais' picture, in a bonfire which created the smoke for the paintings of Carrière. In the garden of the palace one feels that all will soon be transformed into the mauve shades of Dulac's and Osbert's landscapes (16).

A heraldic system was also elaborated by the Symbolists as a means of portraying states of the soul. By the suggestion of a flower or the position of a bird it was often possible to read a painting like a coat of arms. Swans brought back memories of Lohengrin, of the canals of Bruges and of the Isis at Oxford. Peacocks remind us of Whistler as well as of Byzantium. And the Blue Bird, which flits among the trees, was first released by Maeterlinck and then given wing by Wilde in the *Decay of Lying* (17).

Who were the people strolling in this garden? They were those who wished so fervently to become spirits that they soon became nothing more than shadows: women dressed in long shifts with their hair tied in a headband or allowed to flow freely down their backs, women who wished to imitate the maidens of Chelsea. The wisest among them took Puvis de Chavannes' St Genevieve as their ideal; the more fashion-conscious wanted to look like de Feure's drawings; the foolish virgins borrowed their jewels from Moreau's Salome. Some of them dressed in hessian, archaic and lily-like, provincial maidens who moved through the poems of Francis Jammes and the paintings of Aman-Jean, naïve girls of Pont-Aven, ladies painted by Khnopff who looked like the Princess of Wales, but with what *soul*! In the arbours we meet the characters of the past twenty-five years of literature; we move from Laforgue's consumptive Englishwomen to Fournier's Mademoiselle de Galais, Claudel's heroines and Rilke's mistresses. This mixed crowd, however, is no brilliant carnival train but a procession united in expression and in the tone of its members' appearance; the irony of Mona Lisa's smile often belies the hands clasped in prayer.

The women who strolled in the garden did not belong to a wide variety of social classes; they came mostly from the educated bourgeoisie and sometimes held advanced views. They expressed their revolt against conventional life by sleeping with painters. The richer upper middle-class women were often Jewish, and like Mme Verdurin they suffered from aesthetic migraines and reigned over a select group of 'madly arty people'. Society ladies tended to follow the example of the Baronne Deslandes; she fêted the writers, had her portrait painted by Burne-Jones and was a great friend of Oscar Wilde. Liane de Pougy, who had gained access to the garden through her aesthetic relationship with Jean Lorrain, created a disturbance among both male and female strollers as a result of her innocent beauty and scandalous habits. The headbands of Cléo de Mérode, the gothic poses of Marguerite Moreno, and the dresses of Georgette Leblanc, Maeterlinck's companion, inspired by Mélisande, were all imitated. Eleonora Duse's poignant simplicity and beauty of gesture that said so much more than words and were painted by Khnopff and reproduced in bronze by Rodin, were also copied. And Sarah Bernhardt can be included in the choir of Symbolism's muses; whether in the role of the *Princesse Lointaine* (the 'Distant Princess') or of *Gismonda*, she popularized the Symbolist aesthetic in much the same way as Clairin, her favourite painter, popularized her image in his academic renderings of high-flown subjects.

The watercolours of De Feure, the drawings of Khnopff and the pastels of Aman-Jean confirm that there were exquisitely beautiful women amongst the friends of the Symbolists. One can guess from the caricatures of the time that many of the painters were flanked by the sort of aesthetic female admirers 'who revenge themselves for the curse of their sex by making religious music' (*qui se vengent de leurs fleurs blanches en faisant de la musique religieuse*) whom Baudelaire had already discovered some fifty years earlier in the work of Ary Scheffer (*Salon of 1846*). Such caricatured portraits are found for instance in Willy's *Maîtresses d'Esthètes* ('Mistresses of Aesthetes'), in Jean Lorrain's *Pelléastres*, and

especially in the novels of Rachilde. Whereas it would be pointless to search in *Monsieur Vénus* or in the *Marquise de Sade* for a definition of Symbolist love, it is possible to find in these characters the perverted eroticism which provided the Symbolists with yet other means of escape from their century. Having already interested Swinburne, these sadistic and even necrophiliac horrors provided the favourite themes for such poets as Samain and Gilkin. Incest appears in Elémir Bourges' *Crépuscule des Dieux* ('Twilight of the Gods') but blessed by precedent (it had also appeared in Wagner's *Ring*). Perversion and lesbianism can be guessed at in the novels of Jean Lorrain and Catulle Mendès. Nevertheless nothing was so disturbing in fact as purity for the seekers after the insubstantial (18, 19).

The art of 'telling all' in an exquisite manner was really no more than a rhetorical trick and it seems unlikely that Rémy de Gourmont or Albert Samain ever actually experienced the tormented love-affairs which they described. However, the Decadents did revel in manifestations of evil such as the description of a black mass in Huysmans' *Là-Bas* ('Down There'), and it is through this poisoned atmosphere that we should see Jeanne Jacquemin's pastels, Lenoir's drawings and the blackest visions of Delville.

There were some novels which became the canvases upon which the strollers in the garden could embroider their own personal experiences. There was, of course, *A Rebours* ('Against Nature'); there were also the novels of Elémir Bourges, mentioned above, *La Crépuscule des Dieux, Les Oiseaux s'envolent et les Fleurs tombent* ('The Birds Fly Away and the Flowers Fall'), fabulous treasure-troves, dream-gardens, melancholic archduchesses and chimeric grand-dukes with attendant legions of mistresses and servants. There was the *Picture of Dorian Gray* with its complete recipe of how to live and how to come to a bad end. For the more intense there were *Il Piacere* ('The Child of Pleasure') and *Le Vergini delle Rocce* ('The Virgins of the Rocks') by d'Annunzio. The basic style was the same as that first developed by Jules Laforgue in his book *Moralités légendaires* ('Mythical Moralities'), published in 1885; in this book, subtle ideas were expressed with great simplicity in a way which invited comparison with the suspended notes in musical cadences. (The series of novels about Jean Christophe by Romain Rolland, which appeared a little later, owed a good deal to the musical atmosphere of Symbolism.) However, the most perfect example of a Symbolist novel, *Demian*—one of the first to be written by Hermann Hesse—remained unknown in France; in it we meet those intense, adolescent girls of Khnopff, who seem more withdrawn than mysterious. There was also Dujardin's *Les Lauriers sont coupés* ('The Laurels are Cut'), a typical Symbolist novel with its tale of jealousy couched in a vague interior soliloquy (20); it has been dug up recently, as a possible source for *Un Amour de Swann* ('Swann in Love'). Proust, however, was too interested in social relationships to confine himself within the limitations of poetic writing. The Symbolists liked the world in the Proustian sense no more than in any other. This attitude is characteristically revealed in the passages full of escapism and irony in *Sixtine*, a tale by Rémy de Gourmont (21).

The Symbolists were people who loved intimate relationships and shrank from bright lights. They enjoyed a gentle stroll with a fellow-spirit, or, better still, with a book in their hand—and they read more poetry than novels. These self-styled heroines of writers' tales, these painters' models, these friends of musicians (such were Debussy's early mistresses) lived as if they were imitating the characters described by their favourite poets. It was an epoch of silent women. They dreamed of being loved by an artist who would die in the prime of life, and indeed two of the most characteristic of Symbolist writers, Albert Samain and Georges Rodenbach, died before they were forty. Mallarmé blessed the former with the words: 'Your friend always gives the luxurious impression of having all the time in the world'; the latter was described as the poet of 'pale water which passes along channels of silence'. Samain's lines were known interminably, from: 'My soul is like an Infanta decked in her processional robes . . .', to 'I dream of soft verses and intimate warblings, of lines which will touch the soul as lightly as a feather', or, 'There are mysterious evenings when flowers acquire a soul'.

It was the Belgians who probably held the most prominent position in poetry during this period. They lived in a society in which the medieval traditions were better preserved than in France, where works of art were still to be found in churches and so retained some of their original mystery which is killed in the atmosphere of a museum. A walk through Ghent will suffice to show that the Belgians'

love of the past was no elaborate reconstruction such as the Pre-Raphaelites had undertaken, but rather a revival of existing traditions. Ghent was also the birthplace of one of their greatest poets: Maeterlinck. Ever since the publication of his *Serres Chaudes* ('Hothouses') in 1889, this poet had provided a mine of images for painters; the isolation of the artist in society described in the *Cloche à Plongeur* ('The Diving Bell'), for example, immediately reminds us of paintings by Delville:

> O plongeur à jamais sous la cloche
> Toute une mer de verre éternellement chaude

> ('O diver for ever in your diving bell,
> A sea of glass, eternally warm').

The poet and art critic Verhaeren wrote of the *Serres Chaudes*: 'These fluid images depend so much on indistinct outline and fuzzy drawing that all attempts at definition would be false . . . From this anguish, from this uncertainty comes a seductive power. . . .' In Verhaeren's own work collected under the titles of *Villes Tentaculaires* ('Octopus Cities') and *Campagnes Hallucinées* ('Haunted Landscapes'), we can find parallels with pictures by De Groux and Spilliaert. Redon supplied him with a lithograph for the frontispiece to his first volume of published poems. One is reminded also of the fine drawings of Gustave Doré when reading Verhaeren (22). Such parallels between text and image can also be found in the work of other Belgian writers: Grégoire le Roy's work immediately evokes a garden painted by Degouve de Nunques, and Max Elskamp's *Tour d'Ivoire* calls to mind some small corner of an engraving by Bresdin (23).

Parallels between poetry and art can also be found in the work of French poets at this time. Redon comes to mind when one reads one of Moreas' poems (24), and Gustave Kahn comes close to Khnopff in his *Palais Nomades* ('Nomad Palaces') (25). Stuart Merrill and Francis Viélé-Griffin, two American poets who settled in France at an early age, became the most representative writers of the Symbolist Movement in Paris apart from Henri de Regnier. Stuart Merrill's wife inspired a portrait by Delville which became the Gioconda of the Nineties. It was also perhaps this woman who inspired Merrill to write: 'The enchantress of Thule has ravished my soul on her island'. These lines of Viélé-Griffin were much loved:

> Quand la pluie tombait sur le jardin
> J'ai pris la pluie entre mes mains,
> De la pluie chaude comme des larmes.

> ('When the raindrops fell on the garden
> I caught the drops in my hands,
> Raindrops warm as tears').

Rain is also mentioned in the poems of Henri Bataille, and in those of André Gide: 'It was raining and we turned up the lamps which the setting sun had temporarily eclipsed.'

Rustling through the dead leaves in the Symbolist garden, the figures of Claudel, Anna de Noailles and Paul Valéry flit past. It was in this garden that Alfred Jarry drew up a list of the people he most admired and entered them into his *Du Petit Nombre des Elus* ('Of the Small Number of the Elect') (26). This title reflects the Symbolists' desire to establish an intellectual élite; never had there been so many of the 'Happy Few'!

In order to gain access to this garden, the Decadents had to give up their sartorial and verbal extravagances. Superior to mere rebellion, they pushed away with the butts of their canes all that they did not like. As Decadents, they had shouted down the paternalistic pretensions of official art; but as Symbolists, 'dandies of the soul', their dislike of official art was more discreetly expressed. They came to dislike music-halls and quickly forgot the way to the *Chat Noir* (the great music-hall of Montmartre). They preferred the literary gatherings inspired by Mallarmé's Tuesday soirées which they found at Bailly's bookshop or in Mme Vanor's salon—Debussy's Egeria. The real Decadents belonged to Montmartre, the Symbolists to the Left Bank. The paths of the Luxembourg Gardens could almost be the paths in our

secret garden, and St-Germain-des-Prés was the area in which the small reviews had their offices—those salons-cum-chapels of the movement. The most famous review was the *Mercure de France* presided over by Rachilde, the wife of the director, who was always ready to accept anything new. Dujardin, at the *Revue Contemporaine*, tended to be more selective. The *Revue Blanche*, edited by Nathanson and originally published in Brussels, was both the most progressive and the most 'snobbish' of the reviews; during the past sixty years all the work which managed to survive the downfall of Symbolism is work that first appeared in this review: that of Denis, Roussel, Vuillard and even Bonnard.

The reviews also organized banquets which forced the 'souls' of Symbolism to mix with journalists, politicians and Paris society—the ivory tower must have seemed rather far removed from the banqueting halls. One of the most famous of these occasions was organized by the *Mercure de France* in February 1891. The president of the proceedings was Mallarmé. As he raised his glass to toast the guest of honour, Moréas, he declared that the writer had 'united the whole of dawning youth with some of their ancestors to celebrate his *Pélerin Passionné* ("Passionate Pilgrim")'. This toast was followed by numerous others to writers such as Baudelaire and Barrès. The company included Chabrier, Redon, Vanor, Seurat, Gide, Samain and Rops. Another banquet was held two months later at the Café Voltaire to celebrate Gauguin's departure to Tahiti; the importance of the occasion was not lost on the less travelled dreamers. Around Mallarmé on this occasion were Saint-Pôl-Roux, Redon, Trachsel, Carrière, Willumsen. These banquets provided an opportunity for the Symbolists to get excited but they booed the toast to the academician Brunetière at the banquet organized in honour of Puvis de Chavannes, because he spoke superciliously about the movement.

These banquets were disliked by two people who were involved with, but were not part of, the Symbolist world. They strolled in the Symbolist garden among artists and poets in order to discover the latest poetical trends which they then made available to the general public. These two were Count Robert de Montesquiou and Jean Lorrain; the Symbolists distrusted the former a little and the latter a great deal. Apart from providing the model for Huysmans' Des Esseintes, the Count wrote a series of rapturous articles which were responsible for bringing the names of Moreau, Whistler, Gallé and Bresdin to the attention of the smarter circles of Parisian society. He was Proust's 'Professor of Beauty' and wrote some very beautiful lines: *L'écharpe de la nuit flotte vers les cœurs sombres* . . . ('the cloak of Night wafts towards sombre hearts . . .').

Jean Lorrain was the Count's rival. He also wrote of lilies and peacocks, but rather less successfully; he celebrated artists such as Jeanne Jacquemin and Marcius Simons because they externalized his secret fantasies, and in his tales he transformed princesses modelled on Sarah Bernhardt into frogs. He took himself for the Merlin of the movement, with the Bois de Boulogne as his Forest of Broceliande, and for him Paris society was bathed in the mauve light of Symbolism. He can be compared with certain painters like Rochegrosse and Gaston La Touche who had also been affected by the movement. Both Lorrain and Montesquiou thought of themselves as 'artists'. They both wrote in an elaborate 'artistic' style like that of the Goncourts; Proust's Mme Verdurin summed them up with her favourite compliment, when she drawled: 'You are so much the artist.'

The fact that snobbery obliged that lady to like music rather than painting and to swoon on hearing a sonata rather than a poem, shows how important was the position occupied by music in the Palace of Arts. Reserving for the Basilica the blessed strains of Wagner, César Franck, Beethoven's Ninth and Palestrina, in the garden of the Palace one can hear therefore those sonatas of which Proust was thinking when he described Vinteuil's sonata, as well as the quartets and songs of Fauré, the *Demoiselle Elue* by Debussy, the themes of Chausson, the early compositions of Ravel, Schoenberg and Scriabin, and the voice of Mary Garden floating clearly over the fountains. The relationship between music and painting in this period was so intimate that works by Vincent d'Indy, Duparc, Albeniz, Chabrier and Ravel were performed against a background of paintings by Redon and Khnopff at the 1893 *Salon de la Libre Esthétique* (Salon of Free Aesthetics) in Brussels, and Maurice Denis was in demand as the designer of music covers.

The theatre played a rather less prominent role than music in the development of the Symbolist sensibility. Only Maeterlinck's plays—*Les Sept Princesses* ('The Seven Princesses'), *Pelléas et Mélisande,*

and *Les Aveugles* ('The Blind')—had an influence on the visual arts. Full of pregnant silences and pessimistic allusions, these plays were pale imitations of Shakespeare and Wagner's librettos in which the 'souls' could find much to fascinate them in the misty settings which left everything to the imagination (27). Theatres never quite achieved the exalted status of concert halls. However, the smaller theatres did commission young artists to design simple stage sets and programme covers. A little later, the Théâtre de l'Œuvre, for example, employed the artists who belonged to the circle of the *Revue Blanche*: Maurice Denis, Vuillard, Bonnard and Munch. The director of this theatre was the great actor Lugné-Poë, who had had the courage to stage productions of plays by Strindberg, as well as those of Ibsen who was regarded at the time as part of the *avant-garde*. The Symbolists liked the Scandinavian writers and artists for their simplicity, and they used them as sources of inspiration for interior design.

It has to be admitted that Symbolist theatre is a bore; only Claudel's *L'Annonce faite à Marie* ('The Annunciation') has managed to survive the disgrace of the movement. Even *Axel* by Villiers de l'Isle Adam has *longueurs* which make one think of Wagner without music. Paul Vérola's Hindu-style trilogy, *Rama*, which inspired Mucha, other Symbolist plays such as *La Belle au Bois Dormant* ('The Sleeping Beauty') by Bataille and d'Humières (with sets by Burne-Jones) have sunk into oblivion (28). Generally speaking, Symbolist plays tended to be totally unplayable, like Claudel's *Tête d'Or* ('The Golden Head') and the plays of Alfred Jarry and Saint-Pôl-Roux. On the edge of the Movement we find the plays of Rostand such as *La Samaritaine* ('The Samaritan Woman') and *La Princesse Lointaine* ('The Distant Princess'); the carefully detailed stage directions of these plays bring to mind the paintings of Maxence or Henri Martin.

All these musicians and poets, a few thinkers such as Schuré and the insipid Jean Lahore, some plays which were acts of suspended disbelief, provided the common intellectual background and idealism of the strollers in the garden. Mention should also be made of a name which forged links through the intense dislike he aroused: Zola. Through his glorification of money and the machine, and his support for democracy, this writer became the Symbolists' arch-enemy. His world was trivial, sometimes sordid as in *La Terre* ('Earth'), and his excursion into the world of fantasy, *Le Rêve* ('The Dream'), was felt to be an insipid ersatz; he was not forgiven for including a portrait of a failed Symbolist artist in *L'Œuvre* ('The Masterpiece'). His courageous support of Dreyfus brought little softening of this opinion among the Symbolists. A poster for the Salon de la Rose+Croix even shows Art brandishing the severed head of the novelist. After Huysmans' famous repudiation of Zola in 1885 the 'artists' did not miss any opportunity to attack him. Thus in 1891 Léon Bloy gave a lecture entitled 'The Funeral Rites of Naturalism', at Copenhagen. The Symbolists disliked Impressionism because Zola had supported it, but they disliked even more the Zolas of painting, whom they called photographic artists, such as Gérôme, Bouguereau, Gervex and of course Meissonier.

By nature anxious for a return to the past or dreaming of a distant and fantastic socialism the Symbolists, especially those nearest the Decadents, were closest politically to anarchism (29). The anarchist Jean Grave, editor of *La Révolte* ('Revolt'), was held in great respect in *avant-garde* circles, for he took up William Morris' ideas about the ugliness created by industry and proclaimed the absolute independence of the 'artist'. In the public mind the Symbolists were sometimes confused with anarchists; in fact they supported anarchism only in so far as they were disgusted by politics. This attitude is described by Alphonse Germain, the critic for *L'Ermitage* ('The Hermitage'), in his book *Pour le Beau* ('Forward Beauty'): 'Artists can feel nothing but disgust for politics . . . disgust for profiteers, for warmongers, and for colonialists', and he then went on to recall that it was the artists who had forged the real glory of France (30). Thus we will not find any political posters pasted to the walls of the garden. Instead the walls will be hung with paintings which guard treasured memories like dried flowers picked long ago in the garden—dead roses, long tresses of hair through which a face is barely visible, shutters behind which Schubert is being played, footprints of naked feet in wet sand, a glove left behind by a woman once loved, and masks which alone are capable, according to Wilde, of telling the truth.

5. Leaders and Critics

The intense literary ferment which accompanied the various manifestations of idealist art was responsible for creating far wider public support for the Symbolists than that enjoyed by the Impressionists. This success did not last for more than ten years, with 1891 being the year of greatest acclaim. Today, some eighty years later, with the revival of interest in these forgotten artists, it is only right that we should examine the ideas of the men who led Symbolist taste, with its plentiful prejudices and critics who encouraged and analysed the new idea of Beauty. The term 'Symbolist' was only generally accepted when the links between 'ideist' painting and Symbolist poetry had been recognized and defined, as they were by Jean Moréas in his famous manifesto of September 1886. However, people still hesitated between *Cloisonnistes* (Dujardin in the *Revue Indépendante,* 1888), *Néo-traditionnistes* (Maurice Denis in *Art et Critique,* 1890), *Idéistes* (Albert Aurier in the *Mercure de France,* 1891), *Symbolistes déformateurs* (Alphonse Germain in *La Plume,* 1891), and let us not forget the *Nabis,* or 'Prophets', who, by 1889, were combining all these tendencies.

Standing in the basilica, contemplating the statues, meditating on the inscriptions, the visitor to the Palace of Arts meets two personalities who, though rather different from one another, both burn incense and are passionately interested in all things unusual. The first one impresses us by his Latin fluency of speech and general appearance which earned him the appellation 'one-man orchestra of the infinite'; this is Joséphin Péladan, the self-styled 'Sâr', that is, 'magician' in ancient Persian. The more discerning visitor prefers to follow the other, a discreet, erudite and salacious sacristan, Joris-Karl Huysmans. Péladan is more important in the history of ideas; Huysmans was above all a great writer who reflected the tastes of his day.

Péladan could be compared to the 'self-made prophets' of the Hippie Movement had he not been so remarkably well-read and really gifted in everything to do with extrasensory activities. Born in Lyons, the son of a spiritualist, Péladan spent some time in Florence in order to study Dante and the Primitives, and then after a stay at Bayreuth, he arrived in Paris ready to conquer the city. From 1883 onwards he published in rapid succession a series of amazing novels under the collective title of *La Décadence Latine* ('Latin Decadence'). Two basic ideas emerge from this work; first, that the hermaphrodite is the creature of the Future, and secondly, that civilization, corrupted by materialism and lack of Faith, is heading towards its own destruction. Only an art based on music and magic which seeks its inspiration in a past Age of Faith will be able to save the Latin world. Several artists found their inspiration in his descriptions of the androgynous ideal (19).

Péladan, who knew less about painting than about music or the esoteric, cried out one Easter Day: 'Artist—you are the king! Artist—you are the priest! Artist—you are the Magician!' This proclamation certainly went to the heads of some of our artists. Always full of energy, the Sâr organized lectures and concerts for some time before the foundation of his famous *Salon*. He cast a spell over the last of the Romantic writers, the old Barbey d'Aurévilly, who provided prefaces to his novel *Le Vice Suprême* ('The Supreme Vice') (frontispiece by Khnopff) and to his collected essays, *Critiques de l'Art Ochlocratique* ('Studies of "mob-art"'), in which he congratulated the author on being 'the defender of the aristocracy, of Catholicism, and of originality'. One of Péladan's first disciples was Count Antoine de La Rochefoucauld, dubbed with the title 'archonte' after he had financed the Sâr's various projects. As much through his critics as through his supporters, Péladan rapidly became a vivid personality in Paris: he declared himself the leader of an esoteric order, the Rosicrucians (Rose+Croix), which had flourished in Germany at the close of the Middle Ages. By the age of thirty-four he attracted almost all the painters of the Ideal to these highly influential Rosicrucian exhibitions, in spite of the fact that not all the painters kept strictly within the terms of the main rules laid down in his 'Monitoire' (31).

Opposite:
3. Edmond Aman-Jean:
The girl with the peacock. 1895.
Oil on canvas, 150 × 104 cm.
Musée des
Arts Décoratifs, Paris

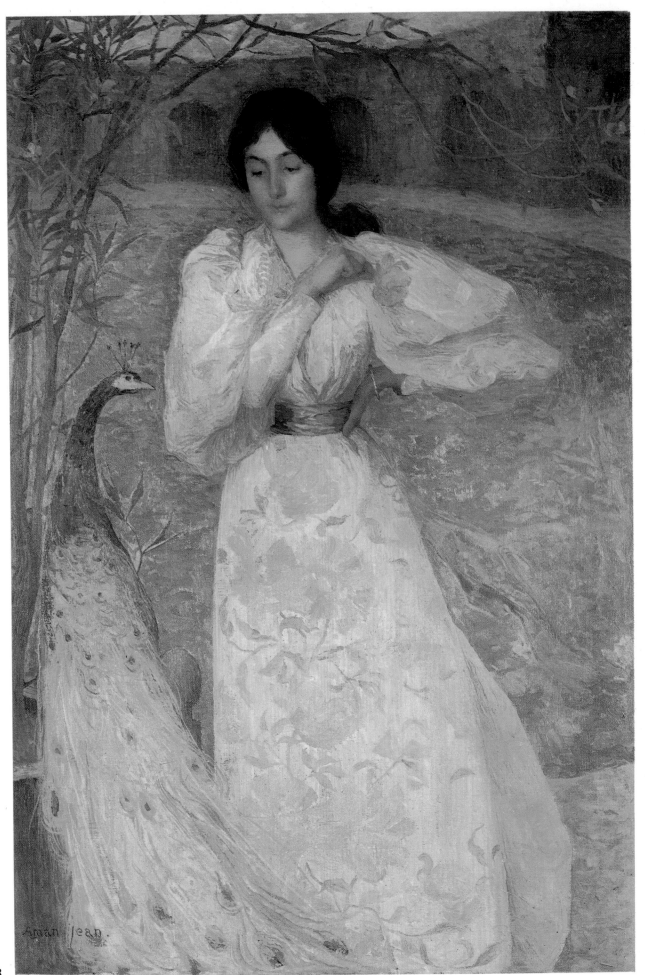

3

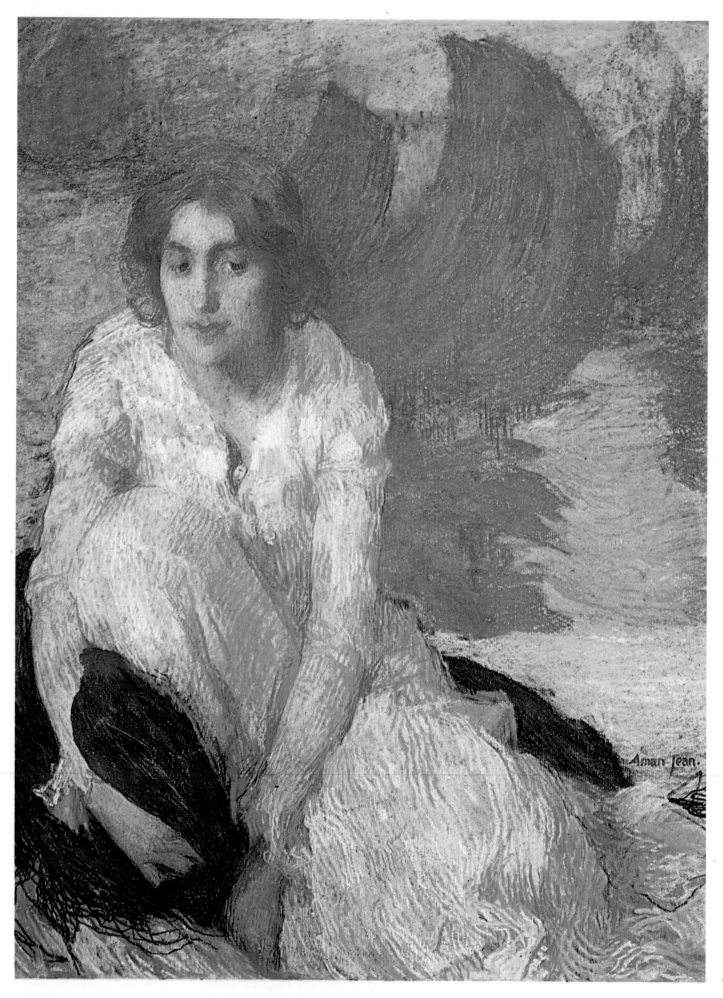

4

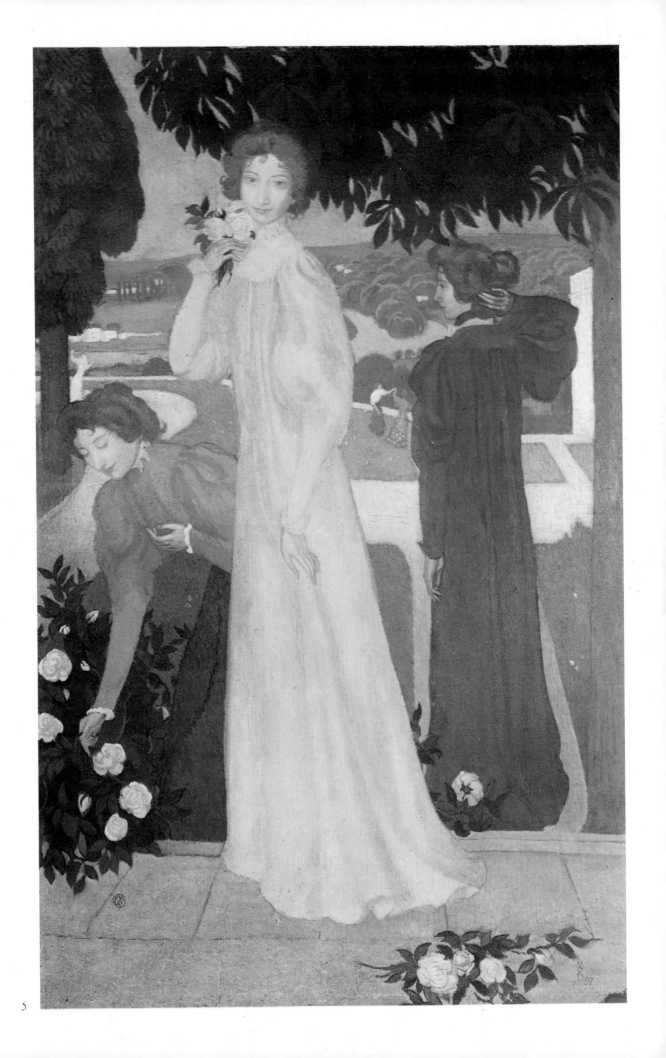

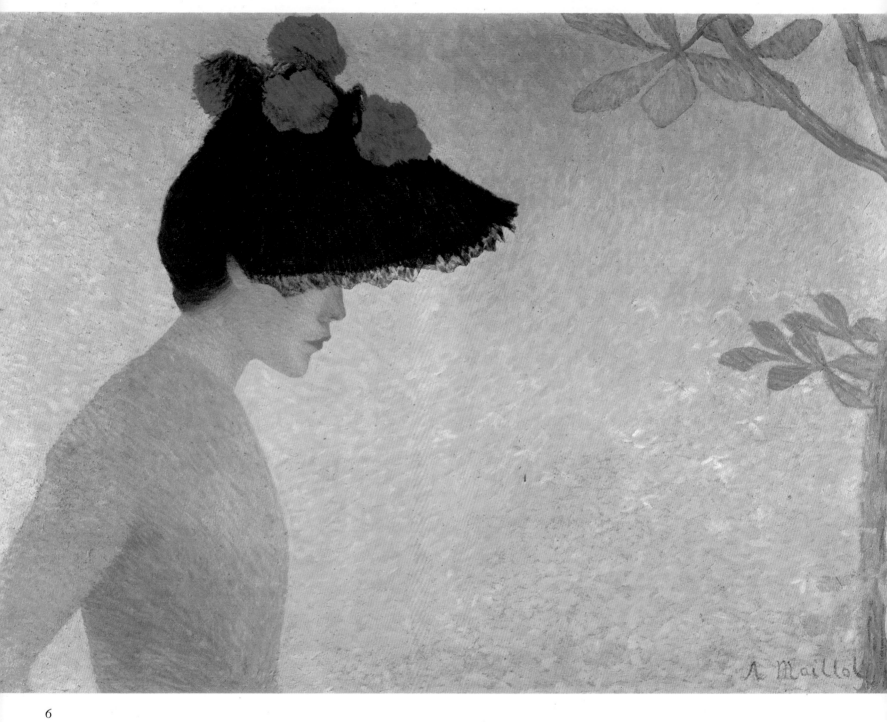

6

These rules were followed shortly afterwards by the cry: 'Artists! You who believe in Leonardo and in the *Victory of Samothrace,* you will be members of the Rose+Croix. Our aim is to tear out love from the Western soul and replace it with the love of Beauty, the love of the Idea, the love of Mystery. We shall unite the emotions of literature, the Louvre and Bayreuth in a state of harmonious ecstasy. . . .'

And the artists hurried to his call. The most notable among them were, however, not French; thus on 10 March 1892, at the Durand-Ruel gallery, the Parisian public was able to see Hodler's *Disappointed Souls,* Toorop's *Three Brides,* Khnopff's *Sphinx* and Delville's *Idol of Perversity.* Jean Lorrain, in his rather cutting review, also noticed Armand Point, Séon, and several others now forgotten (32).

For his part, the critic of the *Mercure* neatly summarized the situation by comparing it to the *Salon des Indépendants*: 'One can see therefore, that two separate schools exist at the same time: Impressionists and Symbolists. There are those who, with total objectivity, want to transpose on to an unprimed, vibrant canvas the pure, direct impression which one aspect of an object has made upon their sensory imagination; there are others who dissect this same impression in order to put it together again in their own time, according to their desire to express not the transitory but the permanent things, those things of eternal significance.'

The success of the *Salon de la Rose+Croix* among the younger artists was enormous. The Swiss artist Vallotton wrote, after having exhibited a series of drawings there, 'Now everyone is, or thinks that he is, a mystic or a Symbolist. The energy of past years has now given way to pale, mysterious works, to ghostly or cataleptic paintings, and the need for the quintessential is becoming widespread. . . .'

The following year, Péladan had an angry exchange with La Rochefoucauld who as the great protector of the painters of Pont-Aven had hung an *Annunciation* by Emile Bernard and a *Madonna and Child* by Filiger—both entirely in keeping with the Rosicrucian aesthetic—in the exhibition without Péladan's consent.

There were six *Salons de la Rose+Croix* held between 1892 and 1897; Schwabe, Aman-Jean and Khnopff designed their posters. In spite of derisive comments these exhibitions were always highly successful, and even if he did not succeed in attracting the masters whom he admired, Moreau, Puvis de Chavannes, Redon, Watts and Burne-Jones, Péladan could be proud of his achievement. Some of the *Salons* were held at the Palais du Champ de Mars and the final one in the luxurious gallery owned by Georges Petit. The Sâr was not present, however, at the opening of this *Sixième geste Esthétique* ('Sixth display of the Aesthetic Movement') at which Moreau had made his pupil, Rouault, exhibit; sensing a change in the prevailing atmosphere, he had gone on a pilgrimage to the Holy Land. On his return he devoted himself to a study of the work of Leonardo da Vinci and died in 1918 with no more than a handful of faithful followers.

Péladan had entrusted the propagation of his aesthetic gospel to Delville, and there was a series of *Salons* in the spirit of the *Rose+Croix* held in Brussels. Even today one can visit a Hall of Religions at the Theosophists' sanctuary in Madras which was decorated only ten years or so ago in a very poor imitation of Delville. Péladan was endowed with a genius for public relations and had a genuine goodness of heart, although he was not entirely disinterested, preferring as he did to lead rich women to the Truth; nevertheless he spurned any form of black magic with all its sinister incantations.

One can say exactly the opposite of Huysmans: sober and honest, but always ready to give in to the worst temptations right up to the day when he found salvation in a monastery. No one has ever known how to pour scorn on stupidity with so much verve, whether it appeared in the guise of vulgarity, pretentiousness or bad taste; on the other hand he was always indulgent for anything odd or out of the way. His name, Dutch in origin, with the initials 'J-K', by itself suggested something cabbalistic. In his early naturalist novels, he revelled in the sordid, and his art criticism extolled the Impressionists. Huysmans was reponsible for introducing the suburb into literature; then, disgusted by the omnipotent Zola and bored by the limited horizons of his universe, he published *A Rebours* ('Against Nature') in 1884, a book which immediately became the bible of the Decadents, and imposed his personal taste on the Symbolists.

Using as a model the figure of Robert de Montesquiou (whom Mallarmé had pointed out to him), Huysmans invented the archetype of the exasperated aesthete, the Duc des Esseintes who used as his

motto the words of the Chimera in Flaubert's *Tentation de Saint-Antoine*: 'I look for new scents, larger flowers, untried pleasures!' Trying 'desperately to escape from the penitentiary of this century', Des Esseintes dabbled in vice without much success; he then fell back on a collection of objects which formed the Symbolists' 'museum without walls'. Moreau was the most prominent, and several fine pages in the novel about his *Salomé* encapsulate the aesthetic masochism of the *fin-de-siècle*. He hung lithographs by Bresdin and Redon next to engravings by Dürer and Goya; he ordered a copy of the *Fleurs du Mal* to be bound in the form of a sumptuous missal. His library contained works by obscure theologians, by poets of the later Roman Empire, books on torture and the occult. Des Esseintes also had some amazing inventions such as the liqueur mouth organ. All this was enclosed within the walls of a suburban villa, very ordinary from the outside, madly luxurious within. Today we could describe *A Rebours* as an anti-novel on the grounds that nothing actually happens in it; its journeys and pleasures are purely imaginary; it is a novel of onanism. Was it not the representation of solitary self-indulgence in private pleasures which the more vigorous critics of Symbolism such as Octave Mirbeau were to hold against the 'painters of the soul'? Sixteen years after the publication of *A Rebours*, Jean Lorrain published his novel *Monsieur de Phocas*, that carried the eccentricities of *A Rebours* to the point of madness and sounded the death-knell of Aestheticism. (Lorrain's favourite artists were Ensor, Toorop, Jeanne Jacquemin and of course Moreau.)

Huysmans, who was far more knowledgeable about painting than Péladan, did not wish to shackle it with mysticism; the influence of his critical essays on the *Salons* was enormous; he was largely responsible for Gauguin's decision to reject Impressionism. Let us take as an example of one of his critical reviews, which were published in the *Revue Indépendante*, this judgement of Whistler, for it allows us to understand the prestige which the American enjoyed in Symbolist circles: 'Whistler almost breaks the boundaries of painting with his suggestive harmonies; he enters the land of literature and advances through its morbid mists, there where the pale flowers of Verlaine grow.' Reproductions of the old masters which Huysmans liked appeared in the studios, the nether-world of a pictorial universe in which Botticelli was the guardian of paradise: the *Dead Christ* of Holbein and the altarpiece of Grünewald. In *Là-Bas*, published eight years after *A Rebours*, Huysmans made a horrifying excursion into the world of Satanism which so frequently tempted the Symbolist painters; here we are rather too frequently reminded of the work of Rops. However different, Péladan and Huysmans both voiced a nostalgia for religion at a time when the ordinariness of Catholicism had deprived it of any appeal to the imagination. Péladan provided a stock of sublime or ridiculous images for Symbolism; Huysmans drew up an erudite catalogue of its tastes and dislikes.

A long way behind these two masters, and influential only among the limited readership of *avant-garde* reviews, came the critics who tried to codify what was essentially an amorphous movement and to catalogue its various stages of development from one exhibition to the next. Maurice Denis, who wrote as a practising artist, may strike us as more intelligent than all the other critics who were weighed down by their theories. First place however goes to Albert Aurier, the critic of the *Mercure de France*, author of the *Sonnets Byzantins* and unproduceable plays, who did even more for the development of modern art generally than for Symbolism as such. From 1890 onwards, he could find nothing more beautiful than the work of Vincent van Gogh; praising the symbolism of the *Sower*, he saw also in the suns and sunflowers a 'persistent preoccupation with some vague and glorious allegory of sun-mythology'. Writing about Gauguin, Aurier formulated five fundamental laws which govern a work of art (33).

After his death at the age of twenty-seven, Aurier's essays on art were collected by Rémy de Gourmont. He demanded 'that transcendental sense of emotion which makes the soul shiver before the rippling drama of abstractions'. It was at this time that the taste for placing metaphysical texts as prefaces to exhibitions of paintings first developed; the existential jargon which one used to find some fifteen years ago was hardly more obscure than the preciosity of the Symbolists. Aurier wanted the artist to be 'the spokesman of absolute beings'; thus he must 'simplify the handwriting of signs'. We have seen the value he set on Baudelaire and Swedenborg; a line from Plotinus summarizes his ideas: 'We are attached to the exterior of objects, forgetting that it is what is inside them that contains the things which move us.' He naturally hated the scientific critical system of Taine (34).

Like his friend Gauguin, Aurier longed for a 'return to the craftsmen who created the myths of Assyria or Egypt'; he wanted the Symbolists to be like the Japanese. Placed in front of paintings without his philosophically-tinted spectacles, Aurier had the gift for a nice turn of phrase. At the Second Exhibition of Impressionist and Symbolist Painters held in 1892 at the gallery of Le Barc de Boutteville, he found 'everything charming because far removed from academicism'; then he went on to single out 'De Feure's slightly dissolute fantasies, Maurice Denis' discreet mysteries, Jeanne Jacquemin's sorrowful springs of bitterness, Ranson's far eastern monstrosities'. The last long article which Aurier wrote on the Symbolists appeared in the *Revue Encyclopédique,* illustrated by Redon and Gauguin. When he died in October 1892 his place on the *Mercure de France* was taken by Camille Mauclair; but Rémy de Gourmont, a less theoretical writer with a good deal more curiosity, was also writing in it about all the new movements in the art world; he discovered 'Douanier' Rousseau and encouraged Filiger. In *L'Ermitage,* a less important review which appeared between 1890 and 1896, Alphonse Germain indicated what he thought appropriate to like in art, expressed in a language even more precious than Aurier's because he had a less well-defined programme. He admired Péladan for 'having given an ideal to a France rotting from Grévy, and having cursed "ochlocratic" (that is, mob) art'. Writing about his favourite artist, Séon, Germain developed his theory of colour symbolism, with these words as a superscription: 'Beauty in Art is placed as far above that found in Nature as the distance which separates Nature from the Spirit'. It would be wrong to see a connection between such theories of colour symbolism and Rimbaud's poem, *Voyelles* ('vowels'), since according to the most recent interpretations, there is no certainty that the equivalents which Rimbaud saw had any aesthetic significance. The poem *Des Couleurs* ('On colours') by Marie Krysinska published in the *Revue Blanche* in 1892 is probably more characteristic (35).

La Plume, for which Germain also provided articles until 1900, was unfortunately illustrated and printed on rather poor paper; in a series of special numbers it publicized the work of leading Symbolists, like De Groux, Grasset, des Gachons, Osbert, Rops and Mucha, some minor poets, and articles on the occult. Widely read in the provinces, *La Plume* vulgarized, to a certain extent, the eccentricities of the Decadents and the delicacies of the Symbolists. Thanks to it, the public learnt the names of Seurat, Gauguin and Van Gogh. *La Plume* made a cult of Verlaine and Rodin, and cheerfully organized banquets, the most famous of which were those given for Puvis de Chavannes in 1895 and attended by five hundred people, and for Rodin in 1900. *La Plume* also held its own *Salons* at which were shown the work of delicate artists such as des Gachons, the 'Imagist', Henry Rivière, the painter of 'japanist' landscapes, or Séguin, an artist who merited an important article by Maurice Denis. Sometimes also there were Willette, the painter of Montmartre, or Chéret and Mucha, the poster-painters, or Mérovâk, who drew imaginary cathedrals. *La Plume* lacked good taste but at least it was enthusiastic.

Nathanson's *Revue Blanche* was a complete contrast, the mouthpiece of an up-to-the-minute, even slightly snobbish intelligentsia. It was very well printed, and was accompanied by lithographs by Denis, Roussel, Vuillard, and drawings by Toulouse-Lautrec. The review's muse was Misia Godebska, sister-in-law of Alexander Nathanson: Polish by birth, a gifted pianist and a very entertaining personality who fifty years later was still one of the most scintillating women in Paris. The *Revue Blanche* was certainly chic, otherwise Proust would not have published his early short stories with their strong Symbolist flavour: *Les Plaisirs* ('Pleasures') and *Les Jours* ('Days'). The review had originally been founded by the Nathanson brothers in Brussels in 1889, but two years later it transferred its offices to Paris. The first number bore these lines from Maeterlinck: 'The symbol is an organic and interior allegory; it has its roots in the shadows.'

The most important reports on art remained those devoted to the *Salon des XX,* founded during this period in Brussels by Octave Maus; even more than the *Salons de la Rose+Croix,* these offered the critic a first-class selection of works of art because it was so eclectic. Thus in 1891, an article by Krexpel mentions that alongside the Impressionists and the younger Symbolists were works by Seurat, Gauguin and Van Gogh which were to achieve notoriety some twenty years later (36).

During the 1892 *Salon des XX* there were lectures given by Verlaine and Vincent d'Indy; it was really, as we would say today, a 'cultural centre'. In his report on the proceedings, Nathanson refers to Rodin's

medallion of César Franck (which was to influence Charpentier's *Gomorrah*), Signac, Toulouse-Lautrec, the *Fiancée* by Thorn-Prikker, Toorop's *Old Garden of Suffering,* Doudelet's *Garden of Agony*: 'Thus their works oscillate from painting to, now, poetry or metaphysical allegory, and the choice made between each of these forms—still plastic or almost exclusively allegorical—depending upon which type was most suited to the translation of their disquieting literary ideas.' The Symbolists hung next to examples of *art nouveau,* 'the sentimental embroidery of Van de Velde, the stained-glass windows of Besnard', a juxtapositioning which leads to a 'distinction between the artists of the head and the artists of the hand'.

Of all the Symbolist reviews, the *Revue Blanche* remains the one which is still the most enjoyable to read; it heralds the *Nouvelle Revue Française.* On its pages one discovers the signatures of Léon Blum, Pierre Louÿs, André Gide; one finds the strange poems of Saint-Pôl-Roux next to the intimate sketches of society life by Proust and a very important article by Charles Henry on the theory concerning the aesthetic of form, in which aesthetics were reduced to a single system of graphic representation. The *Revue Blanche* was a link between one form of modern art, Bonnard, Vuillard, and the Symbolists. It was only the artists it patronized who were to have lasting success. Maurice Denis' paintings and essays were the best examples of the aesthetic of the *Revue Blanche.* Under the title *Théories* (1890–1910), Denis brought together a group of articles in which he had outlined the phenomenon of Symbolism; we have frequently quoted him. He revealed the crudeness of the Neo-primitive artists such as Emile Bernard who 'lacked a sense of tradition'; he suggested that Seurat's researches tended towards a mathematical system. Attentively he followed the evolution of the movement from the exhibition at the Café Volpini in 1889; thus by the end of 1891 at the Le Barc de Boutteville gallery he found that: 'the flat colours appeared no more with so much conviction, the forms were no more so prominently outlined in black; pure colour was no longer used exclusively'. The era of purely speculative and theoretical formulations had passed.

Having visited the *Salon du Champ de Mars* in 1890, Denis announced 'the universal triumph of the imagination of the aesthetes over the efforts of stupid imitation, the triumph of the feeling for Beauty over the lie of Naturalism'. But five years later he expressed this wish in the preface to the exhibition at the Le Barc de Boutteville gallery: 'Perhaps there will come a day when the young Symbolists will eventually arrive at Nature; they have had the courage to return to tradition and to turn their backs on the gloomy academies with their plaster casts and their models.'

A less acute critic than Denis, Alfred Mellério, who had the merit of working hard to make Redon's name known, in his book *L'Idéalisme en Peinture* ('Idealism in Painting', 1889) helped to distinguish Symbolism satisfactorily from all the other movements of the period (37). He also established a link between masters whose reputations did not decline when Symbolism was pushed into oblivion: 'The Rose+Croix have disappointed me; the Idealists can claim Puvis, Moreau, Redon, Gauguin; we can add two artists whose names are less known to the public at large but who are highly regarded by the younger generation: Cézanne and Van Gogh.' When writing about Sérusier and the Synthetists this critic very subtly describes the progression from Nature to the Idea (38).

Leafing through the reviews of the last ten years of the century, one becomes aware of the small number of galleries apart from the *Salons de la Rose+Croix* where one could come to know the new painting which the *Salons* rejected for a while. The most interesting exhibitions took place in Brussels. In 1884, Octave Maus of the *Revue de l'Art Moderne* founded the *Salon des XX* and invited 'the audacious, the brave, the revolutionary' artists to exhibit, a move which, as we have seen, allowed first of all Impressionism to become known in Belgium, and then Symbolism to spring into life supported by a remarkable renaissance in poetry. The Belgian stars of this *salon* were Khnopff and his enemy Ensor, Van Rysselberghe who was influenced by Whistler and then by Seurat, Delville, Péladan's most faithful disciple; they were hung next to Watts, Whistler, Rodin, Monet, Seurat. In 1894, *La Libre Esthétique* replaced *Les XX* 'because it is wrong for artistic circles to last for too many years since they run the risk of falling into decay and become retrogressive'. Albert Mockel was the best Belgian theoretician of the Symbolist aesthetic; in his *Propos de la littérature* ('On Literature')—a collection of articles written for *La Wallonie* and published in 1894—he made a clear distinction between allegory and symbol (39).

L'Art Moderne broadcast the names of the painters of the Imaginary; there were also the *Revue Mauve,* the *Revue Rouge,* and several other reviews, all witnesses to the aesthetic ferment in Brussels at this time. The French did contribute to these reviews although more Belgians wrote for the French ones; thus Verhaeren worked regularly for the *Mercure,* writing articles with a socialist bias which one also finds in Théodore de Wyzéwa.

It would be impossible to list all the critics whose articles either influenced Symbolism or else captured its changing moods. However, it is worth noting Jean Dolent who had been waiting for the arrival of Symbolism since the days of the Second Empire, or Cazalis, a great friend of Mallarmé who published poems under the pseudonym of Jean Lahore and who was fascinated by Hindu philosophy, or, above all, Georges Vanor, the author of the first book on Symbolist art, published in 1889. It was in the drawing room of Vanor's wife that Debussy on his return from Italy made friends with young artists such as Maurice Denis. Vanor wanted to win over to the Symbolist cause a young art critic who was really too penetrating to be tempted by dreams: Felix Fénéon. He admired Seurat above everyone else, and it is in the company of the painter of the *Grande Jatte* that a *rapprochement* with Symbolism could have been arranged (40). Vanor's ideas would have been perfectly applicable to Seurat's ideal if only it had been realized that Seurat could have painted a *Rape of the Sabine Women* just as easily as the *Grande Jatte,* so little did the subject of a picture matter to him. And at all the Symbolist exhibitions one sees Fénéon mocking derisively in front of a descriptive painting: 'Three apples by Cézanne contain far more mystical value than all the exhibitors at one of Péladan's exhibitions put together.' Signac was even more severe than Fénéon; Puvis alone was able to find favour in his sight.

The first exhibition of Impressionist and Symbolist painters was held, as has been mentioned, in 1891 at the gallery of Le Barc de Boutteville, a small gallery where the art lover could riffle through piles of canvases brought in by the young artists. The year 1893 saw the opening of Ambroise Vollard's gallery and an exhibition of Gauguin's work at Durand-Ruel's. In 1895 the German dealer and specialist in Japanese art, Bing, opened his gallery of *art nouveau* work, where decorative artists were accorded as important a place as painters. The Symbolists were also well received at the Société Nationale des Beaux-Arts (otherwise known as the *Salon du Champ de Mars*) founded in 1890 by Puvis, Rodin and Carrière as a protest against the tyranny of the École des Beaux-Arts in the official *Salon*. Mauve shadows and flat colours immediately spread through these exhibitions. Obviously the Symbolists were not rejected; they were so only in as far as the press mocked at them, but this it did far less than it had done to the Impressionists. They quickly acquired galleries and clients, and the most important among them even had their paintings hung next to the official contemporary masters in the galleries of the Luxembourg palace which had been dedicated to contemporary art since 1891. Thus in less than ten years the Symbolist ideal triumphed in the *Salon*, although perhaps with this triumph it lost part of its charm, revealing the mere technical competence below the cloak of mystery.

To follow this development in taste, it is interesting to study the annual reports of the *Salons* given in the *Gazette des Beaux-Arts*, a review which was published by people with taste but with little real feeling for new art. By 1883 it is apparent that religious and mythological subjects are on the way out and that the most talented artists seem to be exclusively concerned with contemporary subject-matter. Two years later the word 'symbolic' makes an appearance in reference to two allegorical paintings of the City of Paris, one by Aman-Jean, the other by Besnard: 'There is also a symbolic representation of the capital by M. Besnard, painted on a canvas which is vast, boldly handled, strange and slightly disquieting; it combines fantasy and reality in a bizarre way.' In 1890 there is great enthusiasm for Puvis' *Inter Artes et Naturam* with its suggestion of the ideal of aesthetic life; in 1891 another triumph for Puvis as well as quotations from Baudelaire and Verlaine in Edouard Rod's report on Carrière and Besnard. The consecration of Symbolism took place in 1893 around an important painting sent by Burne-Jones to the *Salon du Champ de Mars*, while the Champs-Elysées remained more academic: 'If there is anything which demonstrates the vitality of contemporary art at the moment it is certainly the advance of Symbolic painting, totally unexpected in our worldly utilitarian society.' In 1895 Roger Marx talks of Naturalism as if it were a dead, ridiculous movement, and then praises the emancipation of the imagination. He particularly likes Carrière's *Théâtre Populaire* and Dagnan-Bouveret's *Christ*; a convert from Naturalism,

Roger Marx notes that the influence of Moreau now seems to be as great as that of Puvis, and he cites Rouault and Denis as examples. Paul Adam, a visionary novelist, notes with a certain touch of irony 'the nymphs in diaphanous garments who flit through woods of red trees all over the salon . . . rather pale and almost always thin, long-thighed and graced with embryonic breasts, they seem to be still waiting for the state of womanhood'. After several pages about Puvis and ecstatic comments about Aman-Jean, he praises Dagnan-Bouveret's *Last Supper*. In 1897, Paul Adam's irony gives way to Besnard's strictures about 'thinkers without ideas, albinos of art. . . . Their art is only admired by literary figures because they paint in metaphors. . . . Literature ends where painting begins.' From this year onwards adverse criticism becomes increasingly frequent; after 1900, the critics are kind only to Henri Martin, Le Sidaner, Aman-Jean and, occasionally, to Lévy-Dhurmer. One can easily trace a success curve for the Symbolists which describes their rapid rise and their even more rapid fall. They desperately wanted their success. A letter from Gauguin to Maurice Denis is witness of this bitterness (41).

From 1897, the year of the final *Salon de la Rose+Croix* and the first exhibition of the *Nabis* at Vollard's gallery, the public began to turn their attention away from Symbolism. In a few years the visitors to the Palace of Symbolism will appear affected and out-of-date; poets from the provinces, ripe spinsters or failures, embittered or melancholic, will be the only people to stroll down the paths of the garden now deserted for the sun-drenched beaches where the Ballets Russes set up the tent of Scheherazade and the Fauves raucously celebrate their *joie de vivre*. The year 1898 was marked by the deaths of Moreau, Mallarmé, Burne-Jones and Puvis de Chavannes. With the passing of these masters, inspiration seemed to disappear. In 1899 Redon published his last folio of lithographs, and in 1900 Maurice Denis exhibited his large homage to Cézanne. Since the public tended to link Symbolism to Aestheticism, the attacks on the movement really dated from the trial of Oscar Wilde in the spring of 1895. Octave Mirbeau, the defender of the Impressionists, the admirer of Rodin, was the first writer openly to claim that the Symbolist movement was for 'snobs, Jews and pederasts' (42). Jean Lorrain mocked 'the bargain Botticellis and the Giocondas of Montmartre'. In the same year the critic of *L'Ermitage* wrote that 'Pre-Raphaelitism has lived, come back Manet, all glory be to Monet, to the health of Gaul as it reacts against the mystico-symbolist fogs of intellectual myths and sentimental charades. Life has at last revolted against the nightmares of dreams.'

A few years later a charming novelist called René Boylesve notes the decline of the 'soul' in literature in the same review (43). *La Plume* itself finally gave up its Symbolist affiliations (44). In 1901 we find it publishing articles very characteristic of the new school of criticism which is more politically committed and which mocks the ivory tower; thus Eugène Montfort wrote in a study of Modern Beauty coloured by scientific socialism and dedicated to Jean Jaurès: 'How wonderful are our times. Life has found a new medium of expression' (thanks to electricity). Finally it was Proust in the *Revue Blanche,* which had done so much for Symbolism, who compared the artists who had fallen so rapidly from favour with 'sea shells, empty and resonant, which have been washed up onto the sea-shore and lie there at the mercy of the first passer-by.' (This article was written in 1900.) It seems as if the Paris Exhibition of 1900 had forced its visitors to leave the Symbolist Palace in order to attract them to places even more bizarre, lit with electricity and in which the way of life was already that of the twentieth century. A new surge of energy was replacing the *fin-de-siècle* pessimism, the nervous disorders of the Decadents. *Art nouveau* finally triumphed with such a display of vulgarity that it even disgusted those who had originally supported it. Meanwhile the Symbolist painters did retain a public of their own for the next ten years, but they repeated themselves, their dreams became stereotyped and their links with contemporary literature and music became remote.

6. The Masters

We can begin our visit to the exhibition of painting in the Symbolist Palace, having now met the public which animated it and scanned the works of the critics who formed this public's taste. Our attention is immediately caught by the work of two masters which hang in opposite galleries: the one—Gustave Moreau—attracts us by his brilliant and strange paintings, the other more because of his immense influence than because of his work itself, whose quality is respectable rather than exciting. Having been despised by all but a few of the Surrealists, Moreau was given a triumphant revival at the exhibition mounted at the Louvre in 1960. The youth of today has discovered its own myths in his work, and even a presentiment of psychedelic art. Enthusiasts for the turn of the century believed that Moreau could simply be incorporated in the world of Gaudí or Lalique. For the more serious, he took his place beside Delacroix, whom he had so much admired. Puvis de Chavannes, on the other hand, has never fallen out of favour; he was the only Symbolist artist who found grace in the sight of Elie Faure: 'Among the components of vision, great learning alone offers strength sufficient to satisfy taste, insufficient to overcome it' (*Art Moderne, 1923*).

Both artists belonged to the same generation—Puvis was born in 1824 and Moreau in 1826—and both were completely agnostic, like most intelligent people in the middle of the nineteenth century, which did not prevent them from dreaming of other worlds than that in which they lived. Moreau chose the pagan world, exotic and archaic; the universe of Puvis is secular, French and timeless. Moreau gives birth to an endless procession of treacherous queens, excessively beautiful martyrs and gilded gods; Puvis paints figures draped in white floating above the Ile de France, who represent the Liberal Arts, or Patriotism, but who might just as well symbolize a primary school. This painter of allegories was taken for a Symbolist, and finally he became one. Moreau was a magician and Puvis a teacher; it is this rational side of him which annoys the devotees of imagination.

But Moreau is almost alone in the room which is dedicated to him and to a few of his disciples, for he is the end of a line, the final flourish of Romanticism, the most beautiful cry of what Professor Mario Praz calls 'The Romantic Agony'. He admitted to his studio only the faithful few, without ever giving a hint of the passions which his canvases betray today. One need only think of how he received Péladan when he came to ask him to exhibit at the *Salon de la Rose+Croix*: 'Small, worried, nervous, dressed with the meticulous propriety of Hoffmann's magistrate, he appeared to me to be exclusively preoccupied with getting rid of me politely: "I wish to accumulate evocative ideas in my paintings so that the owner of a single one may find a source of renewed ferment; and my dream would be to make iconostases rather than paintings in the strict sense of the word. From year to year I add fresh details to my two hundred posthumous works as the ideas come to me, for immediately after I die I want my art to appear at once in its entirety"' (*L'Ermitage*, 1893).

Moreau came from a well-to-do family. Never did he need to sell a painting or to flatter public taste. At the Ecole des Beaux-Arts, while under the influence of Ingres, he dreamed of Delacroix. He made friends with Chassériau and Degas; he met the latter in Italy, where he spent two years around 1864. In Rome he copied Michelangelo and antique paintings; in Florence, Benozzo Gozzoli; and in Venice, Carpaccio, whose work, so full of strangeness, was to influence him to the end: decaying vegetation, exotic architecture, and ambiguous silhouettes. From Mantegna he took the beautiful archers and the rocks capped with ruins.

From 1864 Moreau achieved great success at the *Salon*; commissions from the state; articles by Théophile Gautier. In many ways he remained a painter of the Second Empire, with overloaded and embossed surfaces, and voluptuousness in even the most tragic subjects. Degas said, 'Moreau reminds

us that the gods used to wear watch-chains.' His detailed and nostalgic view of antiquity was, however, far more profound than that evoked by the Parnassian poets during the same period; the feeling that there can be no beauty without sorrow, the feeling of blood beside the most intensely sensual images, brings Moreau much closer to Baudelaire. In fact, he adored the author of *Les Fleurs du Mal*; and a year after Baudelaire's death the artist went to Honfleur to meet the poet's mother, and to paint his house.

After holding aloof from the *Salon* for some years Moreau returned in triumph in 1876 with a painting of *Salome*, in which one finds a setting influenced by Flaubert's *Salammbô*, and an atmosphere reflecting his story of Herodias. In truth, this is a similarity of feeling rather than a direct influence. In the same way the lives of these two artists, which were in no way linked, resembled each other: solitude, work and extravagant dreams. There was another success at the *Exposition Universelle* of 1878 with some dazzling watercolours, among them the *Apparition*. Moreau exhibited for the last time at the *Salon* in 1880, with *Helen* and *Galatea,* and five years later, at the Galerie Goupil, he showed sixty-five illustrations to La Fontaine's *Fables*, but as far removed from the spirit of the author as it is possible to be. It was thus very difficult to see Moreau's works; people only knew them in engravings, particularly Bracquemont's engraving after *Salome*. All this gave them a mysterious prestige.

In his old age Moreau painted immense canvases, which he constantly reworked and then abandoned: *The Suitors, The Chimeras* and *Dead Lyres*. Several hundred fine pencil and watercolour studies were left, together with these unfinished works, to the museum which bears the artist's name. In 1884, the death of his mother, with whom he had lived, and of his best friend Eugène Fromentin turned him into a hermit; but, as Degas described it, 'a hermit who knows what time the trains run'. In 1892 Moreau became Professor at the Ecole des Beaux-Arts; this superb teacher repeated the lessons of Delacroix to pupils called Matisse, Marquet and Rouault, his favourite. Khnopff, whom he hardly knew, was, intellectually speaking, his only follower, albeit in a form washed out by northern rains. Ary Renan, his closest disciple, wrote a beautiful study of his master. On his death in 1898, Moreau ordered a pupil to destroy all his personal papers. His notes on art, however, did survive (45).

This semi-retreat from the world meant that Moreau's name appeared but rarely, and was only referred to in passing, in articles on the *Salon* and art galleries. By contrast, there has never been an artist who was so frequently and so enthusiastically lauded by a whole generation of writers. In fact, his influence was far greater upon writers than upon artists. Huysmans and Jean Lorrain adored him. And Proust, too, during his youth when he was close to the Symbolists, mentioned him at length when writing on Ruskin (46).

Puvis, however, was more admired by painters than by writers, more respected, too, by the well-informed critics who, after 1880, observed the spread of his influence at a time when Moreau's influence remained hidden, awaiting its much later flowering in Klimt and Lévy-Dhurmer. In the *Revue Indépendante* ('Independent Review') of 1886, Théodore de Wyzéwa compared Puvis favourably to Moreau: 'M. Puvis de Chavannes is an incomparable master who produces symphonies of power or sorrow. M. Gustave Moreau, with a perhaps more remarkable talent, seems to have become purely a virtuoso of colour.'

Puvis' career was one of integrity and without mystery, and if he accepted honours, at least he did not run after them. The fact that his career was, taken as a whole, that of an official painter, should make us revise the excessively severe judgement of official taste under the Third Republic. Puvis certainly represents a hard-working France, bent on expiating the sins of the Second Empire. One of his best pictures, *Hope,* was painted just after 1870.

Born in Lyons, the son of an engineer, Pierre Puvis de Chavannes did not decide to become a painter until after a visit to Italy in 1847. He loved the work of Raphael, and above all the paintings of Pompeii, for he found in them 'supreme beauty, clarity of subject-matter, exquisitely measured gestures'. He was also among the very first to admire the frescoes of Piero della Francesca. On his return to Paris, it was the frescoes in the Cour des Comptes (destroyed by the Commune) which his friend Chassériau had just finished which finally decided his vocation. He began to paint huge canvases which were well received at the *Salon*, and decorated the staircases of the museums at Amiens and Marseilles. In 1874 he embarked on the decoration of the Panthéon; he worked there until the end of his life.

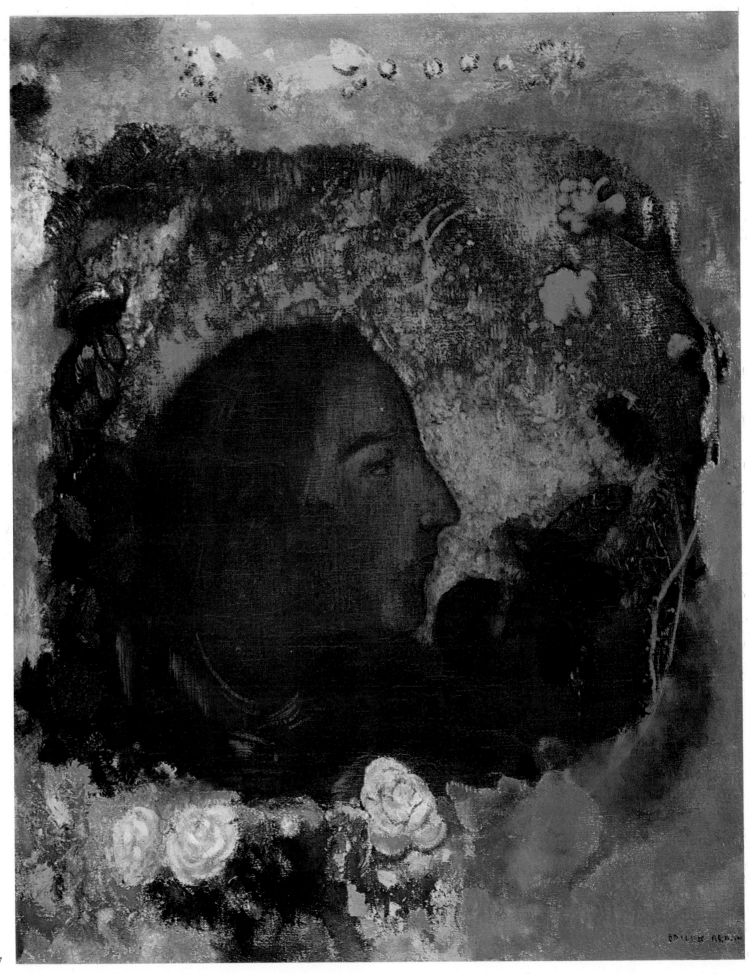

7

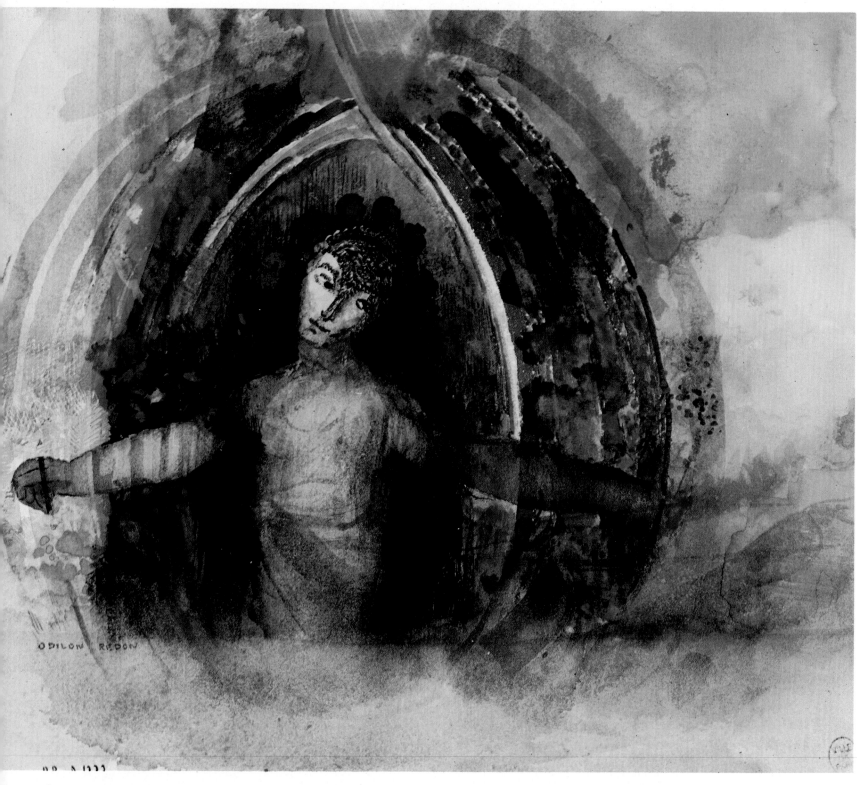

8

In fact Puvis never painted fresco, but always in oil, on vast canvases fixed to the wall, thus avoiding surface-buckling. He imitated the tonality of the frescoes which he had seen in Italy, without trying to use a technique which is so risky in a northern climate. From the Second Empire onwards Puvis' large compositions were highly regarded. The wonderful *Marseilles, Gateway of the West* dates from this period (1869). This picture has a sense of balance, a technique adopted from the picturesque tradition which recalls the style of Ernest Renan, the writer, with whom he was closely associated. Commissions from the State never affected his artistic integrity; he resigned from the jury, when the *Salon* excluded Courbet for having taken part in the Commune. Apart from the Panthéon, Puvis decorated the Hôtel de Ville (town hall) of Poitiers in 1875, the Palais des Arts at Lyons in 1883, the Sorbonne in 1887, the Museum of Rouen in 1890, and the Hôtel de Ville of Paris in 1894, as well as providing the famous *Ludus pro Patria* for Amiens in 1884. His final work was the left-hand side of the choir in the Panthéon, and here he came under the influence of his admirers, the Symbolists; and that *St Genevieve*, reproductions of which in blue-tinted gravure hung in our grandmothers' bedrooms, is bathed in the twilight of Maeterlinck's plays, and has the simplicity of Claudel's *Violaine*. It is the anti-Salome. Puvis' work was also greatly admired by the Americans, and he received a commission for the extensive decoration of the library at Boston, which became the inspiration for a whole new school of decorative artists of whom the best was John LaFarge.

Puvis' three most famous pictures were *Hope* of 1872, the *Prodigal Son* of 1878 and the *Poor Fisherman* of 1881. Despite a somewhat ironic reception by the press, these paintings were far more influential than his large murals. The summit of Puvis' career was that triumphal banquet organized by *La Plume* on 15 January 1895. Here Puvis appeared as the equal of Rodin who presided over this love-feast, at the end of which the painter was presented with an anthology of works by Symbolist poets such as Mallarmé and Verlaine.

There was nothing mysterious about Puvis as there was about Moreau. It is well known that for a long time he was in love with the Princesse Cantacuzène, a Rumanian of great intelligence, and that he married her shortly before his death; he had met her in Chassériau's studio. The harshest critic of the Symbolists, Fénéon, bowed before the master in the *Revue Indépendante* of 1889: 'In the only pastel which he exhibits, M. Puvis de Chavannes brings together the sorrowful serenity present in all his work with a sense of inevitability: the unity of his colour and his line.'

It is important to consider the influence of Puvis de Chavannes on the Symbolists, and on those artists too great to be so labelled, but who were to a greater or lesser extent connected with Symbolism. As he approached his sixtieth year, Puvis, who until then had been little liked by the critics, watched his studio fill with young painters; he confided to Ary Renan his surprise at being considered as one of the leaders of Symbolism, because his doctrine was pure, without any pretence to aesthetic pose. Unlike Moreau, he seldom spoke about his art (47, 48). Puvis said, 'Art completes what nature crudely sketches. How then can one succeed when one wishes to help nature to express herself? By abbreviation and simplification . . .', and this became a law for the Symbolists.

Puvis de Chavannes was largely self-taught, but the atmosphere of Lyons where he was raised was conducive to artistic development through the influence of that school of mystical painters so much admired by Baudelaire. People were far removed from the capital, from the taste of the Second Empire. His periods of study in the studios of Delacroix and of Couture had been brief, and he had no pupils. He willingly opened his studio doors, however, to young artists who were disgusted with the teaching at the Ecole des Beaux-Arts. Around 1885 Seurat was a frequent visitor, accompanied by his friend Aman-Jean. These two artists helped Puvis square up one of his compositions for enlargement, receiving in exchange the Master's observations on Italian art handed down from the top of a moving ladder. It is certainly as much the compositional style of Puvis as the work of Piero della Francesca that has given the *Grande Jatte* its static, majestic character.

His influence was even greater on Gauguin, who pinned a reproduction of *Hope* to the wall of the inn at Pont-Aven and of his hut in Tahiti. Even more than in Seurat's masterpiece, the spirit of Puvis can be felt in the huge picture in the Boston museum, *Where do we come from? What are we? Where are we going?*, the greatest work inspired by Symbolism. Gauguin said of Puvis, 'He's a Greek' (49). The School

Opposite:
8. Odilon Redon: *Woman, half-length, with outstretched arms.* 1910–14. Watercolour, 17 × 20 cm. Petit Palais, Paris

of Pont-Aven owes to Puvis its hieratic compositions, its unrealistic nudes in forest clearings; but, with their interest in the occult, in naïve or exotic art, and in the brilliance of their palettes, these artists went well beyond their master.

Maurice Denis, on the other hand, refined Puvis' style, adapted it to his world of intimate family scenes, but hoped to give them a Symbolist charm with twilight colours, albeit the twilight of a summer day. Memories of Puvis can also be found in his highly successful decoration of the Théâtre des Champs-Elysées.

Signac, who painted at the same time as Maurice Denis, also admired Puvis de Chavannes, although his researches based upon Delacroix seem far removed from the serene decorative artist. He noticed the underlying symbolism of the *Poor Fisherman*, such as the negative, anti-clockwise direction in which the mast leans. The *Poor Fisherman* is one of the most important paintings of the nineteenth century, whether one regards it in relation to contemporary painting or from the point of view of its influence on the future. It is such a stripped, severe painting, that at the *Salon* of 1882 those who were to become the most fervent propagators of Symbolism were horrified by it; Péladan himself could scarcely defend it. By March 1891, the *Poor Fisherman* had become one of the most popular paintings of the younger generation (50).

The influence of Puvis de Chavannes is present in the Swiss artist, Hodler, at the same time more bizarre and more robust. Hodler exhibited at the *Salon de la Rose+Croix* organized by Péladan and there one could compare the influence of Moreau with that of Puvis (although neither master exhibited there). Puvis was very much the stronger. Some imitated him faithfully, such as Séon, the most intelligent of the recently re-discovered Symbolists, or the charming but rather monotonous Osbert. Others borrowed his compositions and his allegories but treated them with an almost *pointilliste* technique, like Henri Martin. Still others adopted his palette to illustrate themes drawn from Verlaine, such as Aman-Jean. As has been pointed out, it was these young Symbolist artists who inspired the older master when he came to paint his St Genevieve. Hope, that scarcely pubescent girl, contributed greatly to the creation of the Symbolist ideal, for she resembled a Burne-Jones. In fact, what many of the Symbolists liked in Puvis was the qualities which he had in common with the last of the Pre-Raphaelites: a silent world bathed in a pale light, and static compositions; in fact they preferred the English artist who offered them, in addition to an indefinable sense of anxiety, a total decorative system foreshadowing *art nouveau*. Puvis is far removed from *art nouveau*; Rodin, Moreau, and even Redon are much closer to it.

Odilon Redon, on the other hand, was loved by writers (the same as those who admired Huysmans), closely followed by the critics, and respected by artists younger than himself whom he received in his small flat in the Avenue Wagram. 'He was the Mallarmé of painting' (Maurice Denis), yet his influence on Symbolism was, from a distance, not nearly as important as that of his two seniors. His work is like a plant which is at times gloomy and at others enchanting, and which does not fruit. Redon had venerated Delacroix, was taught by Bresdin, and admired Moreau although with certain reservations. One of the passages in *A Soi-Même* admirably shows what separated him from Salome's jeweller: 'The meaning of mystery is always to be equivocal, to suggest the double, triple aspect, to give hints of an aspect, forms which may become one, or which will become one, according to the spectator's state of mind.' This book, *A Soi-Même*—a collection of personal thoughts and diary entries—appears to be a work of explanation; Redon spurned all involvement in the excesses and absurdities into which so many Symbolists fell under the influence of Péladan and Huysmans (51). He never touched the occult; he was wary of ideas: 'Every time a painting lacks plastic invention, it is nothing but a literary idea.' He only offers 'a small door which opens onto the world of mystery', through which his admirers can freely pass and travel as far as they wish without involving him further. For Redon himself, the texts which his lithographs illustrated, Poe, and above all the *Tentation de Saint-Antoine* ('Temptation of St Anthony'), were the little doors through which his own imagination escaped to travel far down the black paths of lithography. These texts were for Redon what a deck of Tarot cards is for a fortune-teller, a springboard for jumping into the unknown and returning laden with images. But when he kept too close to the text, his genius left him; hence his very bad portrait of Des Esseintes. There are also some very

bad paintings by Redon; he was a visionary and often his inspiration would abandon him in the middle of creation.

Gauguin, in contrast to Redon, always remained much closer to nature, and, of course, his influence was enormous. Standing in front of some Gauguins, Mallarmé declared: 'It is amazing that so much brilliance can be invested with so much mystery.' Closer to Puvis than Redon ever was to Moreau, both artists are too important to be considered merely in the light of their older masters. The School of Pont-Aven merits a whole book to itself, and this has been admirably done by Mme Jaworska. In many ways its Symbolist members were far more lively and far less concerned with a search for the bizarre than the real Symbolists, but they had found in Brittany a land which recalled a wild version of the garden of the Ivory Tower; there, close to the menhirs, the carved calvaries, they were even further away from the world, surrounded by a people forgotten by progress, still faithful to their legends—and what legends! The town of Ys, King Arthur and Merlin, Broceliande. As in Ireland which was undergoing its own Celtic renaissance at this time, an ever-changing sky encouraged day-dreams. Timeless costumes, a naïve faith seemed to endow the peasants praying in their chapels and the boys wrestling at the fairs with a symbolic meaning more significant than any allegory by Puvis. Several years later in Tahiti, when Gauguin was painting *Where do we come from? What are we? Where are we going?*, he pointed out this difference: 'Puvis certainly explains his idea, but he never paints it. . . .' Gauguin's letters represent, almost to the same extent as Redon's *A Soi-Même*, one of the most perfect documents of Symbolism (52).

On his arrival in Brittany, Gauguin wrote: 'When my clogs echo on the granite rocks, I hear the dull, muffled, strong sound which I am looking for in painting.' He found several young artists there under the influence of the most intelligent of them, Emile Bernard, who saw himself as a reincarnation of a man of the Middle Ages; his sister Madeleine wore the Breton headdress and disturbed the friends. Jealousy was rife. Gauguin's personality immediately established him as the leader of Pont-Aven. Aurier's article on pictorial symbolism, dedicated to the greater glory of Gauguin, was published in the February 1892 issue of the *Mercure de France*, and Bernard's mystical crisis during the previous winter brought about a break. At a later date Bernard claimed that he had revealed the new style of painting to Gauguin, thus turning him away from Impressionism. In his old age, Maurice Denis recalled in the *Gazette des Beaux-Arts* of 1934 the shock which he felt when he saw the painters of Pont-Aven hung together in the Café Volpini opposite the entrance of the *Exposition Universelle* of 1889, surrounded by the incongruous sound of a gipsy orchestra and the uproar of customers. Apart from Gauguin, there were Emile Bernard, Sérusier, Schuffenecker, and some others (53).

The public was put out, the sales were few, but the effect on the young was considerable; it was here that Maillol found his vocation. Gauguin was the only Symbolist to find favour in the eyes of Octave Mirbeau. One of the best connoisseurs of the painting of this period, he saw in his work 'an unsettling yet fascinating blend of barbaric splendour, Catholic liturgy, Indian meditation, gothic imagery and subtle symbolism'.

In Maurice Denis can be found facets of both Gauguin and Puvis; he venerated Cézanne, and as a good Catholic, he would cry out in front of Moreau's paintings, 'Vade, retro Satanas!' The best artist of his generation, he continued to work right up to the thirties. He unites perfectly all the qualities of Symbolism within a limited world and with a balanced imagination. With the decline of the movement, Denis devoted himself to religious and decorative works that are rather monotonous but always of high quality. Maurice Denis' post-Symbolist paintings, with their dominant tonalities of pink and mauve, remind us of the colourless miracles and vague promises made by Saint Thérèse of Lisieux who was meant to cover the earth with a shower of roses. Although he was an excellent book-illustrator and the best landscape painter of the Symbolist Movement, one cannot help thinking that he was slightly contemptuous of the painters of the Imagination: 'As with all periods of decadence', he wrote, 'the plastic arts blossom with literary affectations and anti-naturalism.'

In Paris, Maurice Denis' paintings and intelligent art criticism won him the title of 'master' very early in his career. But his reputation hardly spread beyond the frontier. In Brussels, on the other hand, Fernand Khnopff was also praised early in his career and was widely regarded as a 'genius' and as the

equivalent of Maeterlinck in painting. For instance Wilde asked him to illustrate the *Ballad of Reading Gaol* and the Emperor of Austria commissioned him to paint a portrait from photographs of his recently assassinated wife, the Empress Elizabeth. His reputation spread rapidly throughout Symbolist Europe; he contributed regularly to *Studio* and to *Pan*, helped create a type of feminine beauty, and lived in the style of a modern magician of art, in his beautiful house built to provide a backdrop for his paintings and to harbour a way of life like that of Des Esseintes.

Brought up in Bruges, Khnopff was the son of a wealthy family from the Ardennes and spent his childhood in Bruges. He was one of those rare Decadents who managed to be both an artist and an aesthete (54). Khnopff spent several years in England; he trained in Mellery's studio, but admired Moreau above all other painters. But he was even more profoundly influenced by the Pre-Raphaelites, especially Watts whose portraits of aristocratic ladies, superb and glacial, he greatly admired. Always fascinated by his own face (a cold d'Annunzio) he frequently had himself photographed in vast, bare halls relieved by antique marbles and grey-blue hangings (55).

Péladan adored Khnopff's work, in which he found his androgynous ideal, and the artist drew the frontispiece of the *Vice Suprême*. The Sâr wrote in the preface of the second *Salon de la Rose+Croix*: 'I regard you as the equal of Gustave Moreau, of Burne-Jones, of Chavannes and of Rops. I regard you as a wonderful master! *Silence*, the *Female Sphinx*, the *Cavalier and the Chimera* are masterpieces! I want this booklet to ring with your name. I pray to the angels, the friends of my beautiful project, that you remain faithful to the Order of the Rose+Croix which, through my voice, proclaims you a wonderful and immortal master.'

In fact, Khnopff, a regular exhibitor, was always one of the most admired artists at this salon. However, his facility of execution sometimes aggravated the French critics. Aurier once referred to him as 'the Bouguereau of the occult'; Fénéon in his review of the first *Salon de la Rose+Croix* used him as a weapon with which to attack all painters of the ideal (56). Khnopff's influence is only directly seen in Lévy-Dhurmer; his achievement showed in the most elegant way how an artist could stand aside from his own century. He conveyed this elegance to the sphinxes and chimeras. Tinged with melancholy it colours his vast pastel, *Memories*—which one might call the *Grande Jatte* of Symbolism. Seven women —all the same model—stand at dusk, at some distance from each other, in a simple English parkland, and, as Mme Francine Legrand has described so well, they are 'witnesses to the impossibility of communication between human beings'. Some of this sense of mystery can also be found in the early drawings of La Gandara when he was under the influence of Montesquiou, as well as in the chalk drawings of Seurat.

But it would seem odd to include Seurat in a book on Symbolism despite his admiration for Puvis de Chavannes, his friendship with Aman-Jean and Osbert and, briefly, with Gauguin. His interests were far more scientific than metaphysical; still one cannot deny that his hieratic compositions come close to Symbolist experiments. He invented no chimeras, but he reinvented what he saw, and the strollers of the *Grande Jatte* are just as unreal as the monsters of Redon.

By contrast, several reasons make it right to accord a very important position to Rodin. In France he filled the role of artist-god, or at least national hero, in the same way as Wagner had done in Germany; his groups of lovers tortured by pleasure and his cursed women represent the most faithful interpretations of Baudelairian eroticism; at the same time, in the sinuous handling of marble, in the knotted bronze bodies like roots for the *Gates of Hell*, one can discern the line of *art nouveau*. Certainly his work gains from being exhibited in a Modern Style interior. One could find everything in Rodin just as in Victor Hugo, whose position as the first man among 'great Frenchmen' Rodin took over; no one was so admired, even, ultimately, by the official world itself. A pavilion at the entrance of the *Exposition Universelle* of 1900 was dedicated to the glory of Rodin; *La Plume* devoted a special issue to him with articles for England by Arthur Symons and Frank Harris (57, 58). His writings on art, apart from the passages in which he deals with the technique of sculpture, are as vague as oracles, albeit an oracle with Symbolist tendencies (59).

There were two other sculptors, both Belgian, whom the Symbolists admired: Constantin Meunier who, in a spirit very close to the poems of Verhaeren, idealized the world of work, portraying toil or

weariness, and George Minne who depicted emaciated adolescents but was above all a distinguished draughtsman. Bourdelle exhibited statuettes and drawings at the *Salon de la Rose+Croix*. Finally a rather academic sculptor, Bartholomé, happily came under the influence of Symbolism in the very beautiful monument of Death at the Cemetery of Père Lachaise; this is a Puvis de Chavannes in stone.

Eugène Carrière, who drew the well-known lithograph of Rodin at work, owned only one marble statue by Rodin and a drawing by Puvis de Chavannes among a vast pile of his own works. Carrière, a dozen or so years older than the young Symbolists, was much admired by them; they found in his 'Motherhoods', in his portraits and even in his landscapes that mistiness which expresses the soul. The public adopted this taste and reproductions of Carrière's work sold nearly as well as Puvis' St Genevieve. Monotonous and repetitive, he reminds one of a remark by Gide about a Catholic writer 'who talks of the soul as one might talk of one's nose'. If Mallarmé saw in Carrière 'the opacity of the ghosts of the future', Redon was more severe: 'He unpleasantly evokes the memory of this sullied, neutral umber matter which he then uses and out of which emerge his paintings of Motherhood.' He lived in London, admired Turner, and knew Whistler whose washes, impastos, pinks emerging from brown glazes he imitated, but rather sadly. But although influenced by Symbolism, he did not paint 'typical' Carrière paintings until 1888. Until then he had been a painter of sad intimate little scenes in the manner of Louis Deschamps. Men of letters doted on Carrière; he painted excellent portraits of Verlaine and Edmond de Goncourt, a group portrait of the family of Alphonse Daudet which was immensely successful; but Degas merely was typically sarcastic: 'They have been smoking again in the children's bedroom.' Carrière's lithographs were more interesting than his paintings; they give off the same sadness that one finds in some of Samain's poems. In politics, Carrière belonged to the Left; he admired the world of labour. Lacking the energy of his friend Constantin Meunier he was nevertheless as successful as Khnopff in creating a model of the Symbolist woman, although he replaced the elegance with tenderness and misery.

Cazin was another painter of sorrow. Much less gifted, he certainly influenced the Symbolists. Redon admired him and Maurice Denis wrote that 'he glosses over the details, removes the irregularities of contours; he simplifies in order to unify and expand the meaning'. But Fénéon found this painter who placed biblical subjects among the sand dunes of the Pas de Calais 'melancholic by profession'. Cazin had also paid long visits to London and his spirituality often seems to come close to that of the Pre-Raphaelites; in short, he was the Puvis of the poor.

Although Fantin-Latour also visited London (and it was the only journey made by this timid man) his work was much more important than that of Cazin. He is at times a refined painter close to his Impressionist friends, at times an excellent portraitist as, for example, in his *Hommages*, which group together all the leading lights of the *avant-garde* (he was hardly one himself) around a bouquet of flowers or a bust. Fantin was also very much a painter of the Second Empire in spite of his pictures of subjects drawn from Wagner's operas. His Valkyries, his Rhine Maidens could have been Baudry's models with their languorous forms drawn out in the mist of a blue-tinted forest scene. (They are really much closer to Gounod!) However, the exhibition of a *Tannhäuser* at the *Salon* of 1864 made him one of the fathers of the movement. In his late works such as the *Temptation of St Anthony* (1897) or the *Prelude to Lohengrin* the influence of Symbolism can be clearly felt. As with Puvis and Carrière, Symbolism learnt from him after he had initially learnt from it. His lithographs, inspired by Schumann and Berlioz as well as by Wagner, revealed a technique to Seurat and Redon who were closely associated with him. He still clung to Impressionism through his friendships and through his flower paintings which were very popular in England, where Whistler published them.

Among the minor precursors of Symbolism there are two other artists worth mentioning: Leopold Lévy, at times very similar to Moreau, and Charles Sellier, an artist from Nancy who was of some importance for Gallé and Prouvé. Neither of these gave to Symbolism such fundamental images as did Victor Hugo, Bresdin or Doré, whom we placed beside Burne-Jones and Chassériau as the inspirers of the movement. They responded to a certain public demand for poetic ideas, on the fringes of Moreau and Puvis, and thus they prepared the ground in the *Salon* after the end of the Second Empire. There were also some extremely Parisian eclectic painters who followed fashion in the direction of Symbolist

subject-matter, but who retained their Ecole des Beaux-Arts techniques. The most charming was Clairin who lived in the shadow of Sarah Bernhardt and who recorded in paint the actress's appearance either in her various dramatic roles or simply, but no less stunningly, in her own home. Then there was Mucha whose posters popularized the treasures discovered by Sarah Bernhardt in Gustave Moreau's studio. There are references also to Sarah's plays *Gismonda* and the *Princesse Lointaine* in front of some of the canvases by Rochegrosse, the illustrator of *Salammbô*. This purveyor of mythological salads tossed together some Symbolist themes in his unbelievably vulgar *Chevalier des Fleurs* ('Knight of the Flowers') just as he assimilated socialist theories for his allegories of realism, like his *Lutte pour La Vie* ('Battle for Life').

What was the influence of the Impressionists on Symbolism? It is well known that Redon found them 'too low-brow' and that Gauguin, having left them, reproached them for 'working too much with the eye instead of seeking out the mysterious centre of thought'. The names of Renoir and Sisley are scarcely mentioned in the Symbolist reviews. At the *Salon des Indépendants* of 1881, Huysmans merely notes in passing 'two recruits from Impressionism: Seurat and Signac', then hurries on to talk about Redon. Monet's name alone appears frequently and covered with praise. Aurier, in 1892, notes his unconscious influence on his favourite artists (60). One finds, he claims, Monet's influence, a sort of feathery use of colour, in Schuffenecker, in Henri Martin, in Le Sidaner. The cathedrals received wide acclaim in the Symbolist press, but this may have been because they were cathedrals rather than hay-stacks; they were seen at Durand-Ruel's and then at the Libre Esthétique in Brussels. Finally, in 1900 Jean Lorrain, disgusted with the Symbolists but still searching for the painting of dreams, found his ideal in Monet's *Waterlilies*, the blue luminosity, the watery transparency, the fairyland of light and *chiaroscuro* . . . (61).

By 1900 it was thought that the Symbolists had taken the wrong road in their search for the mysterious and that it would be more worthwhile to be dazzled by a garden on the banks of the Seine than by forests full of princesses and peacocks. The dead glories created by Gustave Moreau were rapidly covered in dust and the time had come to yawn in front of Puvis de Chavannes; the only artists who escaped this change in taste were Redon, saved by his flower paintings, and Rodin whom patriotism had turned into the Wagner of France.

Albert Trachsel:
Temple of Sorrow.
1897

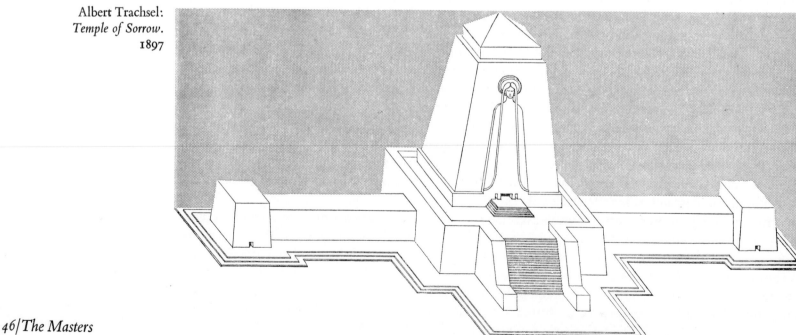

After looking at the rooms in the Palace of Arts devoted to the great masters and their followers, and the corridors of painters who thought of themselves as masters, we should go on to see some rooms devoted to the different types of painting which felt the influence of Symbolism. But it is worth considering first whether there were pictorial techniques which were as peculiar to the Symbolist movement as were its sources of inspiration.

Most of the critics mentioned in this book had their own theories to explain the new style of painting. Thus Alphonse Germain, working in close association with Séon, established rules which were most sympathetic to the work of Puvis de Chavannes (62). Séon himself evolved a theory about perspectival gradation of tones. This was published in an article in *La Plume*, and in September of the same year, 1891, it was further developed to include the theory of colour based on Chevreul's system of complementary colours and supported by quotations from Ruskin and Charles Henry: 'The aim of every artist ought without doubt to be the establishment of harmony between the colour peculiar to the object and the colour of the space which this object occupies; but the artist must also know the harmony which exists between colours and emotions.' This desire of Séon was more precisely defined by the spiritualist Jules Bois: 'Our work here on earth is to single out our distant homeland and to invoke its influence through the symbolism of colours and precious stones.' And Saint-Pôl-Roux declared that 'to create the iconic image of the occult (*iconiser l'occulte*) is the ambition of Art'.

But the taste for the occult had not overshadowed an interest in science. Botany was eagerly studied by all the artists who contributed to *art nouveau*; beyond strange forms, beyond stylizations, they sought in it a complete theory of Creation. Grasset and Gallé were excellent botanists; the letters of the latter to Robert de Montesquiou present a strange theory of aesthetic evolution. Likewise, the theories of Darwin were of importance for the young Redon thanks to a teacher of natural sciences in Bordeaux. This is apparent from his first set of lithographs of 1879 onwards, and even more so in his set of 1883, *Origins*, whose plates bear captions like 'When life was awakening from the depths of obscure matter', 'The deformed Octopus drifted on the sea-shore'. Moreau paid frequent visits to the Natural History Museum to search out the coral and seaweed which decorated Galatea's grotto.

Artists' curiosity for anything which would help to clarify their ideas about a non-realistic art carried them into distant lands. Thus we find among Seurat's papers a text by an eighteenth-century Turkish artist discovered by Gauguin in about 1885. His advice on how to achieve immobility could have been pure Symbolist theory, with its insistence on simplicity of subject-matter and of composition (63). On these grounds Aurier took Monet and Renoir to task for too subtle a technique, comparing them to children for whom painting is nothing more than a fascinating toy; at every opportunity he emphasized the need for a symbolic rhythm of line accompanied by significant colour (64).

Painting was certainly no toy for Gauguin; he attempted a variety of techniques, like Balzac's hero in search of the Absolute, and those who admired him copied him. Having abandoned Impressionism he tried Cloisonnism, invented by Anquetin, ringing the forms with dark blue lines and banishing blacks; then he studied popular engravings with their crude, flat tones. This flat painting, the static composition, and the obvious, frequently even exaggerated outline, are found in the work of several Symbolists although the palette is far less wide-ranging than that of the artists of Pont-Aven. Those artists who preferred Moreau to Puvis generally followed the methods learnt at the Ecole des Beaux-Arts, contenting themselves with lightening their palette and respecting the 'principle of inertia';

Moreau's second great principle—richness—was far less frequently followed except, sometimes, by Delville and by book-illustrators. However, all artists despised the 'recipes', the transparent glazes, the impasto, which art lovers of the Goncourt school found so 'tasty'. In general Symbolism is a style of painting devoid of stage effects. Here again Ensor is an exception, which is yet another reason for placing him outside Symbolism.

Pastel, always slightly indeterminate, allowing scumbling and tonal shading, was used by all painters of the soul who followed Fantin-Latour; Lévy-Dhurmer and Khnopff reveal themselves as greater masters in this medium than in oil. Besides, like all artists of the imagination, the Symbolists were better at drawing than at painting; there are some charming drawings by appalling painters like Charles Maurin and Ernest Laurent, and even for a master such as Redon a charcoal drawing always says far more than a painting.

Symbolist paintings which had been noted at the *Salons* for their strange subject-matter and their pure, flat colours were not encased in the heavily gilded, gingerbread frames which even the Impressionists had been unable to give up. Whistler was the first to harmonize frame with painting; he was quickly copied. As early as 1886, Jules Laforgue admired the variety of frames (65), and a few years later, Maurice Denis was writing that 'white frames surrounding large canvases painted in wax or distemper are considered acceptable; they set off the lightened palettes. Or else, use black frames like Messieurs Bernard and Anquetin. . . . And for this idea of picking up the tonality of a painting in the arabesques which surround it, take the frames covered with flowers, spotted frames, frames embroidered by loving hands, of Messieurs Ranson, Bonnard, Denis. As for Seurat's disciples, they prick their frames according to the laws of contrasting colours and tones' (*Revue Blanche*, 1891). Victor Hugo had been the first to extend the plant-like forms of his drawings on to light frames in pokerwork.

Lithography, in much the same way as pastel, was a favoured medium of expression, and here again the example of Fantin-Latour was decisive. Redon delivered a magnificent eulogy in praise of the technique during an exhibition of his work held at The Hague in 1913, even though he had given it up some twelve years earlier (66).

Generally speaking, the Symbolists, despite differences in technique, did not stray far from the edicts laid down by Péladan: no anecdotes, no still-lifes, no picturesque landscapes; thus religious painting was to be revived. It is first of all the mystical painters therefore who will hold our attention during our visit to the Symbolist palace.

THE DIVINE By 1880 traditional religious painting had reached its nadir; faced with the virgins of Bouguereau people even regretted Flandrin's boring compositions and the sentimental Ary Scheffer, so fashionable under Louis-Philippe. James Tissot, society painter turned convert, was illustrating the Gospels with a concern for exact natural detail comparable to the Pre-Raphaelites. It was at this time that Huysmans attacked the religious bibelots sold around the church of Saint-Sulpice, Madonnas of Lourdes and flaming Sacred Hearts. As we have seen, Péladan was then acclaimed the Messiah; the young Maurice Denis benefited more than anyone else from his lessons, and marked out the path of simplicity: 'The Christ of Byzantium is a symbol; the Christ of modern artists, even if clothed in the most authentic of *kiffieds*, is nothing more than mere literature. In the one it is the form itself which is expressive; in the other it is merely the imitation of Nature which would like to be so.'

There was no more of the Christ in *kiffieds* than the Christ of Byzantium in the paintings of the young Maurice Denis. Certainly he was inspired by Fra Angelico, but his anachronisms and his style of drawing recall Pont-Aven; the nuns who follow the procession to Calvary, the priest who replaces the Angel of the Annunciation, the young girls in the Salutation of the Angel, all underline the truth of the Scriptures in our lives, all make the miracle seem possible on a familiar level. The same anachronisms in the religious paintings by Ensor, the episodes from the Passion set in the middle of a carnival, represent the sorrow of the artist in society. With Henry de Groux, the crowd which hurls insults at Christ possesses all the vulgarity of an affluent populace despite the half-hearted attempt at a Roman setting; hence the success, so difficult to comprehend today, of this immense canvas. The sim-

plicity of this approach is a reflection of the Catholic revival at the end of the century; one finds it in the *Annonce faite à Marie* by Claudel, in the poems of Péguy and in the short stories of Francis Jammes (67). Many years later, in 1919, Denis and his friend, Desvallières, a former pupil of Moreau and admirer of a much more Byzantine style of Christ than was Denis, founded a studio of sacred art which undertook commissions from enlightened religious communities until the Dominicans, in order to be more up-to-date, gave commissions to Matisse.

Byzantium, that haven of all Decadents, was, however, a far more important source of inspiration than the Primitives for the revival of religious art: Byzantium, fascinated by theology, the creator of the 'Christ Pantocrator' in the likeness of an emperor. This was the image, with its vast halo, that was to be chosen by Odilon Redon in his *Temptation of St Anthony*. The hieratic (a favourite word of the period) stiffness of the processions of saints, and even the suggestion of mosaic, can be found in Filiger's Virgins and St John the Baptist's; he was one of the strangest members of the Pont-Aven group. Beside him, Emile Bernard's commitment to medieval religious imagery seems crude rather than truly naïve. It is well known that, in the wake of Verkade, some of the Pont-Aven painters decorated the Benedictine abbey of Beuron in Germany.

Another image of Christ is that of the unkempt rebel with whom the artist identifies himself, as in the canvases of De Groux; with the eyes of a hypnotist, he is more like Rasputin. But the religious painting which caused the most stir in the *Salon* was that of Dagnan-Bouveret, a realistic, almost photographic, artist who after his conversion borrowed much from Symbolism, especially in his *Last Supper* of 1898. In much the same spirit we find the Genevan artist, Burnand, making pencil illustrations for the Parables in a style imbued with Calvinist simplicity. Symbolists openly adopted the image of piety: Luc-Olivier Merson in his famous *Flight into Egypt*, or Edgar Maxence with his angels draped in liturgical finery.

Angels—there were hosts of them, for they represented 'souls', a role which explains the frequent ambiguity of their smiles, the equivocal swelling of their hips. Many Symbolists preferred the supernatural to the divine; with the Decadent Movement, fairies also invaded the studios either in medieval disguise as in the case of Maxence, or ready for dinner at Maxim's as in the case of De Feure. There were the disturbing sorceresses of Lévy-Dhurmer and the ghouls of Lenoir who break the sabbath and swarm through the poems of Jean Lorrain; we also find them in the fairy-like Chinese shadows of Andhré des Gachons. Under the influence of Gustave Moreau, other painters preferred chimeras, like Khnopff, or sirens, like Ary Renan. Fairies or chimeras, all these creatures express a yearning for the fantastical among those who had no religious faith; tainted with a certain malevolence, they symbolized the appeal of evil. The public, however, tired of these more quickly than they did of the angels, for the latter could be transformed into pictures of a First Communion.

At the sale of the contents of Degas' studio in 1918, Daniel Halévy met the greatest of all Symbolist novelists, Elémir Bourges, in a state of great indignation over how a painter of such stature could have spent his entire life painting ugly women and vulgar men (68). In order to discourage the representation of ugliness, Péladan had banned the portrait from his *salons* (although this did not stop him from having his own portrait painted frequently in a number of different disguises by Desboutin, by Delville, by Séon). In spite of the Sâr, the portrait was a *genre* in which the Symbolists excelled, as long as one could read that 'wistfulness of exiles' (Walter Pater) on the faces as one could on those by Botticelli. Some are young, gentle girls, but at times disturbing like the models of Khnopff and of Lévy-Dhurmer, or quite simply wrapped in thought like those of Armand Point and Aman-Jean who came straight out of the garden of Wilde's Blue Bird; the foliage like a tapestry, the rocks like a Leonardo, the indistinctly patterned materials, set these portraits apart from everyday existence. Others, like apparitions, for instance Mme Stuart Merrill by Delville, are endowed with magical properties. The woman must always enter into a world of fantasy. Maurice Denis succeeds in giving even the most bourgeois of scenes a charm of the 'beyond'. The men, with their moustachios and their pince-nez, lent themselves less easily to this type of interpretation; Montesquiou by La Gandara and Rodenbach by

Lévy-Dhurmer are two exceptions. Very occasionally artists, trying to emphasize a particular side of the personality of their sitter, exaggerated a certain feature of the face; Jean Wéber did this, and, even more markedly, Spilliaert, but this tended to descend into caricature or Expressionism.

Symbolists tended to avoid painting the nude because it can reveal material aspirations, and thus the expression of a face may, as in Lévy-Dhurmer's Eve, for example, be contradicted by a large behind. Odilon Redon wanted the nude to remind us of the days before Original Sin, that was to say before the invention of the corset (69). The Symbolist nude can be found in the *Hope* of Puvis de Chavannes and in the Ondines of Burne-Jones; the nudes of Hodler and Gauguin were too sensual. Gauguin had been congratulated at the *Salon* of 1881 by Huysmans, however, for a nude very different from the official ones: 'I am happy to welcome a painter who has expressed with greater vehemence than I an imperious disgust with the mannequins with pink, perfect breasts and neat, firm stomachs, all drawn according to the recipes of plaster-cast copying.' Ten years later the critic Gustave Soulier admired Schwabe's figures for being so thin (70).

NATURE The prototype of Symbolist landscape is found in Puvis de Chavannes evocations of a season, its labours and its afflictions. Holding up a laurel branch one day, the master declared: 'Here is the whole forest of the Sorbonne'; from such a banal object he recreated a vision of the Antique (71).

The same indifference is found in Gustave Moreau: 'What importance does Nature have by Herself? She is nothing more than an excuse for the artist to express himself. . . . Art is the never-ending search for expression of internal feelings by means of plastic form.' If it is not the back-drop for a lesson or for a legend, landscape must express a spiritual state; to do this, one must simplify, one must avoid the picturesque or dramatization of Nature as was done by the school of Barbizon. But one was allowed to emphasize the atmosphere of allusion by placing a Florentine church in the distance like Denis, a view of Venice like Carrière, or Austrian palaces like Degouve de Nunques. Symbolism left its mark on Henry Rivière's large coloured lithographs, made for decorating apartments, landscapes of Brittany which seem to have been seen through the eyes of an anaemic Japanese. This same taste covered the walls of railway stations of around 1900 with a wonderful series of travel posters.

If the Symbolists had known about Chinese painting they might have been able to create a school of landscape-poems or calligraphic still-lifes by pushing the principle of stylization to its very limits. The Six Fundamental Rules of Painting formulated some 1,400 years earlier by Sie Ho would have suited them perfectly: 'The fusion of the rhythm of the Spirit with the movement of living objects.' It was Redon who alone possessed such an intuition, but not Osbert, although Alphonse Germain was to say of the latter: 'The essays in psychic landscape . . . breathe the rhythm of Nature's life.' Schuffenecker came closer perhaps to this definition in some very delicate pastels which could be mistaken for work by Monet.

The ideal Symbolist landscape painter was the much earlier German Romantic painter, Caspar David Friedrich, whose work our artists did not know; his immense spaces invite us to dream while his dead trees, his crosses under the snow, his ruins caught in the last rays of the sinking sun would provide the most beautiful sets for Villiers de l'Isle Adam's *Axel*. Charles-Marie Dulac, the painter of Franciscan landscapes, would seem to come closest to Friedrich, but with a sense of privation bordering on poverty, in those views seen from above, cut by the snaking line of a river. For Dulac, water represented 'the separation of the pure from the impure'; it recalls the sacrament of baptism and it had been the symbol of chastity for St Francis.

The forests, of Broceliande or the Sacred Wood, are also rich in symbols, but there were few instances when these symbols were expressed without the support of fairies or muses. Among the painters of these were: Lacombe, one of the *Nabis*, with his mauve and red tree trunks; Degouve de Nunques with his mysterious and intense green landscapes; Montald, whose wintery trees are reflected in ponds, unlike the French who love to see their houses covered with wisteria and lilac blossom, as in the works of Le Sidaner and Aman-Jean. The Belgians were particularly gifted in painting a world devoid of sunlight, and crossed by sleepy waterways. The painters of the North seem to be obsessed by the House

of Usher as it stands waterlogged and crumbling among mouldering tree stumps. Around 1904 a colony of painters settled round Degouve de Nunques and Gustave van de Woestyne in the village of Laethem Saint Martin. In this Pont-Aven of contemplation, Symbolist landscape painting was cultivated for more than twenty years. Jacob Smits, with his Gospel subjects set in this grey countryside, reminds us of Emile Bernard. Valerius de Saedeler, Georges Lebrun (a great admirer of Maurice Denis), Servaes (the ferryman of souls) show as much Flemish Expressionism as Symbolism; they invite comparison with the wonderful German watercolourist Emil Nolde.

Few animals grace these Symbolist landscapes, apart from a few unicorns, some peacocks and some swans; certainly no cows, that sacred animal of open-air painting and symbol of the most down-to-earth prosperity and domesticity.

Both Péladan and Aurier expressed a preference for fresco; for Gauguin, the latter demanded 'Walls! Give him walls!' Elsewhere he decreed that 'painting could only have been invented in order to decorate the banal walls of man's buildings with thoughts, dreams and ideas'. Alphonse Germain in L'Ermitage in 1892 also praised frescoes (72). This demand reveals Symbolism's anxiety to be protected from the outside world with scenes which have no connection with everyday life, and its feeling for the past, this passion to repeat the example of Giotto and Fra Angelico. Thus many paintings imitated fresco, its static compositions, its flat colours. Even triptychs were painted, so large that, encased in elaborately architectural frames, they covered a whole wall.

The Second Empire and, to an even greater extent, the Third Republic provided vast areas of wall to cover; thus Puvis de Chavannes received in Paris alone huge commissions for the Sorbonne, the Hôtel de Ville and the Panthéon. His most devoted admirer, Séon, had nothing larger than a suburban town hall; by contrast, Puvis' favourite disciple, Henri Martin, had vast surfaces placed at his disposal, especially in Toulouse, his birthplace, which had ironically acquired the name of the 'Athens of the Republic' on account of the number of ministers who came from this region and who obtained commissions for local artists. Martin's Clemence Isaure appearing to Petrarch had a great success at the Salon of 1896. But as he grew older Henri Martin became increasingly concerned with landscape painting, and haymakers replaced the muses. The decorative work of René Menard at the Sorbonne and at the Faculty of Law, and the great decorative cycles of Albert Besnard, stylistically half-way between Academicism and Symbolism, also deserve a mention. Scientific and religious themes are cleverly balanced in Besnard's work: the Hall of Sciences at the Hôtel de Ville, the Chapel at the Faculty of Pharmacy in the Hospital at Berck, and the famous Island of Happiness, an embarkation for Cythera in the style of 1900, which perhaps gives too flattering an idea of the mural decorations hung in the Paris Exhibition. Unfortunately the strange frescoes by De Feure on the façade of Bing's pavilion at the Exhibition have disappeared: they depicted attenuated forms of women dressed in the latest fashion, set against a mauve garden.

A rich and cultivated bourgeoisie occasionally followed the example of the State and was not satisfied with putting together 'historical' interiors in their flats on the Plaine Monceau or in their town houses at Passy. The painters of the Imagination responded more adequately to their needs than did the stars of the Salons. There was the town house of M. Rouche with frescoes by Desvallières; the staircase of Gide's house enriched with the Perfume of the Nymphs by René Piot; the decorative panels by Aman-Jean, which can be seen now at the Musée des Arts Décoratifs; and above all, that extraordinary achievement of the latter phase of Symbolism: the Peacock Dining Room by Lévy-Dhurmer for a house on the Champs de Mars, now in the Metropolitan Museum of Art, encased in panelling whose sinuous shapes pick up the suffocating vegetation and the evil-scented flowers, as in a landscape by Edgar Allan Poe. The frescoes by Odilon Redon for the abbey of Fontfroide are less successful than those of Lévy-Dhurmer; both are late, dating from after 1910. Since 1900 Redon had been tempted by murals and decorative art (73). Later still are the frescoes by Maurice Denis at the Théâtre des Champs-Elysées, perfectly framed by the architecture of Perret; but they only qualify as 'Symbolist' because of their mauve tones, and seem to look forward to the simplicity of 'Art Deco'.

There was a good deal of fresco painting in Belgium also. Rather than remaining a charming painter of intimate interiors Mellery dreamed of decorating the Brussels Palais de Justice with allegories set into a gold background. Montald covered the entrance hall of a museum with the *Ship of the Ideal* and the *Fountain of Inspiration*, in the style of Puvis de Chavannes. Delville painted an immense and icy *School of Plato* for the Sorbonne; Khnopff let himself loose on a series of immense decorations for the town hall of Saint-Giles. The women draped in long robes carrying medallions are closer to allegory than to symbol, but it would have been more suitable for his own house, devoted as it was to silence and to beautiful dreamers worked in *grisaille*; it seems that he was looking forward to a new classicism. Khnopff's work influenced Von Stuck when he built his famous Greek house in Munich; and he heralds the rectilinear Modern Style loved by the Viennese but which was to find its best expression in the Maison Stoclet in Brussels, with its decorations by Klimt. The most remarkable example of Symbolist decorative work is Gauguin's *Where do we come from? What are we? Where are we going?* However well displayed this work may be in Boston, it is in exile in a museum; its home should be in a sanctuary with wooden pillars carved in the form of dragons.

THE GRAPHIC ARTS An important place in the Symbolist Palace is given to the folios of prints. Leaving aside the symbols or allegories of the frescoes, it is worth opening the books of the movement. It is once again Maurice Denis who defines the book-illustrator's ideal: 'To find a decoration which is not servile to the text, which does not provide an exact correspondence between subject and text, but rather an embroidered pattern of arabesques across the page, an accompaniment of expressive lines.' And, as an example, Maurice Denis cites his own illustrations to Verlaine's *Sagesse* which are really one of the greatest achievements of book publishing in the Nineties.

Around 1890 there was a genuine renaissance of the illustrated book which, since the death of Gustave Doré, had fallen into mere anecdote and decoration in the style of Madeleine Lemaire. Luxury reviews spread this new taste among book collectors. Octave Uzanne, a friend of Jean Lorrain and a person interested in the latest trends, founded *L'Art et L'Idée* in 1892. Its first number had an article by Rémy de Gourmont (74). A long-lasting review illustrated with wood engravings, *L'Image*, contained work by Denis, Berthon, and Vallotton. A strange poem about Tahiti by Charles Morice is framed in a woodcut by Séguin in the manner of Gauguin. *L'Image* offered its readers poems illustrated with lithographs either by or after Khnopff, Berthon, De Feure, Aman-Jean, Lenoir. *L'Ymagier*, founded by Rémy de Gourmont and Alfred Jarry, was mainly interested in early woodcuts and popular engravings, but it also included engravings by Filiger and a large woodcut: *War* by the Douanier Rousseau.

There were also a number of artists who designed poetic bindings for books; Prouvé, who came from Nancy, was the most important. For the clients of Gallé and the visitors to the *Salons de la Rose+Croix*, designers decorated books to look like missals, covering them with extraordinary borders of foliage. The most astonishing designer was Carlos Schwabe. His decorative work was like a piece of embroidery; he hemmed it with an appropriate motif and covered the entire page with random design. He illustrated Zola's *Le Rêve* ('The Dream'), Haraucourt's *L'Immortalité* and the *Evangile de l'Enfance* ('The Gospel of Childhood') by Mendès. Mucha's illustrations to Robert de Fler's *Ilsée, Princesse de Tripoli* ('Ilse, Princess of Tripoli') are in the same floral style but more Byzantine than botanical, as are his extraordinary decorations around each word of *Our Father*, which has faces and flowers woven into the arabesques. Beside these, the illustrations by De Feure for Schwob's *Porte des Rêves* ('Door of Dreams') and the poems of Samain seem more straightforwardly tortured. There was a side to De Feure which reflects Félicien Rops, but is saved by the wonderful hues of his watercolours. As for the countless imitators of Rops, it is pointless to name them all; they all illustrated the *Fleurs du Mal* but without the Belgian artist's amazing facility to save them from dismal obscenity. The best illustrations which Rops himself produced were for Barbey d'Aurévilly's *Les Diaboliques*; these have nothing to do with Symbolism, but are a form of bizarre Realism. Eugène Grasset was one of the most interesting illustrators and also a disseminator of *art nouveau*. He owed much to the books of Walter Crane and Kate Greenaway, and his illustrations for the *Quatre Fils d'Aymon* ('The Four Sons of Aymon') of 1884

produced a host of imitators who styled themselves 'ymagiers' or image makers. Grasset also decorated the catalogues of department stores and the Christmas numbers of *L'Illustration* and *Le Figaro Illustré*, thus carrying the new taste into areas previously untouched by the Fine Arts. These issues must be ranked among the successes of popularized Symbolism. Artists such as Orazy, Des Gachons and Chalon propagated enchanters and princesses, poisonous flowers and suggestive angels, all accessories which rapidly went out of fashion.

Belgian publishers remained more faithful to the simplicity of the texts which they selected. Thus George Minne engraved vignettes on wood for Maeterlinck's *Serres Chaudes* and *Princesse Maleine* which look forward to Maillol's *Georgiques*. In an archaic style Doudelet illustrated Maeterlinck's *Douze Chansons*, and Van de Velde, soon to abandon painting for architecture, decorated the poems of Max Elskamp with *art nouveau* woodcuts. A strange illustrator from Antwerp, Edmond van Offel, Mannerist as much as Symbolist, deserves a mention; as does the fact that the collected works of Verhaeren and Ivan Gilkin used lithographs by Odilon Redon as their frontispieces.

Symbolism also made itself felt in the satirical, and often very vulgar, newspapers such as *Le Rire*. Throughout Europe there were imitators of Aubrey Beardsley, but artists such as Ibels, and more especially Vallotton—who revived the art of wood-engraving—used Symbolist techniques to mock a world which they despised. With a few touches of black ink, Vallotton encapsulates the boredom of bourgeois life or the stupidity of a *gendarme*; thick lines like the leading of a stained-glass window outline a face which will never entertain an interesting idea. It was one of the favourite artists of the *Revue Blanche*, Jean Wéber, who drew in his hazy style members of the aesthetic circles, whom he turned into fairies or enchanters, while his middle classes seemed to be on the point of turning into frogs. He designed a cartoon based on the *Tales* of Perrault for the Gobelins tapestry factory which was immensely popular after 1900, and he covered the walls of Rostand's villa near Biarritz with fairies. At the *Salon* of 1900 he exhibited a painting in which the condemnation of Symbolism is plainly to be seen. An artist, slightly mad, sits in his studio with his back to a beautiful nude girl who lies on a couch, his model, life or reality; meanwhile he plays with dolls, princesses and magicians, clothed in the cast-offs of Symbolism; the whole thing is called *Les Pantins* ('The Puppets').

Finally, attention should be drawn to the influence exerted by Symbolism on two fields related to the graphic arts: photography and architectural drawings. Drawings alone are mentioned because it would be beyond the boundaries of this book to search for literary and imaginative influences in the work of Guimard, Horta, or even Gaudí. Péladan had proscribed all architecture except projects for fairy palaces and reconstructions. Two curious artists did adhere to this programme; the first, a sort of sub-Péladan who lived many years in one of the towers of Notre-Dame, signed his over-meticulous drawings of imaginary cathedrals 'Mérovâk'. The other, Albert Trachsel, a Swiss friend of Hodler, had a considerable success at the *Salon de la Rose+Croix* of 1893 when he exhibited a series of lithographs of utopian architecture called *Real Facts, Song of the Ocean* and *Apparitions*. His 'vision into the future' provoked comparisons with Blake and Redon, although he is closer to a neo-classical visionary architect like Boullée. 'Whether reverberating with the sound of festivities, whether hiding pavilions of joy, his monuments are enriched by their creator and governed by expressive rhythms alone. . . . He has looked forward to the forms that will be taken by the temples of a human race at last reconciled with the unknowable' (Stuart Merrill, *La Plume*, 1893).

As for photography, one has but to glance through the issues of *Studio* and of *Le Figaro Illustré* to see what poetic aspirations did to realism. The precise psychological images of Nadar have been succeeded by apparitions, mists have invaded the plates, clever lighting has given even the most insignificant girls the qualities of a ghoul. In other words, the further it moved from realism, the more a photograph was regarded as a work of art. Whistler was an important influence on landscape, Carrière on portraits, and Rodin on the nude. In 1900, a fine book called *L'Esthétique de la Photographie* ('The Aesthetics of Photography') appeared; its text and indistinct images of wan women wandering in abandoned parks suggest the style of Symbolism. The book states that 'the anecdote must be raised to the level of a symbol', that we must find backdrops 'as bare as the walls of a church', and it provides various recipes for not distracting attention away from Beauty by too much detail.

8. Symbolism Perpetuated

It is only right that the last images in our visit to the Symbolist palace should be faded photographs of the Giocondas or Botticelli girls who haunt the autumnal garden, brought back to life in our memories by some lines from Maeterlinck or by a melody by Debussy. The shadows which had enveloped them for so long are finally dispelled; their painters and their poets have found new admirers, and they themselves seem touching rather than ridiculous. These faces, these poses formed by the cult of Beauty or by the search for a spiritual life, are still found, although in a somewhat changed state, in the two types of work which are found in the final hall, whose door leads back to everyday life, the counterpart of the entrance hall in which there were the images which nurtured Symbolism.

The most interesting proofs of the survival of Symbolism are found in painters whose researches were to carry them well beyond this style; there were also of course those who were merely content to follow its precepts when its spirit was already dead. Of all the artists discussed, the one who made the most impression on younger generations was Puvis de Chavannes, and this was due most of all to the *Poor Fisherman*. A very large part of Picasso's Blue Period derives from this painting: the same simplification of design, the same evocation of misery, almost the same colour; the face of the Poor Fisherman also occurs in several Picasso etchings, although the treatment is closer to Goya. Picasso adds to all this a certain erotic charm which Puvis entirely lacks; thin, dressed in rags, a distant look in their eyes, the jugglers and harlequins nevertheless possess a sensual grace. Matisse was also influenced by those compositions, which evoked a feeling of serenity; in 1904 he used a composition derived from Puvis and a Fauve palette to illustrate Baudelaire's line (from *L'Invitation au Voyage*): '*Luxe, calme et volupté*' ('Luxury, calm and voluptuousness').

Apart from an occasional arabesque and an occasional flower, Matisse's debt to his teacher, Moreau, is much harder to define. Moreau's favourite pupil, Rouault, on the other hand, had a personal symbolism which one finds as much in the plates of the *Miserere* as in the watercolours of prostitutes and the oil paintings suggesting biblical landscapes. The Douanier Rousseau, discovered by Rémy de Gourmont and Alfred Jarry, was also a Symbolist in his way. *War*, *The Dream*, and the jungles seething with serpents are as clearly symbolic as the interpretations of a dream by Freud. Rousseau, who admired Bouguereau, thought of himself as a painter of allegories. For Chagall, the combination of Hebraic tradition and Russian folklore provided a complete symbolic system, delightful to begin with, then exploited *ad nauseam*; nothing palls as rapidly as the flavour of true Symbolism. The *Guernica* is the best proof of this; much more than an allegory, this is a Symbolist painting which receives its strength from the horror which it evokes. The same elements in the ambitious canvases painted after the war by a contented Picasso become stereotypes. Political anger also allows us to call Diego Rivera and even Orozco Symbolists, while the official Russian artists on the other hand are either painters of battle scenes or of allegories like those seen in the *Salon* some eighty years ago.

It is outside France that a real continuation of the Symbolist movement is to be found. In England Augustus John's early paintings, Stanley Spencer's *Resurrection* and the drawings of George Moore all have a power of evocation which, whether poetic or social, is impossible to find in the French painters of 'Happiness' like Matisse, Bonnard, or Vuillard whose works make no reference to the idea of Death. This idea on the other hand dominates certain paintings by Tchelitchev in his 'Hide and Seek' period; it obsessed that Chicago painter, Ivan Albright, whose work *The Door*, and especially its motto, 'That which I should have done I did not do', would have delighted the disciples of Péladan. Erotic Symbolism is evident in the work of Balthus and, like all painters of the Imaginary, this realist uses archaistic

produced a host of imitators who styled themselves 'ymagiers' or image makers. Grasset also decorated the catalogues of department stores and the Christmas numbers of *L'Illustration* and *Le Figaro Illustré*, thus carrying the new taste into areas previously untouched by the Fine Arts. These issues must be ranked among the successes of popularized Symbolism. Artists such as Orazy, Des Gachons and Chalon propagated enchanters and princesses, poisonous flowers and suggestive angels, all accessories which rapidly went out of fashion.

Belgian publishers remained more faithful to the simplicity of the texts which they selected. Thus George Minne engraved vignettes on wood for Maeterlinck's *Serres Chaudes* and *Princesse Maleine* which look forward to Maillol's *Georgiques*. In an archaic style Doudelet illustrated Maeterlinck's *Douze Chansons*, and Van de Velde, soon to abandon painting for architecture, decorated the poems of Max Elskamp with *art nouveau* woodcuts. A strange illustrator from Antwerp, Edmond van Offel, Mannerist as much as Symbolist, deserves a mention; as does the fact that the collected works of Verhaeren and Ivan Gilkin used lithographs by Odilon Redon as their frontispieces.

Symbolism also made itself felt in the satirical, and often very vulgar, newspapers such as *Le Rire*. Throughout Europe there were imitators of Aubrey Beardsley, but artists such as Ibels, and more especially Vallotton—who revived the art of wood-engraving—used Symbolist techniques to mock a world which they despised. With a few touches of black ink, Vallotton encapsulates the boredom of bourgeois life or the stupidity of a *gendarme*; thick lines like the leading of a stained-glass window outline a face which will never entertain an interesting idea. It was one of the favourite artists of the *Revue Blanche*, Jean Wéber, who drew in his hazy style members of the aesthetic circles, whom he turned into fairies or enchanters, while his middle classes seemed to be on the point of turning into frogs. He designed a cartoon based on the *Tales* of Perrault for the Gobelins tapestry factory which was immensely popular after 1900, and he covered the walls of Rostand's villa near Biarritz with fairies. At the *Salon* of 1900 he exhibited a painting in which the condemnation of Symbolism is plainly to be seen. An artist, slightly mad, sits in his studio with his back to a beautiful nude girl who lies on a couch, his model, life or reality; meanwhile he plays with dolls, princesses and magicians, clothed in the cast-offs of Symbolism; the whole thing is called *Les Pantins* ('The Puppets').

Finally, attention should be drawn to the influence exerted by Symbolism on two fields related to the graphic arts: photography and architectural drawings. Drawings alone are mentioned because it would be beyond the boundaries of this book to search for literary and imaginative influences in the work of Guimard, Horta, or even Gaudí. Péladan had proscribed all architecture except projects for fairy palaces and reconstructions. Two curious artists did adhere to this programme; the first, a sort of sub-Péladan who lived many years in one of the towers of Notre-Dame, signed his over-meticulous drawings of imaginary cathedrals 'Mérovâk'. The other, Albert Trachsel, a Swiss friend of Hodler, had a considerable success at the *Salon de la Rose+Croix* of 1893 when he exhibited a series of lithographs of utopian architecture called *Real Facts, Song of the Ocean* and *Apparitions*. His 'vision into the future' provoked comparisons with Blake and Redon, although he is closer to a neo-classical visionary architect like Boullée. 'Whether reverberating with the sound of festivities, whether hiding pavilions of joy, his monuments are enriched by their creator and governed by expressive rhythms alone. . . . He has looked forward to the forms that will be taken by the temples of a human race at last reconciled with the unknowable' (Stuart Merrill, *La Plume*, 1893).

As for photography, one has but to glance through the issues of *Studio* and of *Le Figaro Illustré* to see what poetic aspirations did to realism. The precise psychological images of Nadar have been succeeded by apparitions, mists have invaded the plates, clever lighting has given even the most insignificant girls the qualities of a ghoul. In other words, the further it moved from realism, the more a photograph was regarded as a work of art. Whistler was an important influence on landscape, Carrière on portraits, and Rodin on the nude. In 1900, a fine book called *L'Esthétique de la Photographie* ('The Aesthetics of Photography') appeared; its text and indistinct images of wan women wandering in abandoned parks suggest the style of Symbolism. The book states that 'the anecdote must be raised to the level of a symbol', that we must find backdrops 'as bare as the walls of a church', and it provides various recipes for not distracting attention away from Beauty by too much detail.

8. Symbolism Perpetuated

It is only right that the last images in our visit to the Symbolist palace should be faded photographs of the Giocondas or Botticelli girls who haunt the autumnal garden, brought back to life in our memories by some lines from Maeterlinck or by a melody by Debussy. The shadows which had enveloped them for so long are finally dispelled; their painters and their poets have found new admirers, and they themselves seem touching rather than ridiculous. These faces, these poses formed by the cult of Beauty or by the search for a spiritual life, are still found, although in a somewhat changed state, in the two types of work which are found in the final hall, whose door leads back to everyday life, the counterpart of the entrance hall in which there were the images which nurtured Symbolism.

The most interesting proofs of the survival of Symbolism are found in painters whose researches were to carry them well beyond this style; there were also of course those who were merely content to follow its precepts when its spirit was already dead. Of all the artists discussed, the one who made the most impression on younger generations was Puvis de Chavannes, and this was due most of all to the *Poor Fisherman*. A very large part of Picasso's Blue Period derives from this painting: the same simplification of design, the same evocation of misery, almost the same colour; the face of the Poor Fisherman also occurs in several Picasso etchings, although the treatment is closer to Goya. Picasso adds to all this a certain erotic charm which Puvis entirely lacks; thin, dressed in rags, a distant look in their eyes, the jugglers and harlequins nevertheless possess a sensual grace. Matisse was also influenced by those compositions, which evoked a feeling of serenity; in 1904 he used a composition derived from Puvis and a Fauve palette to illustrate Baudelaire's line (from *L'Invitation au Voyage*): '*Luxe, calme et volupté*' ('Luxury, calm and voluptuousness').

Apart from an occasional arabesque and an occasional flower, Matisse's debt to his teacher, Moreau, is much harder to define. Moreau's favourite pupil, Rouault, on the other hand, had a personal symbolism which one finds as much in the plates of the *Miserere* as in the watercolours of prostitutes and the oil paintings suggesting biblical landscapes. The Douanier Rousseau, discovered by Rémy de Gourmont and Alfred Jarry, was also a Symbolist in his way. *War*, *The Dream*, and the jungles seething with serpents are as clearly symbolic as the interpretations of a dream by Freud. Rousseau, who admired Bouguereau, thought of himself as a painter of allegories. For Chagall, the combination of Hebraic tradition and Russian folklore provided a complete symbolic system, delightful to begin with, then exploited *ad nauseam*; nothing palls as rapidly as the flavour of true Symbolism. The *Guernica* is the best proof of this; much more than an allegory, this is a Symbolist painting which receives its strength from the horror which it evokes. The same elements in the ambitious canvases painted after the war by a contented Picasso become stereotypes. Political anger also allows us to call Diego Rivera and even Orozco Symbolists, while the official Russian artists on the other hand are either painters of battle scenes or of allegories like those seen in the *Salon* some eighty years ago.

It is outside France that a real continuation of the Symbolist movement is to be found. In England Augustus John's early paintings, Stanley Spencer's *Resurrection* and the drawings of George Moore all have a power of evocation which, whether poetic or social, is impossible to find in the French painters of 'Happiness' like Matisse, Bonnard, or Vuillard whose works make no reference to the idea of Death. This idea on the other hand dominates certain paintings by Tchelitchev in his 'Hide and Seek' period; it obsessed that Chicago painter, Ivan Albright, whose work *The Door*, and especially its motto, 'That which I should have done I did not do', would have delighted the disciples of Péladan. Erotic Symbolism is evident in the work of Balthus and, like all painters of the Imaginary, this realist uses archaistic

techniques. His large pictures of the 'Street' theme are as indebted to Piero della Francesca as Denis' first paintings were indebted to Fra Angelico. Paul Klee of course had his own personal system of symbols; Munch and certain Expressionists continued Symbolism, and Kandinsky was greatly influenced by it; but this carries us beyond the limits of this book.

As Mme Legrand pointed out, 'Spilliaert is, together with Ensor, one of the last major links between Symbolism and Expressionism', for as we have seen, Symbolism remained so much alive in Belgium that it is hard to place under another banner the Belgian artists who belonged to the Symbolist movement at one stage in their lives. If Surrealism appears to some to be a true resurrection of Symbolism, then this is due above all to the Belgian artists; going from the Symbolist rooms to the Surrealist rooms at the exhibition of Belgian painters at the Grand Palais one found a new expression of the same ideal. Certain views by Magritte look like the thoroughfares of a vulgarized but still weird Bruges; the solitude is as all-pervasive as it is in the paintings of architecture by Khnopff and the forests of Degouve de Nunques. But it is Delvaux who is the true inheritor; his nudes scattered among ruined buildings are as lonely as the tennis players in *Memories*, the skeletons in his *Crucifixion* brothers to those of Ensor.

In France it is only the engravings of Valentine Hugo which combine Surrealism with Symbolism. The forests and birds of Max Ernst also reveal a profound symbolism; while Dali is a collector of odd allegories, a masquerade of myths often more distracting than poetic.

Surrealism hailed Lautréamont and Freud as their Wise Men, yet it possessed the spirit of Symbolism; the Symbolism of Baudelaire and Wagner. The latter had conscientiously sought out the notes that would touch the powers which Freud uncovered from the unconscious; the former owed much to the continuity of myth which would place him under the sign of Jung, besides being a believer in the 'Beyond'. One sometimes finds Bergson coming close to Symbolism; did not he too do battle with materialism? A sentence in *Les Deux Sources de la Morale et de la Religion* ('The Two Sources of Morality and Religion') on the permanence of certain fantastical images sought after so hard by the Symbolists may provide an explanation as to why they recur: 'They play a role which could have been played by instinct as it no doubt would be in a human being devoid of intelligence.'

In this farewell to Symbolism homage should be paid to André Breton, who for thirty years was the only visitor to the Moreau Museum, who rediscovered Filiger, and who, despite changes in fashion, always remained faithful to the painting which sought to go beyond reality (75). One would also take into account stills from silent films in which the spirit of Symbolism was conserved long after it had died in painting, particularly from the sublime *Nosferatu* by Murnau, and from the contemporary frolics of Vadim's *Barbarella* or certain sequences from Fellini; *8½* is, for example, an almost totally Symbolist film, as is also, in a more secretive vein, André Delvaux's *Rendez-vous à Bray*.

The works of art which slavishly continued Symbolism were far less interesting than those that were merely touched by its ideas. Some of the most charming examples are the book illustrations of Arthur Rackham, although he had no French counterpart. The triumph of *art nouveau* in 1900 and the reaction to which this led brought with it the rapid decline in the popularity of Symbolism, for the two movements were quite arbitrarily associated in the minds of people with taste. The Symbolist painters continued to work after 1900, but like priests who are no longer supported by the faith of their congregation, and who repeat rites which become increasingly devoid of meaning. Lévy-Dhurmer, Osbert, Delville continued to copy one another or to search to express ideas which were too profound, until after the Second World War. Other artists settled for lucrative types of painting at the *Salon* which had encouraged their beginnings. Le Sidaner was the painter of country houses, Aman-Jean the melancholic portraitist, Maxence the 'image-maker', Menard the philosopher of landscape. Some fulfilled a tragic destiny; De Groux became the failed artist on a grand scale, and Albert Besnard an academician. The faces and the subjects which our idealist painters depicted after 1900 exude less an air of mystery than one of boredom. Speculators can be left the task of unwrapping these late productions of artists who were so gifted in their youth; they will be sold on the strength of signatures which concern art history only for a period of a dozen or so years.

In Belgium, which did not experience the reaction of 1900, Symbolism was adopted as a national style and perpetuated in landscape painting: the School of Laethem Saint Martin with artists such as Van

de Woestyne, Gustave de Smet, and the disciples of Degouve de Nunques. These Flemings continued a lively form of Symbolism into the nineteen-twenties, despite the rapid decline in the popularity of the work of Khnopff and Delville.

'Fashionable, unfashionable'; it was with these words that we started our visit to the Symbolist palace, now blessed again by fashion after more than fifty years under the dust-sheets of outmodedness; one can find the use of these words cynical, a little too far from aesthetic criteria, but these fluctuations in taste take on greater significance at a time when contemporary art seems incapable of offering attractive routes of escape for those young people who want to get away from the world around them, just as the artists discussed in this book had wanted to escape from the world of Zola, from academic painting, from Realism, in about 1885. Surrealism is no longer fascinating, Abstract Art is frankly boring, and Pop Art, which has made such a major contribution to decorative ideas, is the very negation of a work of art; the obvious links between psychedelic art and Symbolism are not enough to explain the fascination which Symbolist exhibitions have held for younger painters. Taken together with the discovery of Tantric art, it seems that there may be a new imaginative current oriented towards magic rather than towards Surrealism which may dictate the direction in which painting in the next ten years will move.

Drawing by Toulouse-Lautrec for the Salon du Chasseur de Chevelures, reproduced in the *Revue Blanche*

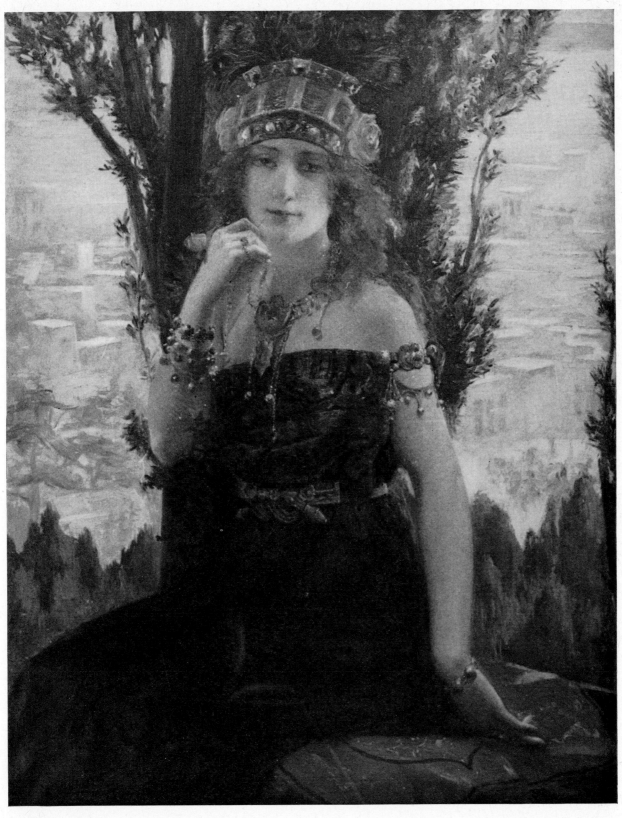

9. Gaston Bussière: *Helen of Troy*. 1895. Oil on canvas, 100 × 80 cm. Musée municipal des Ursulines, Mâcon

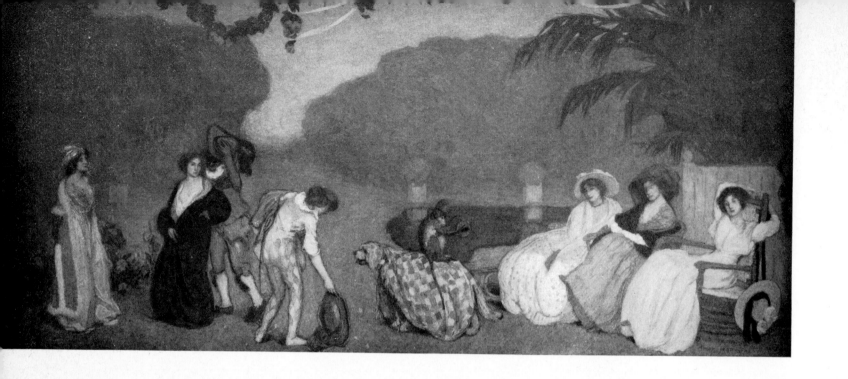

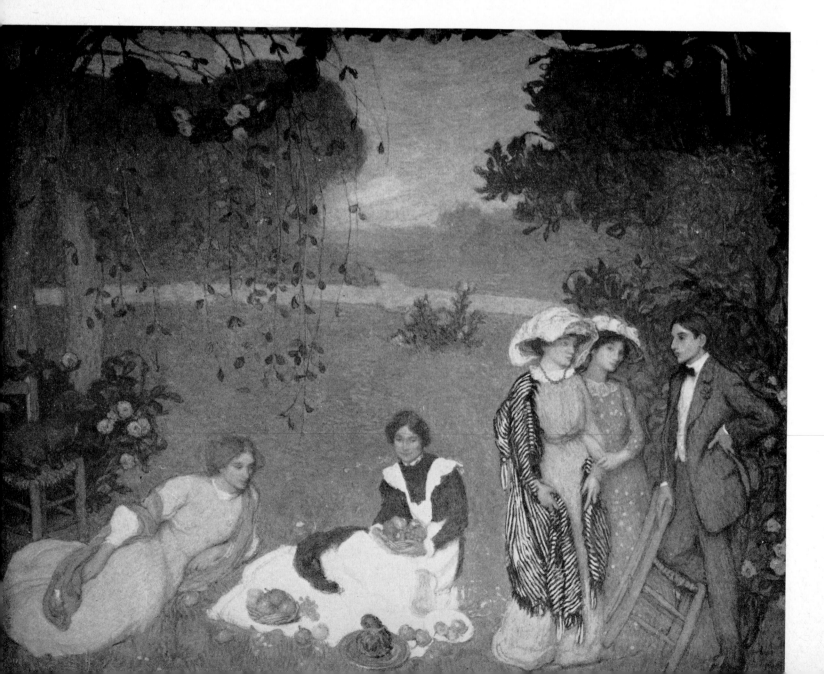

10. Edmond Aman-Jean:
The country outing. 1910.
Oil on canvas.
Musée des Arts Décoratifs,
Paris

11. Edmond Aman-Jean:
The picnic. 1909.
Oil on canvas.
Musée des Arts Décoratifs,
Paris

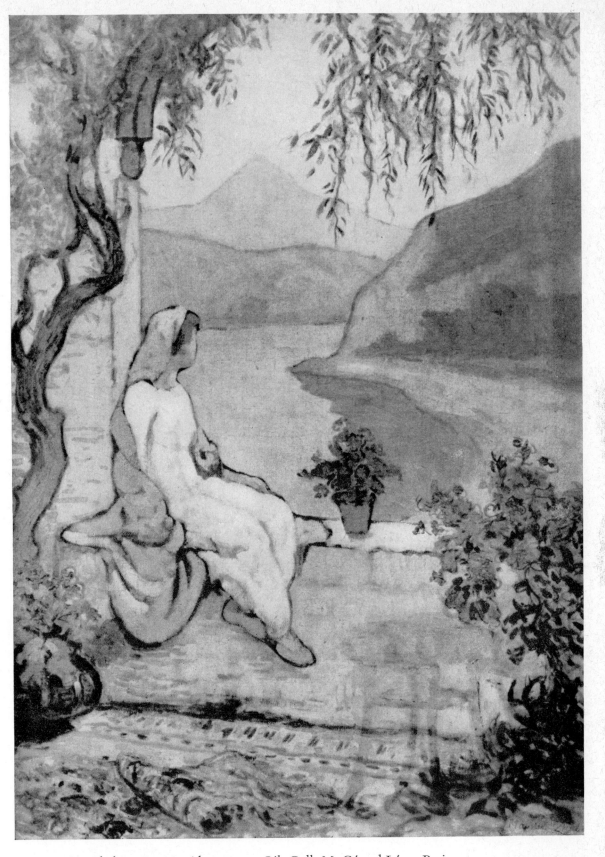

12. Maurice Chabas: *Reverie.* About 1905. Oil. Coll. M. Gérard Lévy, Paris

13. Maurice Chabas: *Landscape*. After 1905. Oil on canvas, 47 × 62 cm. Coll. Flamand-Charbonnier, Paris

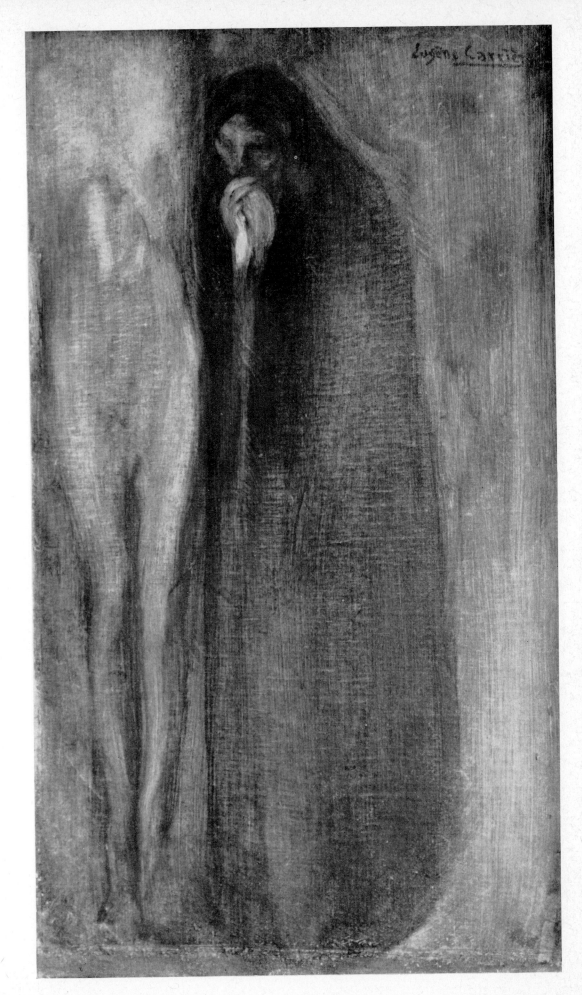

14. Eugène Carrière:
The Virgin at the foot of the Cross.
c.1894–7. Oil on canvas, 66 × 33 cm.
Musée des Beaux-Arts, Strasbourg

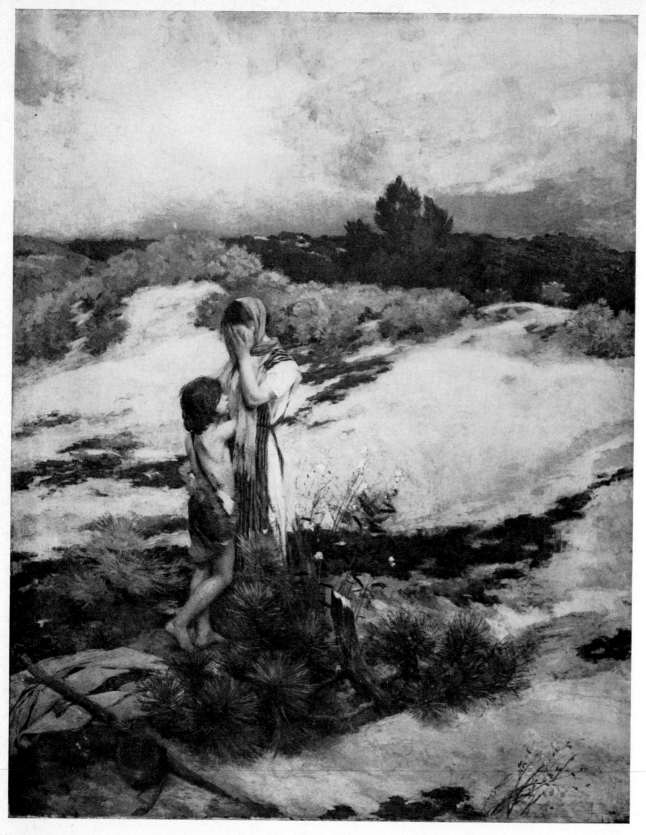

15. Jean-Charles Cazin: *Hagar and Ishmael*. 1880. Oil on canvas, 252 × 202 cm. Musée des Beaux-Arts, Tours

16. Théodore Chassériau: *Sappho*. 1849. Oil on wood, 27 × 21 cm. Louvre, Paris ▶

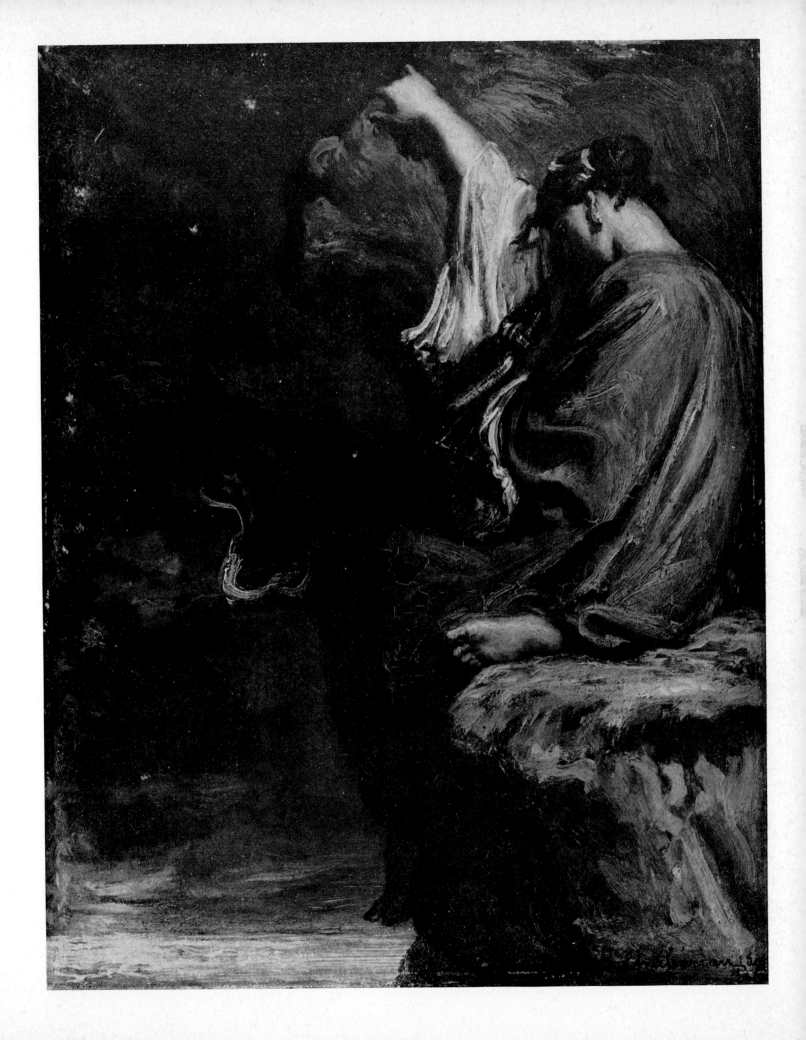

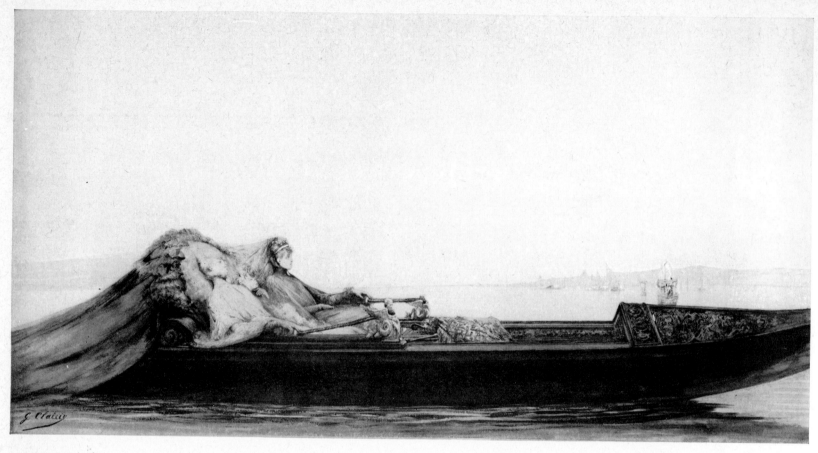

17. Georges Clairin: *The gondola*. c.1897. Watercolour, 30 × 60 cm. Coll. F. H. Duchêne, Paris

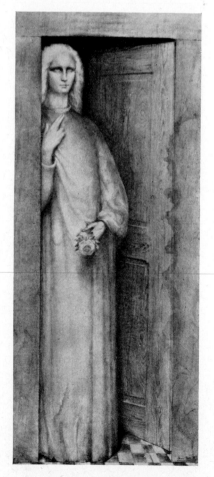

18. Jean Delville: *Waiting*. 1903. Drawing, 96 × 44 cm.
Private collection, New York

19. Théodore Chassériau: *The two sisters*. 1843. Oil, 180 × 135 cm. ▶
Louvre, Paris

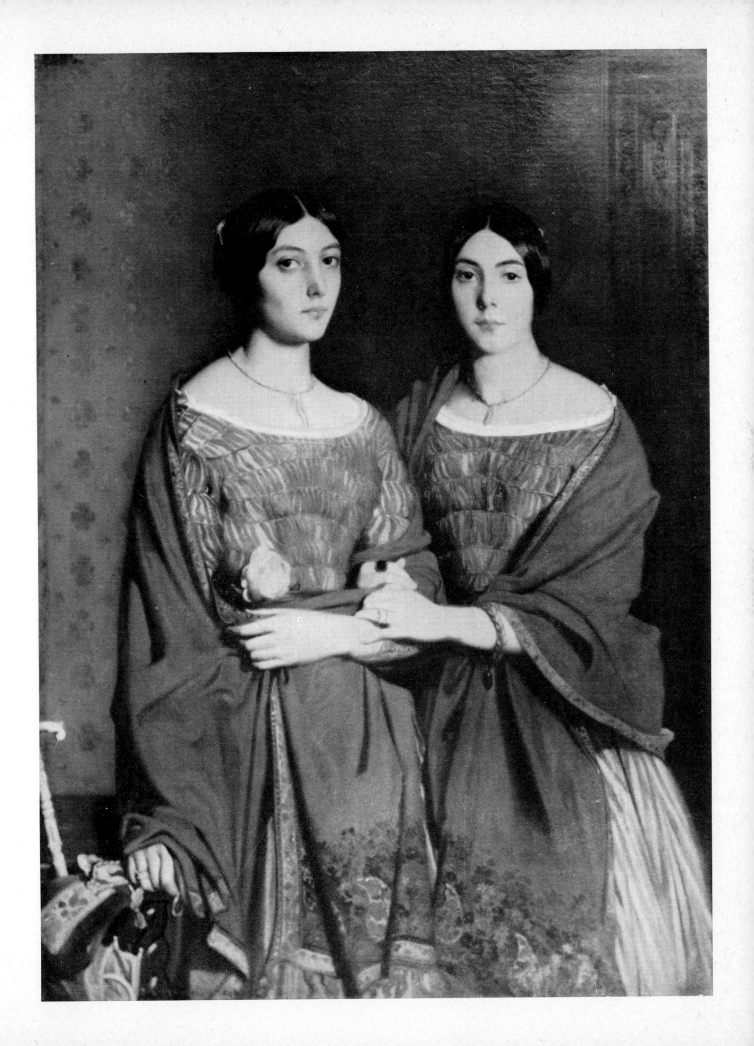

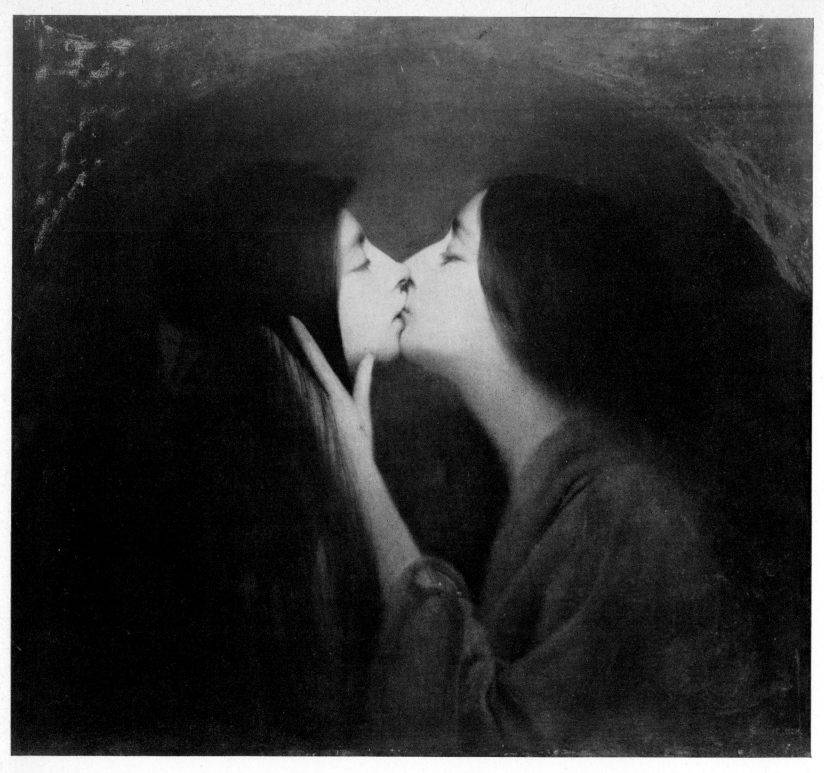

20. Joseph Granié: *The kiss*. 1900. Oil on canvas, 90 × 75 cm. Coll. J. P. Gredy, Paris

21. ? Corbineau: *The friends*. c.1895. Oil on canvas, 35 × 50 cm. Coll. Jullian, Paris ▶

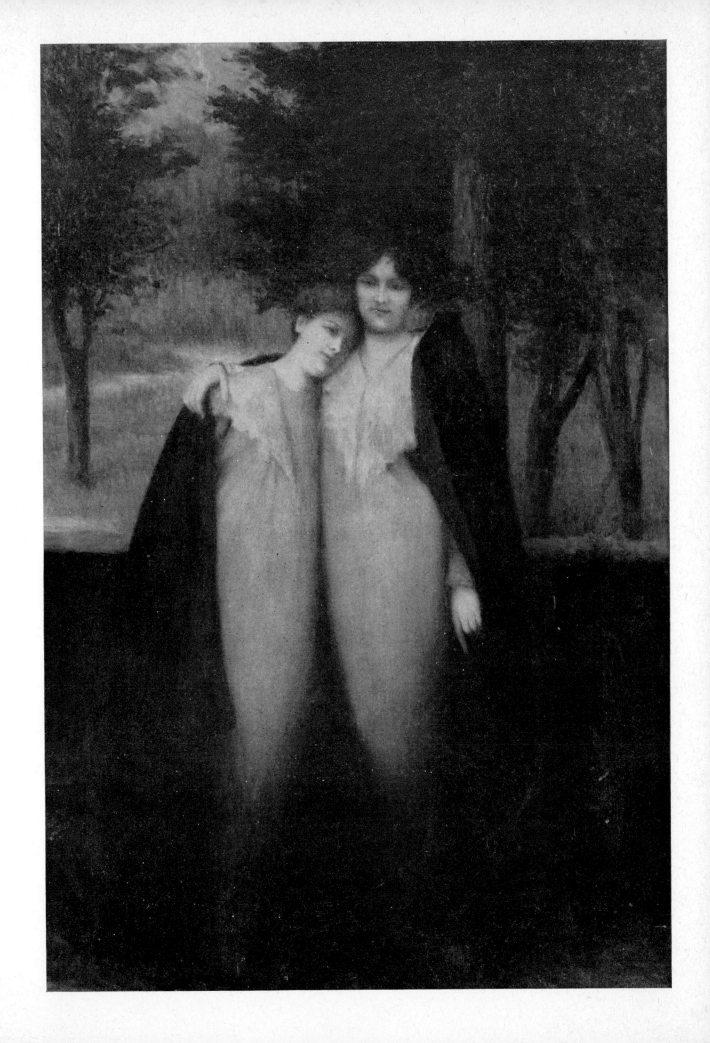

22. William Degouve de Nunques: *Angels in the night*. 1894. Oil on canvas, 48 × 60 cm.
 Rijksmuseum Kröller-Müller, Otterlo

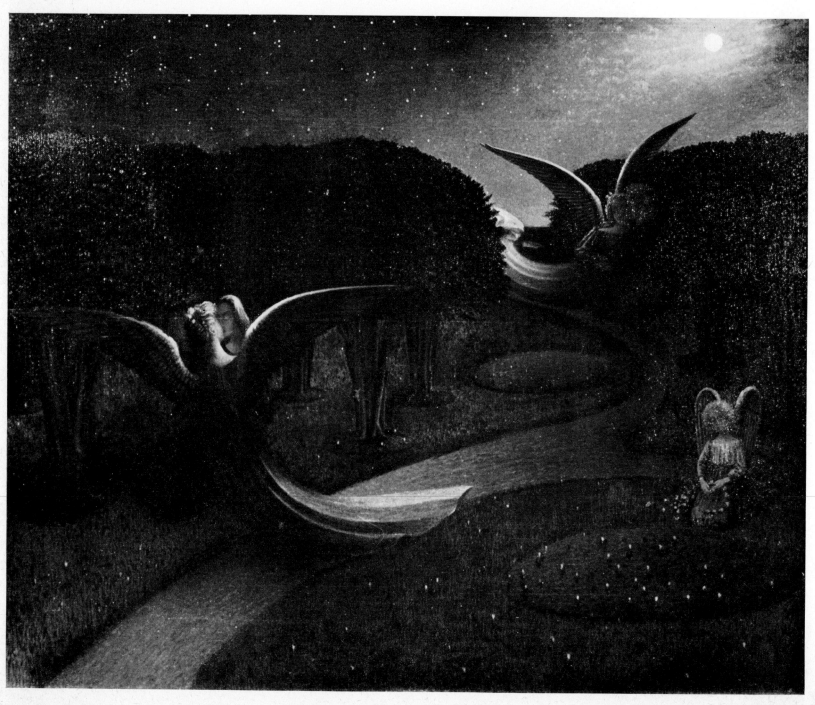

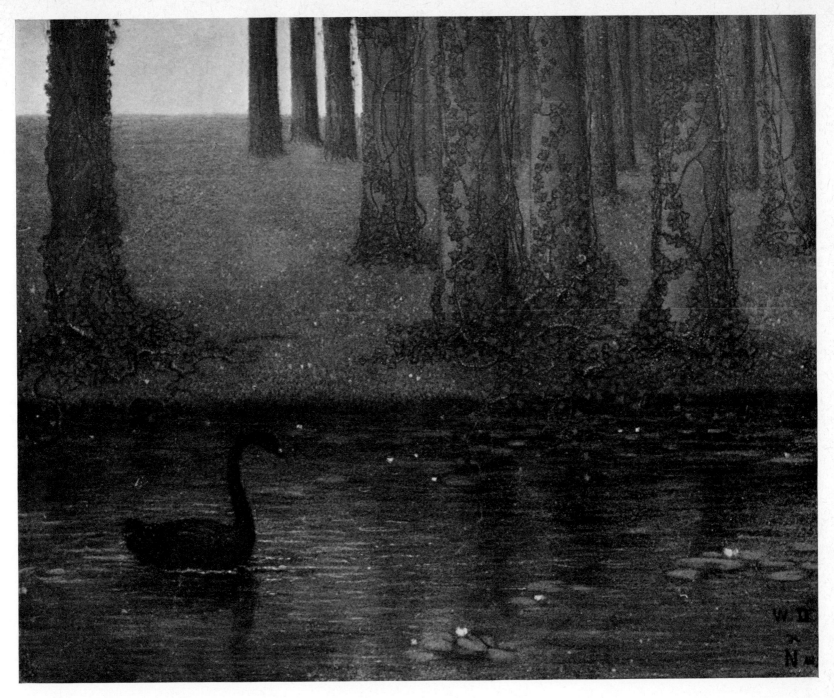

23. William Degouve de Nunques: *The black swan*. 1896. Pastel, 38 × 47 cm.
Rijksmuseum Kröller-Müller, Otterlo

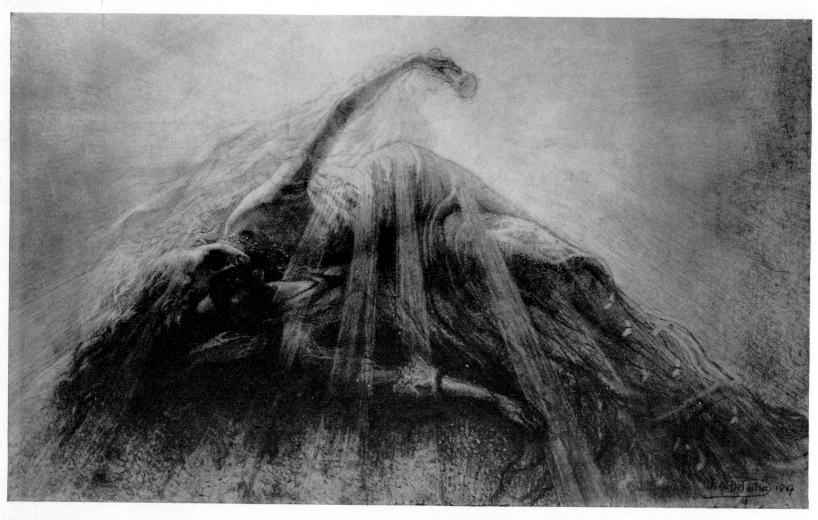

24. Jean Delville: *Tristan and Yseult*. 1887. Drawing, 44 × 75 cm. Musées Royaux des Beaux-Arts, Brussels

25. Jean Delville: *Parsifal*. 1890. Drawing, 70 × 56 cm. Coll. Delville, Brussels ▶

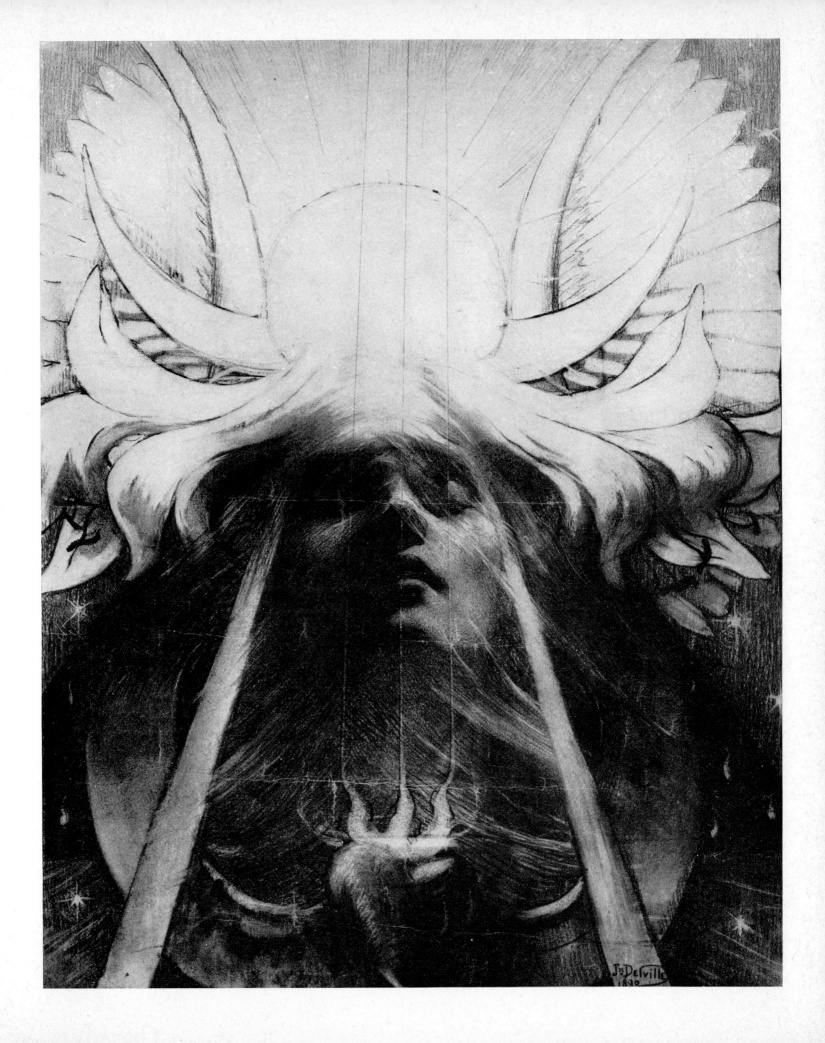

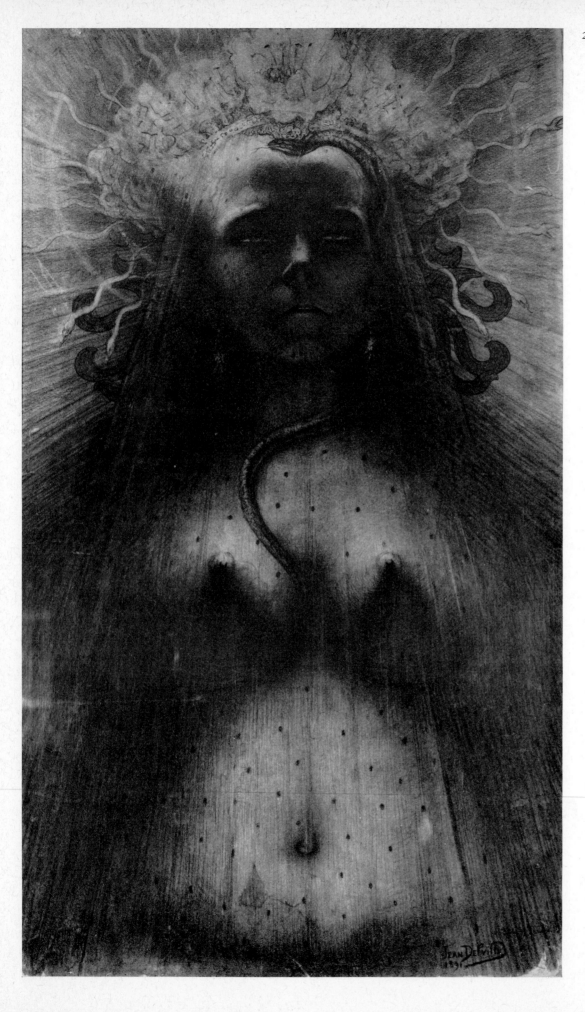

26. Jean Delville:
The idol of perversity. 1891.
Drawing, 98 × 56 cm.
Galleria del Levante, Munich

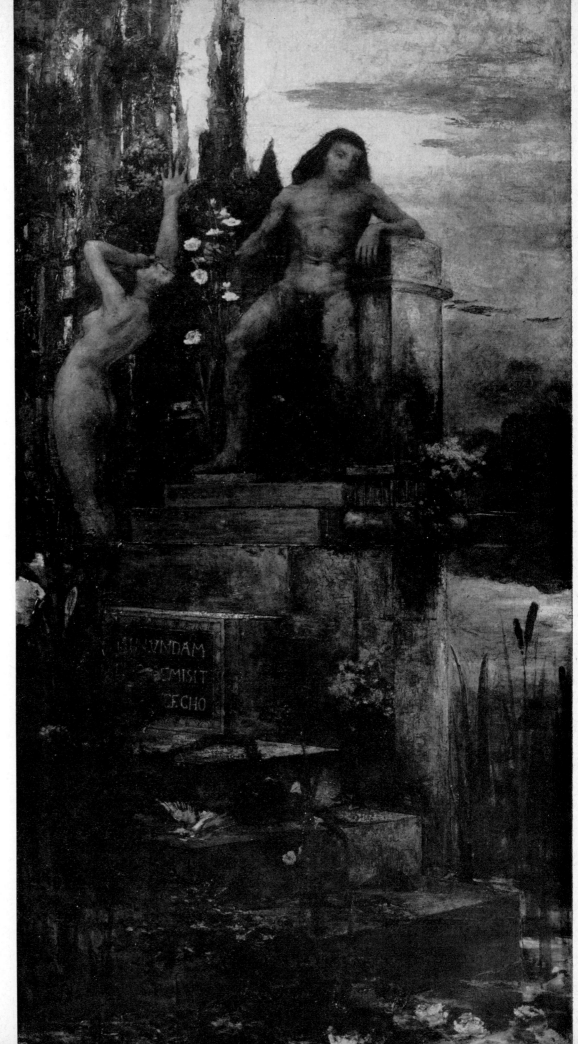

27. Georges Desvallières: *Narcissus*.
1893. Oil on canvas, 206 × 111 cm.
Coll. P. Isorni, Seine-Port

28. Maurice Denis:
The battle of Jacob and the angel. 1893.
Oil on canvas, 48 × 36 cm.
Coll. Josefowitz, Switzerland

30. James Ensor: *The Virgin as a comforter.* ▸
1892. Coll. A. Taevernier, Brussels

29. Maurice Denis: *Catholic mystery.* 1890.
Oil on canvas, 57 × 77 cm.
Coll. M. Jean-François Denis, Alençon

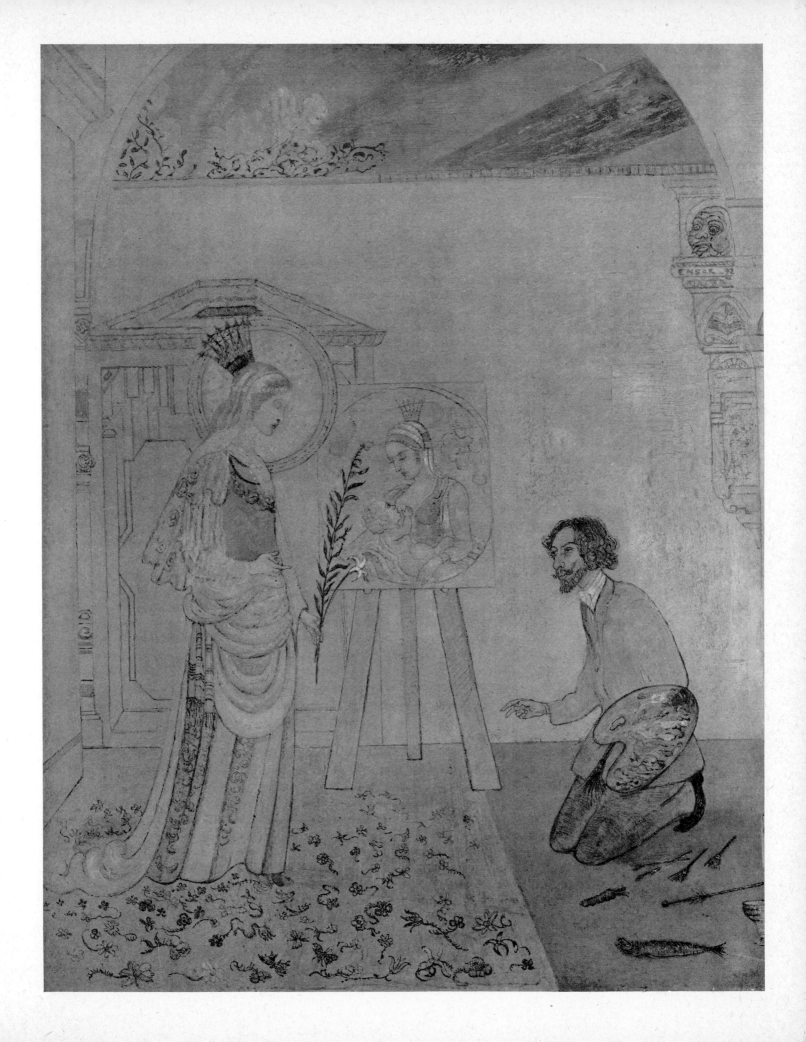

31. Emile Fabry: *Gestures*. 1895. Oil on canvas, 93 × 100 cm. Private collection, Brussels

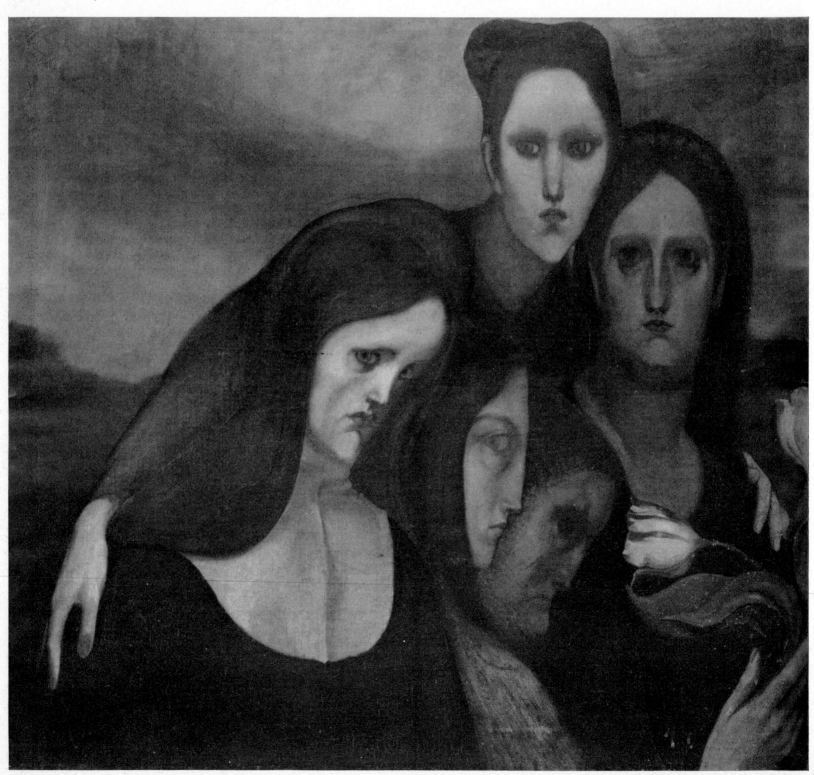

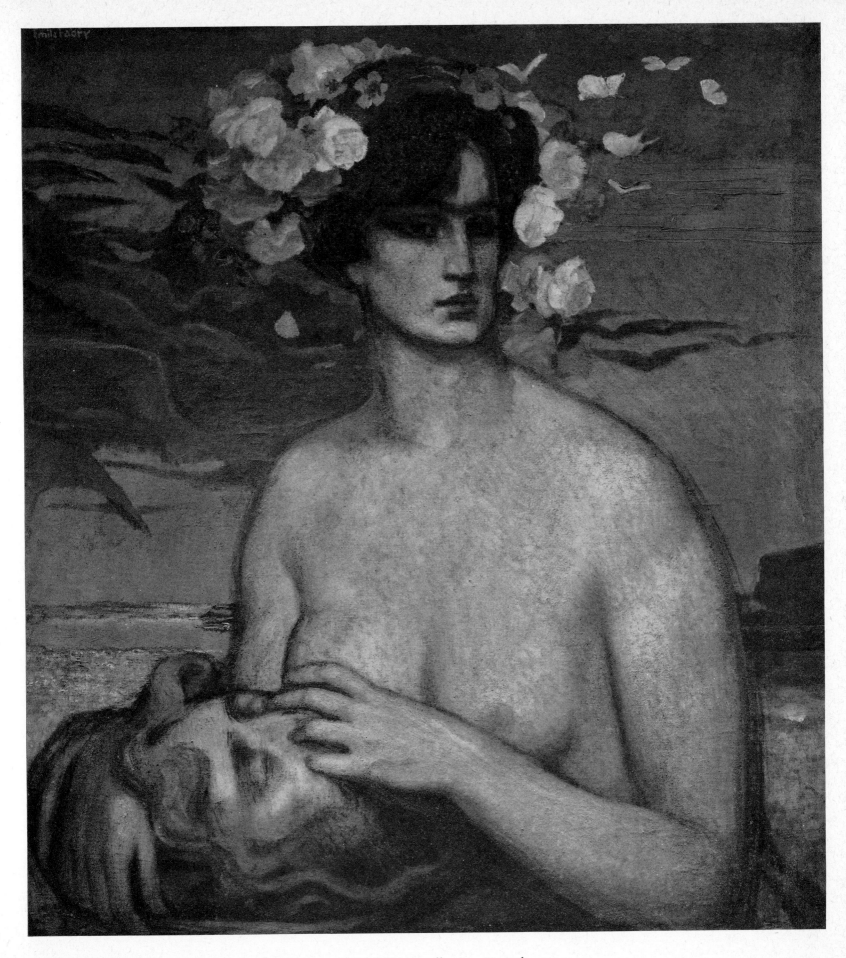

32. Emile Fabry: *Salome*. 1892. Oil on canvas, 105 × 95 cm. Private collection, Brussels

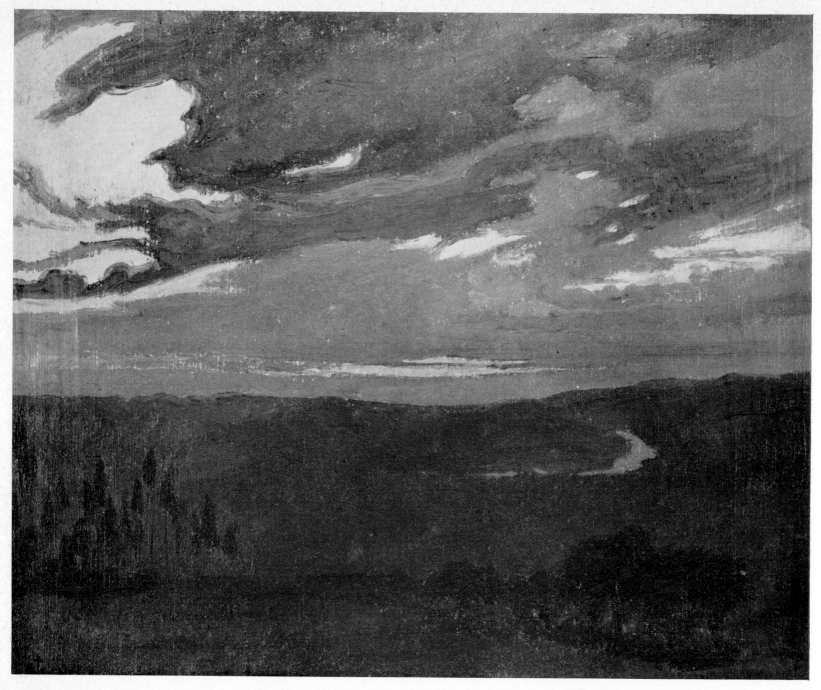

33. Marie-Charles Dulac: *Sunrise over the Arno*. 1898. Oil on canvas, 41 × 53 cm. Musée St-Denis, Rheims

34. Henri Fantin-Latour: *Prelude to Lohengrin*. 1902. Oil on canvas, 56 × 40 cm. Petit Palais, Paris ▶

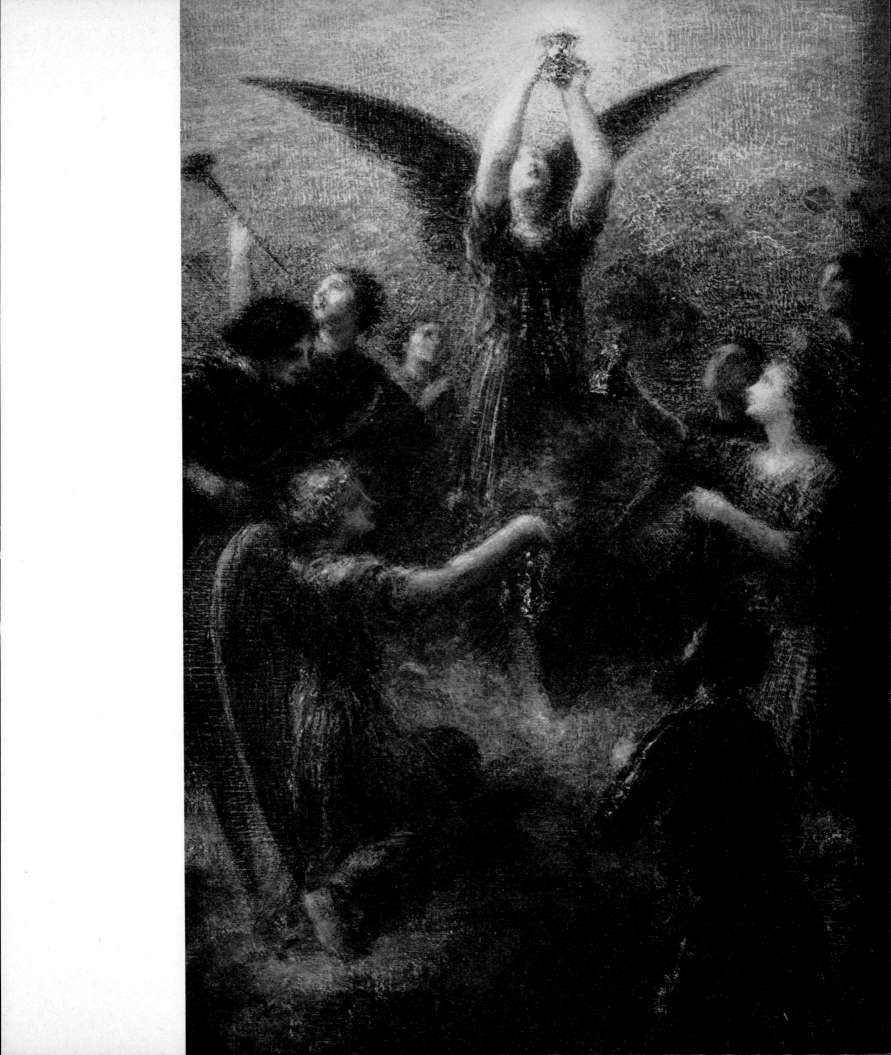

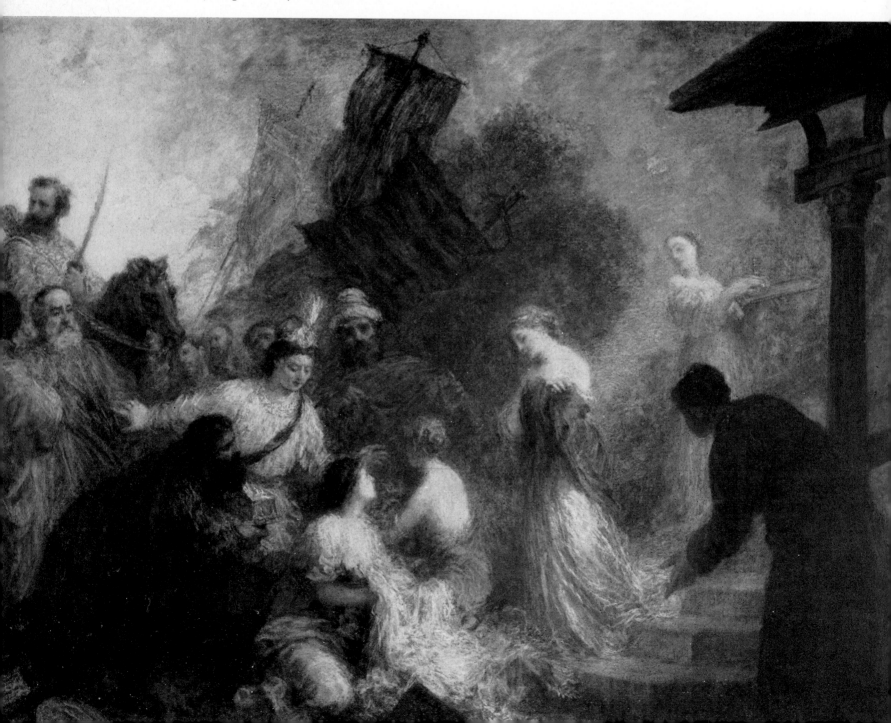

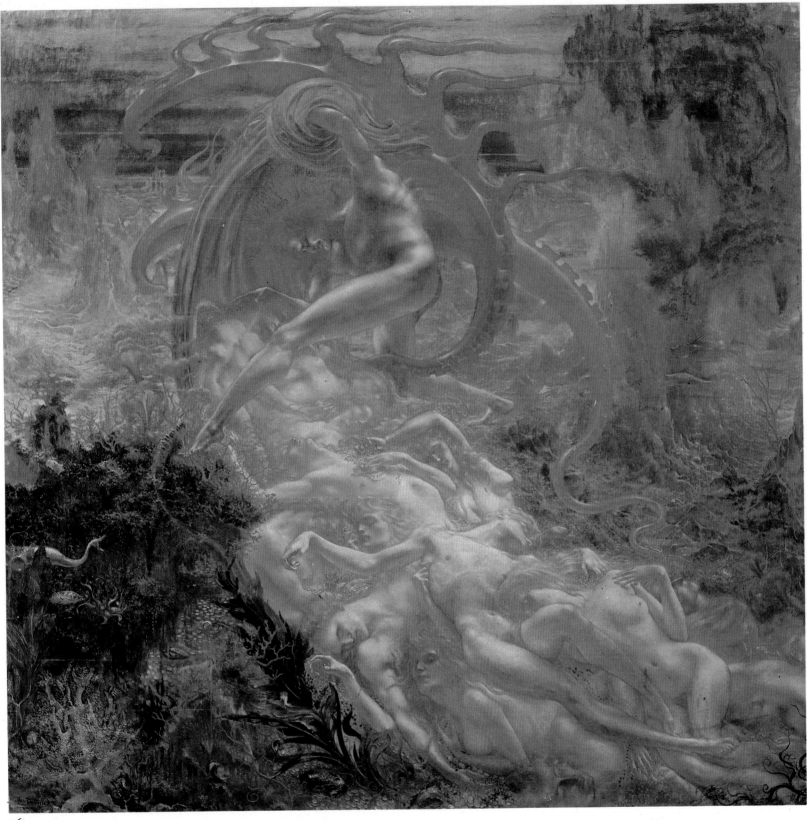

36

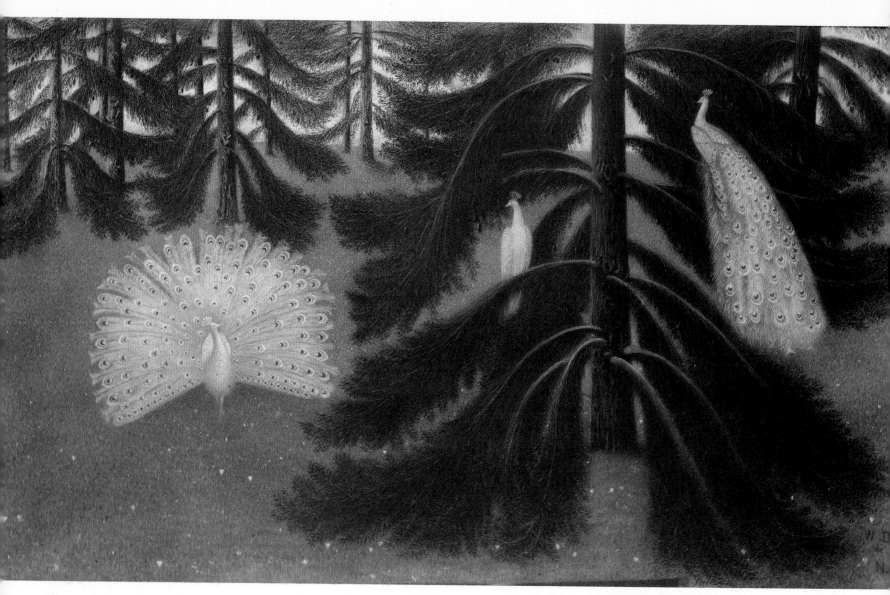

37

38

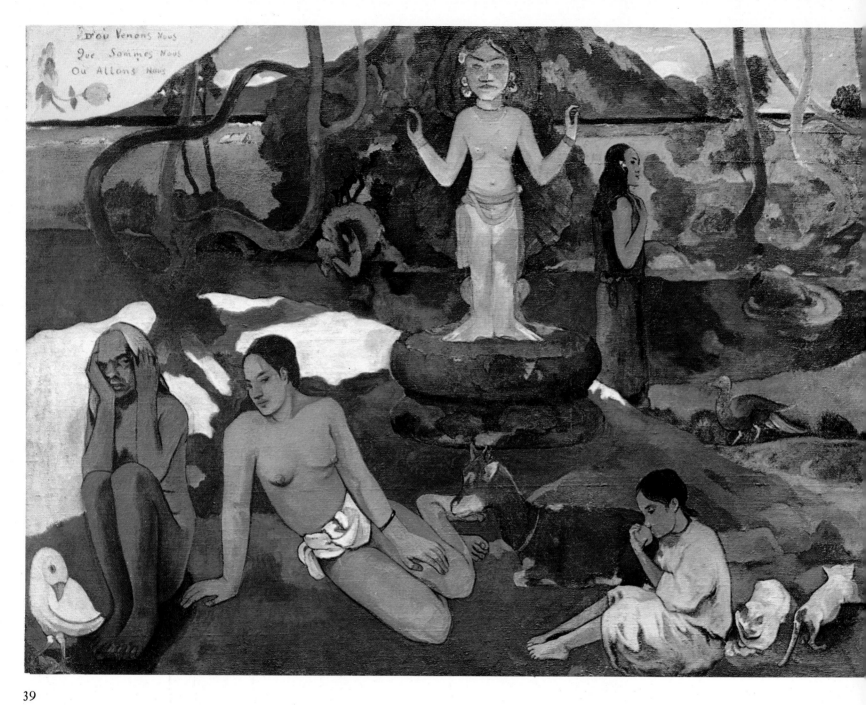

39

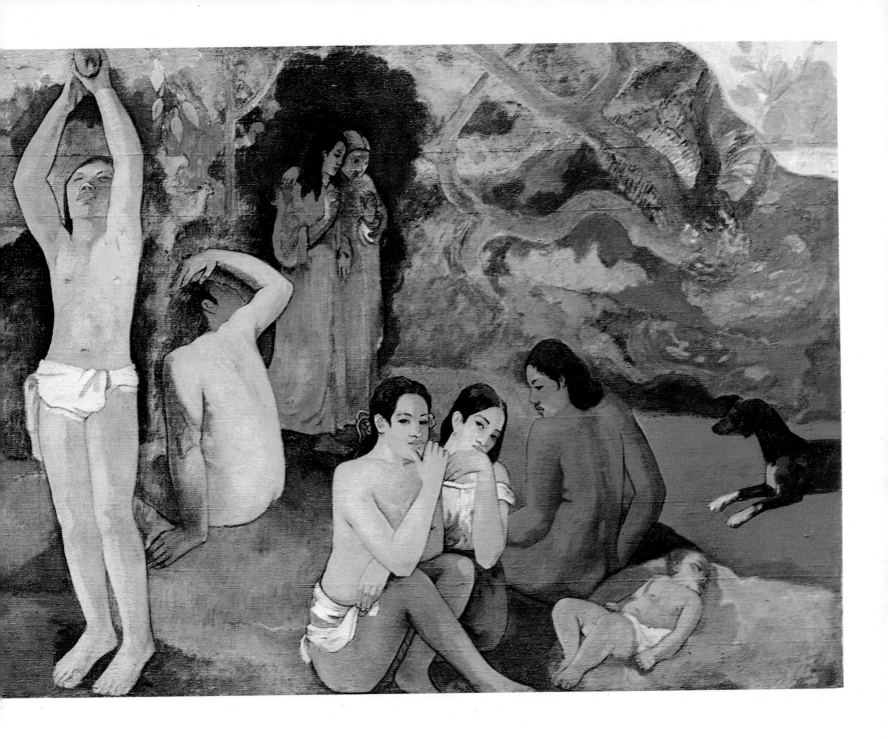

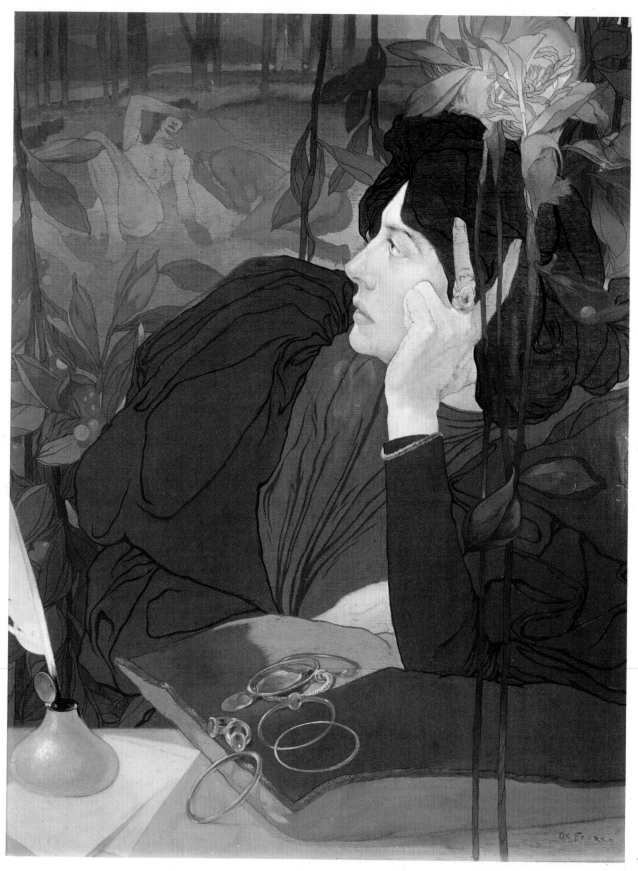

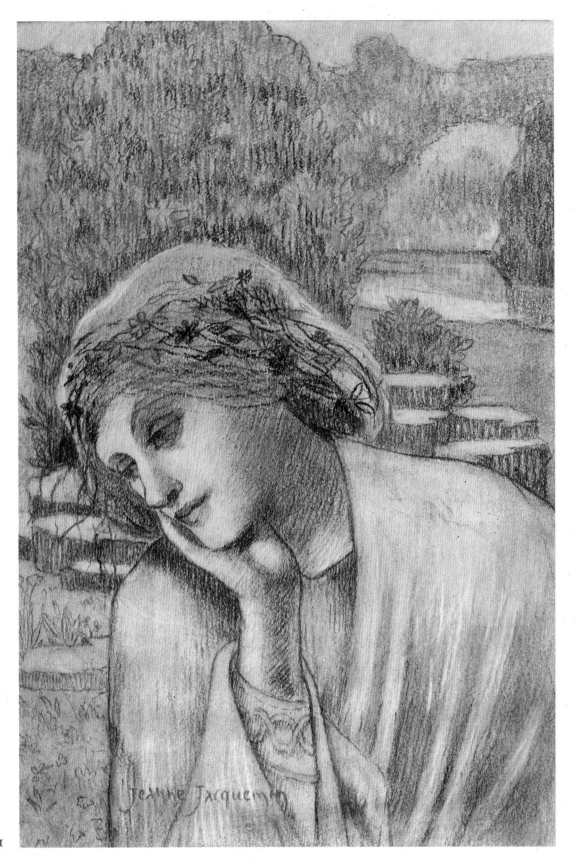

41

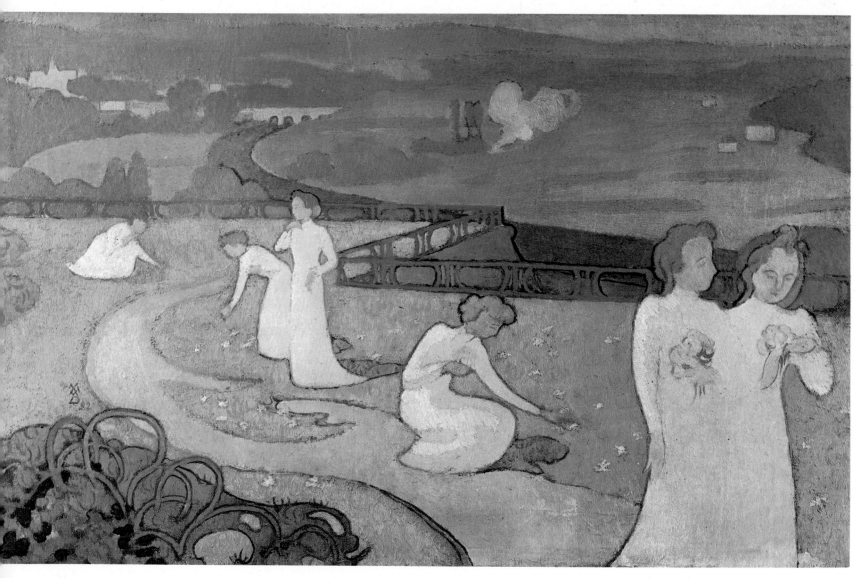

42

40. Georges de Feure: *The voice of evil.* 1895. Oil on wood, 65 × 59 cm.
Coll. M. Robert Walker, Paris

41. Jeanne Jacquemin: *Daydream.* c.1892–4? Pastel, 32 × 22 cm.
Private collection, Paris

◀ 42. Maurice Denis: *April.* 1892. Oil on canvas, 38 × 61 cm.
Rijksmuseum Kröller-Müller, Otterlo

43. Georges de Feure: *Temptation.* c.1898. Oil on wood, 40 × 60 cm. Coll. Tschoudouynen, Paris

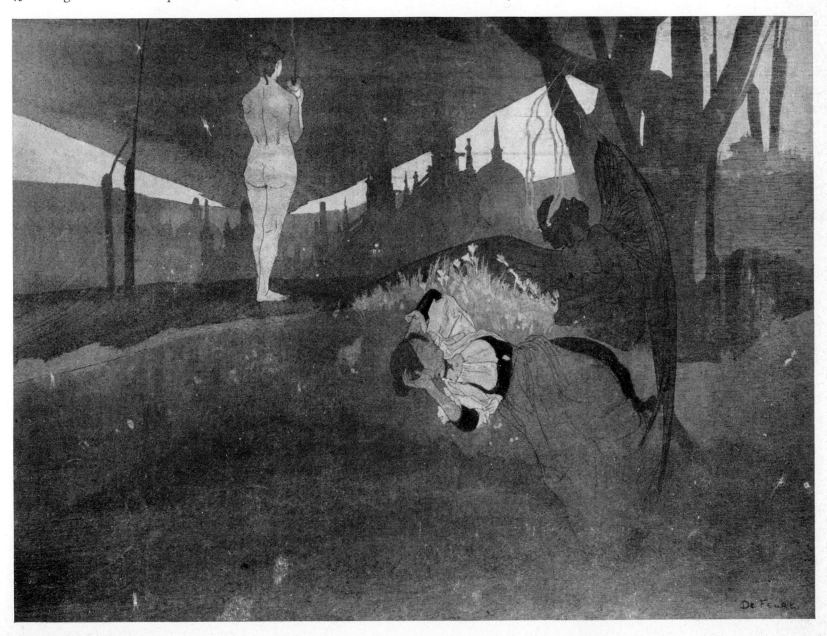

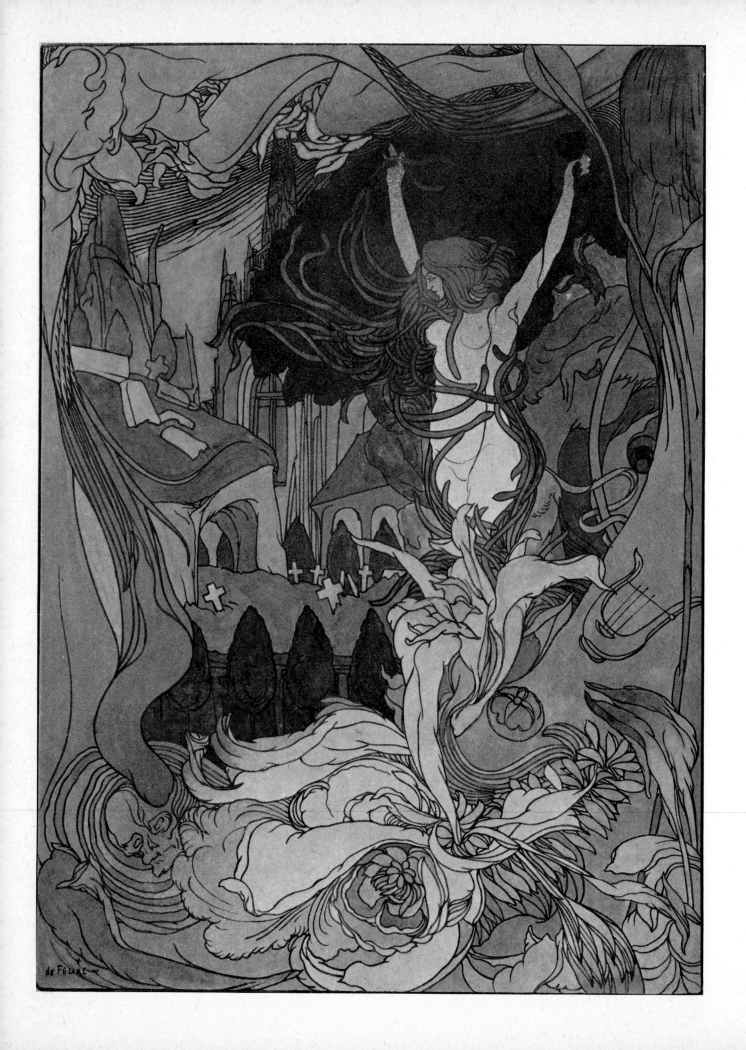

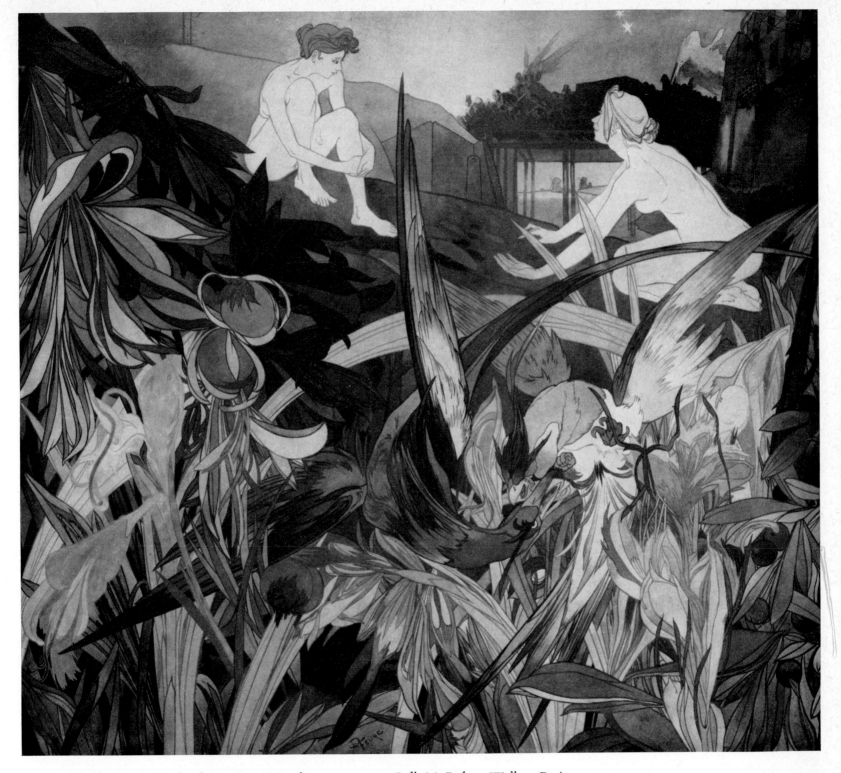

45. Georges de Feure: *To the abyss*. 1894. Gouache, 77 × 90 cm. Coll. M. Robert Walker, Paris

◄ 44. Georges de Feure: *Door of dreams*. c.1897–8. Watercolour, 35 × 25 cm. Piccadilly Gallery, London

46. Charles Filiger:
 Lamentation over the dead Christ. c.1893.
 Gouache, 33 × 35 cm.
 Coll. M. Robert Walker, Paris

47. Charles Filiger: *Head of the Virgin*
 on a yellow ground (from *Four Chromatic Notations*).
 Watercolour, 23 × 23 cm.
 Musée National d'Art Moderne, Paris

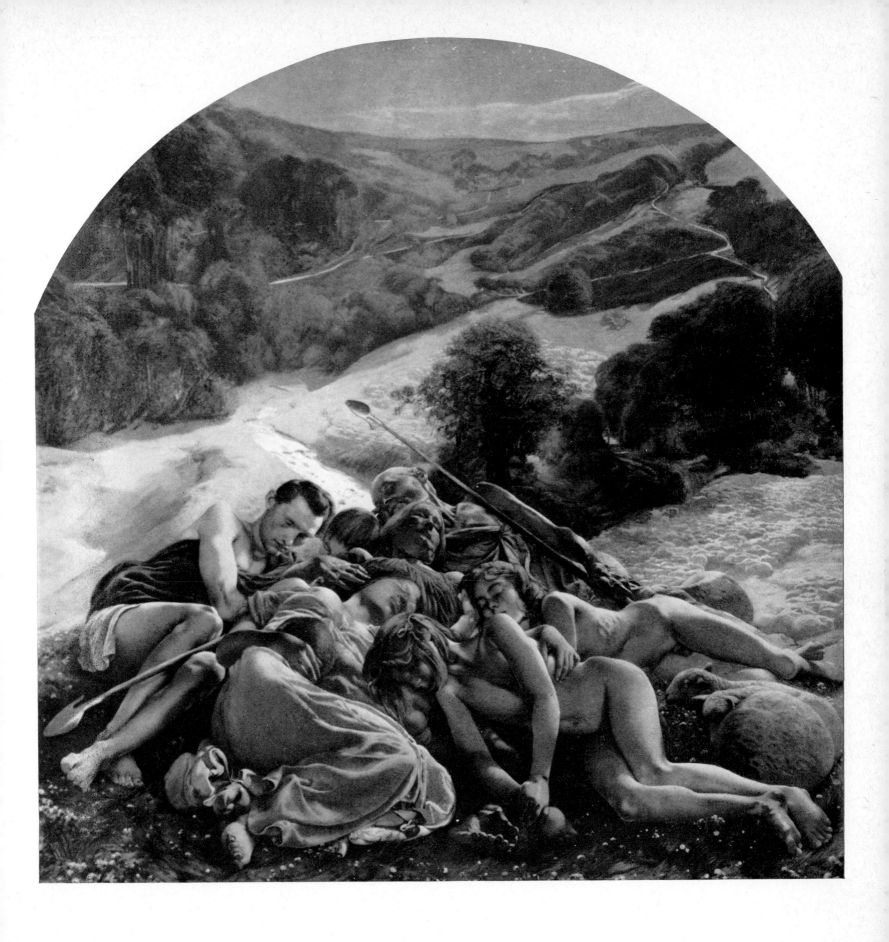

48. Léon Frédéric: *Night* (from *L'âge d'or*). 1891. Oil on canvas, 127 × 117 cm. Musée National d'Art Moderne, Paris

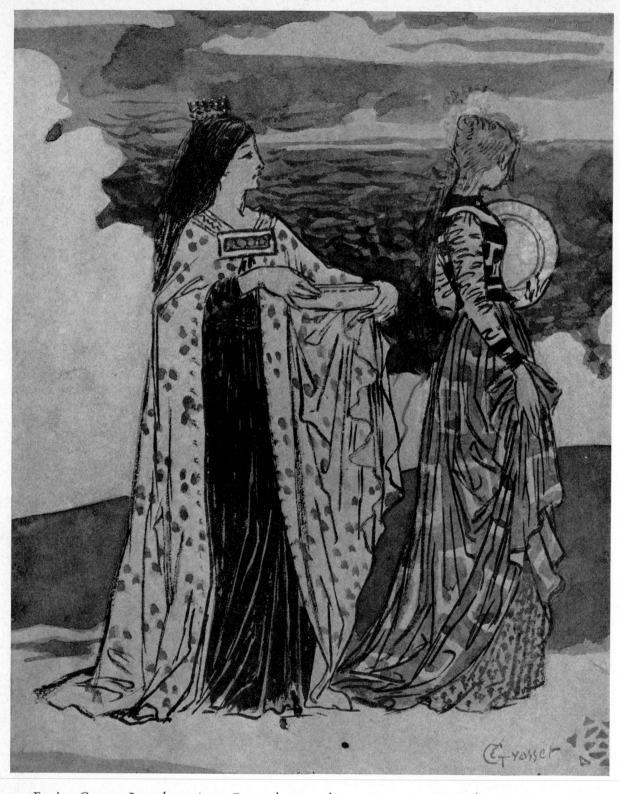

49. Eugène Grasset: *Legendary princess*. Pen and watercolour, 26 × 21 cm. Petit Palais, Paris

50. Eugène Grasset: *Three women with three wolves*. Watercolour with gold, 32 × 24 cm. ▶
Musée des Arts Décoratifs, Paris

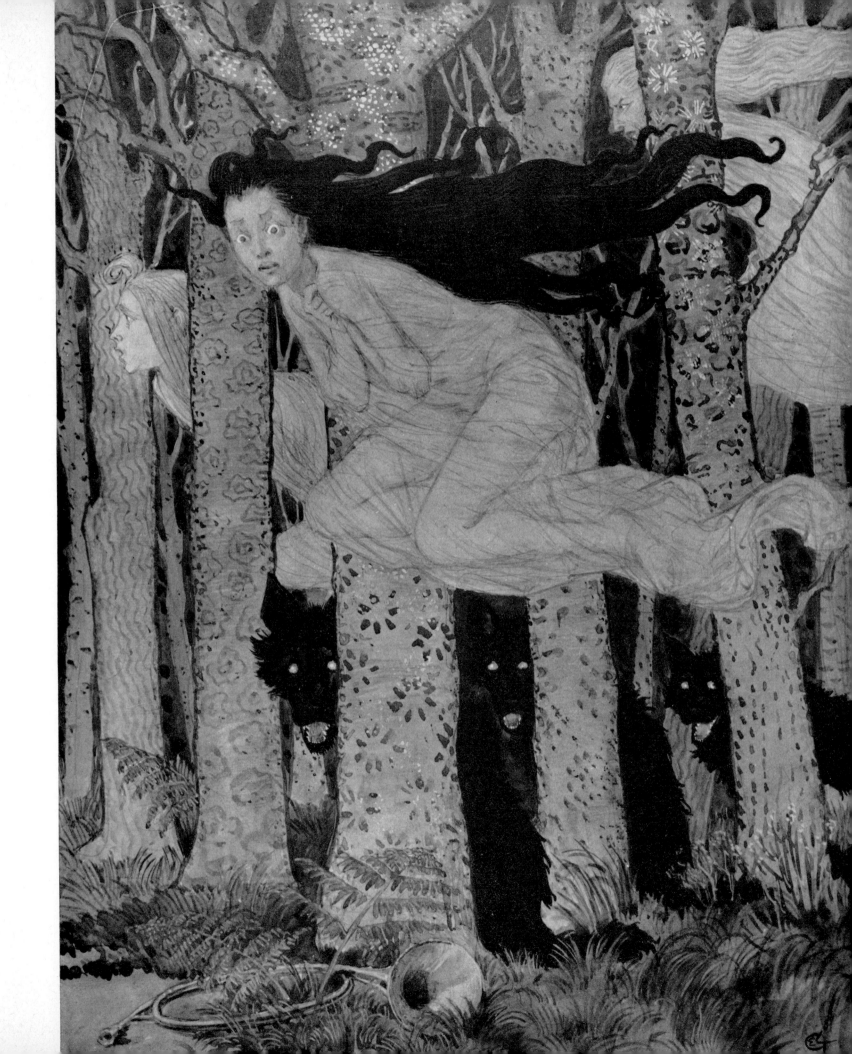

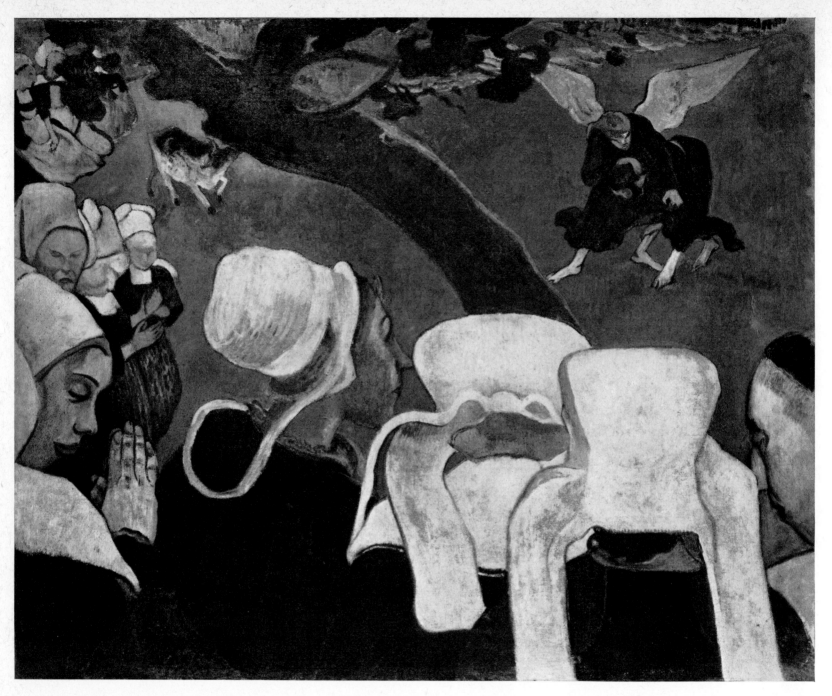

51. Paul Gauguin: *The vision after the sermon*. 1888. Oil on canvas, 74 × 93 cm.
National Gallery of Scotland, Edinburgh

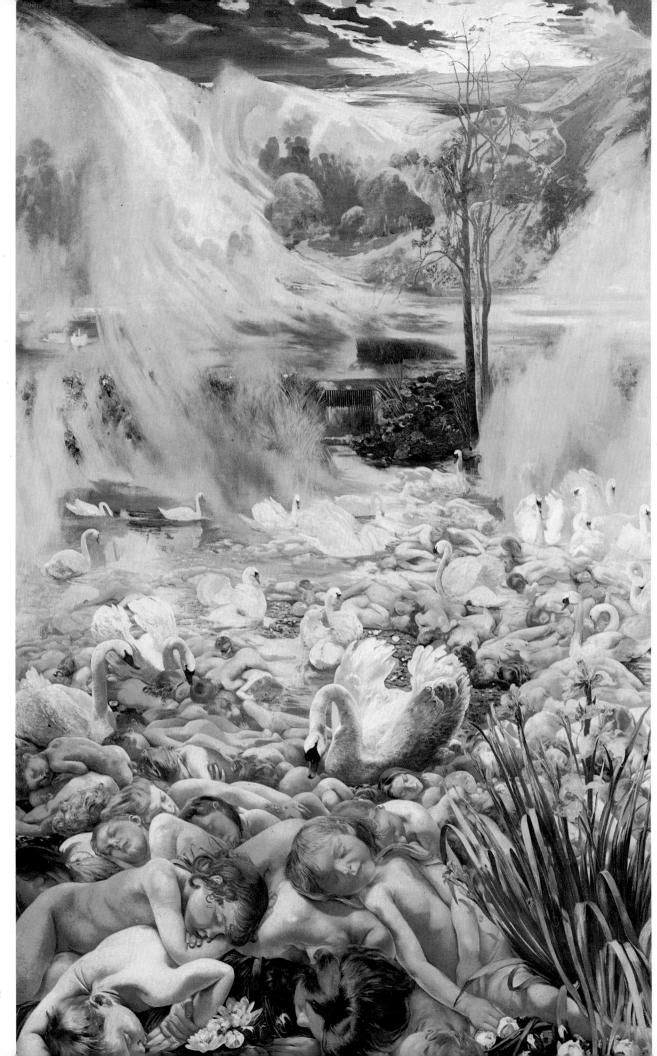

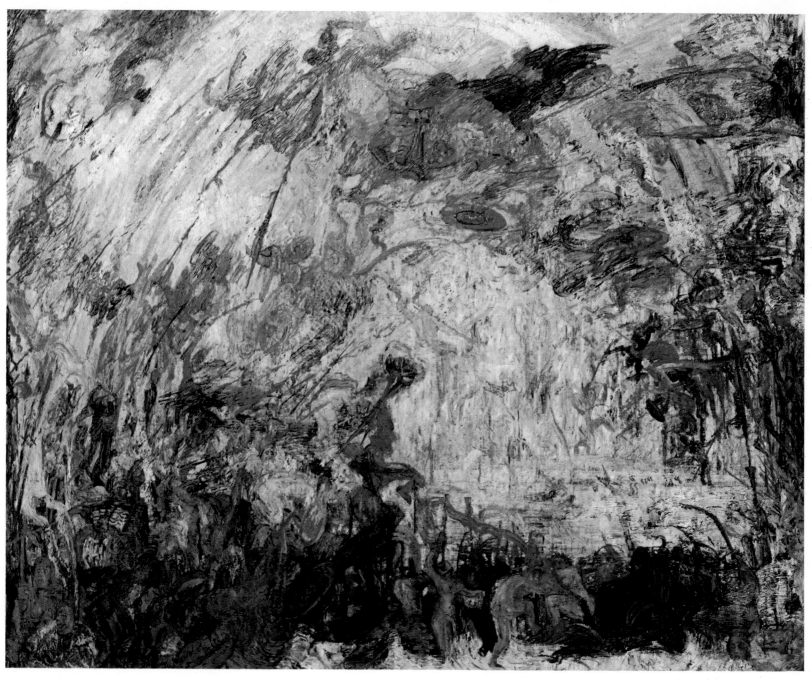

53

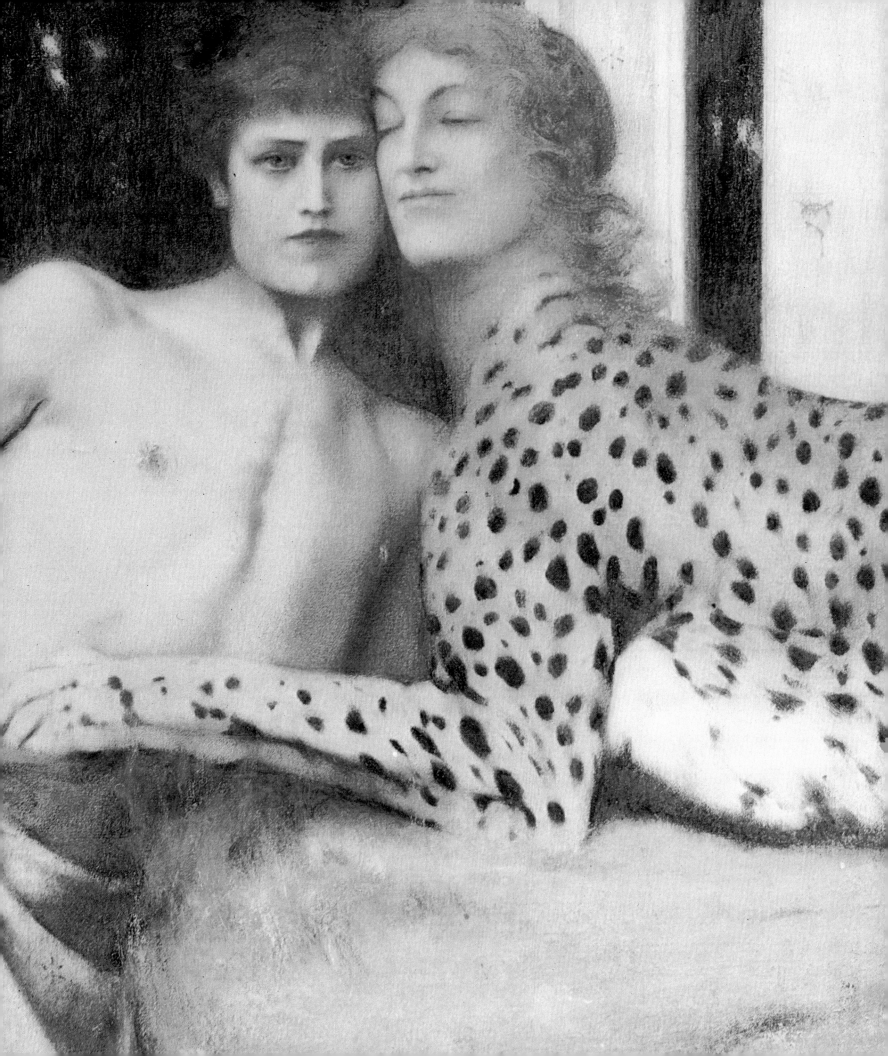

55
56

55. Fernand Khnopff: *Memories.* 1889. Pastel, 127 × 200 cm.
Musées Royaux des Beaux-Arts, Brussels

56. Fernand Khnopff: *Still water* or *The pool at Menil.* 1890. Oil on canvas,
54 × 105 cm. Kunsthistorisches Museum, Vienna

57. Raoul du Gardier: *The sphinx and the gods.* 1893. Oil on canvas, 48 × 85 cm. Musée des Beaux-Arts, Orléans

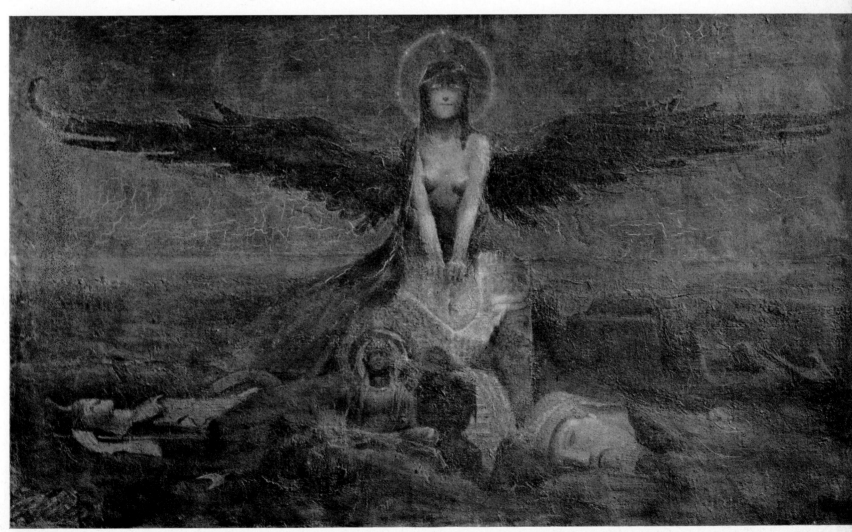

58. Henry de Groux: *Cataclysm*. c.1893. Oil on canvas, 76×98 cm. Coll. Flamand-Charbonnier, Paris

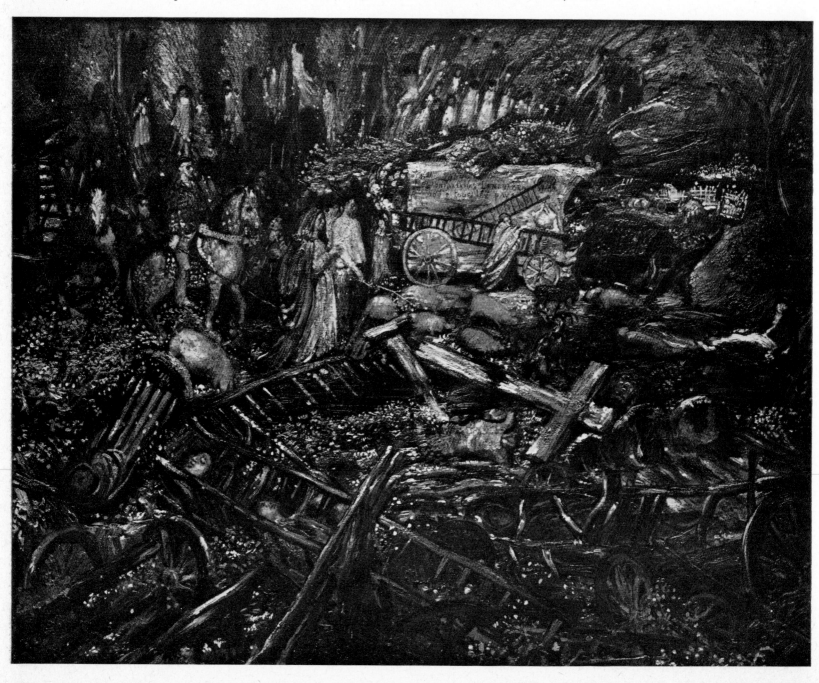

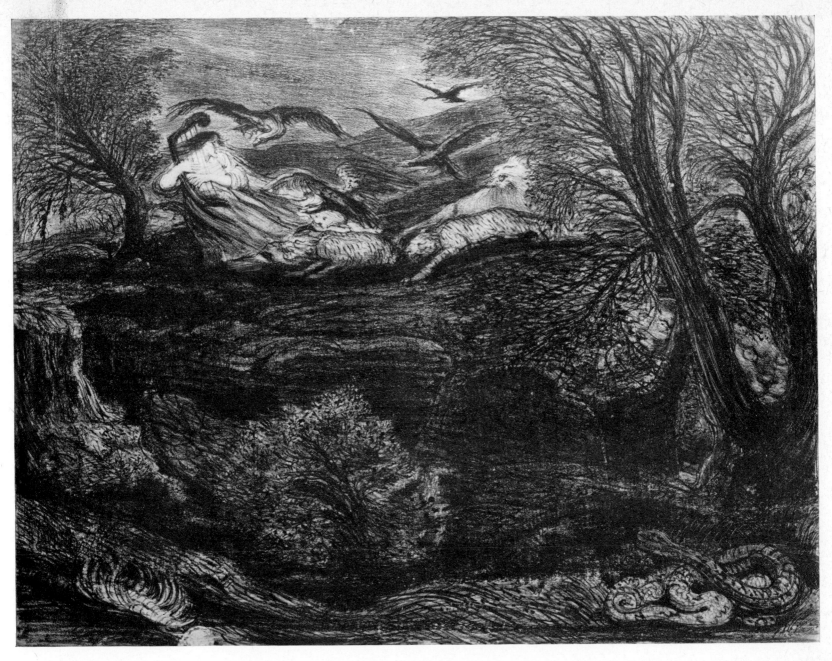

59. Henry de Groux: *Orpheus charming the monsters*. Lithograph. Bibliothèque Royale Albert Ier, Brussels

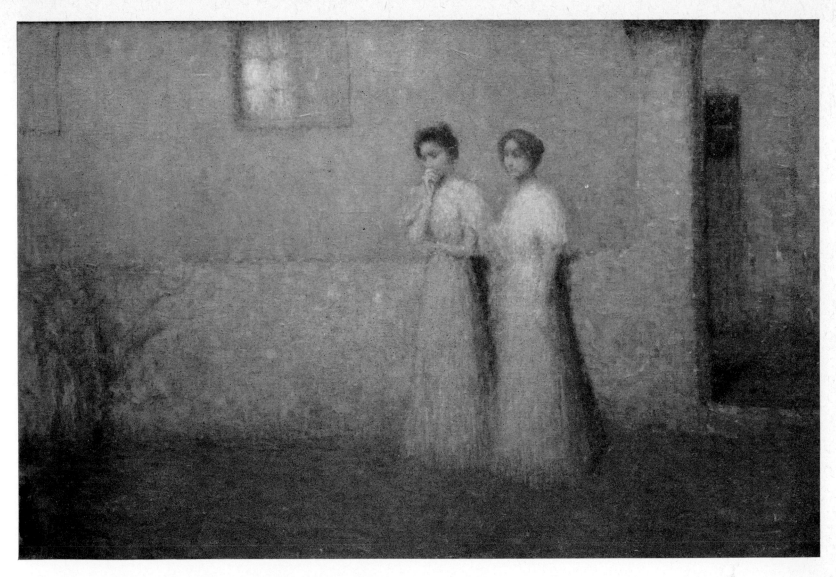

61. Henri Le Sidaner: *White souls* or *Gentle night*. 1897. Oil on canvas, 65 × 100 cm.
Coll. M. Louis Le Sidaner, Paris

◀ 60. Louis Welden Hawkins: *Portrait of Séverine*. 1895. Oil, 115 × 95 cm. (with frame). Louvre, Paris

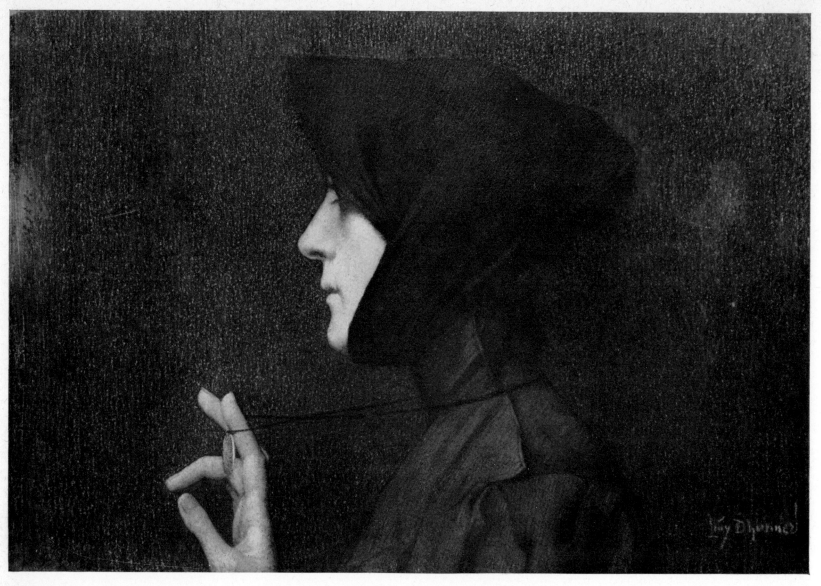

62. Lucien Lévy-Dhurmer: *Medusa*. 1896. Pastel, 40 × 59 cm. Louvre (Cabinet des Dessins), Paris

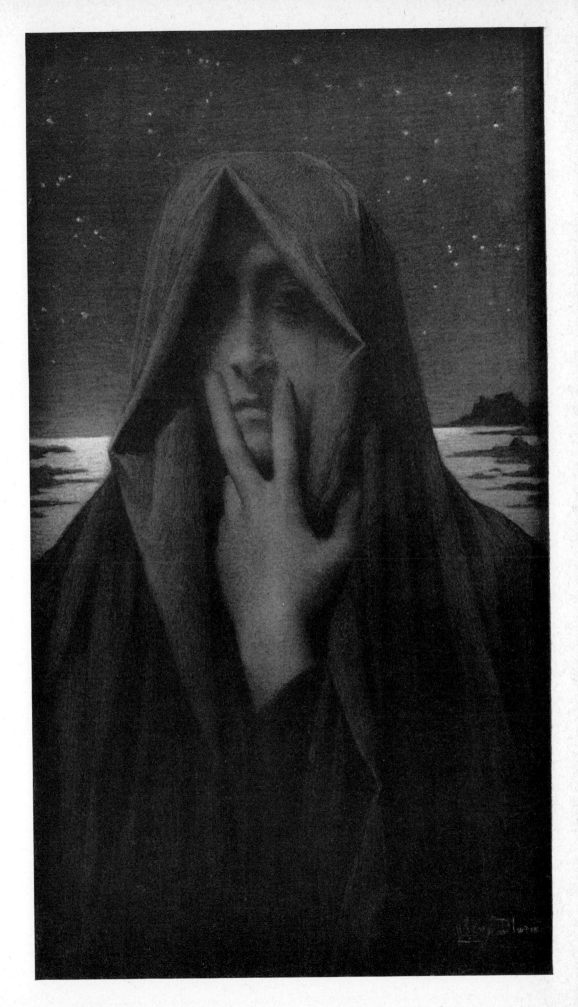

63. Lucien Lévy-Dhurmer: *Silence*. 1895.
Pastel, 54 × 29 cm.
Coll. M. and Mme Zagorowsky, Paris

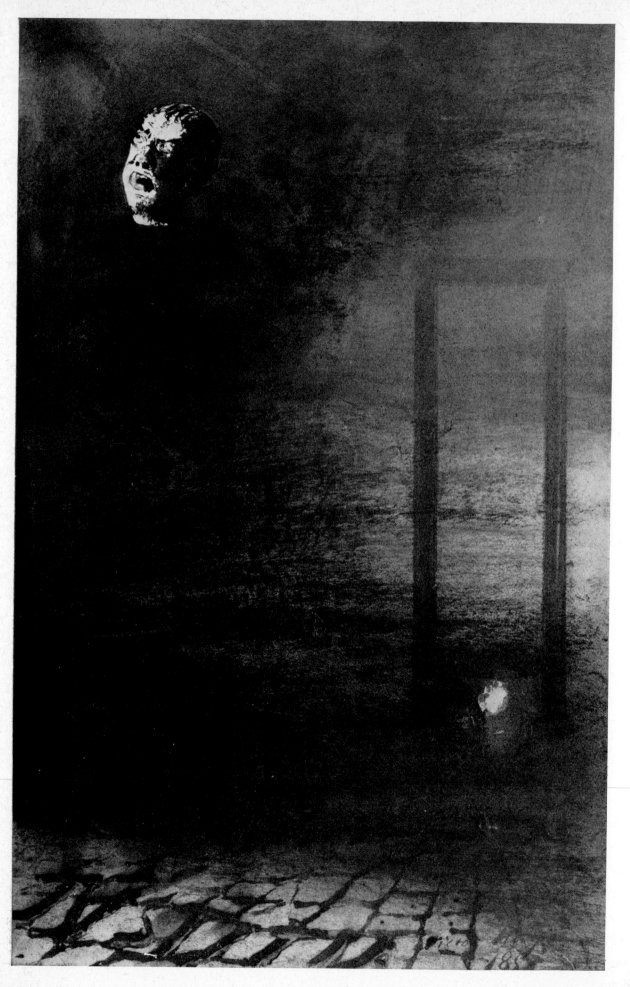

64. Victor Hugo: *Justicia.* 1858.
Sepia wash and indian ink,
53 × 35 cm. Hauteville
House, Guernsey

65. Fernand Khnopff: ▶
Isolation. 1894.
Pastel, 140 × 43 cm.
Galerie de l'Ecuyer, Brussels

66. Fernand Khnopff:
Medusa asleep. 1896. Pastel,
72 × 28 cm. Coll. M. Félix
Labisse, Neuilly-sur-Seine

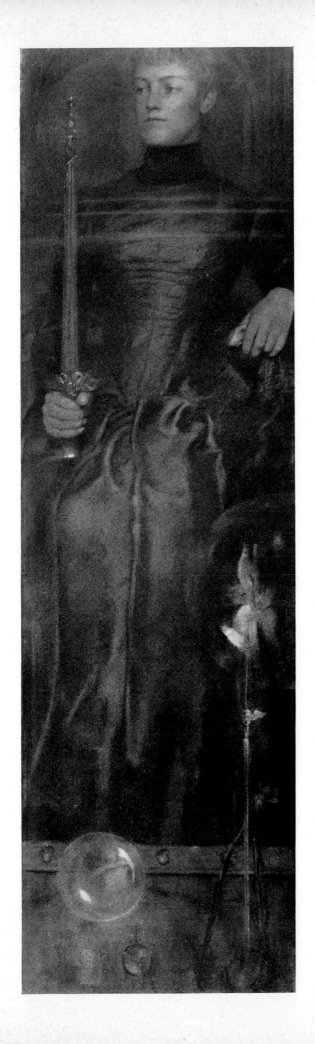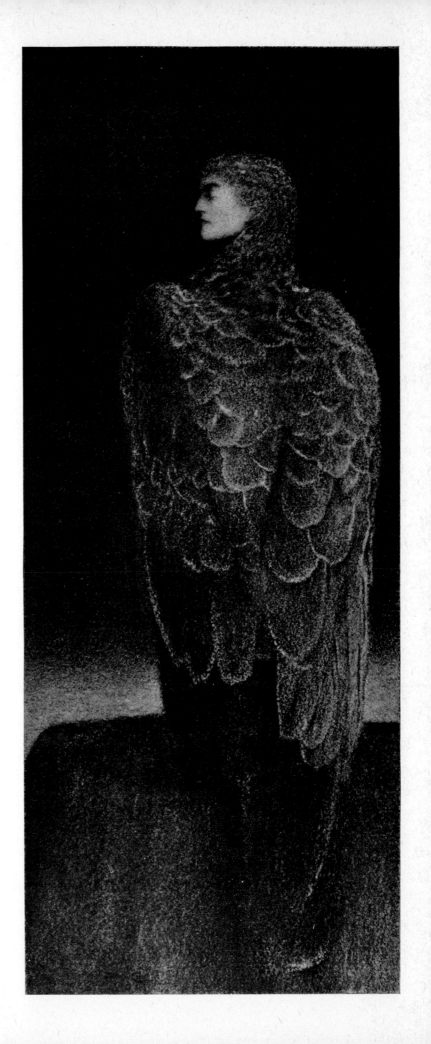

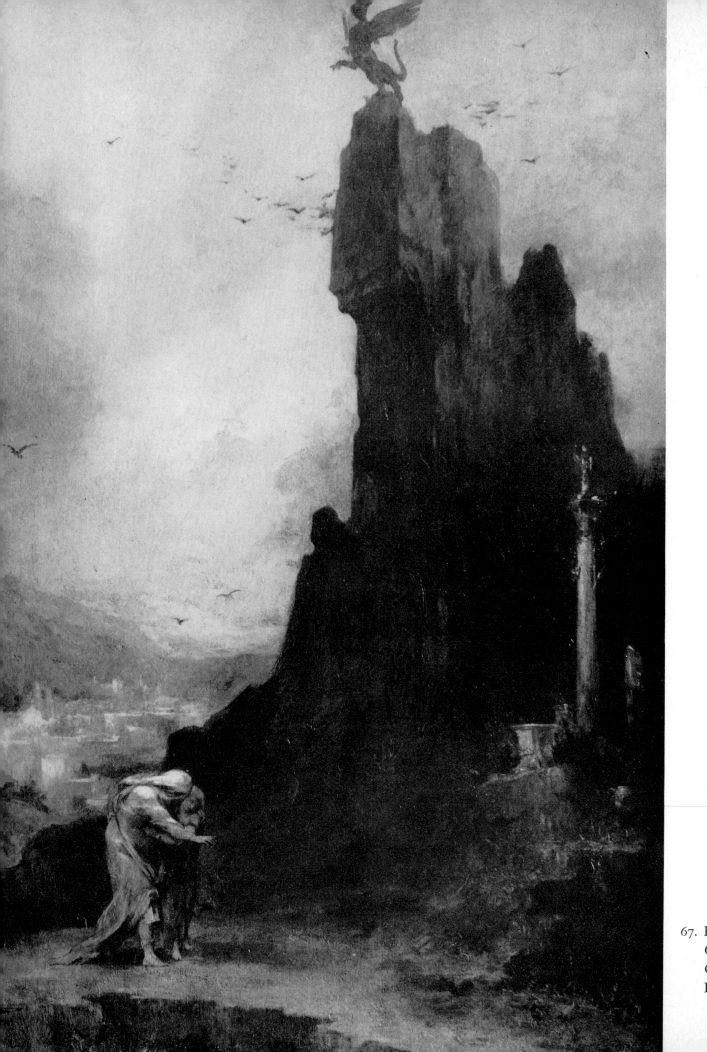

67. Henri-Léopold Lévy:
Oedipus going into exile. 1892.
Oil on canvas, 95 × 67 cm.
Louvre, Paris

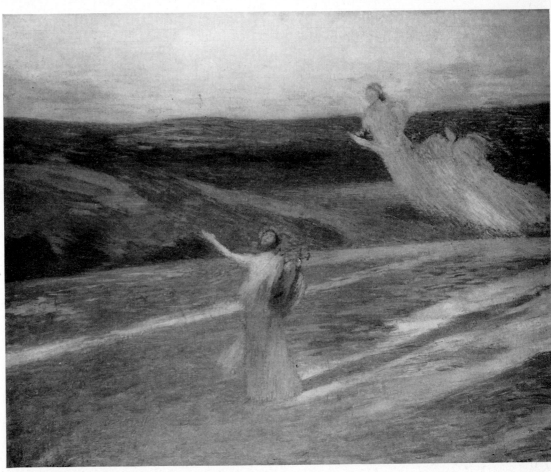

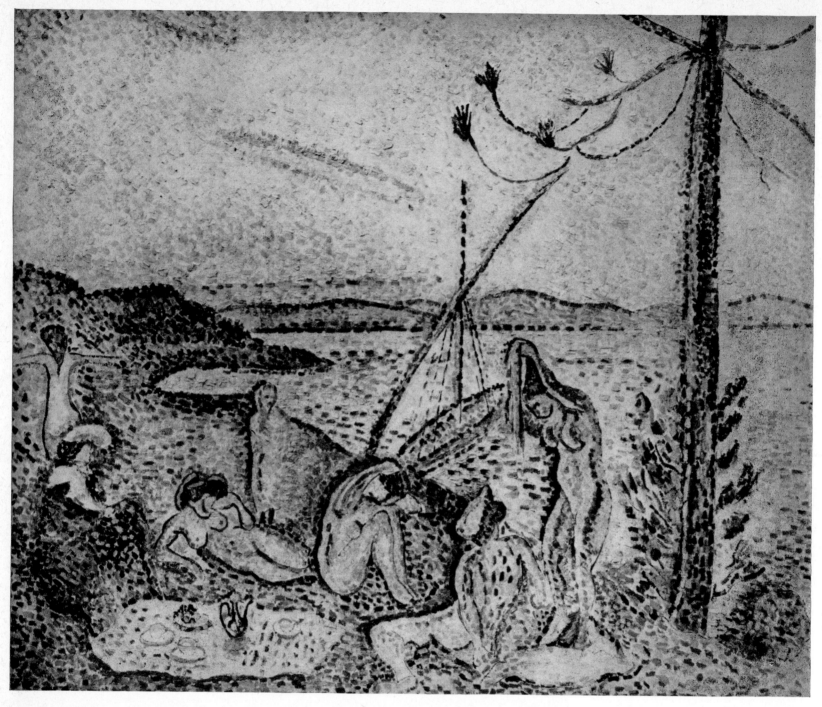

70. Henri Matisse: *Luxe, calme et volupté*. 1904. Oil on canvas, 94 × 117 cm. Private collection, Paris

71. Charles Maurin: *Dawn of love*. c.1891. Oil on canvas, 80 × 100 cm. Piccadilly Gallery, London

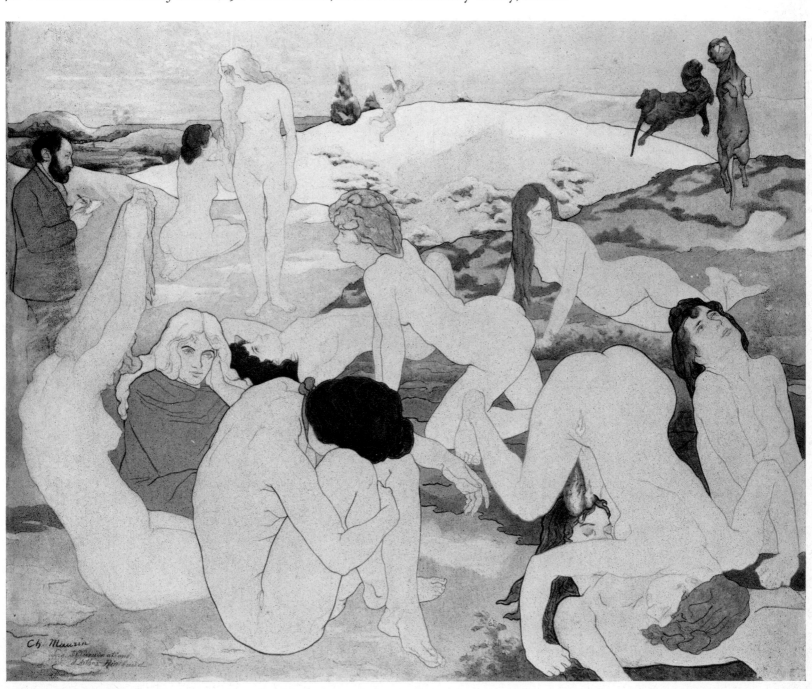

72. Xavier Mellery: *Dream of the evening*. After 1898.
Charcoal and pen, 25 × 20 cm.
Musées Royaux des Beaux-Arts, Brussels

73. Xavier Mellery: *Nuns at prayer*. c.1890. Drawing,
13 × 22 cm. Musées Royaux des Beaux-Arts, Brussels

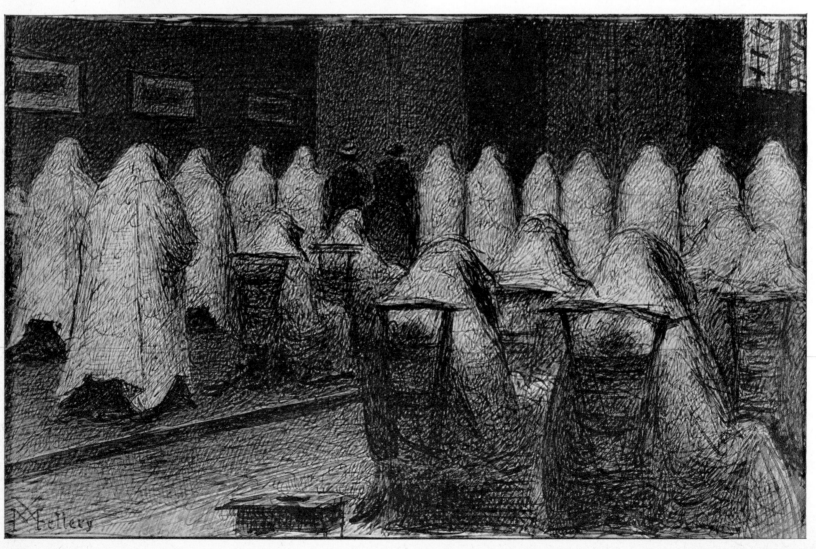

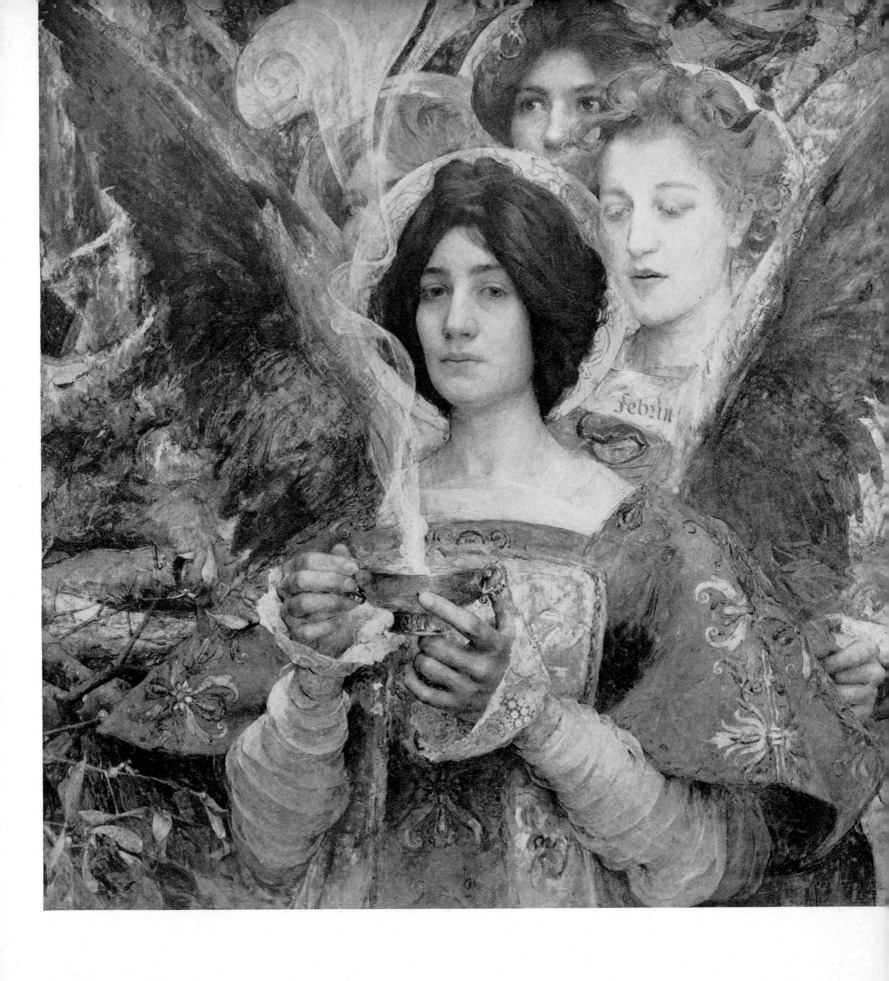

74. Edgar Maxence: *Spirit of the forest.* 1898. Oil on canvas, 88 × 83 cm. Musée des Beaux-Arts, Nantes

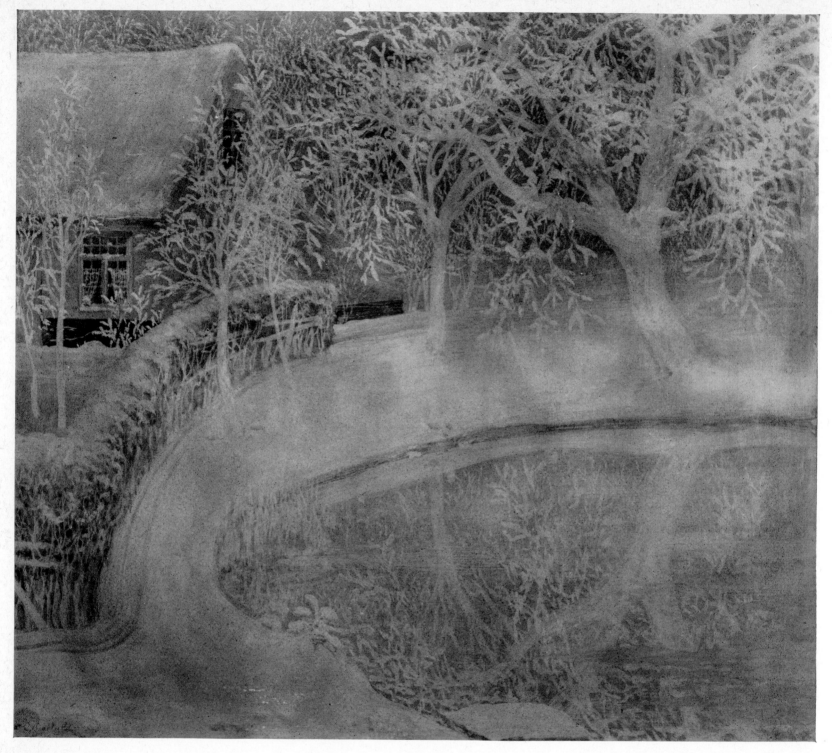

75. Constant Montald: *Garden under snow*. 1910. Oil on paper, 79 × 68 cm. Coll. M. Jean Goffin, Brussels

76. Henri Le Sidaner: *Sunday* (detail). 1898. Oil on canvas, 113 × 192 cm. ▶
Coll. M. Louis Le Sidaner, Paris

77. Georges Lacombe: *Cliffs near Camaret*. c.1893. Tempera on canvas,
81 × 61 cm. Musée Municipal, Brest

78. Lucien Lévy-Dhurmer: *Our Lady of Penmarc'h*. 1896. Oil on canvas,
41 × 33 cm. Coll. M. Robert Walker, Paris

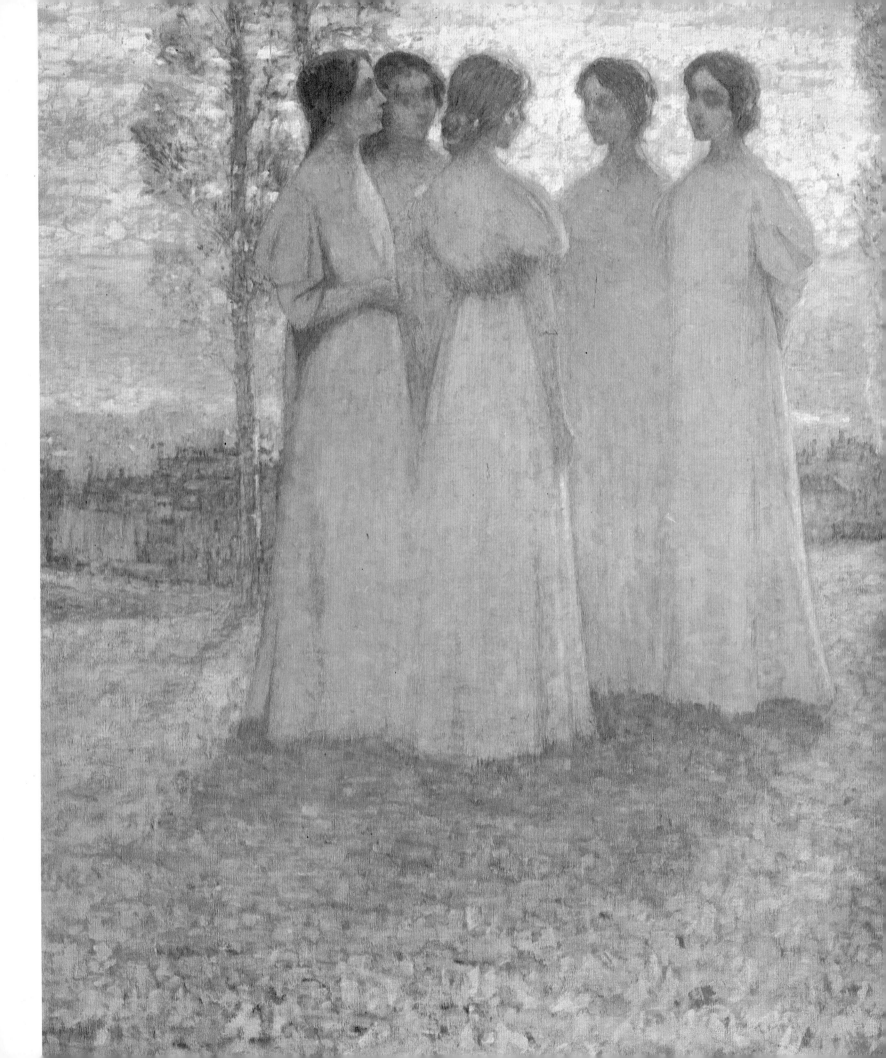

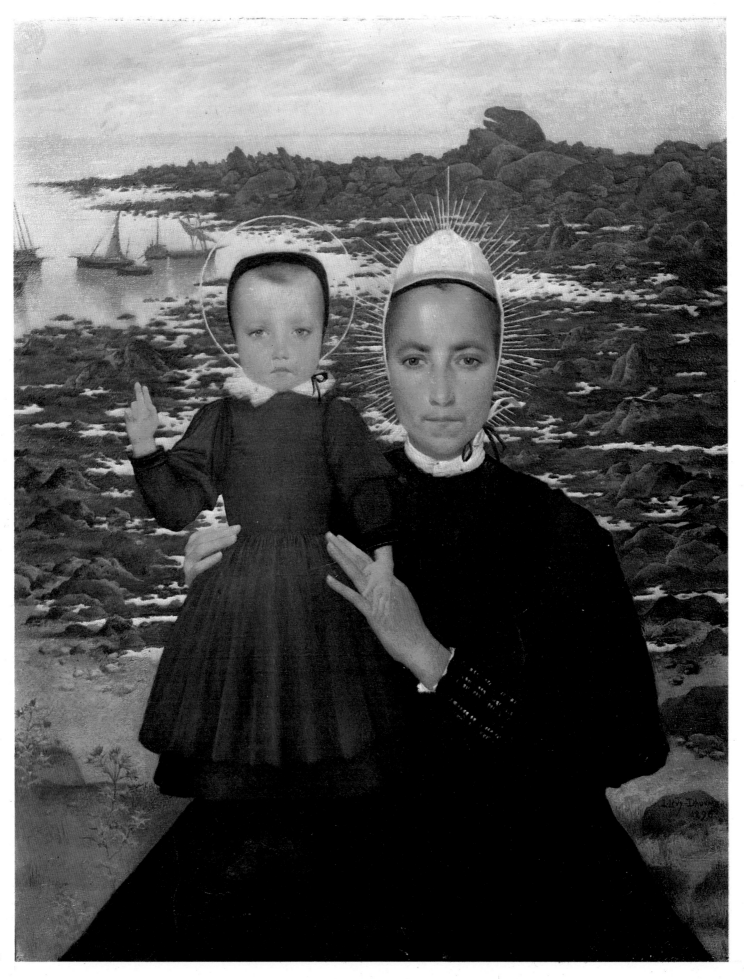

80

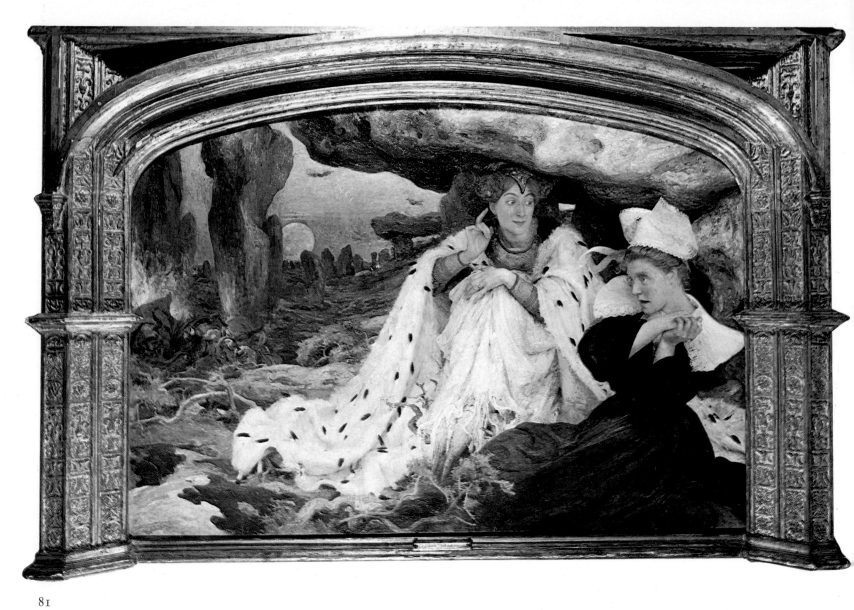

81

79. Lucien Lévy-Dhurmer: *The creek*, c.1898. Pastel, 79 × 63 cm.
Louvre (Cabinet des Dessins), Paris

80. Lucien Lévy-Dhurmer: *Marsh birds in a landscape*. 1910–14.
Oil on canvas (panel), 206 × 290 cm. Metropolitan Museum of
Art (Harris Brisbane Dick Fund 1966), New York

◀ 81. Edgar Maxence: *Breton legend*. 1906. Oil on canvas,
150 × 220 cm. Galerie du Luxembourg, Paris

82. George Minne: *Two kneeling figures*. c.1897. Pencil, 30 × 28 cm.
Coll. M. Paul Eeckhout, Ghent

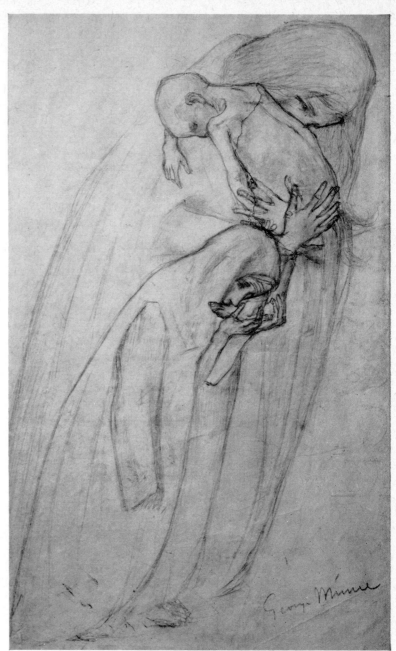

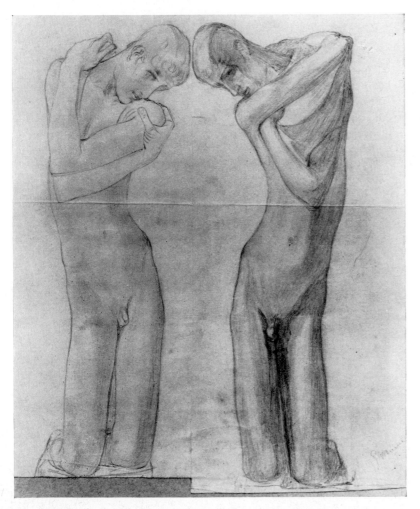

83. George Minne: *Weeping mother*. c.1890. Pencil, 33 × 20 cm.
Coll. M. Paul Eeckhout, Ghent

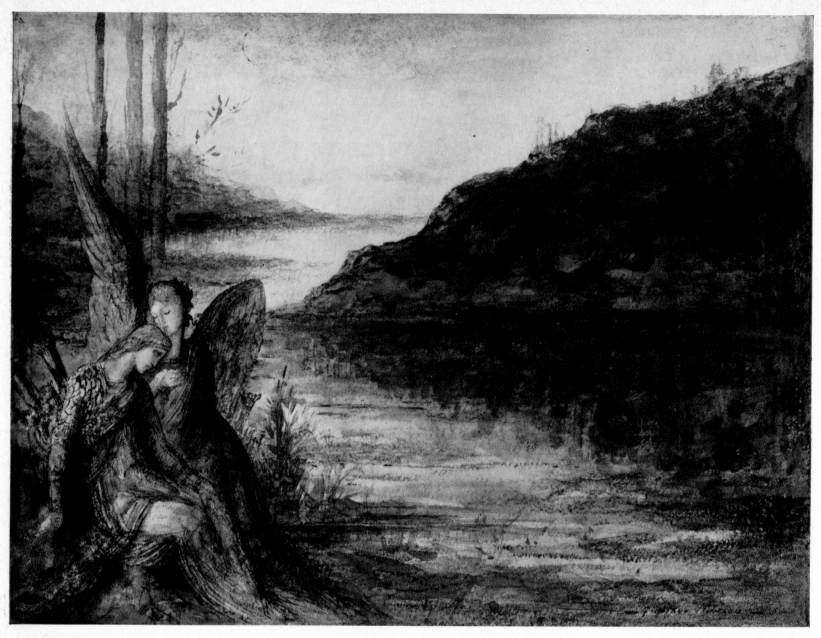

84. Gustave Moreau: *Evening and Sorrow*. c.1870. Watercolour, 24 × 33 cm. Musée Moreau, Paris

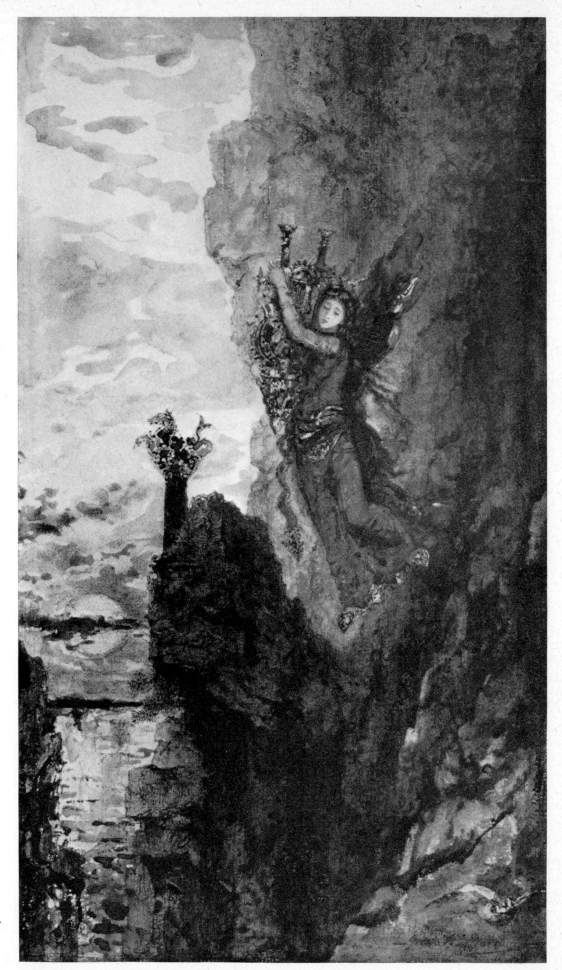

85. Gustave Moreau:
Sappho flinging herself into the sea. c.1884.
Watercolour, 33 × 19 cm.
Private collection, Paris

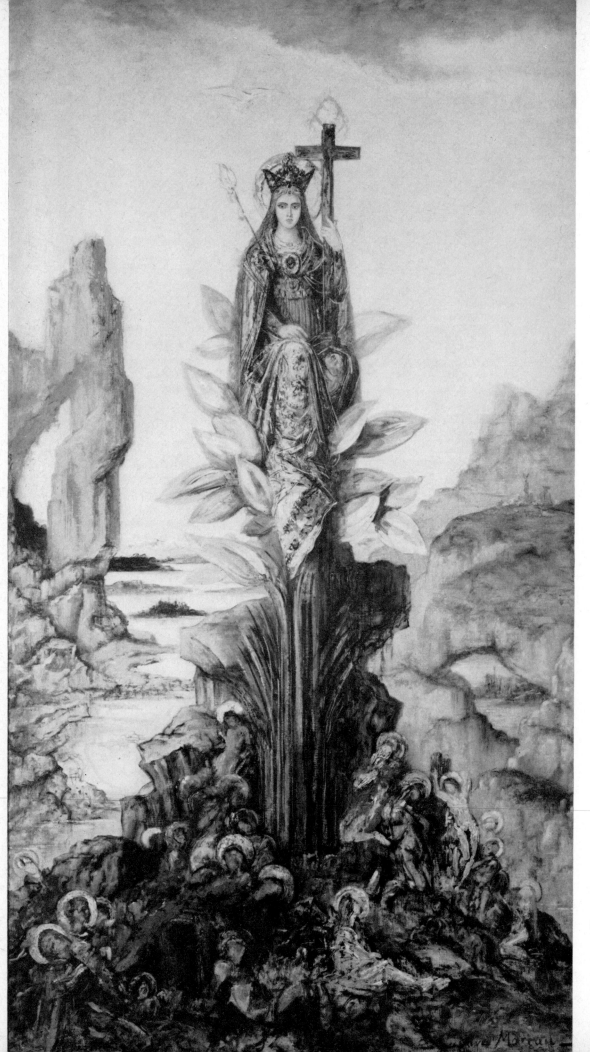

86. Gustave Moreau:
Mystic Flower. c.1875.
Oil on canvas, 253 × 137 cm.
Musée Moreau, Paris

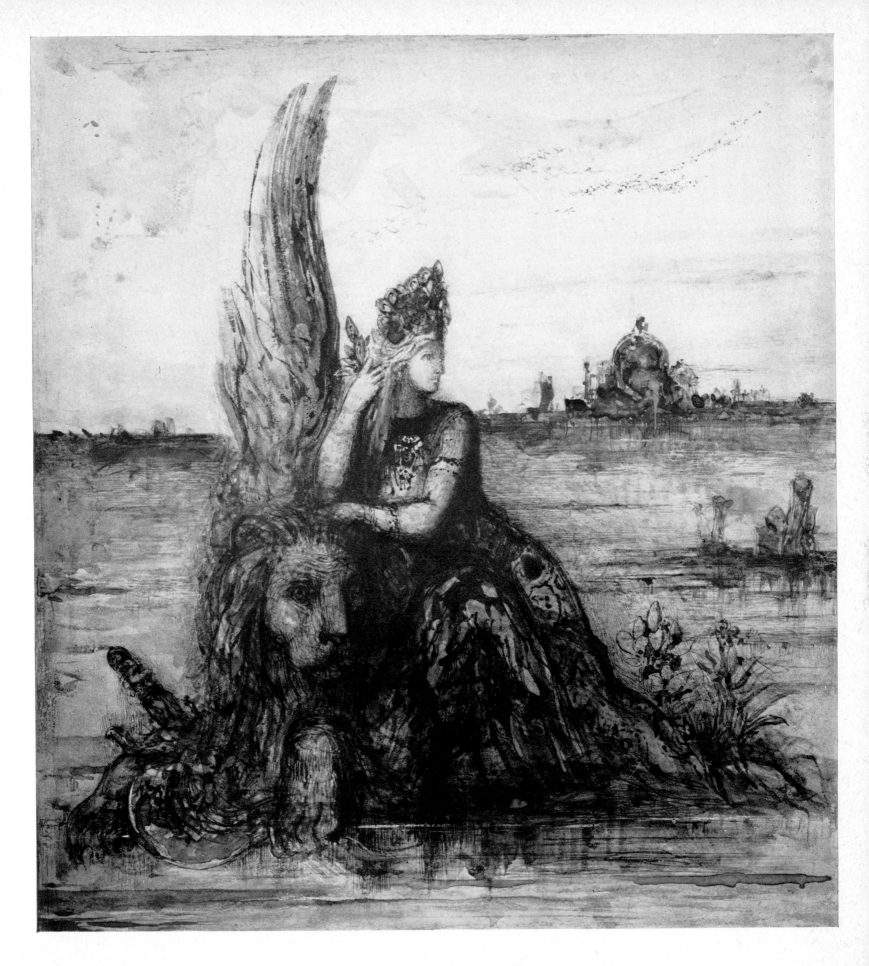

87. Gustave Moreau: *Venice*. c.1870. Watercolour and pencil, 25 × 23 cm. Musée Moreau, Paris

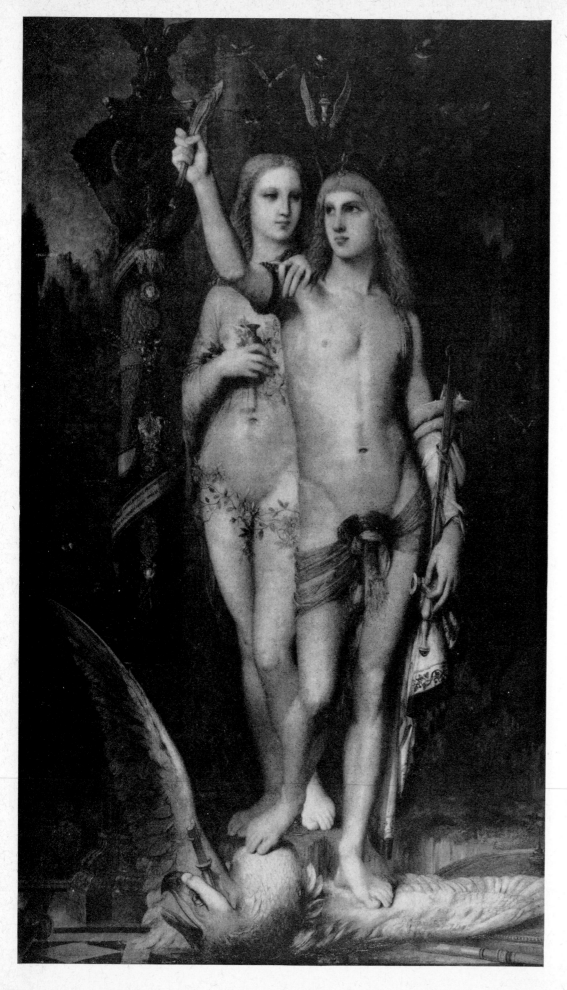

88. Gustave Moreau: *Jason*. 1865.
Oil on canvas, 204 × 156 cm.
Louvre, Paris

89. Gustave Moreau: *Salome dancing.* ▶
1874–6? Oil on canvas, 92 × 60 cm.
Musée Moreau, Paris

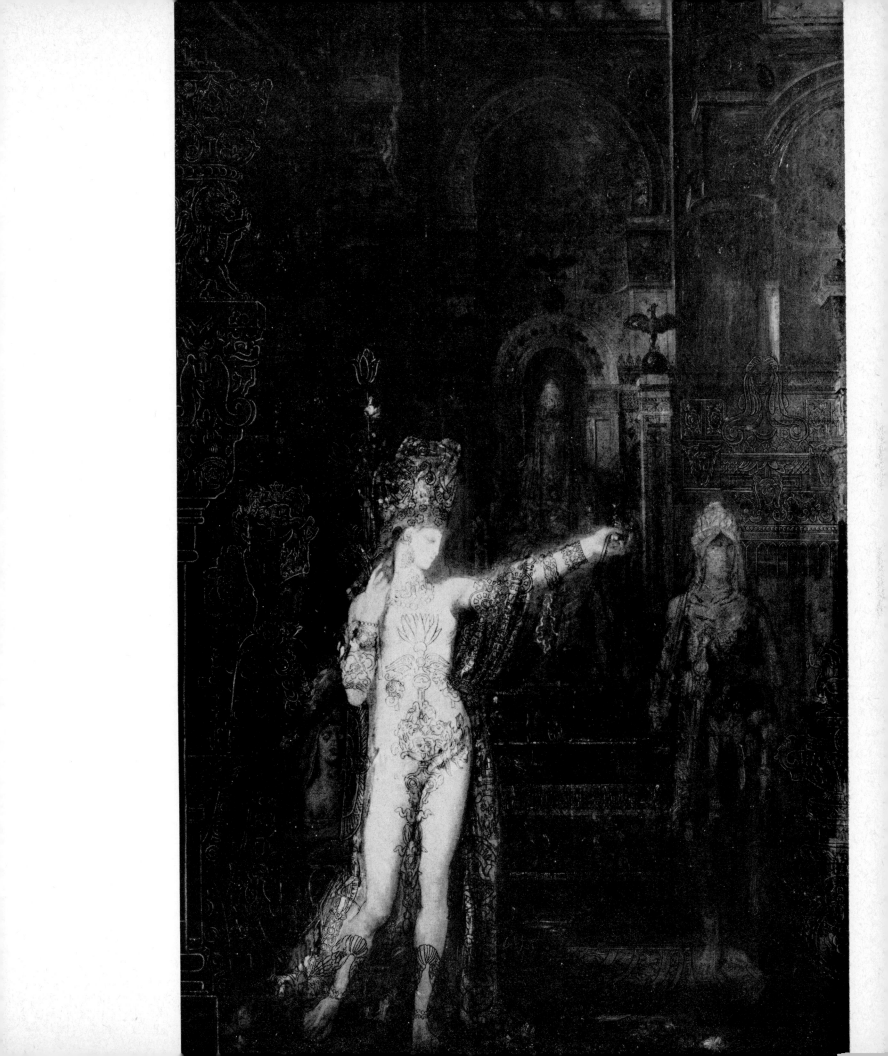

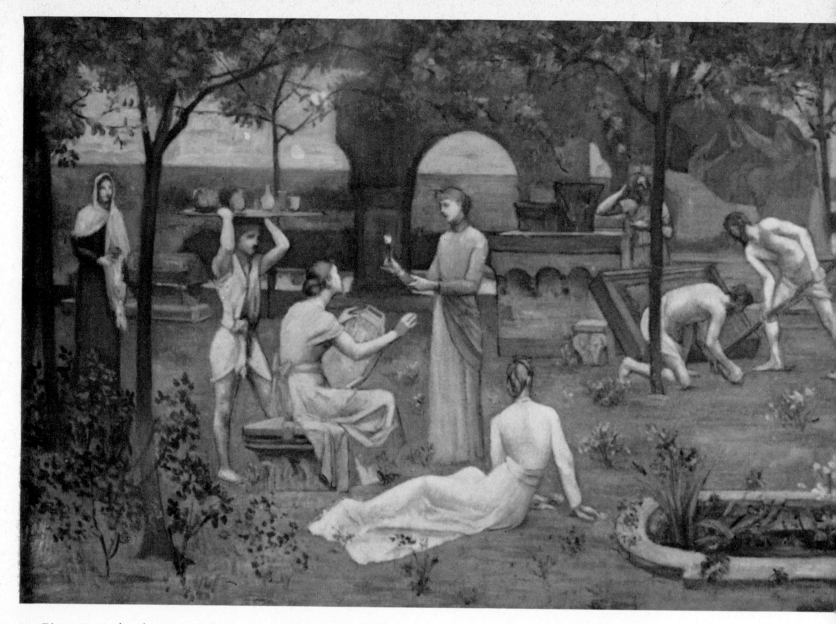

90. Pierre Puvis de Chavannes: *Inter artes et naturam.* c.1890–5. Oil on canvas, 41 × 114 cm. Metropolitan
Museum of Art (Gift of Mrs Harry Payne Bingham 1958), New York

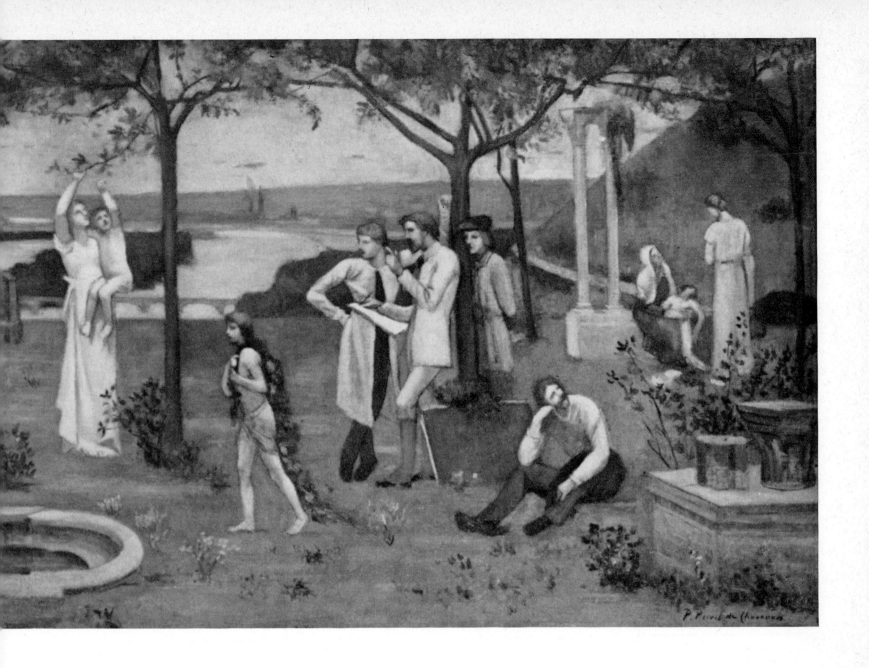

91. Gustave Moreau: *The peri.*
c.1870–5. Pencil and pen,
29 × 18 cm. Musée Moreau, Paris

92. Gustave Moreau: ▶
The rape of Deianira. c.1870–5
Pencil and pen, 25 × 21 cm.
Musée Moreau, Paris

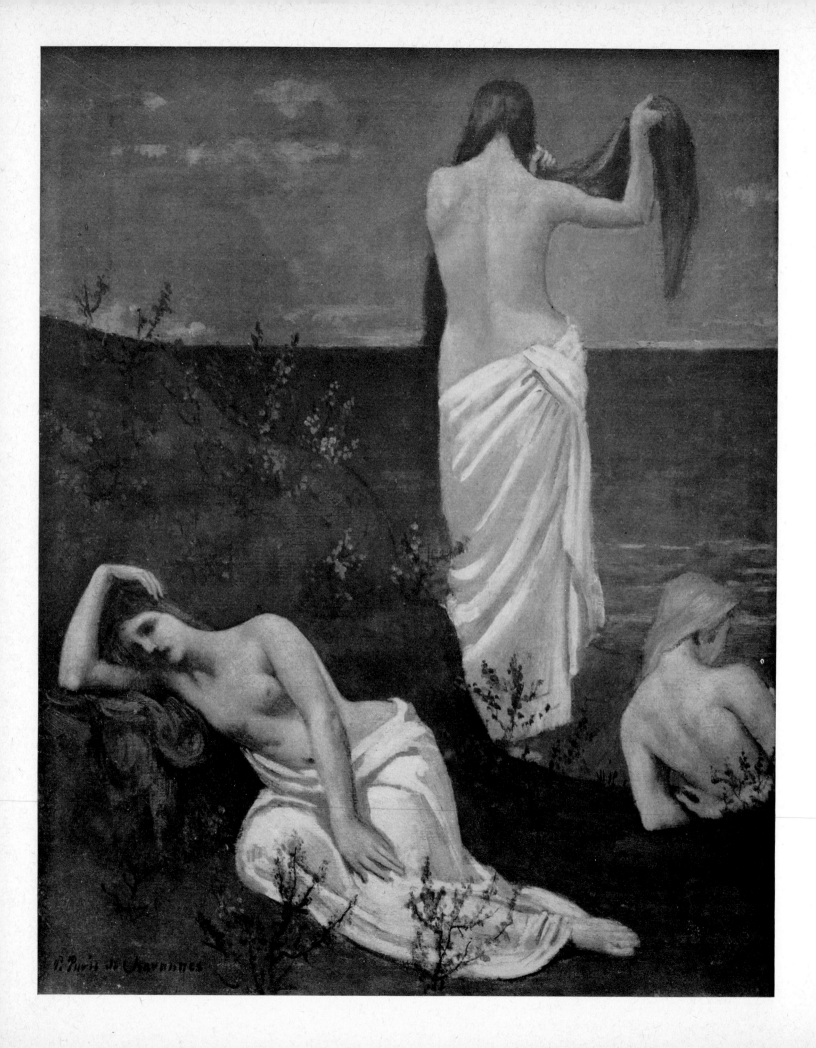

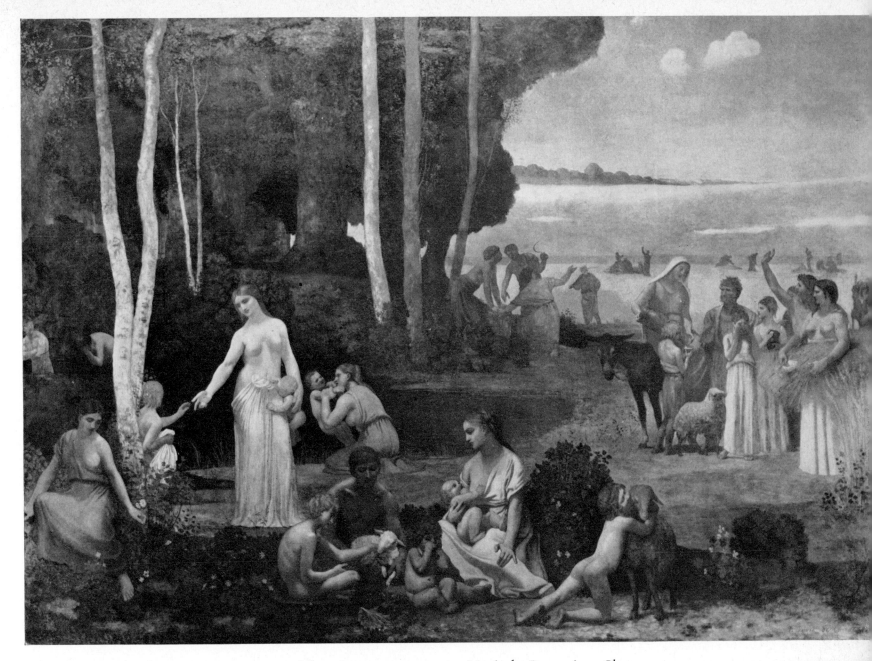

94. Pierre Puvis de Chavannes: *Summer*. 1873. Oil on canvas, 350 × 507 cm. Musée des Beaux-Arts, Chartres

◀ 93. Pierre Puvis de Chavannes: *Girls by the sea shore*. 1879. Oil on canvas, 61 × 47 cm. Louvre, Paris

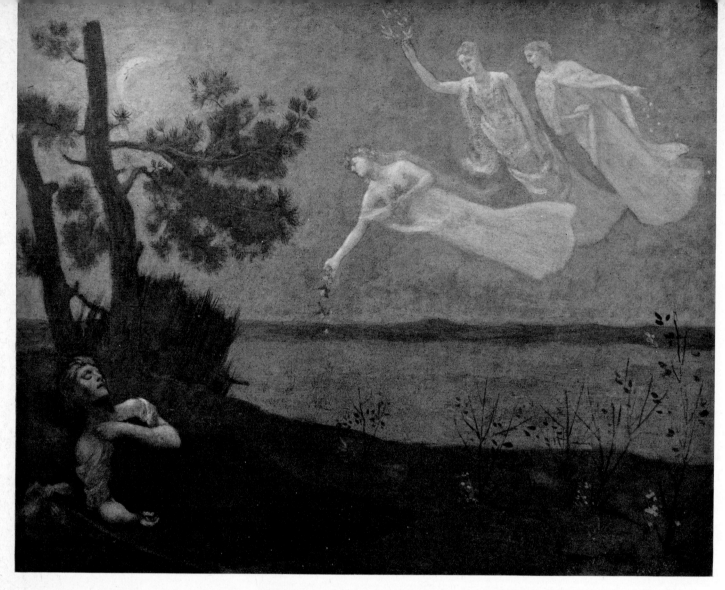

95. Pierre Puvis de Chavannes: *The dream*. 1883. Oil on canvas, 82 × 102 cm. Louvre, Paris

96. Pierre Puvis de Chavannes: *Christ and the fishermen*. c.1885. Oil on canvas, 100 × 40 cm.
Coll. M. le Président Palewski, Paris

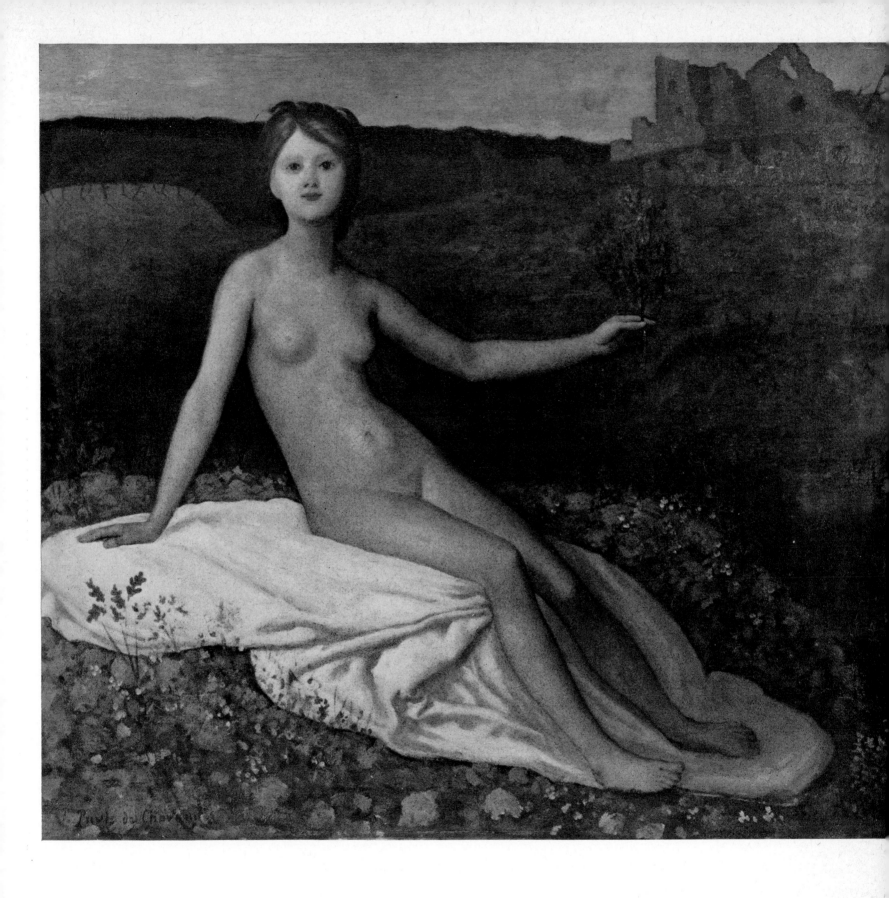

97. Pierre Puvis de Chavannes: *Hope*. c.1871. Oil on canvas, 70 × 82 cm. Louvre, Paris

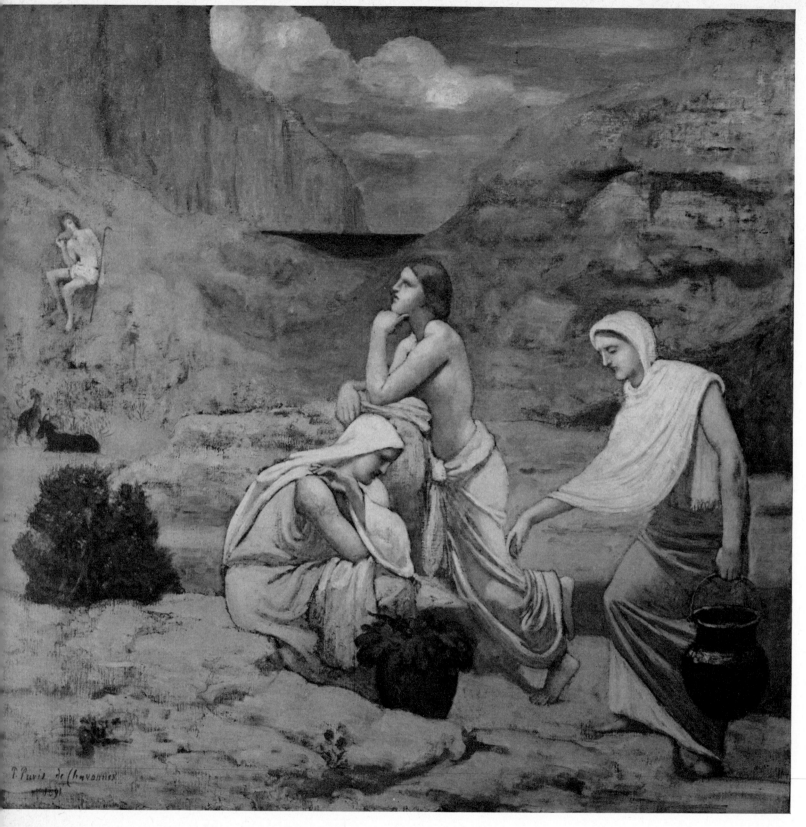

98. Pierre Puvis de Chavannes: *The shepherd's song*. 1891. Oil on canvas, 104 × 109 cm.
Metropolitan Museum of Art (Rogers Fund 1906), New York

99. Constant Montald: *The garden of Paradise*. 1904. Oil on canvas, 110 × 175 cm. ▶
Coll. Count Henri de Limbourg-Stirum, Brussels

100. Gustave Moreau: *Orpheus*. 1865. Oil on panel, 154 × 100 cm. Louvre, Paris

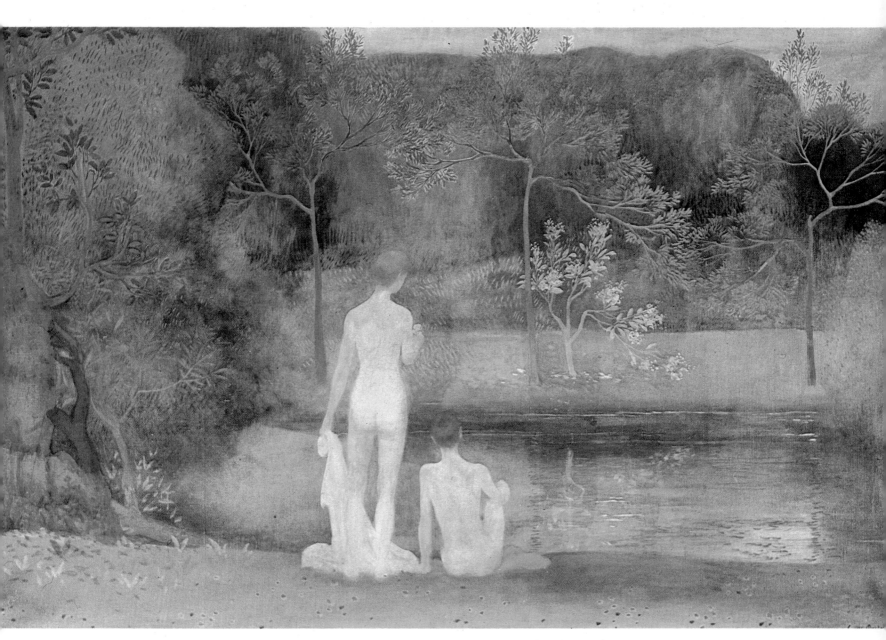

99

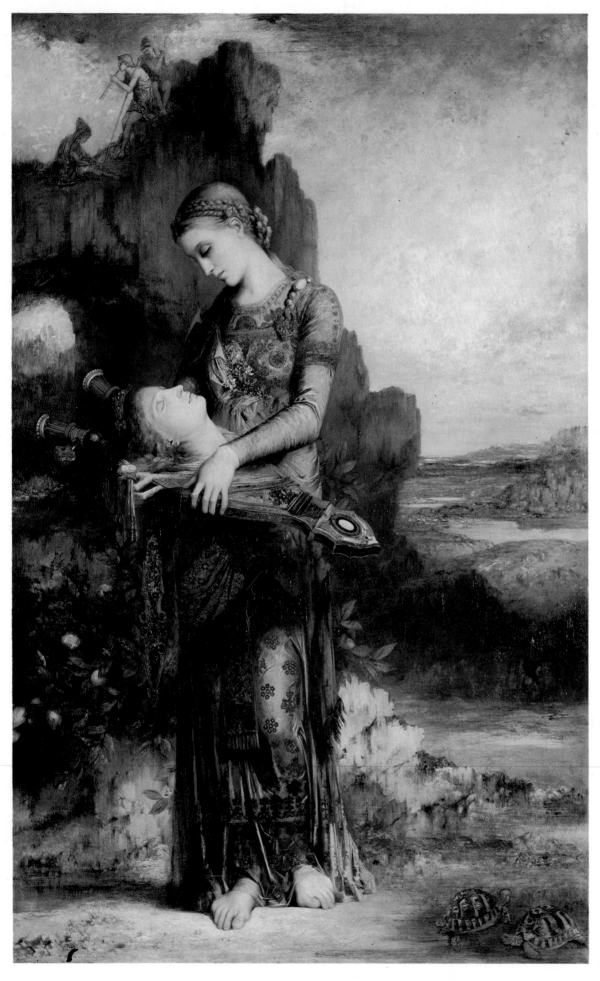

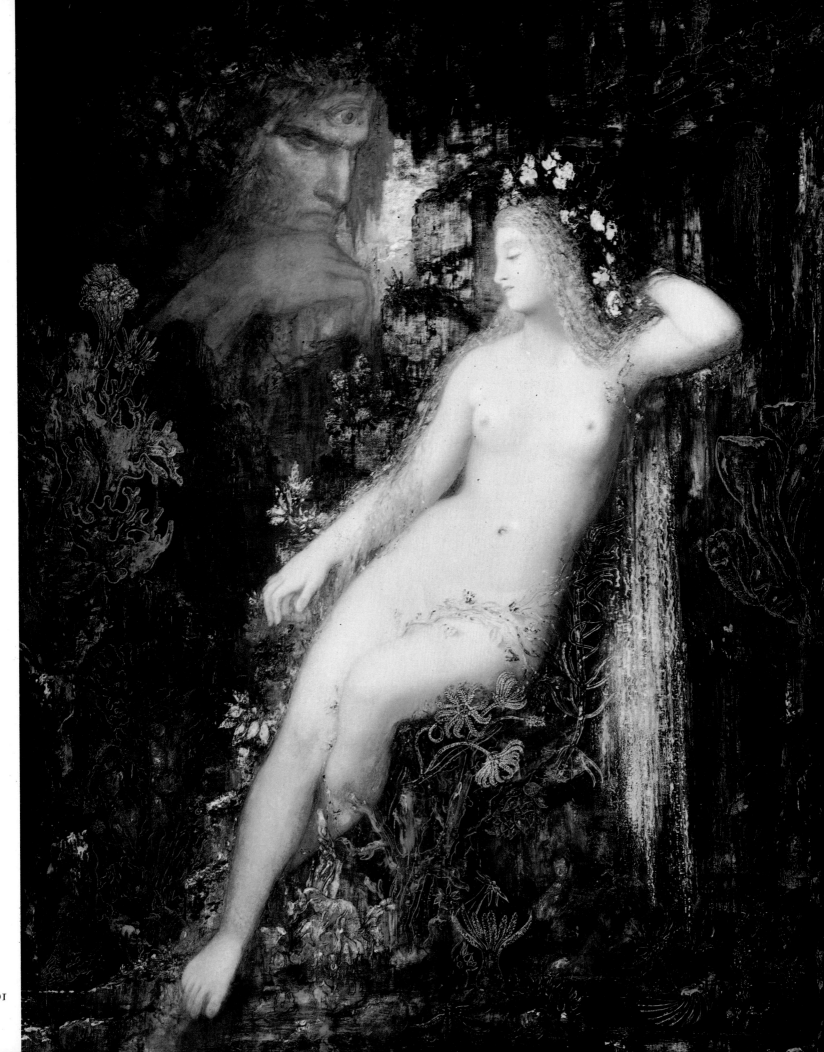

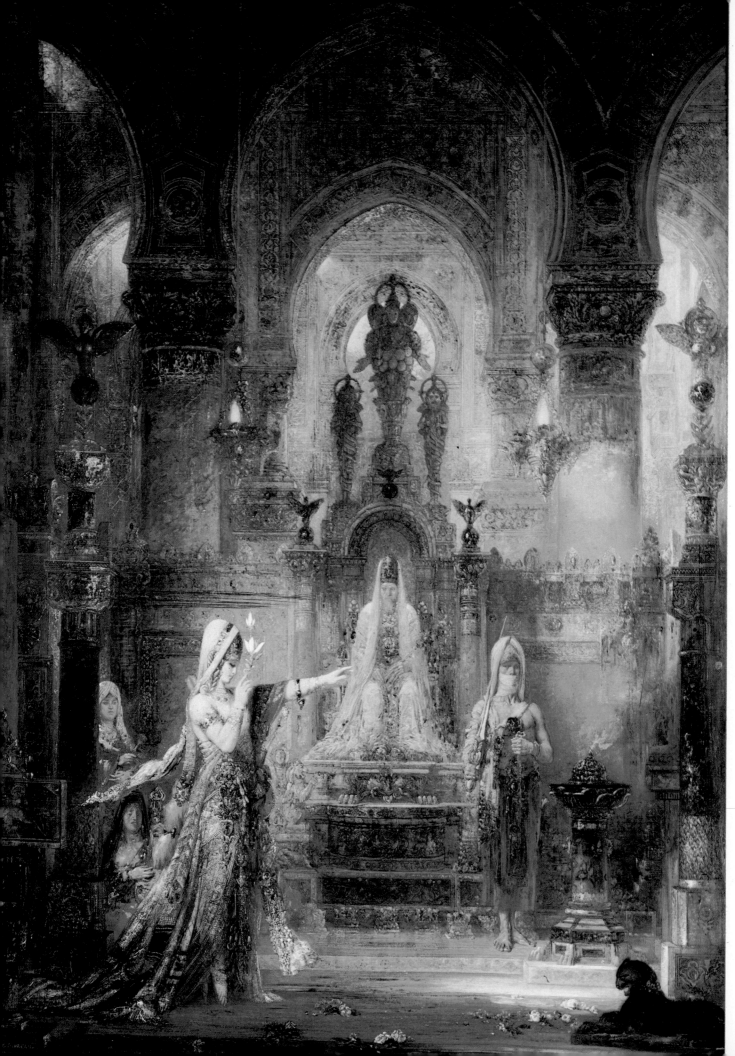

101. Gustave Moreau:
Galatea. 1880–1.
Oil on panel, 85 × 67 cm.
Coll. M. Robert Lebel,
Paris

◀ 102. Gustave Moreau:
Salome. 1876. Oil on
canvas, 144 × 104 cm.
Coll. Armand Hammer,
U.S.A.

103. Pierre Puvis de
Chavannes: *The pigeon*.
1871. Charcoal, 32 × 21
cm. Petit Palais, Paris

104. Pablo Picasso: *The pauper*. 1904. Watercolour, 86×36 cm.
Museo Picasso, Barcelona

105. Pablo Picasso: *Evocation*.
Oil on canvas. Musée d'Art
Moderne de la Ville de Paris

106. Armand Point: *The eternal chimera.*
c.1895. Pastel, 44 × 29 cm.
Piccadilly Gallery, London

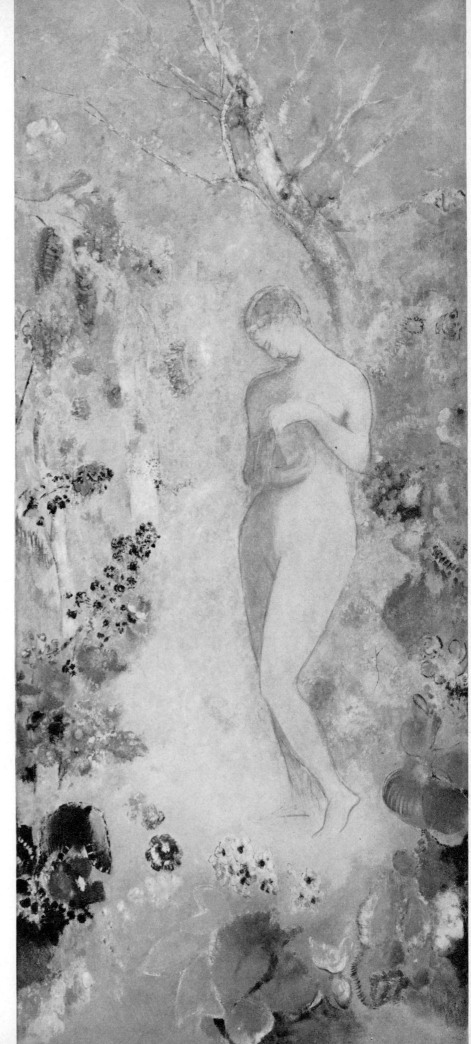

107. Odilon Redon: *Pandora*. c.1910. Oil on canvas,
144 × 62 cm. Metropolitan Museum of Art
(Bequest of Alexander M. Bing 1959), New York

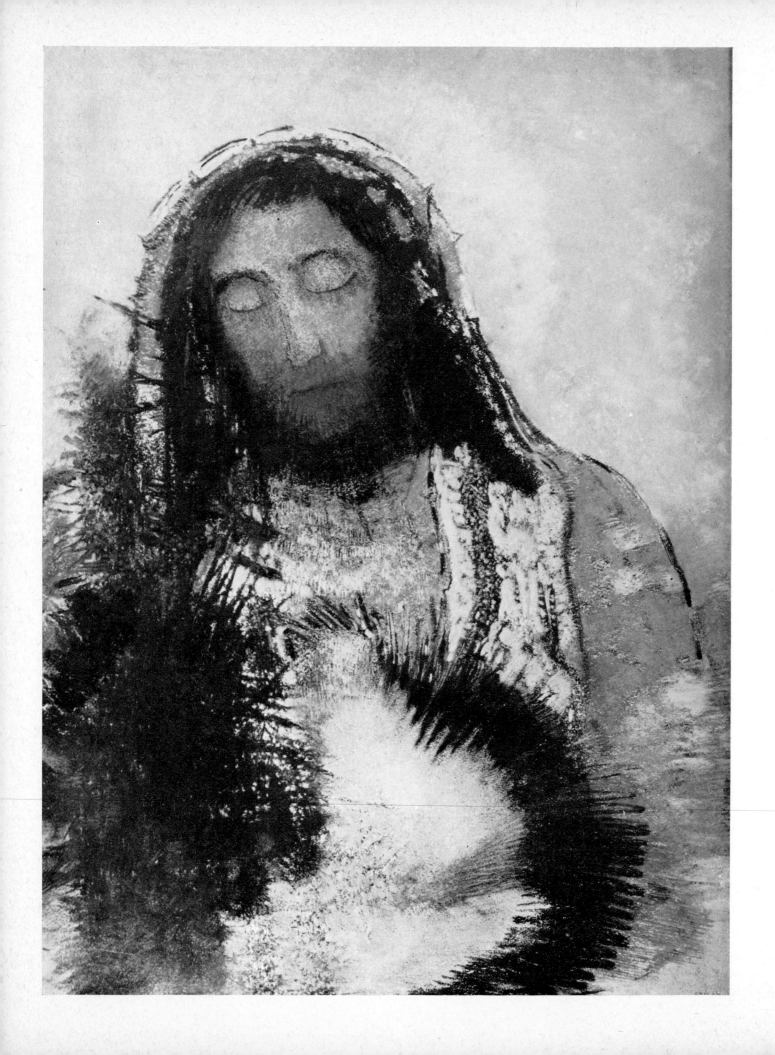

108. Odilon Redon: *The Sacred Heart*. 1895.
Pastel, 60 × 46 cm.
Louvre (Cabinet des Dessins), Paris

109. Odilon Redon: *Woman in profile with wreathed head*.
c.1890–5. Charcoal, 50 × 37 cm.
Rijksmuseum Kröller-Müller, Otterlo

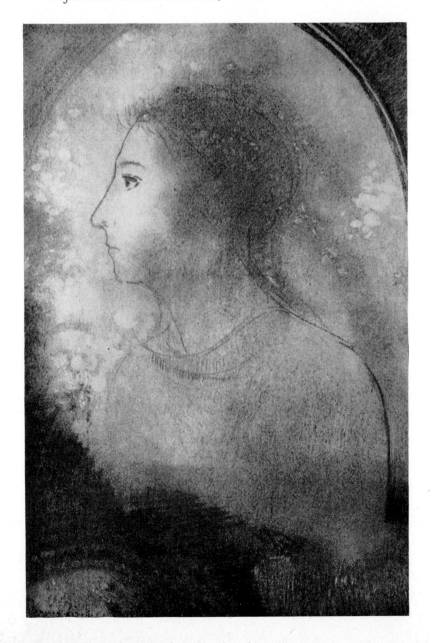

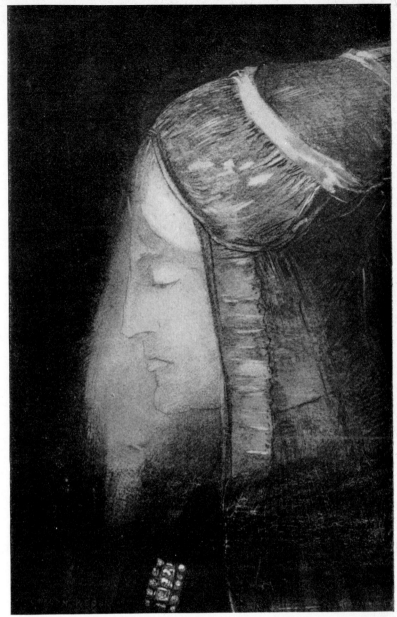

110. Odilon Redon: *Luminous profile*. c.1875. Charcoal,
35 × 23 cm. Petit Palais, Paris

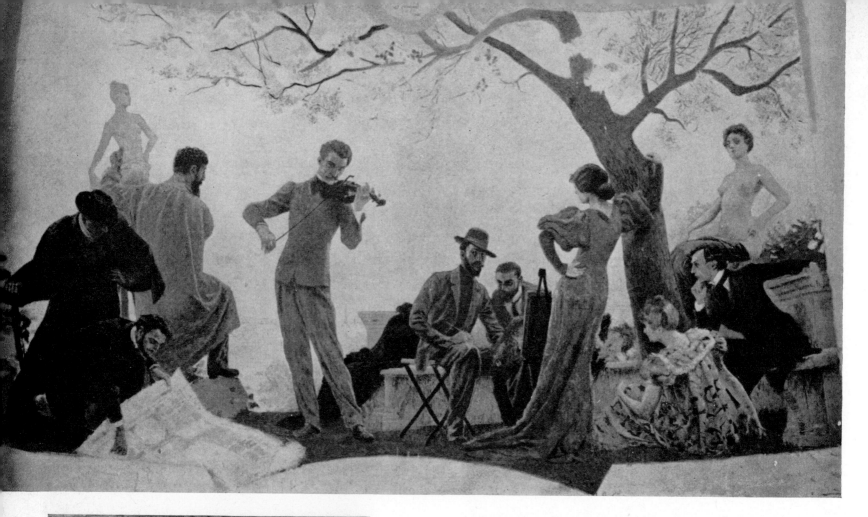

111. Georges Rochegrosse: *The fine arts*. Panel, oil on canvas.
Formerly in the Salle des Fêtes at the International Exhibition of
1900, Paris (now destroyed)

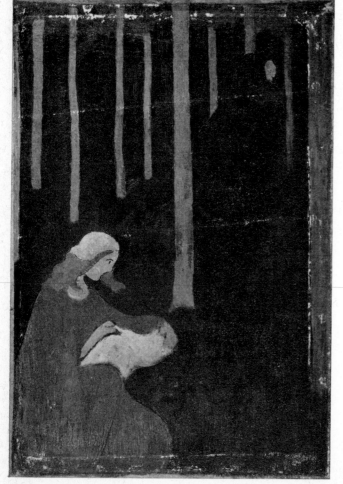

112. Ker-Xavier Roussel: *The Virgin of the path*. c.1890–2.
Oil on canvas, 54 × 37 cm. Private collection, Paris

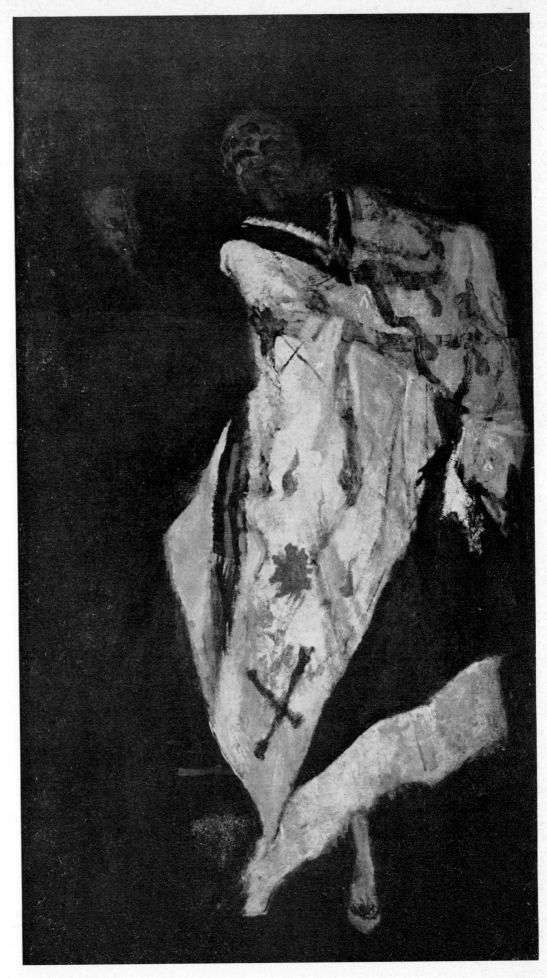

113. Félicien Rops: *Death at the ball.* 1870.
Oil on canvas, 151 × 85 cm.
Rijksmuseum Kröller-Müller, Otterlo

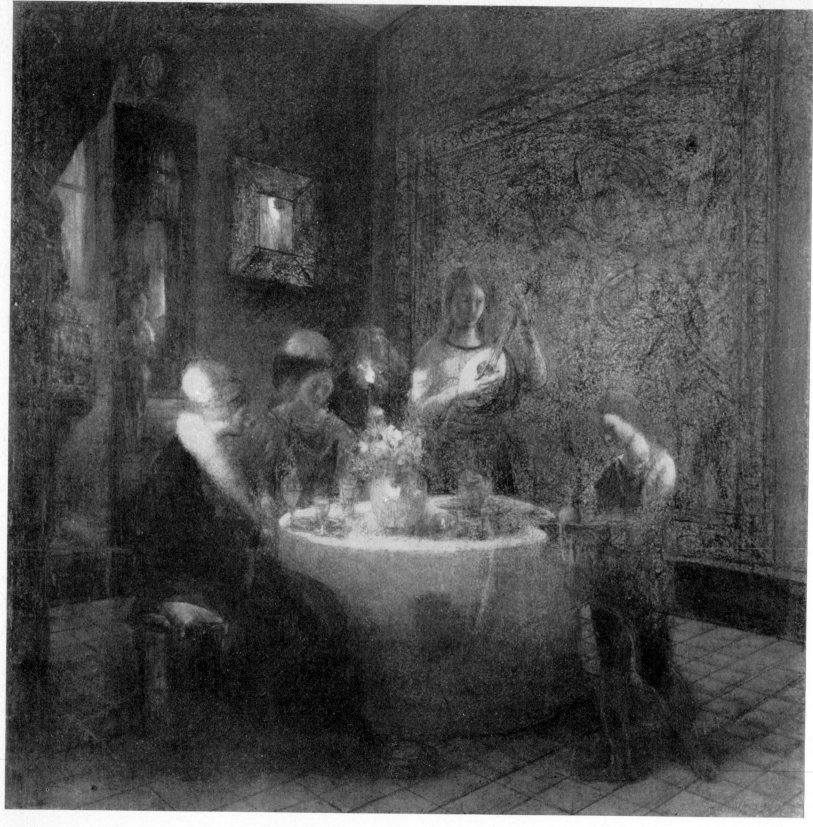

114. Georges Rouault: *The meal*. 1900. Pastel, 28 × 29 cm. Tate Gallery, London

115. Georges Rouault: *Jesus among the doctors*. 1894. Oil on canvas, 164 × 130 cm. ▶
Musée d'Unterlinden, Colmar

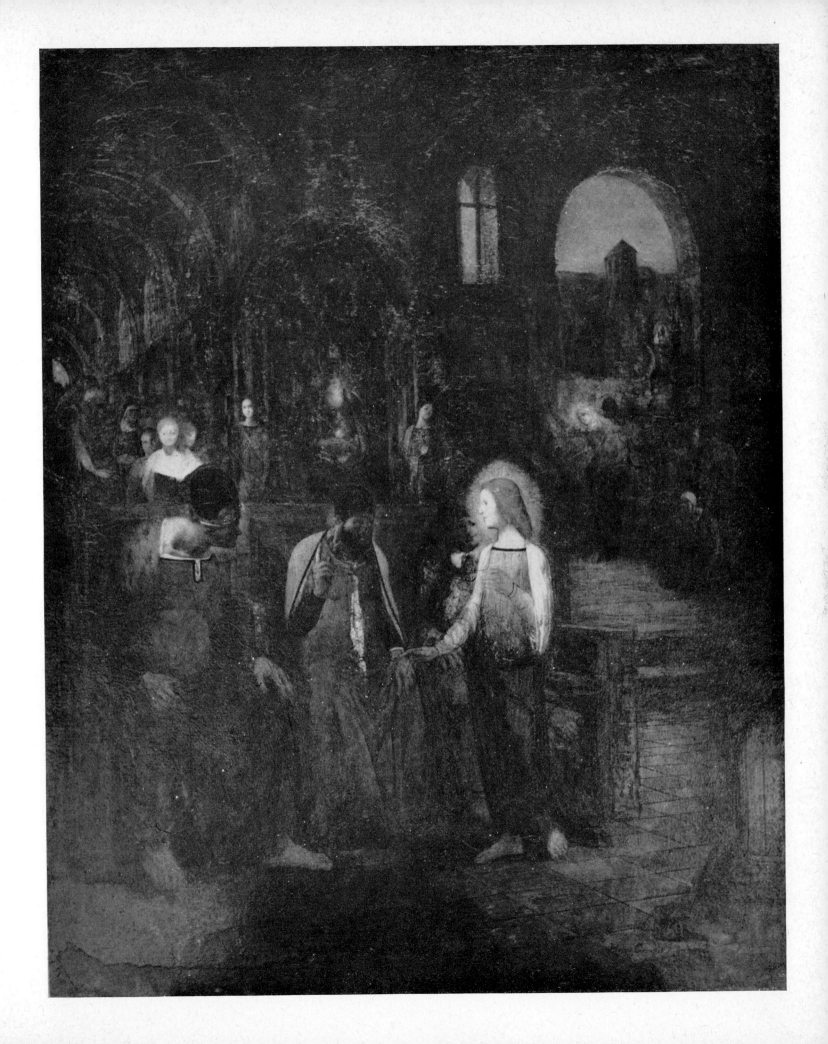

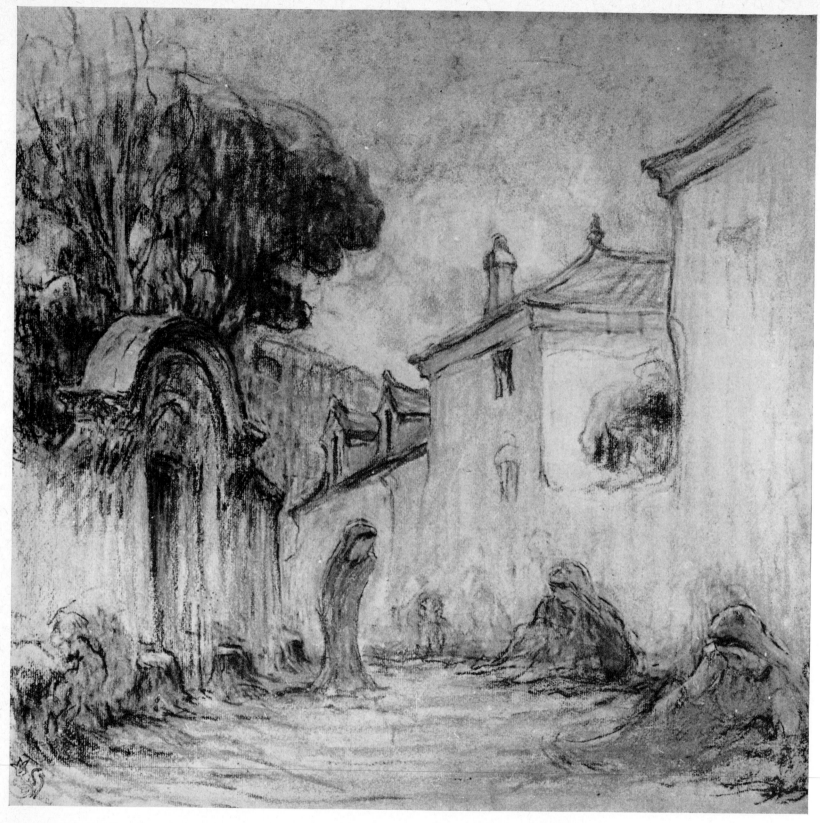

116. Emile Schuffenecker: *Mystic landscape at Meudon.* c.1890. Pastel, 42 × 45 cm. Coll. Fouquet, Paris

117. Armand Séguin:
Les fleurs du mal. 1894.
Oil on canvas, 53 × 35 cm.
Coll. Josefowitz,
Switzerland

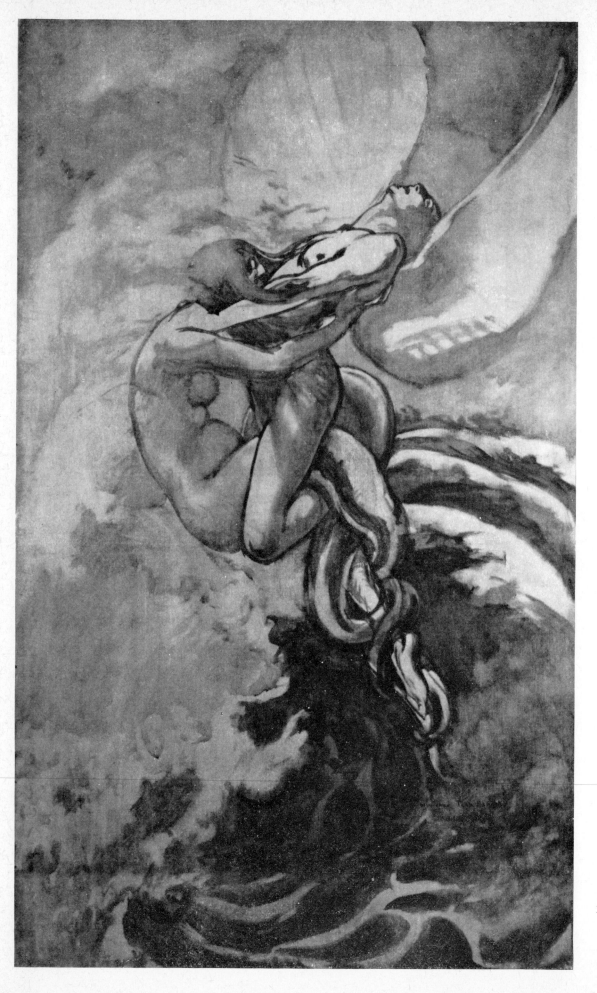

118. Carlos Schwabe: Study for
Spleen et Idéal. 1896.
Oil, 130 × 85 cm.
Coll. M. Gérard Lévy, Paris

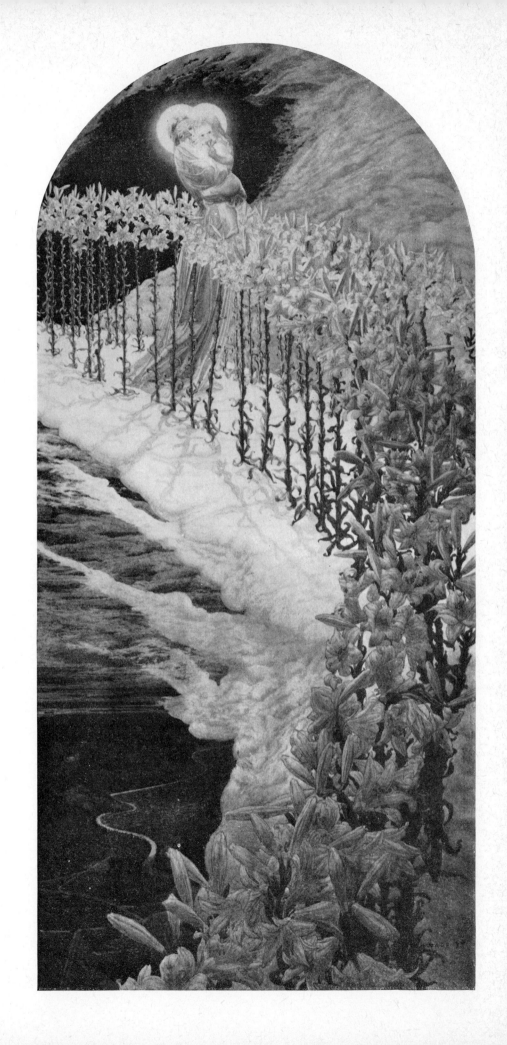

119. Carlos Schwabe: *The Virgin of the lilies*. 1899.
Watercolour, 97 × 47 cm.
Coll. M. Robert Walker, Paris

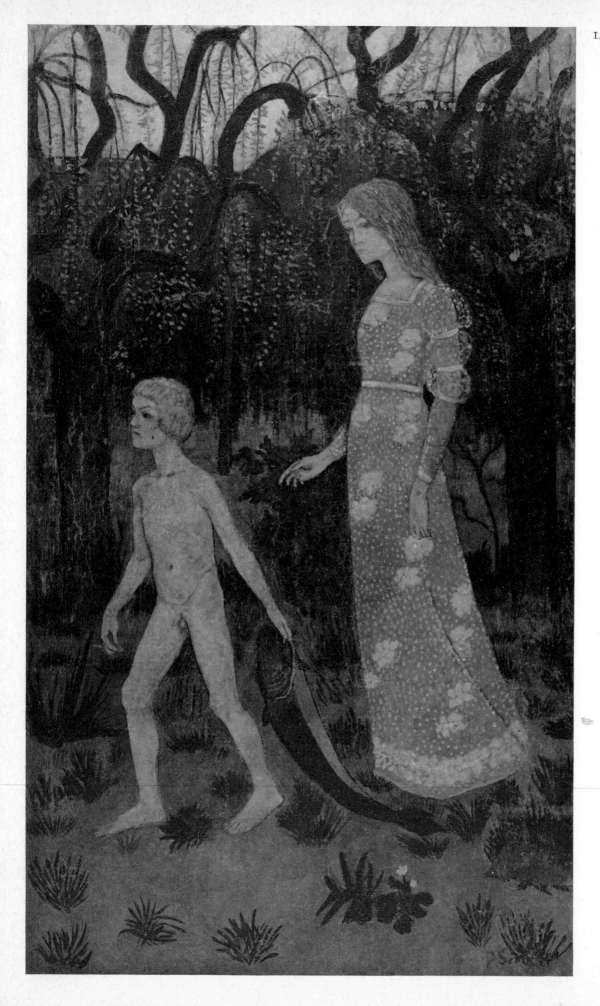

120. Paul Sérusier: *Tobias and the angel.*
c.1895. Oil, 112 × 69 cm.
Coll. Mr. James Kirkman, London

121. Gustave Moreau: ▶
The dead poet borne by a centaur.
c.1870. Watercolour, 44 × 24 cm.
Musée Moreau, Paris

122. Gustave Moreau: *Angel traveller.*
c.1870–80. Watercolour, 30 × 23 cm.
Musée Moreau, Paris

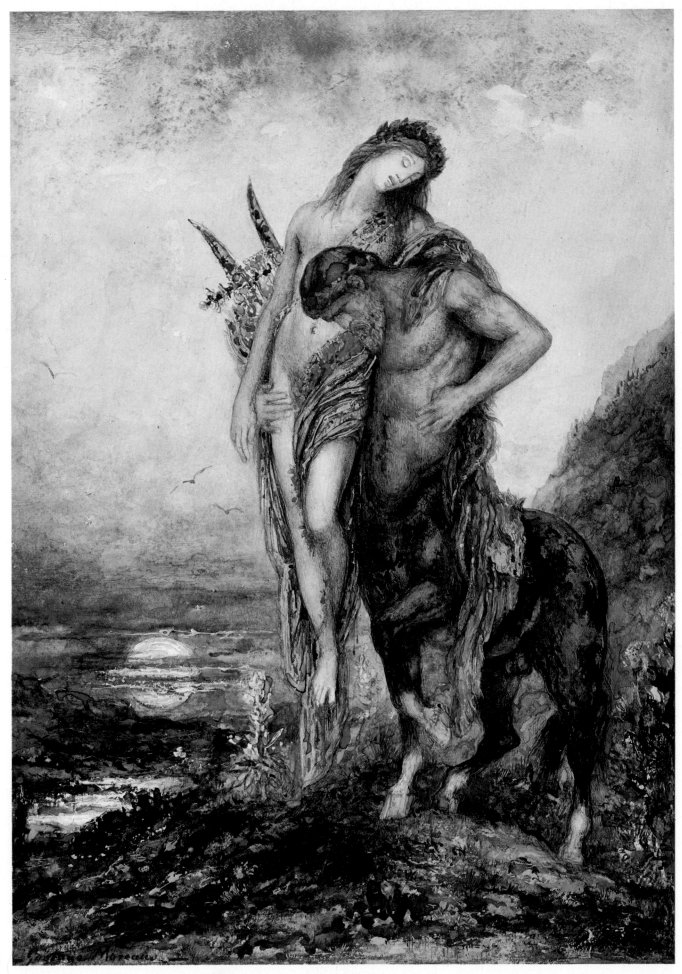

121

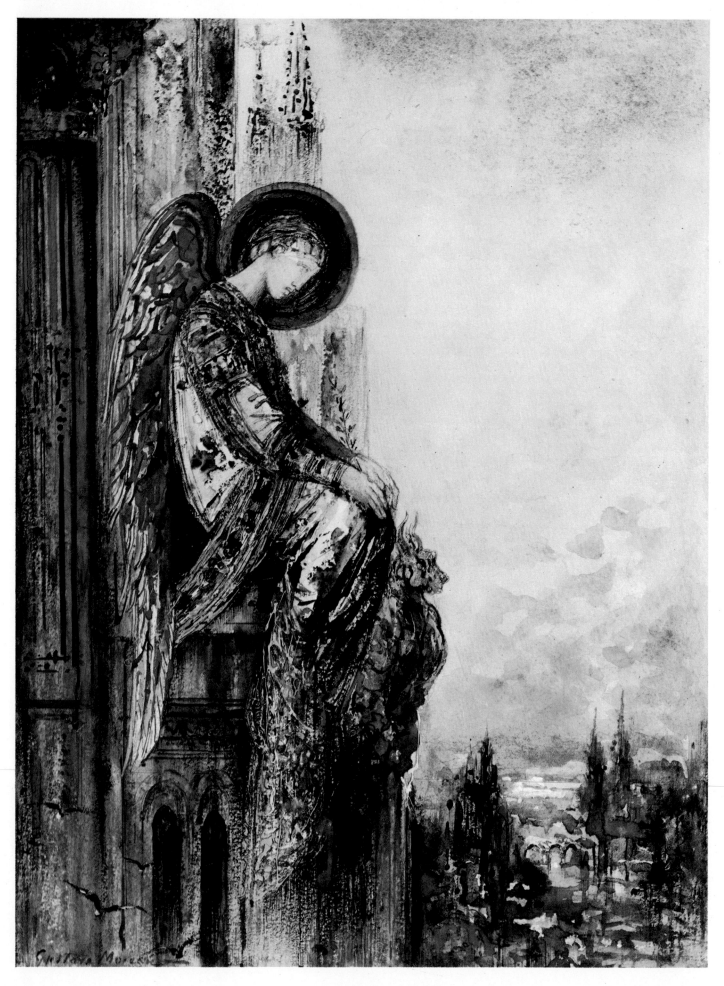

Gustave Moreau

122

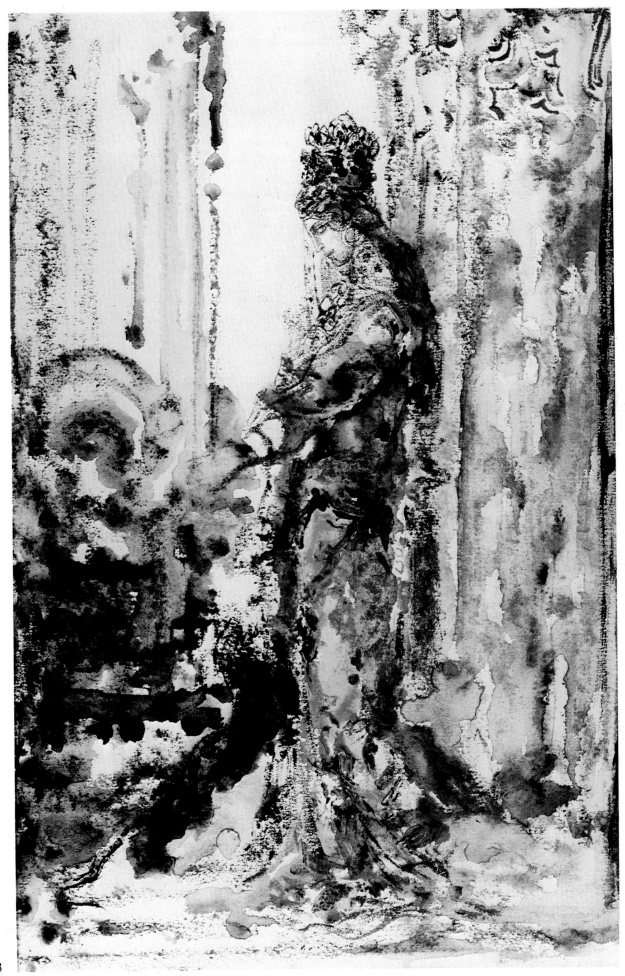

123

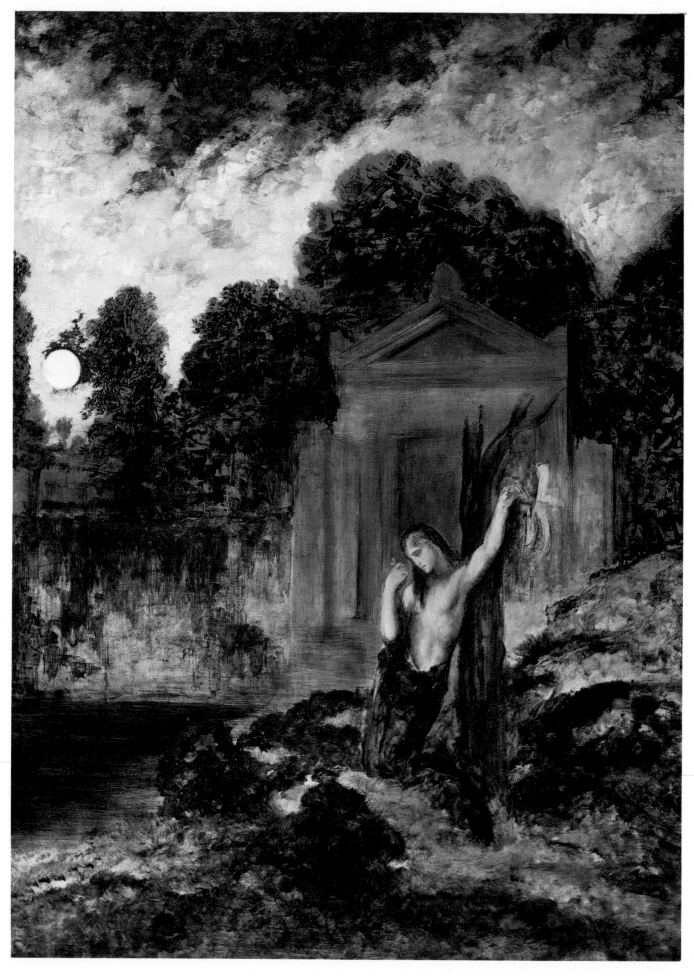

125. Léon Spilliaert: *October evening*. 1912. Pastel, 70 × 90 cm. Coll. Spilliaert, Brussels

123. Gustave Moreau: *Woman and panther*. c.1880. Watercolour, 29 × 19 cm.
Musée Moreau, Paris

◀ 124. Gustave Moreau: *Orpheus at the tomb of Eurydice*. c.1891–7.
Oil on canvas, 174 × 129 cm. Musée Moreau, Paris

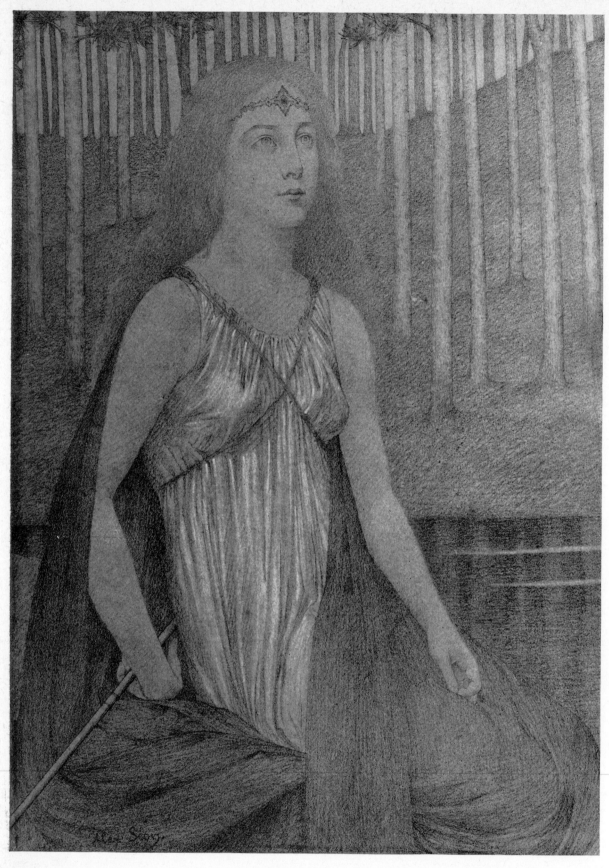

126. Alexandre Séon: *The fairy*. Pastel, 49 × 36 cm. Coll. Flamand-Charbonnier, Paris

127. Alexandre Séon: *The despair of the chimera*. 1890. Oil, 65 × 53 cm. ▶
Coll. Flamand-Charbonnier, Paris

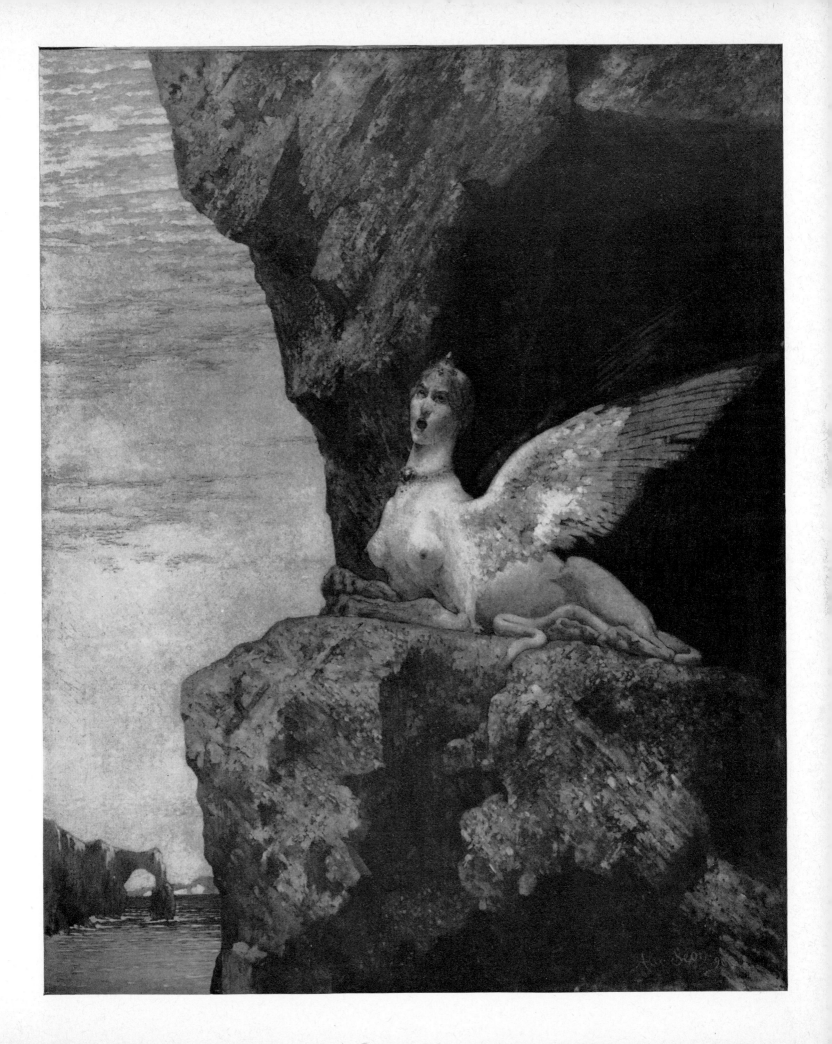

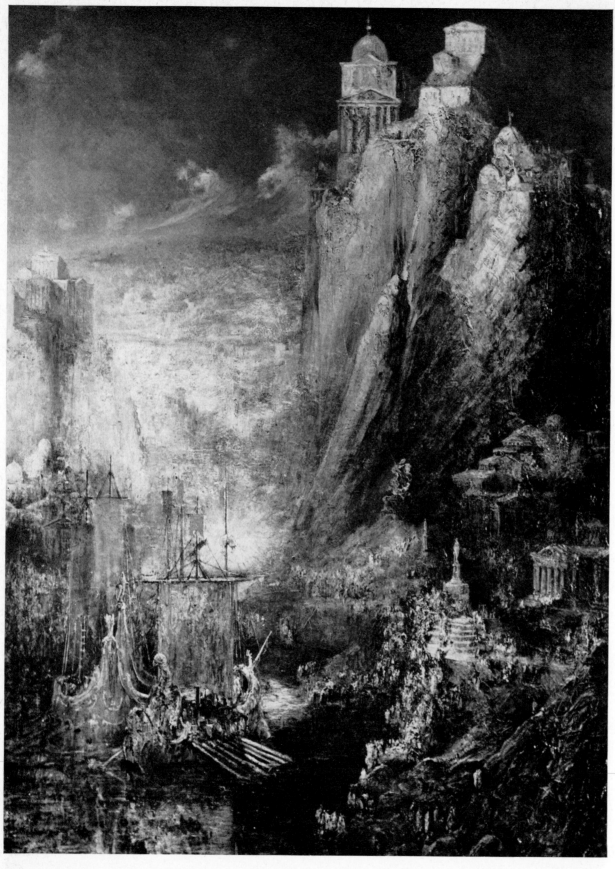

128. Pincus Marcius Simons: *Fantastic town.* c.1895. Oil, 100 × 80 cm. Coll. François-Gérard Seligmann

129. Pincus Marcius Simons: *The Chapel of the Holy Grail.* Oil, 80 × 50 cm. Coll. Camord, Paris ▶

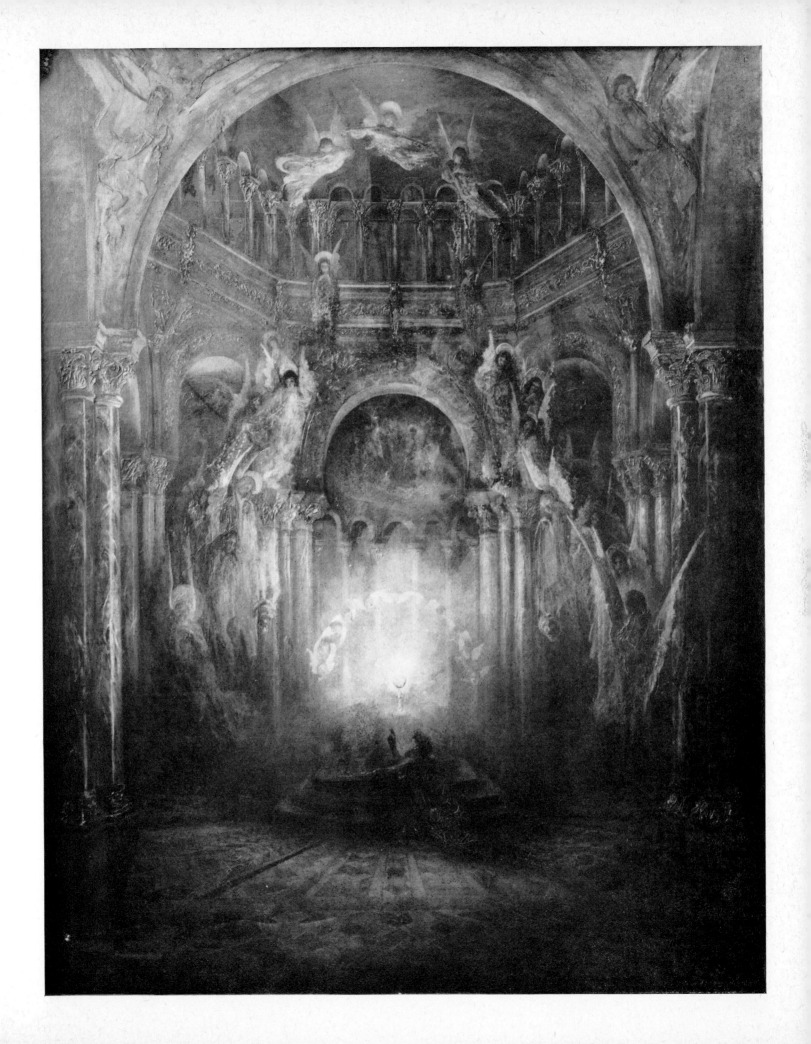

130. Léon Spilliaert: *Winter*. 1915. Watercolour, 28 × 24 cm. Musée des Beaux-Arts, Ghent

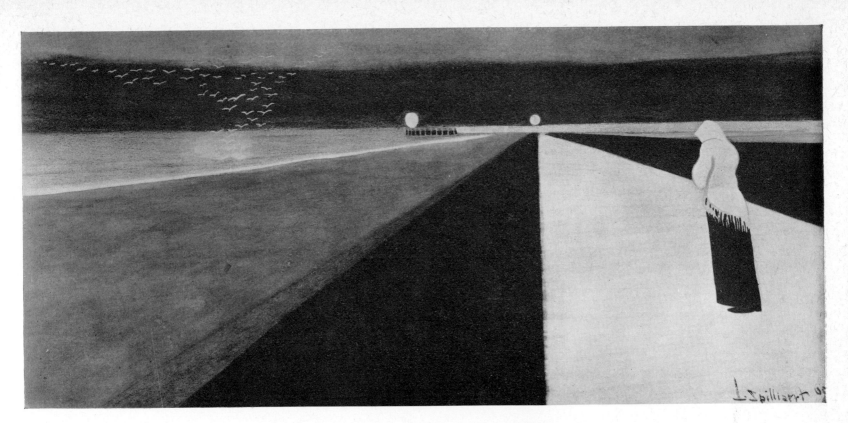

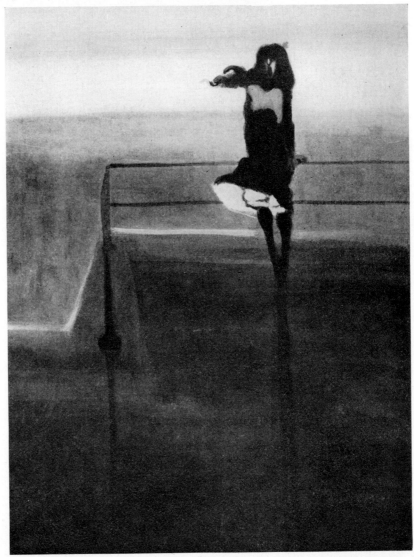

132. Léon Spilliaert: *Gust of wind*. 1904.
Watercolour, 50 × 40 cm.
Musée des Beaux-Arts, Ostend

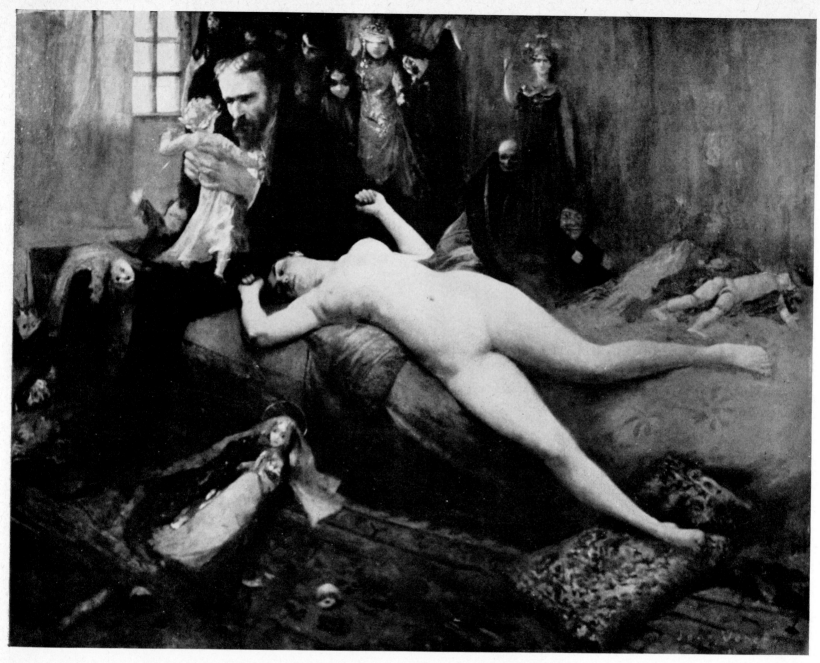

133. Jean Wéber: *The puppets*. 1900. Oil, 180 × 100 cm. Coll. Mlle Yvette Barran, Paris

134. Emile Bernard: *Portrait of my sister Madeleine*. 1888. Oil on canvas, 61 × 50 cm. ▶
Musée Toulouse-Lautrec, Albi

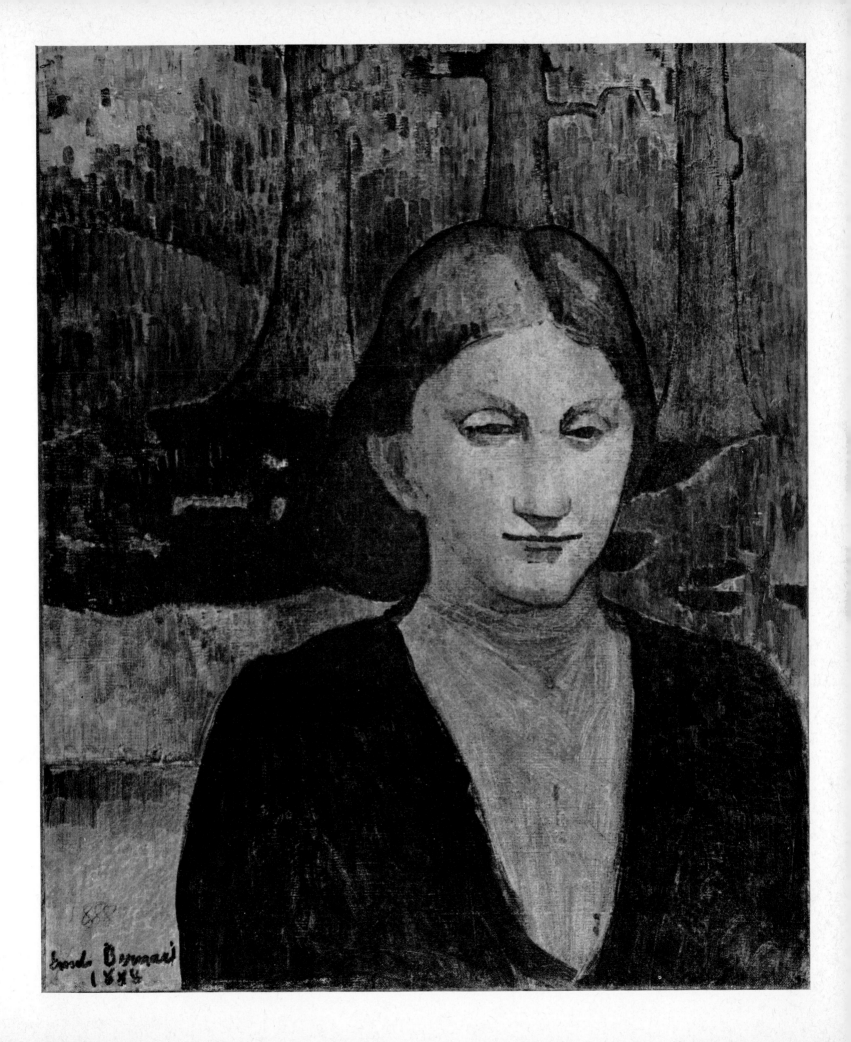

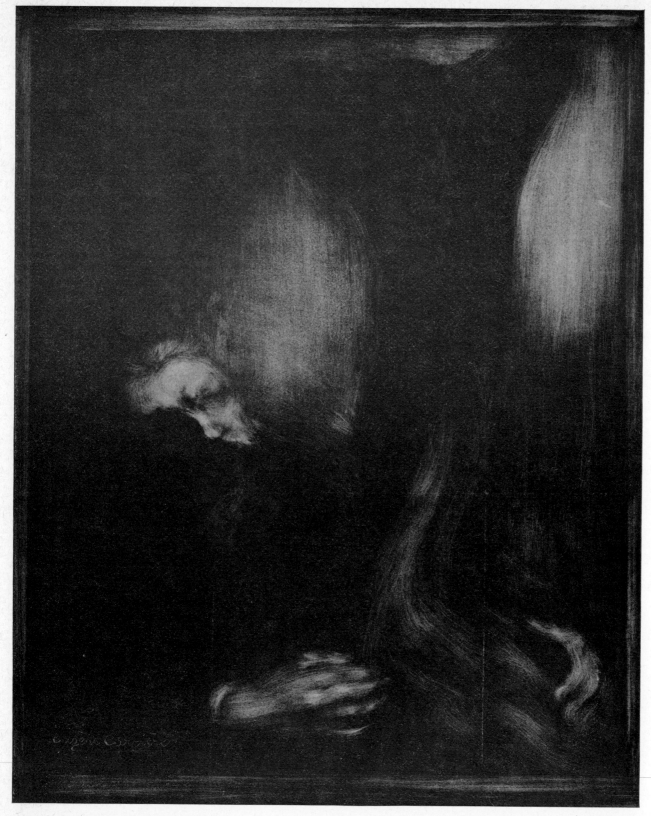

135. Eugène Carrière: *Rodin sculpting*. c.1900. Lithograph, 76 × 59 cm. Coll. Mme Laure Delvolvé-Aubry,
Bourdonné-par-Condé

136. Eugène Carrière: *Portrait of Paul Verlaine*. 1890. Oil, 61 × 51 cm. Louvre, Paris ▶

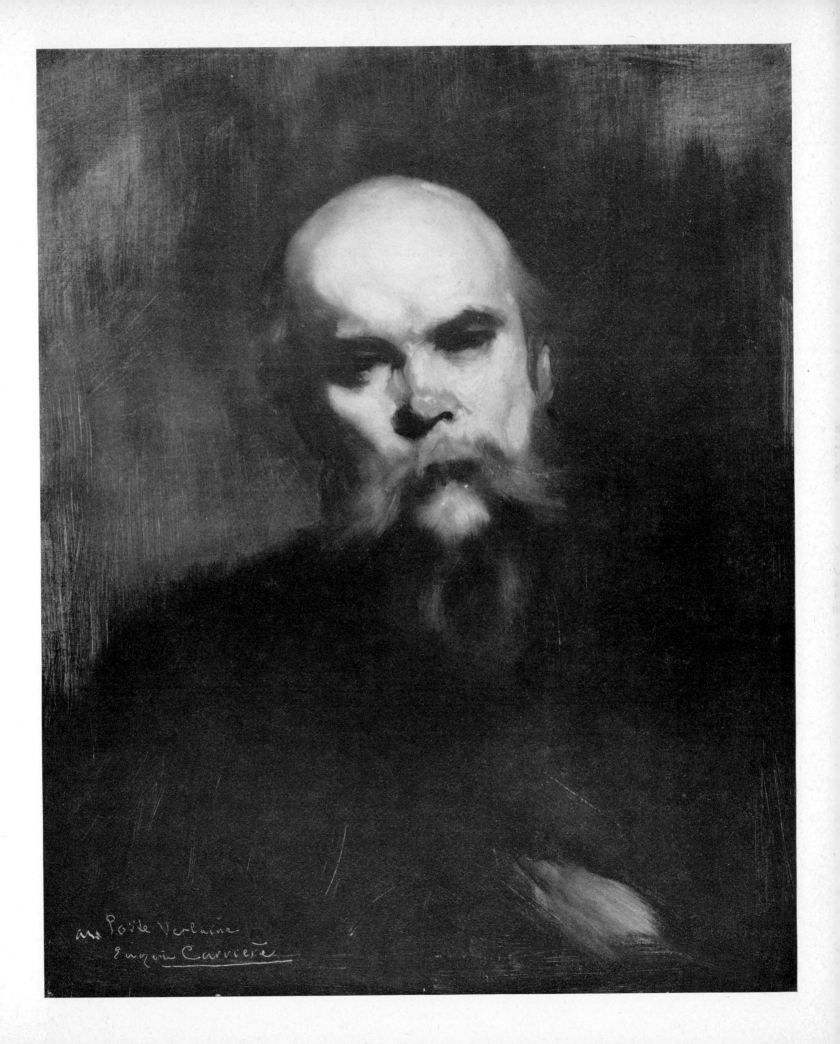

au Poëte Verlaine
Eugène Carrière

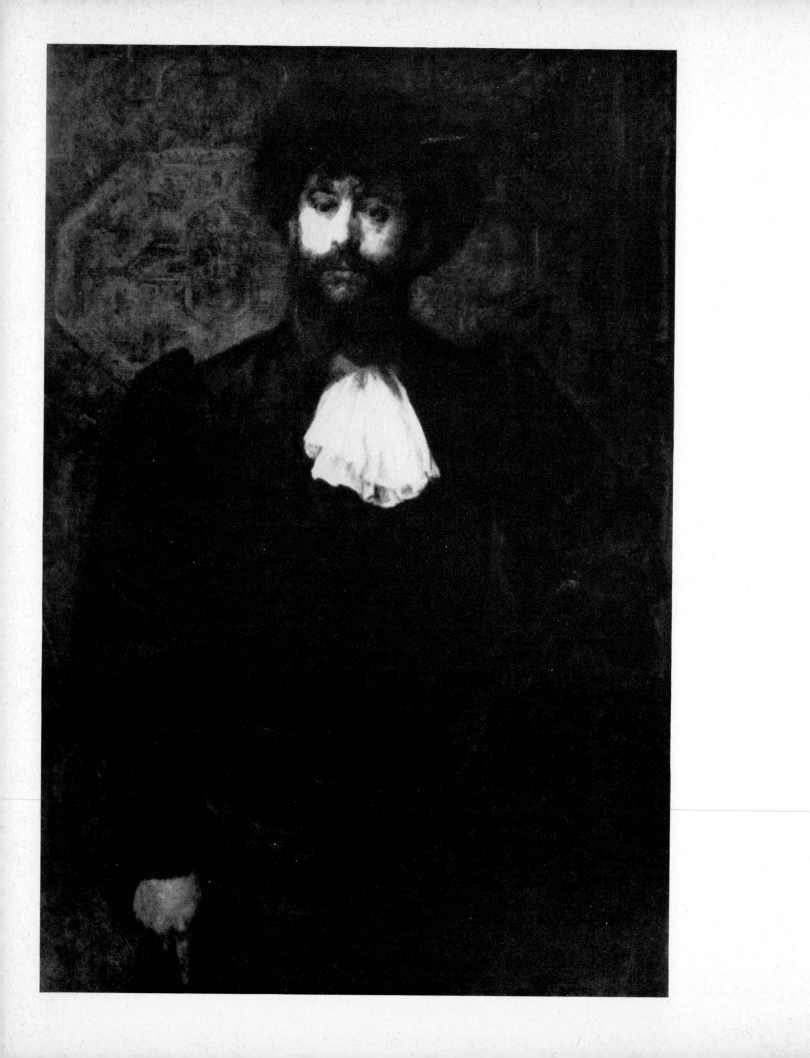

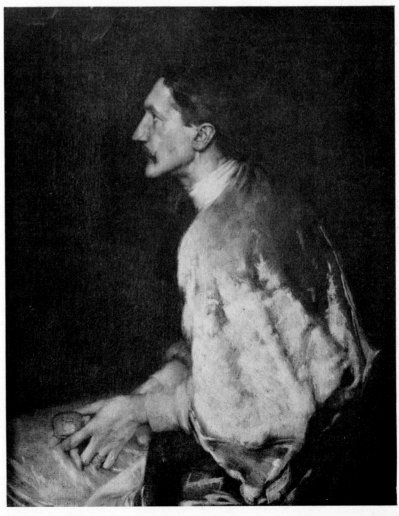

138. Antonio de La Gandara: *Portrait of Jean Lorrain*. 1895. Oil, 150 × 97 cm. Coll. Jullian, Paris

139. Antonio de La Gandara: *Portrait of Count Robert de Montesquiou*. c.1892. Oil, 92 × 72 cm. Château of Azay-le-Ferron

◀ 137. Marcellin Desboutin: *Joséphin Péladan*. 1891. Oil, 121 × 82 cm. Musée des Beaux-Arts, Angers

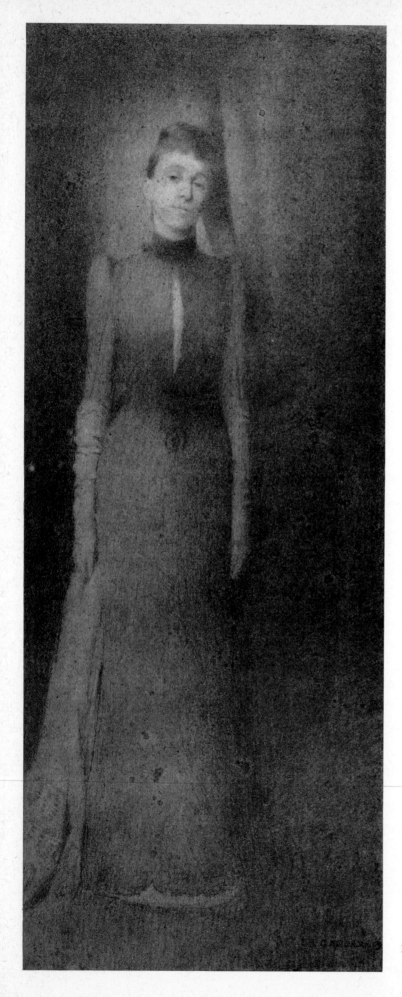

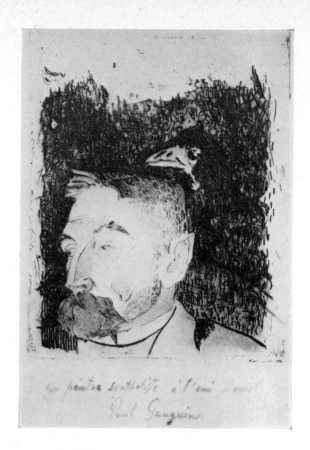

141. Paul Gauguin: *Portrait of Stéphane Mallarmé*. 1891. Etching, 18 × 14 cm. Bibliothèque Littéraire Jacques Doucet, Paris

140. Antonio de La Gandara: *Portrait of a woman*. 1891. Pencil, 76 × 31 cm. Coll. M. Thadée Kopcynski, Paris

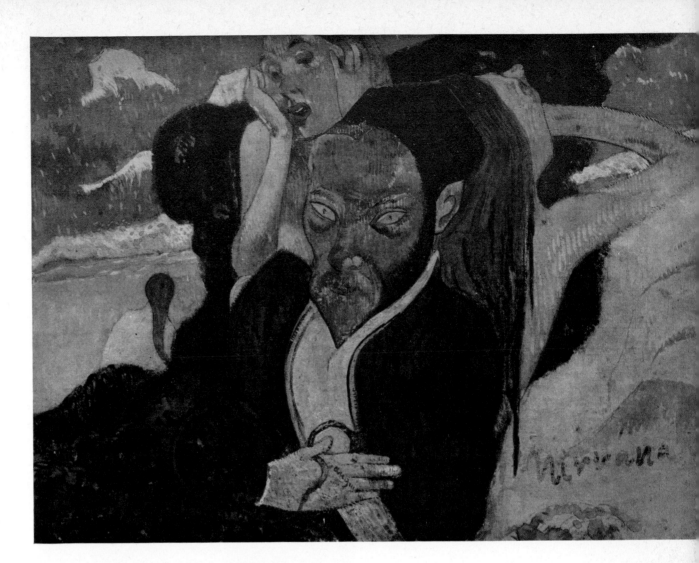

142. Paul Gauguin:
Nirvana (portrait of
Jacob Meyer de
Haan). 1889. Oil on
linen, 20 × 29 cm.
Wadsworth
Atheneum, Hartford
(Conn.)

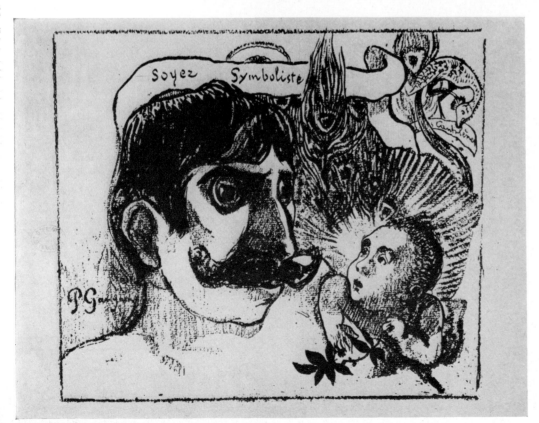

143. Paul Gauguin: *Soyez Symboliste*
(caricature portrait of himself with Jean
Moréas). c.1891. 34 × 40 cm.
Reproduced in *La Plume*

144. Henry de Groux: *Portrait of Rémy de Gourmont*. 1916. Pastel, 130 × 95 cm. Coll. Jullian, Paris

145. Alphonse Osbert: ▶
Songs of the night (detail). 1896.
Oil on canvas, 76 × 123 cm.
Coll. Mlle Yolande Osbert, Paris

146. Pierre Puvis de Chavannes:
Summer. 1891. Oil on canvas,
54 × 86 cm. Petit Palais, Paris

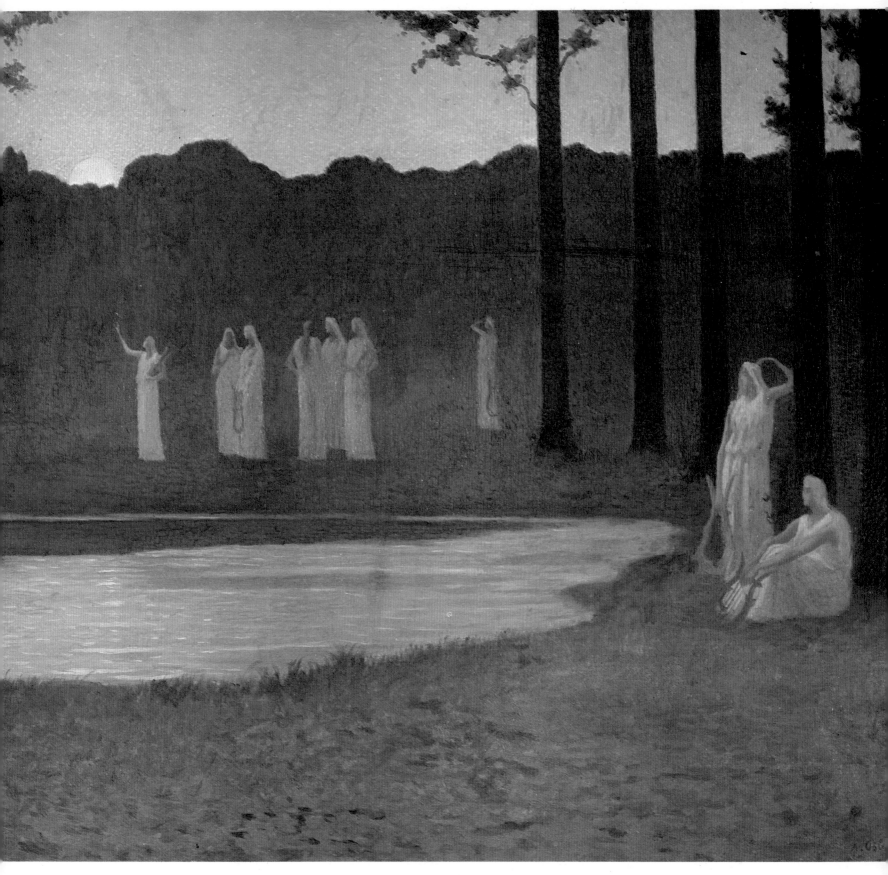

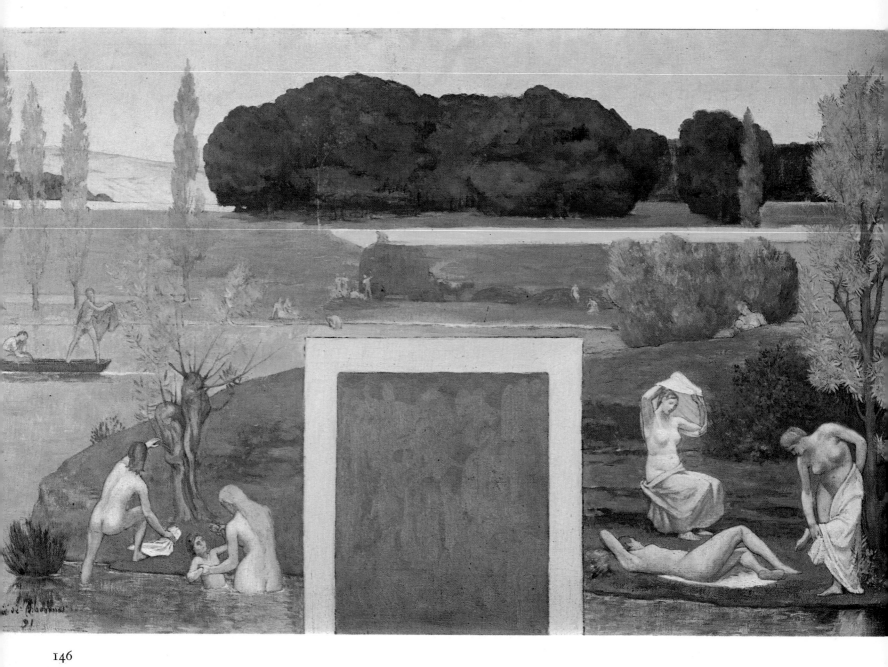

146

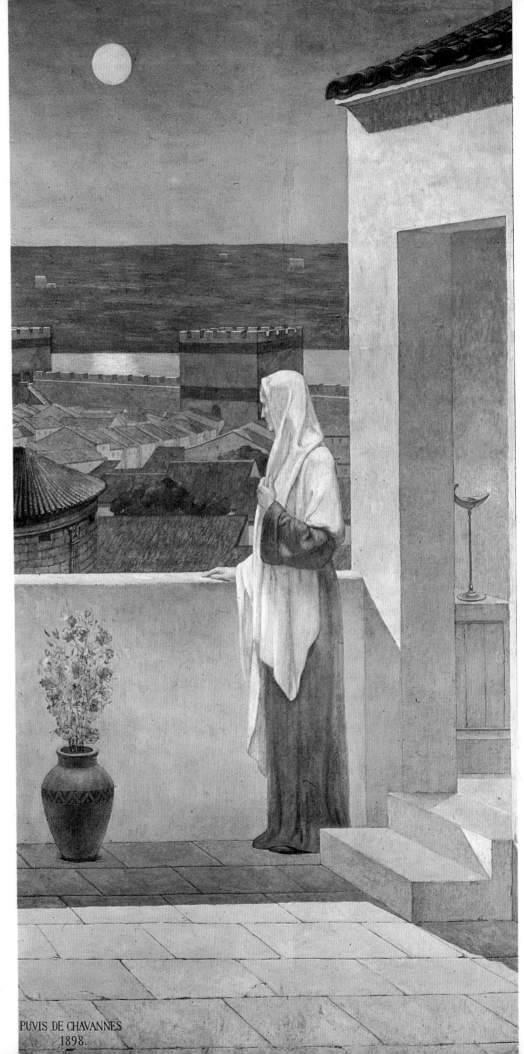

147

PUVIS DE CHAVANNES
1898.

147. Pierre Puvis de Chavannes: *St Genevieve watching over Paris*. 1886.
Oil on canvas (wall panel). Panthéon, Paris

◀ 148. Pierre Puvis de Chavannes: *The beheading of St John the Baptist* (detail). 1869.
Oil on canvas, 123 × 165 cm.
Barber Institute of Fine Arts, Uinversity of Birmingham

149. Pierre Puvis de Chavannes: *The beheading of St John the Baptist*. 1869. Oil on canvas, 123 × 165 cm.
Barber Institute of Fine Arts, University of Birmingham

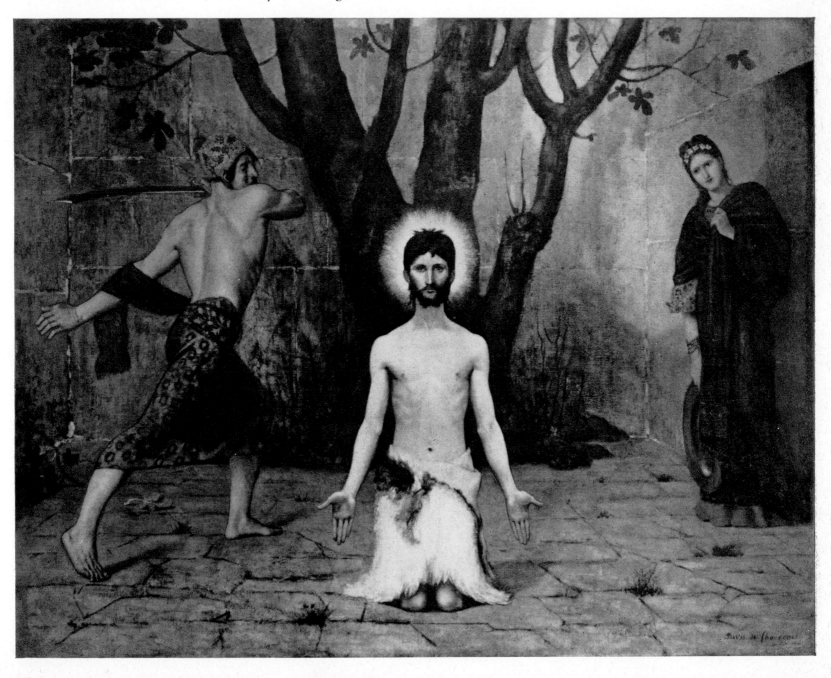

150. Lucien Lévy-Dhurmer: *Portrait of Georges Rodenbach*. 1896. Pastel, 35 × 54 cm.
Musée National d'Art Moderne, Paris

152. Ernest Laurent: *Portrait of Georges Seurat.* 1883. Black chalk,
39 × 29 cm. Musée National d'Art Moderne, Paris

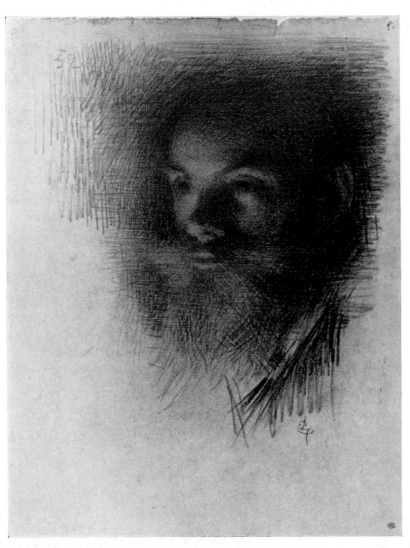

151. Ernest Laurent: *Portrait of Alphonse Osbert.* 1883. Black chalk,
40 × 31 cm. Louvre (Cabinet des Dessins), Paris

153. Armand Point: *Portrait
of Mme Berthelot*. c.1896.
Sanguine on paper, 56 × 34 cm.
Coll. M. Gérard Lévy, Paris

155. Alphonse Mucha: *Portrait of his mistress.* 1909.
Coll. Tschoudouynen, Paris

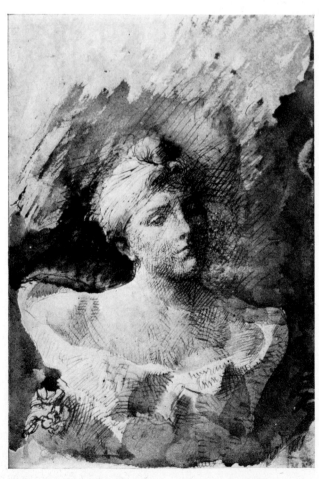

154. Auguste Rodin: *Drawing for the bust of Mme Vichunha.* 1888.
Louvre (Cabinet des Dessins), Paris

156. Georges Seurat: *Portrait of Aman-Jean.* 1883. Crayon, 62 × 48 cm.
Metropolitan Museum of Art (Bequest of Stephen C. Clark 1960), New York

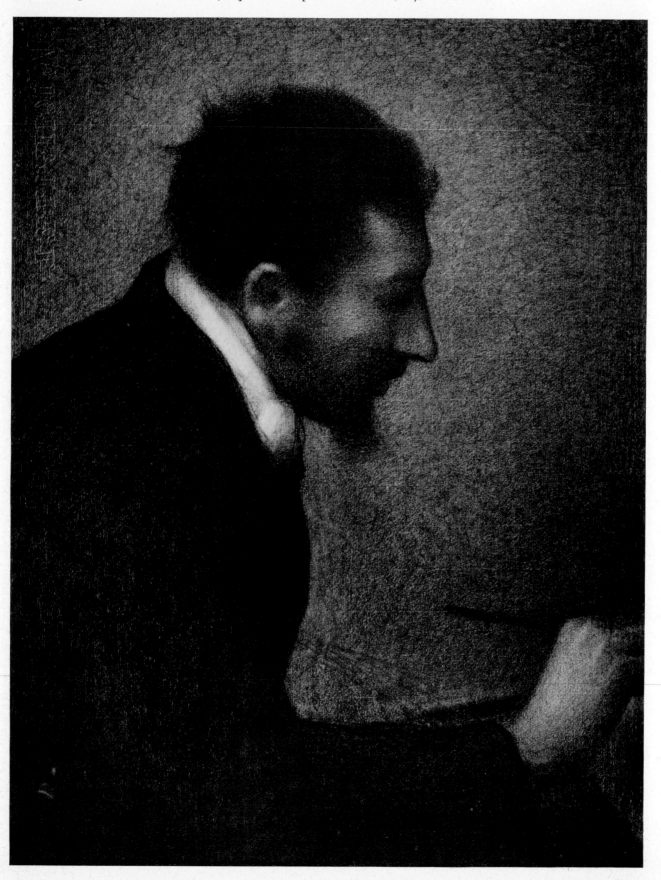

157. Constant Montald: *Portrait of Verhaeren*.
1903. Drawing, 56 × 26 cm.
Coll. M. Jean Goffin, Brussels

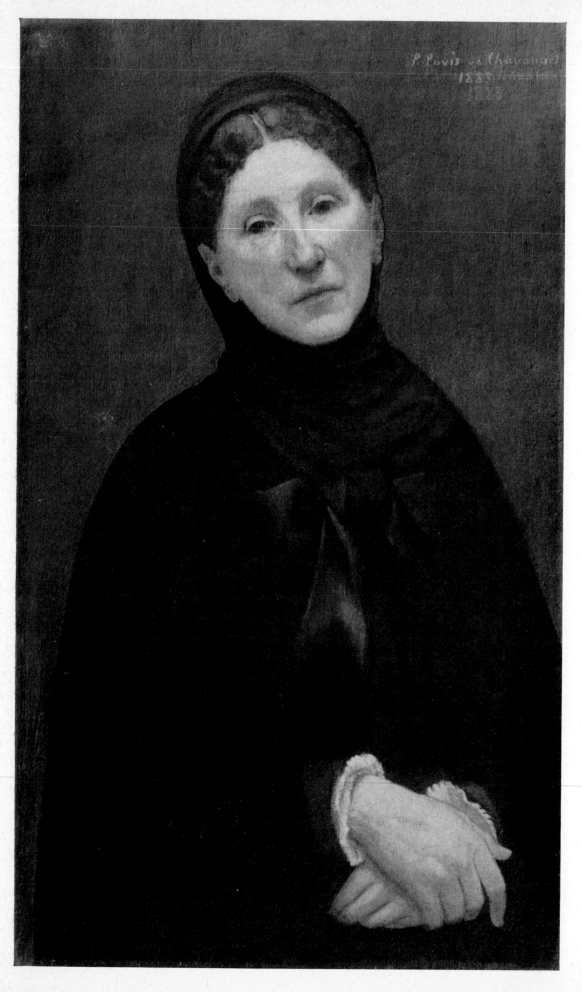

158. Pierre Puvis de Chavannes:
Portrait of his wife. 1883.
Oil on canvas, 78 × 46 cm.
Musée des Beaux-Arts, Lyons

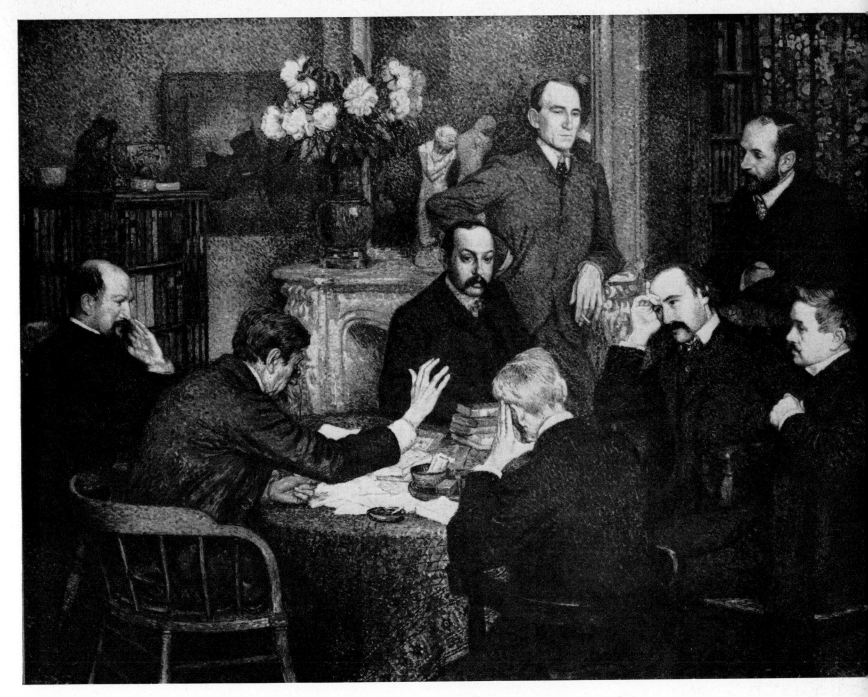

159. Théo van Rysselberghe: *The reading*. 1903. Oil on canvas, 181 × 240 cm. Musée des Beaux-Arts, Ghent

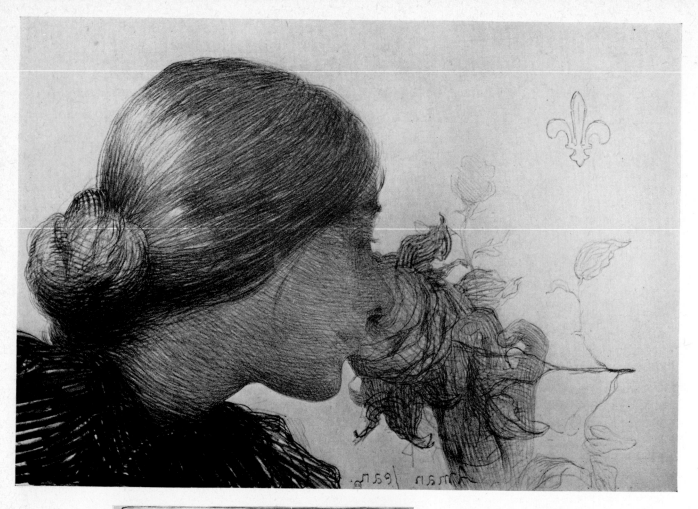

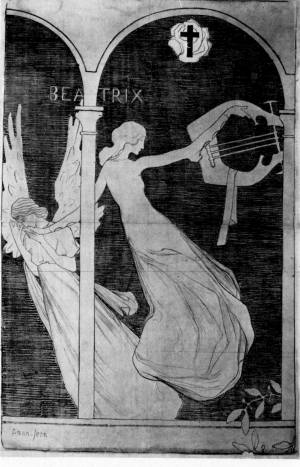

160. Edmond Aman-Jean:
Perfume or *Woman with a rose*. 1891.
Lithograph, 23 × 36 cm.
Bibliothèque Nationale (Cabinet des
Estampes), Paris

161. Edmond Aman-Jean: *Beatrix*. Poster, 109 × 75 cm.
Coll. M. Wittamer-De Camps, Brussels

163. Emile Bernard: *Madonna and Child.* c.1892–4.
Pen and watercolour, 42 × 30 cm. (with frame).
Coll. Flamand-Charbonnier, Paris

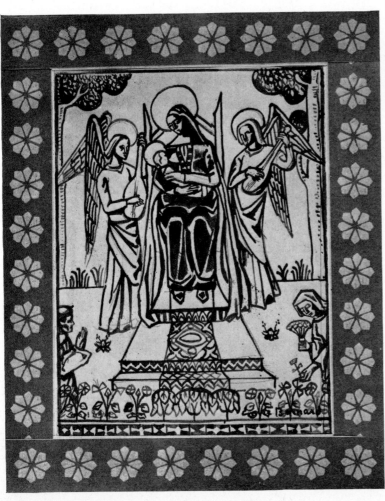

163. Emile Bernard: *Madonna and Child.* c.1892–4.
Pen and watercolour, 42 × 30 cm. (with frame).
Coll. Flamand-Charbonnier, Paris

162. Emile Bernard:
Madonna and Child supported by two music-making angels. 1894.
Pen, 34 × 27 cm. (with frame).
Coll. Flamand-Charbonnier, Paris

166. Rodolphe Bresdin: *The good Samaritan.* 1861. ▶
Lithograph, 78 × 63 cm.
Bibliothèque Nationale (Cabinet des Estampes), Paris

164. Paul Berthon: Poster for the *Salon des Cent*, reproduced
in *La Plume*

165. Jaques-Emile Blanche: *Parsifal.* 1886. Lithograph,
reproduced in the *Revue Wagnerienne*. Bibliothéque
Nationale (Cabinet des Estampes), Paris

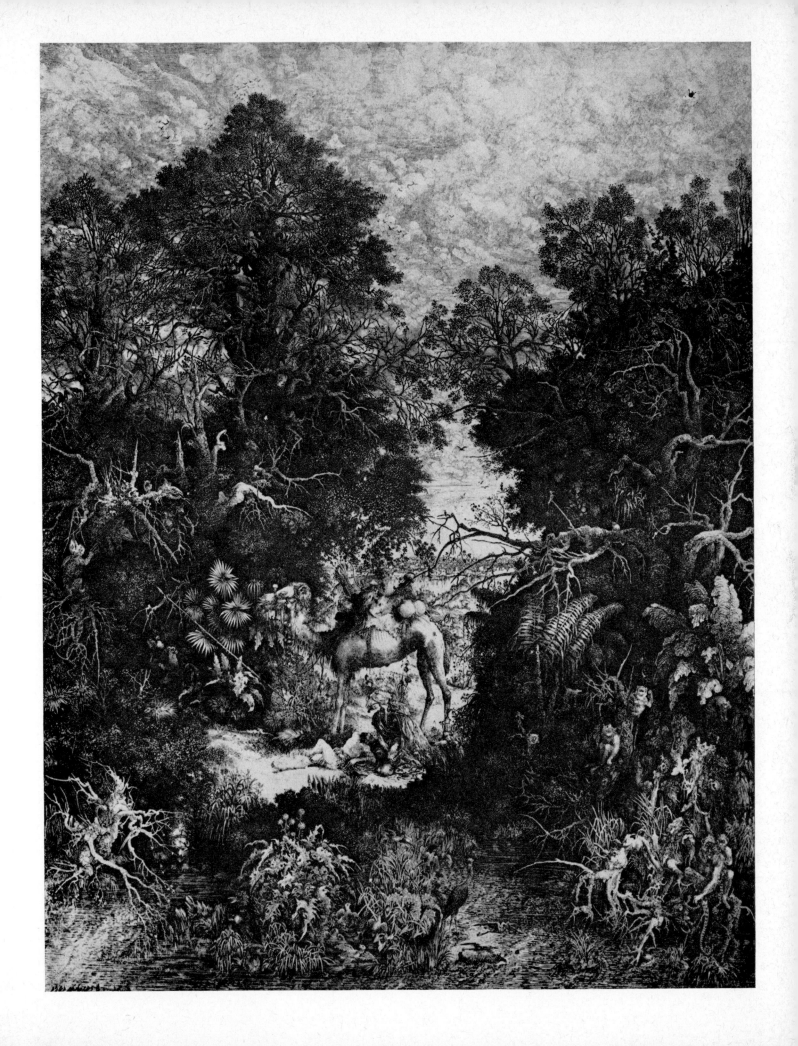

167. Antoine Bourdelle:
The death of Tante Rose.
Gouache, 20 × 17 cm.
Musée Bourdelle, Paris

Paul LACOMBLEZ, éditeur.

168. Henry van de Velde:
Cover for *Salutations*
by Max Elskamp. 1893.
23 × 17 cm.
Harvard College Library,
Cambridge (Mass.)

169. G. Combaz: *The peacock*. Poster
(without lettering), 56 × 44 cm.
Coll. M. Wittamer-De Camps,
Brussels

170. Maurice Denis: Illustration to *Le Voyage d'Urien*
by André Gide. Bibliothèque Littéraire Jacques
Doucet, Paris

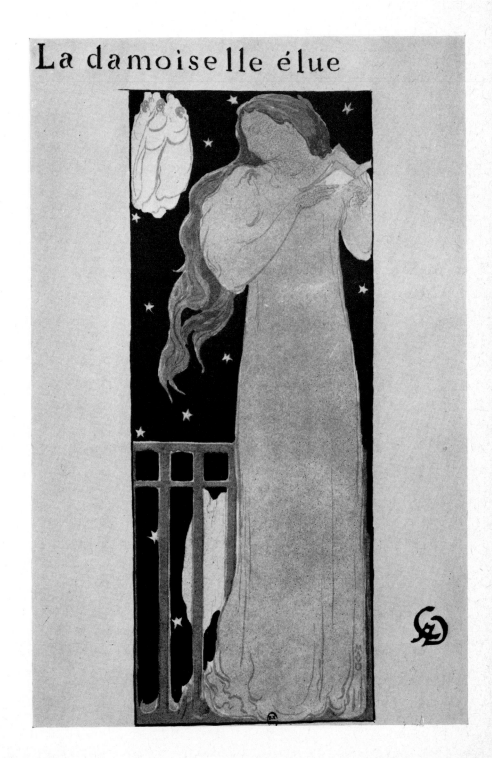

171. Maurice Denis: *The Blessed Damozel*. 1893.
Lithograph, 30 × 11 cm. Bibliothèque Nationale
(Cabinet des Estampes), Paris

173. Pierre Puvis de Chavannes: *The poor fisherman*. 1881. ▶
Oil on canvas, 157 × 191 cm. Louvre, Paris

174 Paul Ranson: *Nabi landscape*.
1890. Oil on canvas, 88 × 114 cm.
Coll. Josefowitz, Switzerland

172. Georges Seurat: *Landscape with Puvis' 'Poor Fisherman'*. c.1882. Oil sketch. Coll. Huguette Berès, Paris

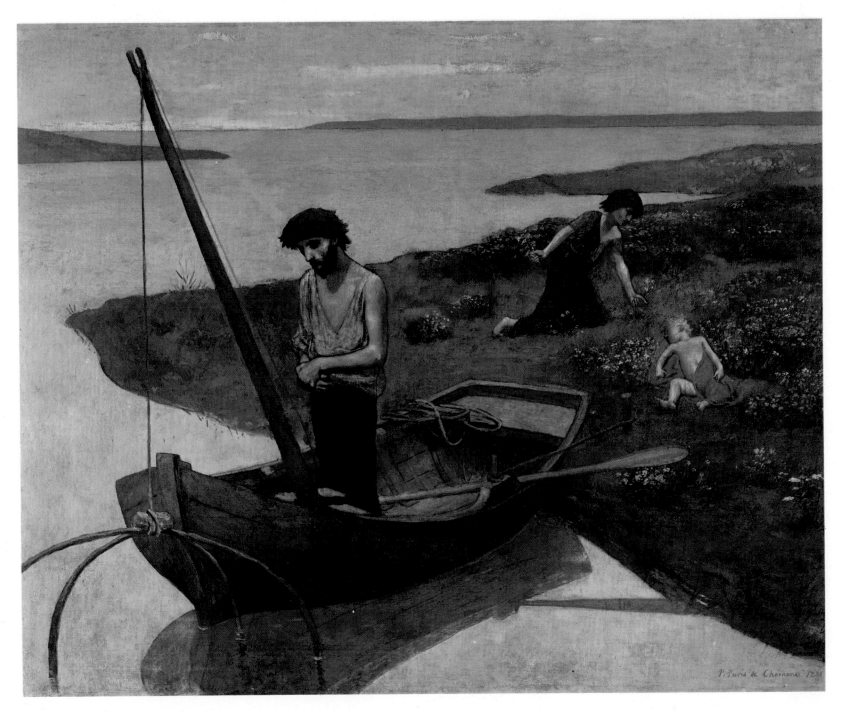

173

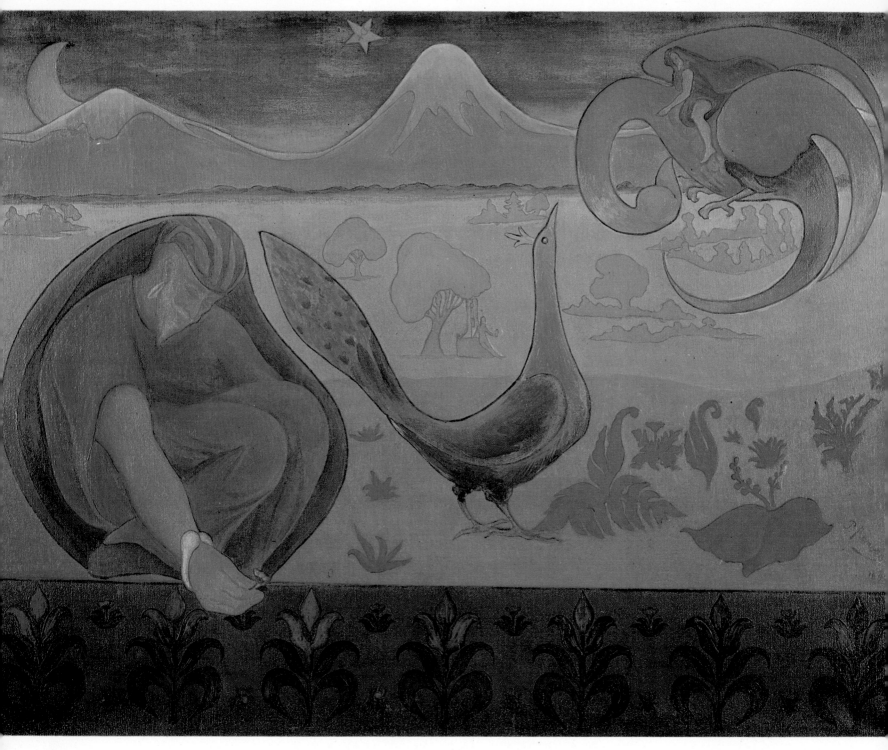

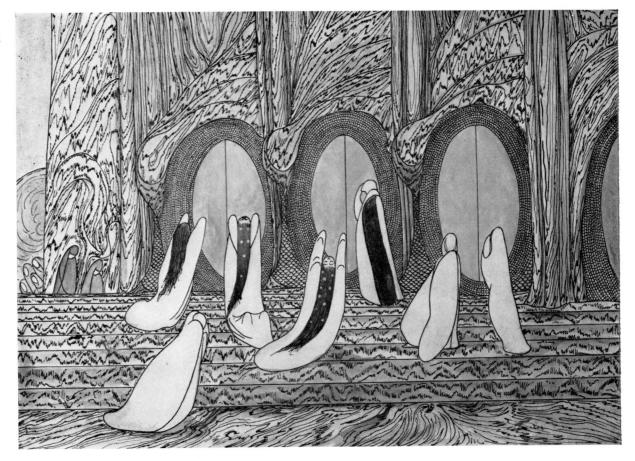

175. Charles Doudelet:
The Golden Gates. Wood
engraving. Musées
Royaux des Beaux-Arts,
Brussels

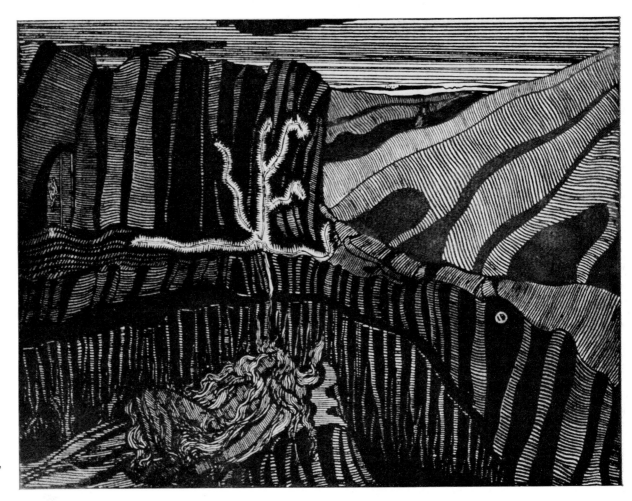

176. Charles Doudelet:
Bewitched girl in a cave.
Coll. M. Paul Eeckhout,
Ghent

178. Gustave Doré: Illustration to *The Raven* by Edgar Allan Poe.
1883. British Museum, London

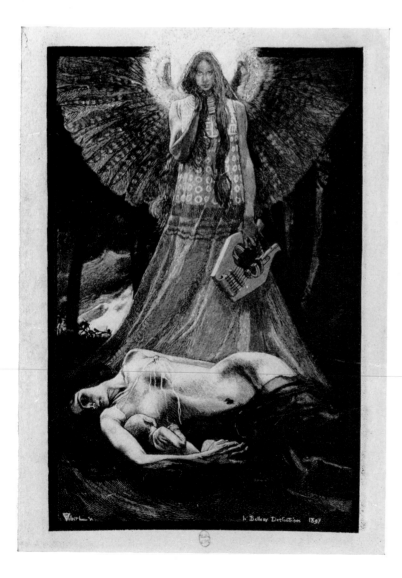

177. Bellery Desfontaines: *The angel of death*. 1897. Wood engraving.
Bibliothèque Nationale (Cabinet des Estampes), Paris

179. Henri Fantin-Latour: *The evocation of Erda* (from *Siegfried*).
Illustration for *Richard Wagner* by Adolphe Jullien. 1886. Lithograph.
Bibliothèque Nationale (Cabinet des Estampes), Paris

180. James Ensor:
The Devil leading Christ in Hell. 1886.
Drawing, 17 × 23 cm.
Musées Royaux des Beaux-Arts, Brussels

181. Rémy de Gourmont: Cover for his own novel *Phocas*.
1895. Wood engraving. Bibliothèque Littéraire
Jacques Doucet, Paris

183. Eugène Grasset: *March*, from the *Belle Jardinière* calendar. ▶
1896. Coloured woodcut, 23 × 18 cm.
Coll. M. François Chapon, Paris

182. Emile Fabry: Part of the poster *Pour l'Art*. 1895. Printed
in red on white ground by Colombier, Belgium

184. Jeanne Jacquemin: *Anguish*.
Drawing, reproduced in the
Mercure de France

185. Georges de Feure: Frontispiece
(open) to *La Porte des Rêves* by
Marcel Schwob. 1898.
Bibliothèque Littéraire
Jacques Doucet, Paris

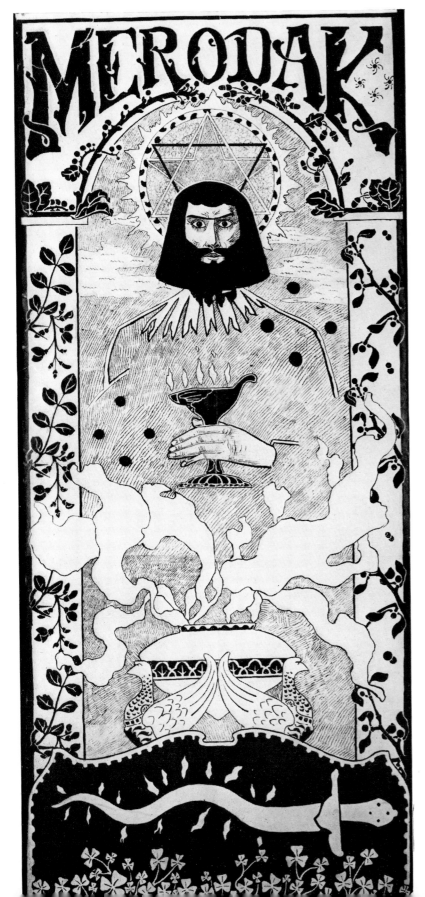

186. *Mérodâk* poster. 160 × 70 cm.
Coll. M. Wittamer-De Camps, Brussels

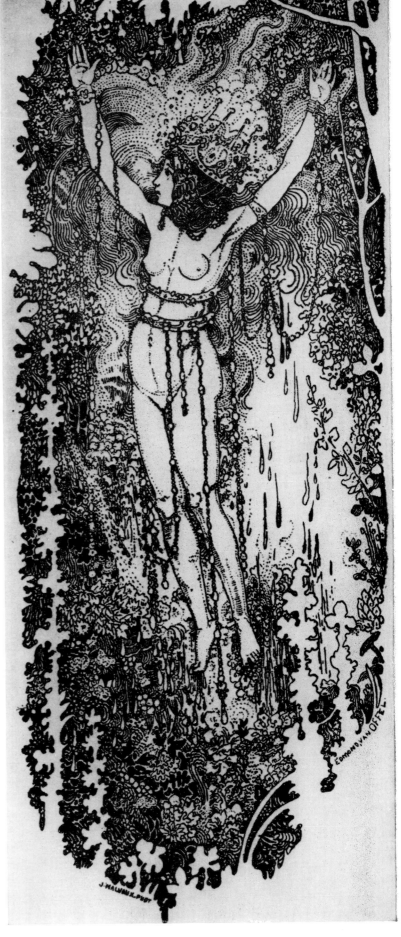

187. Edmond van Offel: *Summer rain*. Lithograph

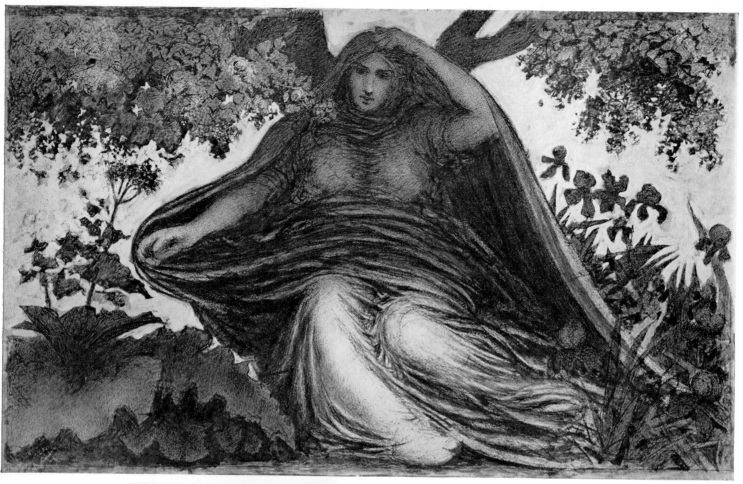

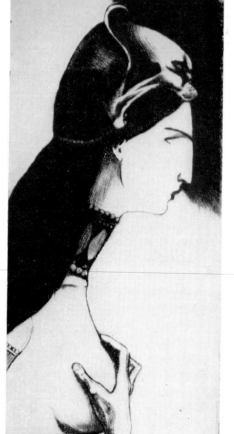

188. Xavier Mellery: *The awakening*. Drawing, 57 × 90 cm. Musées Royaux des Beaux-Arts, Brussels

189. R. P. Rivière: *Herodias* (from *Images after Mallarmé*). 1896. Engraving. Bibliothèque Littéraire Jacques Doucet, Paris

190. Ary Renan: *Sappho* (detail). 1893. Oil on wood, ▶ 56 × 80 cm. Maison Natale d'Ernest Renan, Tréguier

191. Paul Sérusier: *Melancholia*. c.1890. Oil on canvas, 73 × 60 cm. Coll. Mlle Henriette Boutaric, Paris

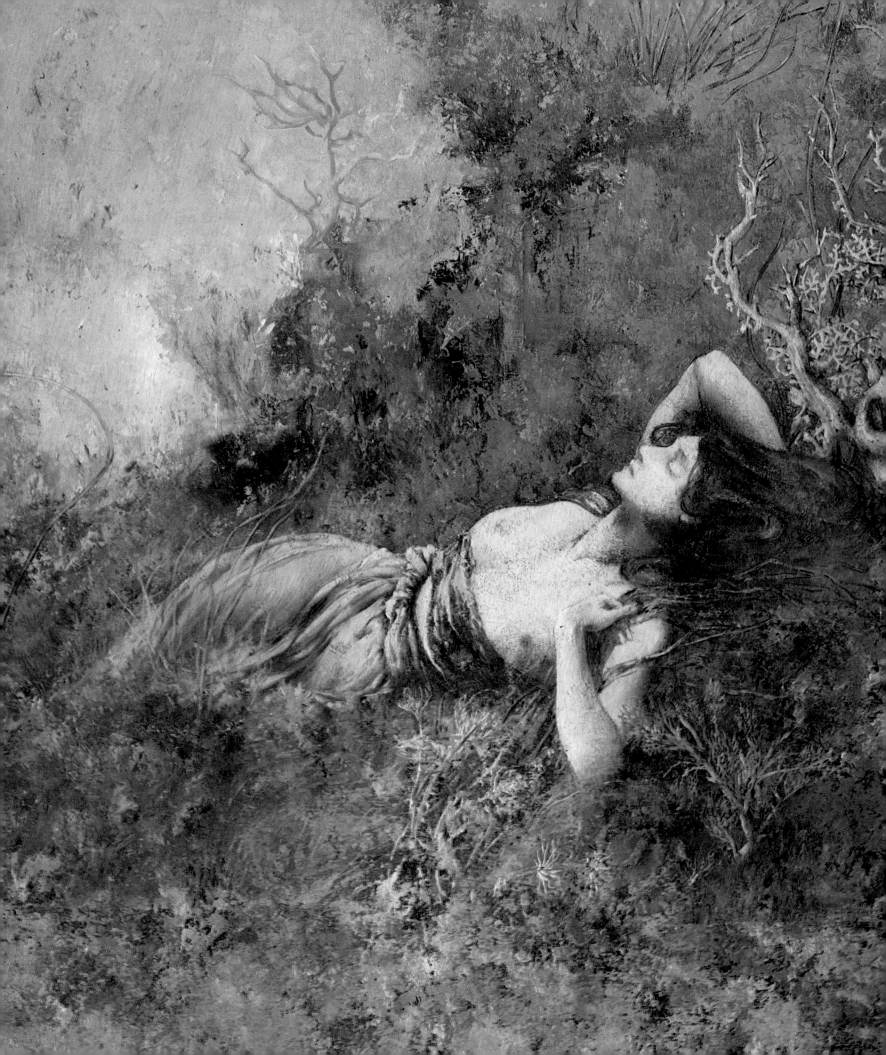

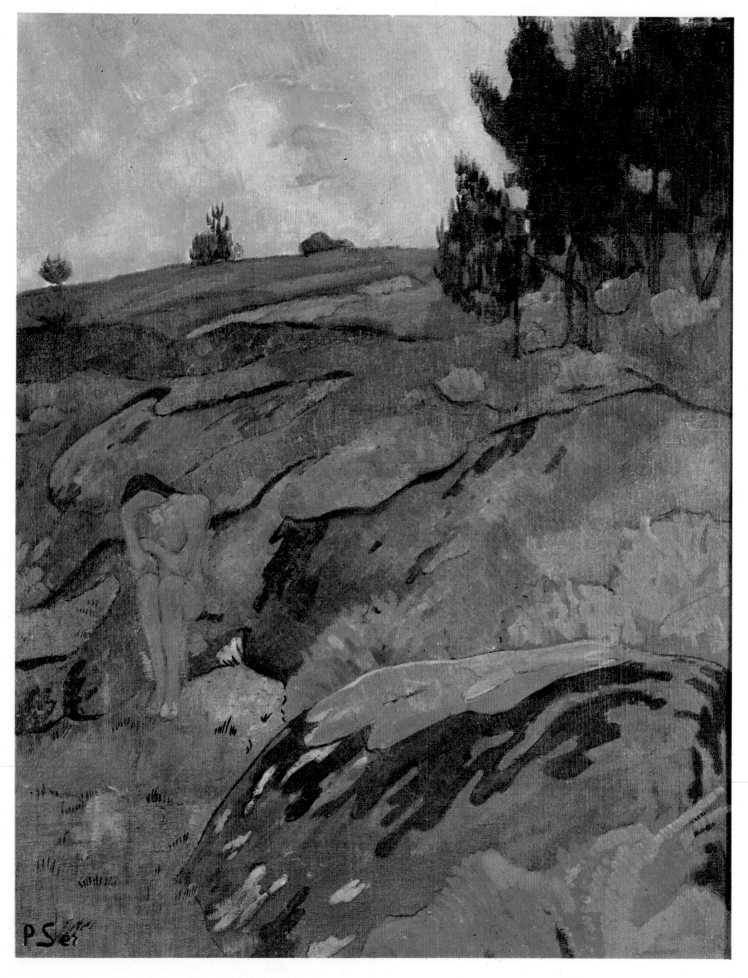

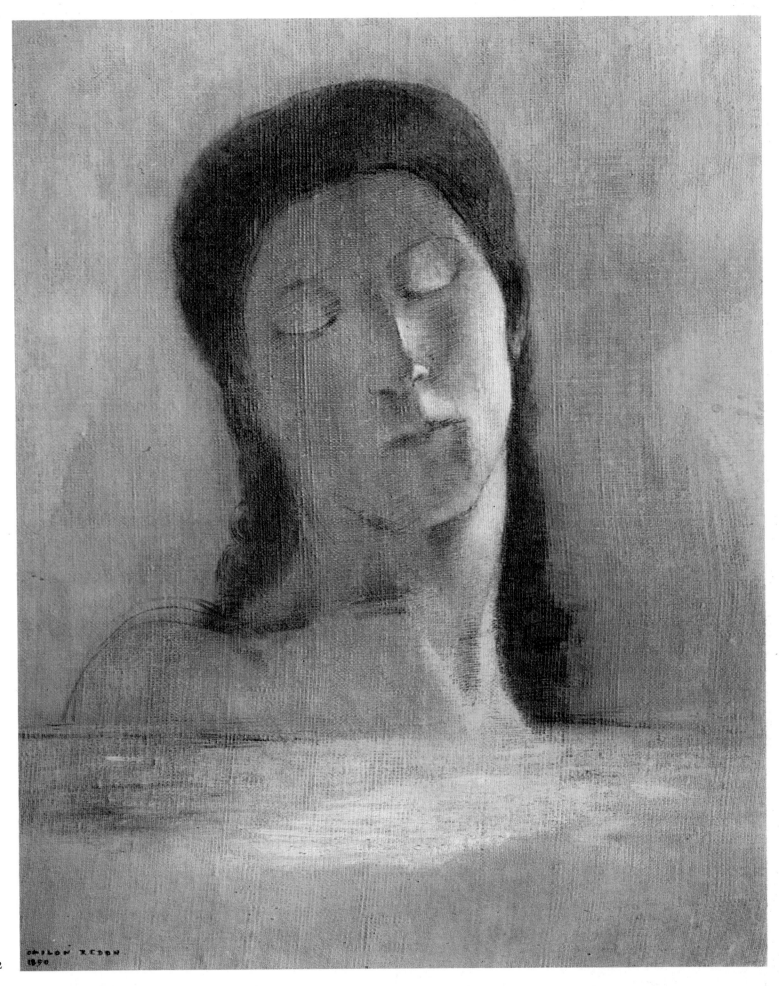

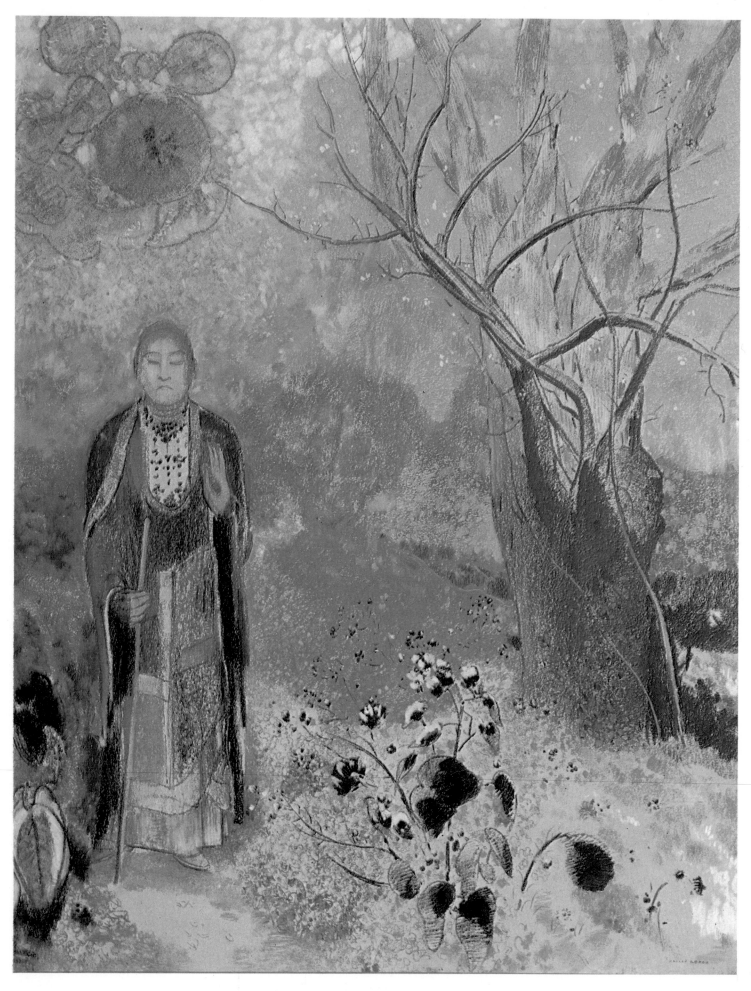

194

195

196

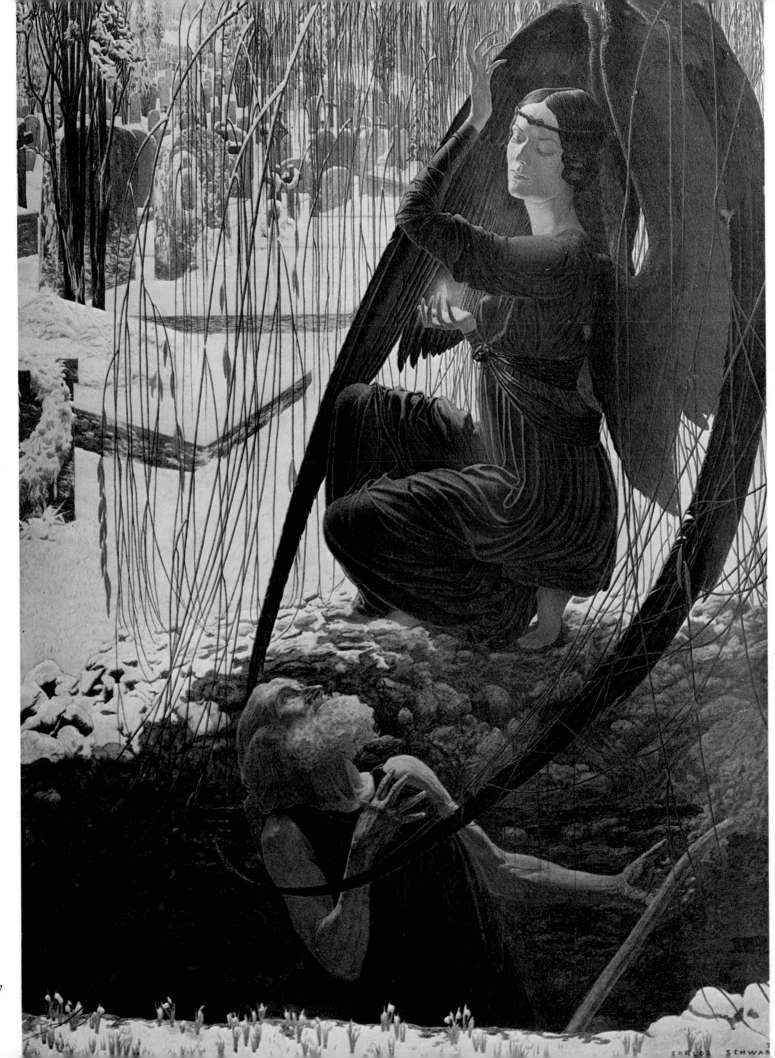

197

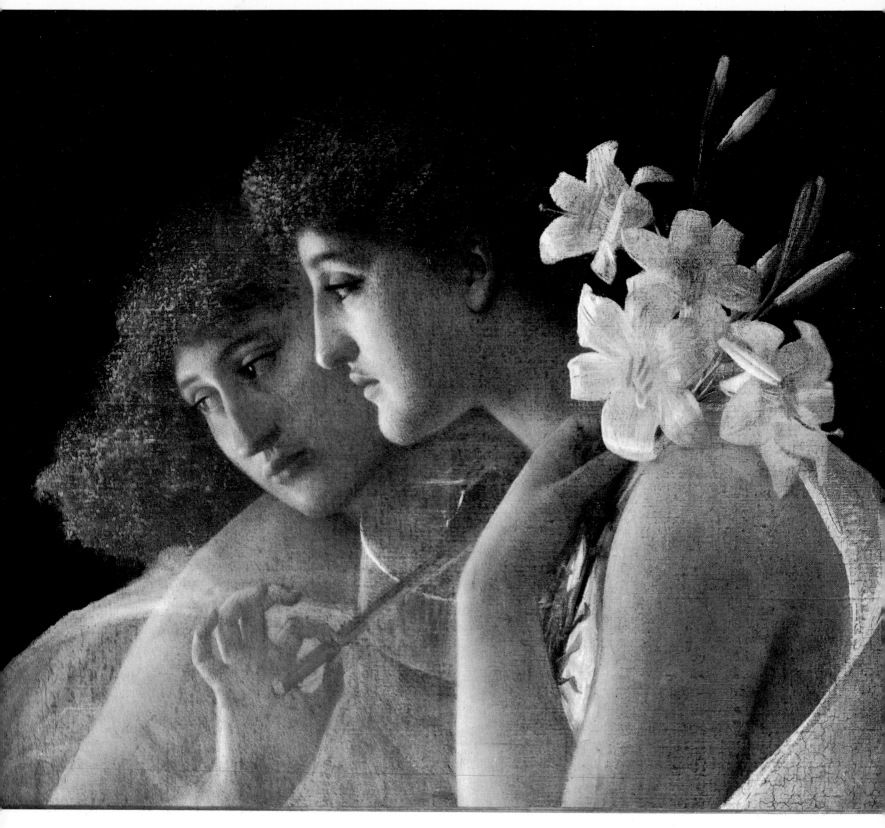

192. Odilon Redon: *Closed eyes.* 1890.
Oil on canvas, 44 × 36 cm.
Louvre (Jeu de Paume), Paris

193. Odilon Redon: *The meditations of Buddha.*
1905. Pastel, 90 × 73 cm.
Louvre (Cabinet des Dessins), Paris

194. Odilon Redon: *Day.* 1910–11.
Tempera (screen), 200 × 650 cm.
Library of Fontfroide Abbey, Narbonne

195. Odilon Redon: *Night.* 1910–11.
Tempera (screen), 200 × 650 cm.
Library of Fontfroide Abbey, Narbonne

196. Emile Schuffenecker: *Pink tree.* c.1894.
Pastel, 56 × 43 cm. Coll. Fouquet, Paris

197. Carlos Schwabe: *Death and the grave-digger.*
1895–1900. Watercolour and gouache,
75 × 56 cm. Louvre (Cabinet des Dessins), Paris

◀ 198. Charles Sellier: *Two angels.* c.1865–70.
Oil on canvas, 54 × 65 cm.
Coll. M. Jean-Claude Bellier, Paris

199. Carlos Schwabe: Poster for the first
Salon Rose+Croix. 1892. 184 × 82 cm.
Piccadilly Gallery, London

200. Carlos Schwabe: Cover for
Le Rêve by Emile Zola. 1892.
28 × 19 cm. Harvard College
Library, Cambridge (Mass.)

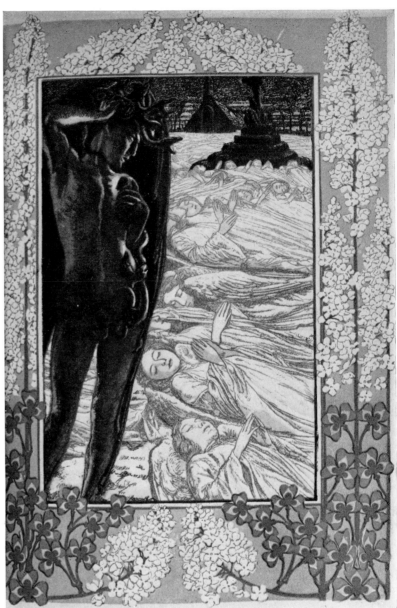

201. Carlos Schwabe: Study for illustration to *Le Rêve* by
Emile Zola. 1891. Chinese ink and watercolour, 40 × 24 cm.
Musée National d'Art Moderne, Paris

202. Carlos Schwabe: Illustration for *Au Jardin de l'Infante* by
Albert Samain. 1908. Wood engraving.
Bibliothèque Littéraire Jacques Doucet, Paris

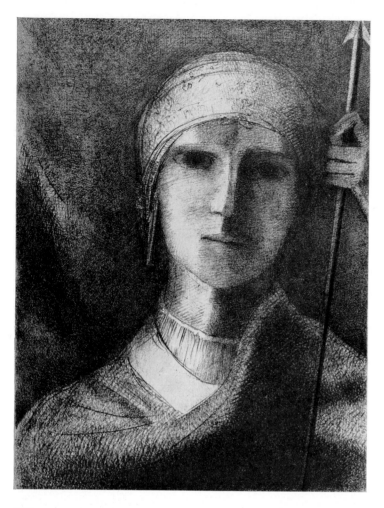

203

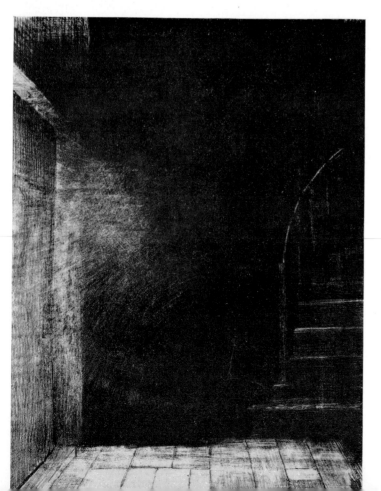

205

204

203. Odilon Redon: *Parsifal*. 1892. Lithograph, 32 × 24 cm.
Bibliothèque Nationale (Cabinet des Estampes), Paris

204. Odilon Redon: *Death: My irony surpasses all others!*
Illustration for *La Tentation de Saint-Antoine* by Gustave
Flaubert. 1889. Lithograph, 26 × 20 cm.
Bibliothèque Nationale (Cabinet des Estampes), Paris

205. Odilon Redon: *I saw a big, pale gleam of light*.
Illustration to *The Haunted and the Haunters* by
Bulwer Lytton. 1896. Lithograph, 23 × 17 cm.
Bibliothèque Nationale (Cabinet des Estampes), Paris

206. Rémy de Gourmont: Frontispiece to his own novel
Le Fantôme. Lithograph

207. Ker-Xavier Roussel: *Noli me tangere*. 1894. Lithograph,
22 × 14 cm. Private collection, Paris

208. Armand Séguin: *The toads*. 1895.
Lithograph, 26 × 28 cm.
Galerie Jean Chauvelin, Paris

210. Alexandre Séon: ▶
The end of the gods. Lithograph

209. Armand Séguin: Frontispiece to
Le Pélerin du Silence by Rémy de
Gourmont. 1896

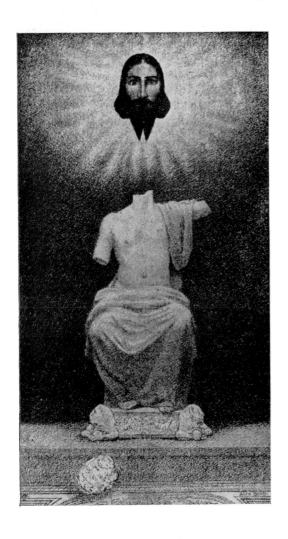

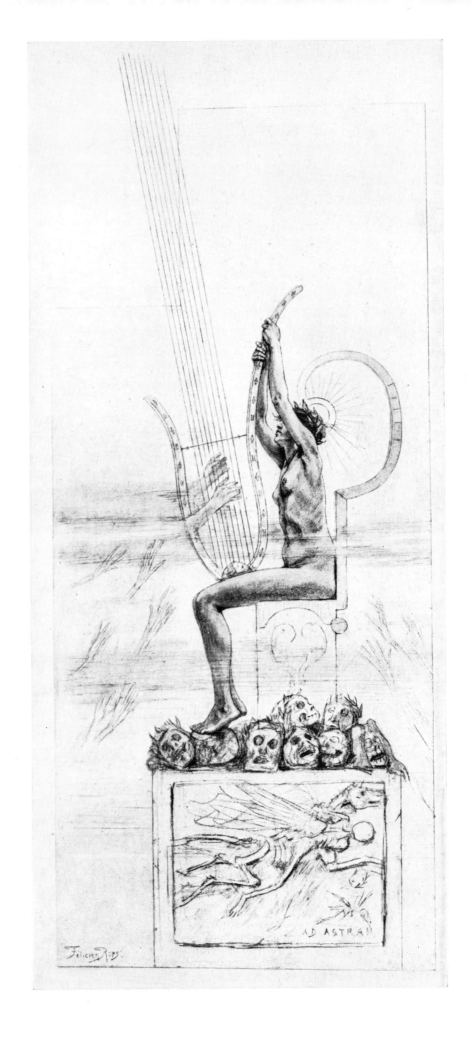

211. Félicien Rops: Frontispiece to *Poésies* by
Stéphane Mallarmé. 1887. Etching.
Bibliothèque Littéraire Jacques Doucet, Paris

212. Photograph by C. Puyo from
Esthétique de la Photographie,
ed. Paul Bourgeois, Paris 1900

213. Photograph by R. Demachy
from *Esthétique de la
Photographie*, ed. Paul
Bourgeois, Paris 1900

1. Enormous pillars placed at regular intervals supported the circumference of the basalt dome. Their decoration, in which the Syrian taste flourished anew, consisted of sheaves of corn and blue-tinted morning glories, which grew from base to capital. A brilliant lamp hung at the end of a rope of gold suspended from the centre of the vault, a star whose azure centre engulfed the rays of the electric light. The split tree which formed the end of the hall opposite the hearth was surmounted by sumptuous green banks, as in a garden; here profusions of creepers and Eastern roses undulated, flowers from the Tropical Isles with luminous pistils and leaves filled with rich sap (Villiers de l'Isle Adam, *L'Eve future*).

2. Phidias and Botticelli, Ingres and Leonardo. Oh! he indeed creates the sacred emotions of the great masterpieces, he indeed practises idealist art in all its glory! (*L'Ermitage*, 1893).

3. Weirdly coloured pictures speckled with gamboge and indigo, and looking as if they had been sketched by an ailing Gustave Moreau, painted in by an anaemic Michelangelo, and retouched by a Raphael armed with a brush of blue paint . . . The strange and mysterious amalgam of these three masters was informed by the personality, at once coarse and refined, of a dreamy and scholarly Englishman afflicted with an obsession for hideous hues (Huysmans, *A Rebours*).

4. When writing about Blake, however, Montesquiou noted that 'it is perhaps only in some of Redon's figures that one finds so much of the stupefying unknown. And there are girl-flowers, long before Grandville and Wagner.'

5. Walter Crane was a mediocre artist whose influence was most pronounced in the field of the decorative arts. Thus William de Ritter in an article in *L'Ermitage* of 1893 praised Crane's large tapestries, *The Complaint of the Forest, The Bridge of Life,* and *The Crown of Life,* and then compared the 'Anglo-Greek' ideal which he sees in them to the 'Italo-Germanic' ideal expressed in Böcklin's *Vita Somnium Breve.*

6. Oh, that moment when the Holy Grail appeared before our eyes! . . . What a revelation of infinite splendour, what an overwhelming feeling in the soul! Oh blessed art, oh real presence of God in Beauty! (Péladan).

7. In no other work of art is the relationship which exists between the state of mind and the physical appearance of the landscape revealed as brilliantly as in the works of Baudelaire. When he describes jealousy, he does so with a fire of pink and violet hues in which the whole of nature seems to participate. If mysterious waters gush before lips parched by a yearning for the unknown, it will be in a circus of strange colours, like the splashing of a divine or diabolic brew (Achille Delaroche).

8. The quotation from Hegel given below was printed in the catalogue of one of the *Salons de la Rose+Croix*: 'Art is the rival of Nature. Like Nature, and with greater success, Art conveys ideas. It uses forms as symbols of experience, and it fashions these in such a way that they become transformed into something more perfect and pure.'

9. I love that word, 'Decadence' . . . all glistening with purple. It is the combination of the sensual spirit and the sorrowful flesh and of all the violent splendours of the later Roman Empire. It is the collapse into flames of races worn out by hearing the sound of invading enemy trumpets (Verlaine).

10. Maeterlinck, like Mallarmé, was one of the poets for whom the process of creating poetry was also a process of thought . . . he sought in the life of the least significant of nature's creatures, in the smallest and most mundane objects, and in the most minute macro- and microcosms of matter, their secret lessons (Catalogue of the exhibition *Les Sources du XXième siècle*, Jean Cassou).

11. In all Wilde's writings on art there can be found a hundred examples of ideas moving in the direction of Symbolist theory. It is interesting to note that he was the first Englishman to point out the painters of the imaginary to an age in which they were still seeking to make their name.
'There is far more to be said in favour of that newer school at Paris, the *Archaicistes*, as they call themselves, who, refusing to leave the artist entirely at the mercy of the weather, do not find the ideal of art in mere atmospheric effect, but seek rather for the imaginative beauty of design and the loveliness of fair colour, and rejecting the tedious realism of those who merely paint what they see, try to see something worth seeing, and to see it not merely with actual and physical vision, but with that nobler vision of the soul which is as far wider in spiritual scope as it is far more splendid in artistic purpose' (*The Critic as Artist*, 1890).

12. My kingdom is not of this world; it is a land which I methodically enrich with the help of all the suggestions given to me by Beauty; it is a dream world more sure than reality itself, and I retreat into it to pass my happiest moments, cut off from my familiar fears (Maurice Barrès).

13. How will all the realities of tomorrow compare with the mirages of life which we have just experienced? Through the repercussions of meaning, every word gives life to what it expresses.

14. In the Magnificent art (*l'art Magnifique*), form is the effulgence of the essential; its tree has its roots in the fundamental and infinite Idea; its flowers and fruits which blossom and ripen in time and space represent the formal and finite manifestations of ideas. The Magnificent art is not concerned with mere decoration such as the stringing of pearls or the gilding of mediocre pieces of wood; its role is to evoke the excellence which lies captive within

the heart of mystery and to make this accessible through its individual and loving symbols to the benefit of mankind (Saint-Pôl–Roux, *Mercure de France*, 1892).

15. In a review of Sartre's book on Flaubert, M. Nadeau highlights this attitude which in fact seems to belong more satisfactorily to the followers of Flaubert than to the master himself: 'The aesthetic attitude displays this nervous condition. Whereas the Romantics had tried to link their chariot to that of an aristocracy which was breaking up, the generation of 1840, children of lawyers and doctors, turned their backs on their class origins and tried to replace them with a true aristocracy based upon the mind, which could rise above the prejudices of this world and exist to one side of the class system, ultimately to lock itself up within its ivory tower. . . . The artist became the untouchable who justified his position outside the limitations of time and place by sacrificing his personality to his work, which thus was transformed into an Absolute. He annihilated himself in it; he became its martyr' (*Quinzaine littéraire*, October 1972).

16.
> *Mauve tendre et vert alangui*
> *Sur les plates bandes fanées*
> *Les asters et les véroniques*
> *Chantent, mezzo voce, la chanson des adieux.*

> (Gentle mauve and languid green
> In the wilted flower beds,
> The asters and the veronica
> Sing mezzo voce the song of farewell)
> (Laurent Tailhade, *Menuet d'Automne*).

17. And over our heads will float the Blue Bird, singing of beautiful and impossible things, of things that are lovely and that never happen, of things that are not and that should be (Oscar Wilde).

18. This is very well expressed in a poem called *Vers ses Mains* by a minor poet, Romain Coolus:
> *Presque pas de chair, si peu: de rêve*
> *Presque pas humaines, si peu: divines*
> *Presque pas vivantes, si peu: défuntes*
> *Presque pas les tiennes, si peu: les miennes*

> (Scarcely any flesh, hardly any: dreamlike
> Scarcely human, hardly at all: divine
> Scarcely alive, hardly at all: dead
> Scarcely yours, hardly at all: mine).

19. Virginal youth of incomparable glamour, the only absolute grace, delicious unpublished poem, concealed on the vellum of the heart, no name is inscribed on the vellum of the body, not a trace of pink; naked flesh which has not weakened, a still-soaring spirit, alabaster which gives off no odour, praise be to You!!' (Péladan).

20. An evening of sunset, of a distant air, of darkened skies; and of crowds wandering confusedly; of noises, of shadows, of multitudes; of spaces infinite through the oblivion of passing hours; a formless evening . . . (Edouard Dujardin, *Revue Indépendante*, 1887).

21. The first time was in some *salon* amongst the cruelty of indiscreet dresses, a society which made us faint with boredom. Those people who had killed their consciences wore a sign, a blood-red cross near their hearts (Rémy de Gourmont).

22.
> *Et ces châles et ces gestes de femmes saoules*
> *Et ces alcools de lettres d'or jusque aux toits*
> *Et tout à coup la mort parmi ces foules*
> *O mon âme du soir, ce Londres noir qui traine en toi.*

> (And those shawls and those gestures of drunk women,
> And those alcohols in letters of gold right to the rooftops
> And suddenly death comes in the middle of these crowds,
> O my evening soul, this black London which drags its
> life within you)
> (Emile Verhaeren, *Les Soirs*).

23.
> *Mais geai qui, paon se rêve aux plumes,*
> *Haut, ces tours sont-ce mes juchoirs?*
> *D'îles de Paques aux fleurs noires*
> *Il me souvient en loins posthumes.*

> (But the jay who dreams of plumage like the peacock's,
> High up, are those towers my perch?
> From the Easter Islands to black flowers
> He remembers me in distant posthumous places)
> (Max Elskamp, *Louanges de la Vie*).

24.
> *Parmi les marroniers, parmi les*
> *Lilas blancs, les lilas violets*
> *La villa de Houblon s'enguirlande*
> *De houblon et de lierre rampant.*
> *La glycine des vases bleus pend,*
> *Des glaïeuls, des tilleuls de Hollande.*

> (Among the chestnuts, among the
> White lilac, the violet lilac,
> The villa of Houblon wreathes itself
> With hops and crawling ivy.
> The wisteria from blue vases hangs down;
> Gladioli, lime blossom of Holland)
> (Jean Moréas, *Les Syrthes*).

25.
> *C'était ton front, la ligne blanche dans l'infini*
> *Et tes masques l'heure des levers d'âmes infinies*
> *Ta bouche sertissait l'absence et l'envolée.*
> *Loin des bruits et des joies à plus vivaces envolées.*

> (It was your forehead, white line in the Infinite,
> And your masks, hour of souls' infinite resurrection,
> Your mouth set in absence and flight,
> You have left far behind to livelier souls the noise and
> the joys)
> (Gustave Kahn, *Les Fêtes dans la Ville*).

26. From Baudelaire, Edgar Poe's silence, while taking pains to retranslate into Greek Baudelaire's translation,
From Bloy, the black pigs of Death, the cortège of the Fiancée,
From Coleridge, the crossbow of the Ancient Mariner, the floating skeleton of a ship, the casting of dice,
From Elskamp, the hares which, as they run over the sheets, change into plump hands and bear the spherical form of the Universe like fruit,
From Kahn, one of those golden resonances of heavenly jewellery,
From Maeterlinck, the lights which the first blind sister heard,
From Péladan, the reflection in the mirror of a brooch whitened by the ashes of an ancestor, by the sacrilegious massacre of the seven planets,

From Régnier, the sorrel where the modern centaur snorted,
From Rimbaud, the shafts of ice thrown by the wind of God into
stagnant pools (Alfred Jarry, *Gestes et Opinions du Docteur Faustroll*).

27. Ridicule killed a number of the more pretentious works, for example Edouard Dujardin's trilogy, *La Légende d'Antonia* (1892), which was acted against a simple but brilliantly lit set by Maurice Denis with its text spoken in unison. Pierre Quillard's *Fille aux mains coupées* suffered a similar fate when it was produced against a backdrop of angels painted by Sérusier. Napoléon Roinard's *Cantique des Cantiques,* performed with incense and perfume let off in the auditorium, caused a riot.

28. *La Voile* by Rodenbach has also disappeared without a trace. It was described as a 'play without movement' or 'a silence machine', and was staged in 1894.

29. There is no Symbolist who has not at least once laid aside his pages of beautiful metaphors, to take up the fight beside some over-excited workers for human, rather than political, rights, in the pages of some liberal newspaper (Rémy de Gourmont, *Livre des masques*).

30. It is imperative that the triple alliance of sods, cads and rotters be confronted by the two-headed eagle, defensive and offensive, composed of artists and 'arists' ('Arist' is a neologism which had a brief period of success; it referred to the aristocrats of thought) (Alphonse Germain).

31. The Order of the *Rose+Croix Esthétique* wishes to restore the cult of the Ideal in all its splendour, with Tradition as its base and Beauty as its means.

The *Salon de la Rose+Croix* wants to *ruin realism*, reform Latin taste and create a school of idealist art.

There is neither jury nor entry fee. The Order is too respectful of the artist to impose a programme on him other than the creation of *beauty, nobility, lyricism*.

These subjects are rejected: history painting, . . . patriotic and military painting, . . . all rustic scenes, . . . picturesque renderings of oriental subject-matter, . . . landscapes unless they be in the manner of Poussin, domestic animals and sporting animals, flowers, still lifes, fruits, accessories, and other exercises that painters normally have the effrontery to exhibit.

The Order favours first the Catholic Ideal and Mysticism, then Legend, Myth, Allegory, the Dream, the Paraphrase of great poetry and finally all Lyricism; the Order prefers work which has a mural character as being of superior significance. Even if the execution is imperfect, . . . the Order will welcome subjects drawn from Catholic dogma, . . . from oriental theogonies (apart from those of the yellow races), allegory, both expressive and decorative, like the work of Puvis de Chavannes.
. . .
Architecture: since this form of art was killed in 1789, restorations and projects for fairy palaces are the only categories which are allowed.
. . .
For the Order of the *Rose+Croix*, the word 'foreign' has no meaning.
. . .
Following the traditions of Magic Law, no work by a woman will ever be exhibited or executed by the Order.

32. What titles for the paintings: 'Legendary Princess', the 'Princess of Vespera', 'Artemis', 'Viviane', 'Morgan', 'Perseus' and 'The Magi', the 'Tower of Regret', 'Guardian of Mourning'; further off I can see the 'Demon of War' dying in a sea of blood, and here are the 'Dead Love' and the 'Fate of Dreams'; a Monsieur Sala exhibits a 'Virginital' (Oh, my head, my poor head!), and M. Alexandre Séon a 'Chimera's Despair' hanging between a 'Mélusine' and a 'Magdalene'. . . .

And to suppose that all these symbolic simpletons represent the cycle of human existence!

Nevertheless, there is talent here, lots of talent in the middle of all these satanic visions, as the good poet Jean Moréas has pointed out (Jean Lorrain, *Echo de Paris*).

33. A work of art . . . must be:
 (1) 'ideist', since its unique ideal is to express the Idea;
 (2) symbolist, since it expresses this Idea by means of forms;
 (3) synthetic, since it arranges these forms or signs according to a generally intelligible system;
 (4) subjective, since the object is not considered as a thing in itself but as a sign apprehended by the subject;
 (5) decorative (which is the logical consequence)—for painting as it was conceived by the Egyptians and the Primitives was no more than a manifestation of art which was at once subjective, synthetic, symbolist and ideist (Albert Aurier).

34. The nineteenth century—which, in its childish enthusiasm, has for eighty years vaunted the omnipotence of scientific deduction, declaring that there is no mystery which does not yield to its microscopes or scalpels—seems at last to be becoming aware of the absurdity of its boasts and the vanity of its efforts. Man is still surrounded by the same mysteries, the same formidable enigmatic unknown which has only become darker and more disturbing since it has been the fashion to ignore it (Albert Aurier).

35. *Mais le sombre indigo des nuits d'été*
 Est la caresse consolante à nos yeux dépités
 . . . Lilas frais et mauves pervers
 Rododendrons où les phalènes vont se pâmer
 . . . Orangés calmes des couchants d'automne
 Orangés tristes des feuilles tombées
 . . . Voici le bleu mystique des soirs.

(But the deep indigo of summer nights
Is as a soothing caress for our vexed eyes
. . . Fresh lilacs and perverse mauves
Rhododendrons in which the moths will soon faint
Calm shades of orange in autumn sunsets,
. . . Gentle shades of orange in fallen leaves
. . . Here is the mystical blue of evening)
 (Marie Krysinska, *Revue Blanche*).

36. A group of travellers arrives in an unknown land, and they then go off in all directions, each one to explore a different part. This is the impression which we get from *Les XX*. Seurat's *Le Chahut*, Gauguin's wood carvings—a strange return to a style which is excessively ancient and rudimentary . . . an admirable *Sower* by Van Gogh which looks like a Byzantine mosaic, a shimmering jewel, largely synthetic . . . Khnopff, a super-delicate artist . . . Ensor's *Masks*, there are still only intentions here . . . (Krexpel, *Revue Blanche*, 1891).

37. For this purpose I include the Chromoluminarists, the Neo-Impressionists, the Neo-Traditionalists, the Synthetists, and the Mystics. The realist artist has only one end in view: the reproduction of nature according to the direct feelings which she provokes; the Idealist artist only regards nature as a distant point of departure for his work. For him, everything lies in the entirely subjective cerebral transformation which the intellect makes him undergo (Mellério, *Idéalisme en Peinture*).

38. Direct contact with nature arouses feelings. These are recalled by the Memory and connected and thus recreated by the Imagination, placing us in an *involuntary emotional state* which is not governed by the will. Then the Idea forms in the mind; superior to its generic source by its very nature and its harmony, it *appears* to the artist. The artist then struggles to express the Idea in all its intensity, an aim which is best achieved by rejecting all detail, and concentrating on *its essential characteristics*. Then the artist and spectator are brought to the same *emotional state* which is the aim of all Art (Mellério).

39. Allegory, like symbol, expresses the abstract by means of the concrete. Both devices are founded on analogy, and both contain an image. . . . Symbolism involves an intuitive quest for the ideas latent in particular forms (Albert Mockel).

40. Vanor gives the following definition of Symbolist art: 'Art is the method by which a dogma is cloaked in a human symbol and by which it is developed in constantly changing harmonies' (quoted by Françoise Cachin in *Textes de Fénéon*).

41. As almost all of you have money, a large clientele and powerful friends, it would be surprising if you failed to reap the fruits to which your talents and discoveries entitle you; I am somewhat apprehensive on your behalf of the ridicule which the *Rose+Croix* arouses, although it provides a marvellous advertisement, as I feel that Art has no part to play in the house of Péladan (Gauguin, June 1899, Tahiti).

42. Ah, these aesthetes of evil caused harm when they discoursed in silken voices on the horror of nature, of life, on the uselessness of drawing, on the need to lead art back to the ideals of Papuan natives, to embryonic forms, to the state of larvae; this is the exasperation of ugliness (Octave Mirbeau).

43. The word 'soul' has been so frequently abused that it will shortly take its place beside those like 'mystery', 'idea', 'heart', even 'life', in that bric-à-brac boutique where all sorts of art guilty of a misalliance with fashion will be forever stranded (René Boylesve).

44. In an article called 'Art and the People' André Beaunier reproached artists for their esoteric leanings, and attempted to censure 'Mallarmé's allusions'.

45. I quote a few examples: 'There is one thing which is of prime importance to me: an enthusiasm and very great desire to move towards abstraction. Of course, I am interested in the expression of human feelings, of passions, but I am less concerned with expressing movements of the soul than I am to render visible, so to speak, the interior light which seems unrelated to anything one knows. . . . As in a dream which has its own peculiarly coloured atmosphere, so a concept, when it turns into a composition, needs to exist within an atmosphere of colour of its own. Then it be-comes obvious that a particular colour belonging to some part of the painting becomes the key to the whole and governs the other parts. . . . All the figures, as they are placed in relation to one another, the landscape, or the interior which acts as background or horizon, their clothes—in short, everything must contribute to the clarification of the general idea, and must bear its real colour—its livery, so to speak' (unpublished note by Gustave Moreau, in the Musée Moreau).

46. When people saw Gustave Moreau's paintings, there was a fashion for sumptuous clothes, for things which were taken out of their natural context and turned into symbols: tortoises had to serve as lyres, flowers crowning a forehead had to be a symbol of death, and, whereas in the past, the desire to return to untrammelled nature had led to the belief that a statue spoilt a field, people felt and wanted the beauty found in a land of Art where statues proliferated on cliffs (as in Moreau's *Sappho*), and they liked to regard people and objects as the mental means through which the spirit of the poet—who alone was enabled to arrange them—moved, jumping from one to the next: from the flowers which encircle a statue to the statue itself, from the statue to the goddess who passes not far away, from the tortoise to the lyre, while the flowers of a corsage almost become jewels and almost stuffs (Marcel Proust, *c.* 1895).

47. A work of art is born out of a state of intense emotional turmoil in which it is sheltered like the chicken in the egg. An idea which lodges in an emotion is then turned over and over in my mind until it becomes clarified and appears to me in its exactest form. Then I turn to look for a subject which will most accurately translate the idea into a plastic form . . . this is Symbolism, if you like (Puvis de Chavannes).

48. Jacques-Emile Blanche, one of the best judges of technique, wrote that 'the treatment of the flesh is such that all his human figures look sterilized, embalmed for eternity like those corpses from Pompeii which have been buried under the lava from Vesuvius and polished like pebbles in a river bed'.

49. Puvis explains his idea but he does not paint it. He is a Greek whereas I am a savage, a wolf without a lead in the forest. Puvis will call one of his paintings 'Purity', and to explain the concept, will paint a picture of a young virgin holding a lily in her hand; a well-known symbol, hence one can understand it. Gauguin, when he paints a picture called 'Purity', will paint a landscape of limpid waters; there will be no taint of civilized man, perhaps just a single figure (Gauguin).

50. An example of this growing taste can be seen in a remark made by Strindberg, who had just refused to write a preface for Gauguin: 'In the middle of the death-throes of Naturalism, there is one name of which everyone talks highly: Puvis de Chavannes.' Maillol, among others, also copied the *Poor Fisherman*.

51. All the mistakes which the critics have made when writing about my work stem from the fact that they cannot understand that things must not be defined, understood, limited, made precise, because everything which is sincerely and subtly new, like Beauty for instance, carries its own meaning within itself (Odilon Redon, *A Soi-Même*).

52. However, in a more belligerent mood, he wrote to Emile Bernard in June 1890 that 'as for the abuses which the cliques

bawl at my paintings, they make no impression on me at all, especially since I know that my work is still not fully developed. One must make sacrifices in art, phase by phase, make experiments, a thought suspended with no definite or direct expression. But damn it! Comes a moment where one can touch the sky, it changes again; on the other hand, this half-apprehended dream is far more powerful than any physical object.'

53. At that time I was still a student at the Académie Julian and then also at the Ecole des Beaux-Arts. Our first reaction was one of utter amazement, our second of revelation! Instead of being like the Impressionist paintings with their windows opened on to nature, it was all heavily-loaded, decorated surfaces, strong colours and outlines in a harsh *cloisonniste* style, for people spoke of cloisonnism and japonism. In these peculiar works we found references to Japanese prints, medieval woodcuts, signboard painting, and romanesque stylization. And we also were reminded of the crude simplifications of Pissarro's peasant subjects and above all of Puvis de Chavannes—the Puvis of the *Poor Fisherman*, the work of that forgotten great master whose enormous influence at the end of the nineteenth century will never be sufficiently recognized (Maurice Denis, 1934).

54. Two small, very sharp, metallic eyes, a slightly receding chin, a disdainful mouth, and a head of hair, Oh! beautiful red hair of a barbarian; describing comma-like curls on his forehead and giving him a kind of wild crown; upright posture, neatly dressed, a simple person who had a horror of appearing dishevelled; a Clergyman in the process of becoming a Dandy (Verhaeren, *L'Art Moderne*, 1886).

55. If stupidity becomes so persistent that it pushes you beyond all possible endurance, amuse yourself by playing a charming practical joke which is intelligently conceived, cruelly carried out, and punctuated at its close by a discreet laugh which is the concentrated and sublime expression of joy (Khnopff).

56. It will never be possible to make M. Fernand Khnopff and a number of his fellow exhibitors understand that a painting must above all else seduce by its rhythms, and that a painter gives the impression of having too much humility when he chooses his subjects from ones which are already richly laden with literary meaning (Félix Fénéon).

57. The following quotation is characteristic of the homage paid to the great sculptor by one of the Symbolist writers: 'He has inscribed in bronze the eternal battle which rages between matter and spirit. Rodin is a poet of every aspect of the soul. . . . He plays upon the human body in the same way as a lyre which gives voice to the breath of the gods' (Stuart Merrill).

'The hands of the great sculptor are as immediate and alive as the hands of the poet Verlaine; they are sad, angry, listless, hands which grasp at the chimera or at passions, hands of heroism or hands of vice' (Gustave Kahn). And there was a whole book by Rilke!

58. However, both Moreau and Redon were more reserved in their comments. Redon, for example, wrote in *A Soi-Même* that 'All that humanity of Rodin's work is not humanity; all those hysterical figures who twist and turn seem to me to be moved by an electricity of death; they lack soul.'

59. If there were no religion at all, I would have to invent one. Real artists are generally the most religious of the human race. . . .

Beneath the surfaces of objects we look into the spirit; when we reproduce their contours, we enhance them with the spiritual content which they contain (*Propos de Rodin, recueillis par Gsell*).

60. His works are nothing more than admirable, tender hymns written to the glory of the star which gives life, happiness, and Beauty; hymns which are no doubt shorter than one would have wished . . . Ideas, beings, things no longer exist for him, dissolved as they are in his fiery breath (Albert Aurier, *L'Art Symboliste*).

61. Faithful to his method, Monet, visionary painter of his own chosen surroundings, has painted this pond of waterlilies ten times, at all hours of the day, catching the enchantment of different lights. These are the dream-timetables in my world of reality (Jean Lorrain).

62. Séon was the first really to define doctrinally the reaction of the cult of the Beautiful against the neo-realist trend . . . he works for the rebirth of the ideal: to give the symbol substance by the lines which describe the enlarged form of the archetype, blend the symbol through the use of colour tones (Alphonse Germain, *La Plume*, 1891).

63. 'Every element in your work must express calm and peace of mind, you must avoid *contrapposto*, and every figure must be static.' The Turkish master also advises that plays should avoid action: 'Thus one could pass an hour in front of this scene which is *more tragic because of its tranquillity*, than if, after the initial moment of surprise, the artificiality of the poses had made us smile. Apply yourself to defining the *silhouette* of each object; the exactness of delineation is the attribute of the hand which hesitation of the will has not weakened' (Gauguin's underlining).

64. The desperate tragic rhythm of every line falling in sorrowful curves, here and there dramatically broken by the superior medium of the canvas. Note the lugubrious toning of the colours, this sinister harmony in sombre green, dark blue and black (Aurier on De Groux' *The Stragglers*).

65. In the various independent exhibitions, a refined and intelligent variety of imaginative frames has replaced the eternal moulded gilt frame. A green landscape flooded with sunlight, a white winter beach, an interior scene alive with fluttering lamps, require frames which only the artists who painted the pictures will know how to produce. We noted frames which were flat, white, pale pink, jonquil yellow, and others which were outrageously gaudy (Jules Laforgue).

66. I have looked at my black pictures very carefully and have decided that it is above all in my lithographs that the black is most completely striking, without any adulteration (Odilon Redon, *A Soi-Même*).

67. Is it not the iconography produced by Flandrin and Signac which is responsible for the poverty of the miraculous images which have appeared recently in France to this or that modest shepherd-girl? Painters are responsible for the visual beauty of religion (*L'Art et la Vie*, 1896).

68. Some years earlier, according to Robert de Montesquiou, Moreau had expressed much the same view: 'He remained convinced that the reproduction of ugliness could never create any beautiful work of art; he could forgive neither Manet nor Degas

for being doubly sacrilegious because they used their talents, which he recognized, to such a base end.'

69. No artist is intellectual when, having painted a nude woman, he leaves us with the feeling that she is going to get dressed straight away. The intellectual painter shows us a nude girl in such an honest way that we are convinced of her nudity. . . . Puvis de Chavannes' female nudes never get dressed straight away (Odilon Redon, *A Soi-Même*).

70. The bone structure which always re-emerges under the modelling of the flesh retains the sculptural and personal qualities of his figures. Heads have an emaciated, ascetic gravity, mouths tremble, necks undulate, tresses of hair are combed or remain in knots—at one and the same time controlled or angry—and hands stiffen in response to some mysterious shudder (Gustave Soulier, *Art et Décoration*, 1889).

71. A few trees on the cliff at Varengeville, the boles of pines in the Bois de Boulogne, a party of children bathing on a Normandy beach under the blue August sky, which he filed in his memory without even making a painted study—and this would become Hellas, the Mediterranean, Nausicaa and her companions, an antique vision (Jacques-Emile Blanche).

72. What a wonderful way of transforming our depressing hovels into oases where the spirit can quench its thirst after the worries of mundane existence. Oh! frescoes on the walls, harmonious patterns of colour bounded by the knowledgeable lines of the masters. Oh! to forget the ugliness of the street when we look at an idealized landscape, the lyrical messenger of the infinite.

73. His imagination, which had already marvellously rendered the spirit of a book in black and white, set itself the task of re-clothing the walls of a dining-room or a boudoir with visions of unreality, enlivening the richness of the furnishings with poetry (Maurice Denis, *L'Occident*, 1903).

74. This way of understanding art excludes the mediocre artist, who retains nothing of eternity in himself, and who would not be able to express an idea of a little humanity or divinity without using boundaries.

75. If in our times there is a general rule which by itself can define those people who do not accept it, it is the habit of labelling with the adjective 'literary' all painting whose ambition is to go further than merely offering us the image of the external world, or which, in the final analysis, does nothing more than to provide a pleasure for the eyes . . . This type of painting (realist), with its lazy dissertations on how to make dots on a canvas, is opposed by a style of painting which sees itself as a reaction against the world as a result of the interior demands felt by the artist (André Breton).

Notes on the Plates

Notes have been provided only for those illustrations which the author considers require explanation or for which there are contemporary literary references.

3. AMAN-JEAN: *The girl with the peacock*. Aman-Jean was a great admirer of the Pre-Raphaelites and of the poems of Christina Rossetti. This painting was immensely successful at the *Salon* of 1895. Roger Marx wrote in the *Gazette des Beaux-Arts*: 'There is something sphinx-like in the eternal female; M. Aman-Jean employs a searching, subtle analysis in order to resolve these enigmas. He uncovers the secrets of the soul.'

The model for the girl was the artist's young wife. A few years later, fearing that he had tuberculosis, Aman-Jean spent some time near Naples; his pastels from this period are much more highly coloured. This portrait could have inspired d'Annunzio when he was writing *Le Vergini delle Rocce*.

6. MAILLOL: *Profile of a young girl*. A young stroller in the Symbolist garden who displays the influence of both the *Nabis* and of Gallé.

7. REDON: *Portrait of Gauguin*. Shattered by Gauguin's death, Redon executed a pastel and this painting, 'the dark profile'. Redon had been among those who had tried to buy *Where do we come from? What are we? Where are we going?* for the Luxembourg.

9. BUSSIERE: *Helen of Troy*. Popularizer of Symbolist themes for the *Salon* public, Bussière was a more delicate, less bizarre Rochegrosse. A great Wagner enthusiast, he often painted scenes from his operas. Here, however, his picture of Helen is closer to the spirit of Massenet's *Thaïs*.

14. CARRIERE: *The Virgin at the foot of the Cross*. For the painter Besnard, this virgin represented Sorrow, or a revulsion against the irremediable. The depth of religious sentiment in the work of an anticlerical was much admired and it was hoped that this image would one day be placed in a church dedicated to the cult of the ideal.

'He has appealed to the inner light in order to decipher the obscure enigma hidden beneath the visible exterior. His research bears the modern stamp of despair and by making our fear beautiful we only like it even more' (Roger Marx, *L'Image*, 1897).

'These figures in M. Carrière's paintings . . . are like images caught in a mirror . . . They appear in the perspective—is it of space or of time? Are they exiles or posthumous images?' (Georges Rodenbach).

15. CAZIN: *Hagar and Ishmael*. 'He glosses over the details, removes the irregularities of contours, he simplifies in order to unify and expand the meaning'—Maurice Denis.
'Professionally melancholic'—Fénéon.

16. CHASSERIAU: *Sappho*. One of the favourite themes of Symbolism treated by a precursor. Throwing away her lyre before flinging herself off the top of a cliff, Sappho represents the incapacity of poetry to console an unhappy love, one of the images that illustrated the tragic destiny of geniuses.

'Chassériau was an enchanter whose power of seduction seemed to derive from a dual descent from illustrious stock; Ingres and Delacroix meet in him and their opposing doctrines merge within his breast; he in his turn nourishes two independent disciples, he fosters two basically opposed spirits: Puvis de Chavannes and Gustave Moreau' (Ary Renan, *Gazette des Beaux-Arts*, 1899).

21. CORBINEAU: *The friends.* Scenes of lesbianism are not rare. This one foreshadows the portrayal of Mademoiselle Vinteuil and her friend in *Du Côté de chez Swann*.

22. DEGOUVE DE NUNQUES: *Angels in the night.* There were two influences on the formative stages of this most poetic of the painters of the Belgian School: Toorop and Henry de Groux.

'Do not ask him for the charm of colour; for him this is a material thing and his intellectual art flies to the beyond, into the unsettling domain of unreality and dreams'—Verhaeren, 1895.

23. DEGOUVE DE NUNQUES: *The black swan.* 'Edgar Poe . . . What strange telepathy exists between Degouve and him'— Maria Bierne, 1899.

27. DESVALLIERES: *Narcissus.* Desvallières (1861–1950), like many of the Symbolists, passed through Delaunay's studio before coming under the influence of Moreau. An energetic designer, he decorated the Hôtel Rouché in Paris, and then founded the Studio of Sacred Art in 1919 with Maurice Denis. He decorated several churches with frescoes and stained-glass windows.

29. DENIS: *Catholic mystery.* The artist painted several replicas of this Symbolist Annunciation, which, ever since its exhibition at the *Salon des Indépendants* of 1891, had been an immensely successful picture.

'The artist gives the subject a new and symbolic meaning by transforming the angel of the Annunciation into a priest who is charged with presenting the Gospels to the Virgin. Thus the Annunciation is seen not as a single historical event but rather as a constantly repeated promise of salvation' (Geneviève Lacambre).

34. FANTIN-LATOUR: *Prelude to Lohengrin.* A subject which the artist had already treated in a lithograph of 1882, and which was praised by Péladan in *Le Théâtre complet de Wagner*; but many critics accused the artist of lingering too long over these subjects drawn from operas.

39. GAUGUIN: *Where do we come from? What are we? Where are we going?* In considering this canvas, probably Symbolism's most important work, one can cite two critics who show the fervour which Gauguin evoked. Aurier felt that *Be mysterious, you will be beautiful* celebrates the pure joys of the esoteric, the unsettling caresses of the enigmatic. And Octave Mirbeau, in an article in the *Echo de Paris* of 1891 which brought the artist to public notice, wrote: 'In this work there is an unsettling yet rich blend of barbaric splendour, Catholic liturgy, Indian meditation, gothic imagery and subtle symbolism.'

40. DE FEURE: *The voice of evil.* De Feure was the most *art nouveau* of all the Symbolists and above all an exquisite illustrator of books and designer of fabrics. His father was a Dutch architect and his mother Belgian. In 1894 he worked with the poster designer Cheret. His watercolours were much remarked on at the

first two *Salons de la Rose+Croix.* Then he worked with Bing when he opened his *art nouveau* shop in the Rue de Provence. He also decorated the façade of the Bing pavilion at the exhibition of 1900, and designed a complete set of furniture for it. He then became a professor at the Ecole des Beaux-Arts. De Feure was a friend of Debussy, who wanted to write a ballet for him so that he could design the sets.

This painting could be called the 'Temptation of Lesbos' for the muse who is distracted from her mission by these visions is a Sappho of the year 1900; only a strange ring graces her beautiful masculine hand.

44. DE FEURE: *Door of dreams.* A preparatory watercolour for the second story in Marcel Schwob's *Porte des Rêves*, published in 1899. A perfect example of black Symbolism under the influence of de Sade.

45. DE FEURE: *To the abyss.* This work was much commented upon in 1894 at the exhibition which launched De Feure at the *Galerie des Artistes Modernes*, then at the *Salon de la Rose+Croix*.

46. FILIGER: *Lamentation over the dead Christ.* The archaistic style is perhaps attributable to the influence of Rémy de Gourmont, for whom Filiger executed the frontispiece for *Le Latin Mystique*. Here Filiger reworks one of the favourite themes of Byzantine art.

47. FILIGER: *Head of the Virgin, on a yellow ground.* One of the first 'Chromatic Notations'; some were projects for stained-glass windows which were never executed, others were for decorations on Breton stoneware plates; still others were purely theoretical exercises aimed at attaining a simplification of form and colour.

49. GRASSET: *Legendary princess.* Yseult or the Queen of the town of Ys; these princesses reveal the influence of Walter Crane. Grasset was also well versed in botany and he has used his knowledge for his decorative ideas. His book *La Plante et ses applications ornementales* ('The Plant and its ornamental uses') is one of the source-books of *art nouveau*.

50. GRASSET: *Three women with three wolves.* Vision of a witches' sabbath. A favourite theme of the Decadent poets. Perhaps a study for the shadow theatre planned to be part of the staging of Massenet's Symbolist opera, *Esclarmonde*. In spite of this subject, Grasset belongs to white Symbolism.

51. GAUGUIN: *The vision after the sermon.* The struggle between Tobias and the angel in a Breton village. Having heard a sermon given by their parish priest, the women imagine the biblical scene set in a familiar landscape, as would the Primitives and as Maurice Denis was shortly to do.

54. KHNOPFF: *Art* or *The caresses.* Khnopff had not waited to paint this picture before sending his works to the *Salon de la Rose+Croix*. Péladan saw him as 'a Burne-Jones imbued with Baudelaire', and Alphonse Germain wrote in the *Mercure* of 1892: 'An enigmatic composition and faces wrapped in mystery, executed with the fine precision of medieval craftsmen.'

However, not only Fénéon but also critics favourable to the Symbolists reproached Khnopff for being stagnant and stiff. By 1890, he was being called 'the Bouguereau of the occult'.

56. KHNOPFF: *Still water* or *The pool at Menil.* No other canvas illustrates as well as this the influence of water in Symbolism. This

is the park of the House of Usher. The same atmosphere can be found in the drawings inspired by Rodenbach's *Bruges-la-Morte*: 'The most elevated sorrow of Bruges and the slender elegance of her monuments seem to be transmuted in his work . . . He has awakened the great Flemish tradition through this mysterious suggestion of an urban setting.'

57. Du GARDIER: *The sphinx and the gods*. The artist, an admirer of Moreau, has painted a scene inspired by Flaubert's *Tentation de Saint-Antoine*. An excellent example of the return of sphinxes in Decadent mythology, yet treated in an academic style.

58. DE GROUX: *Cataclysm*. From the exhibition of *Les XX* of 1888 onwards, Verhaeren was writing that 'Objective colour is hardly M. de Groux's concern; he gives his subjects the colour of his own tragic vision, which takes flight in sinister greens, cruel reds, livid blues. His palette, where blood, bile and pus fight obscurely with each other, expresses carnage, turmoil, noise.'

61. LE SIDANER: *White souls* or *Gentle night*. Strongly influenced by the work of Rodenbach and Samain, the artist has endowed women and gardens with an air of gentle melancholy. His popularity grew rapidly, as an imaginary conversation by Proust suggests; during this a lawyer friend of Des Cambrennes prefers Le Sidaner to Elstir and even to Monet.

62. LEVY-DHURMER: *Medusa*. It has been said that Lévy-Dhurmer's portraits were the heroines of d'Annunzio seen through the eyes of Leonardo da Vinci.

63. LEVY-DHURMER: *Silence*. This pastel provided much food for thought when it appeared in the first major exhibition of Lévy-Dhurmer's work in 1896. One critic was reminded of Pascal's famous remark, 'The everlasting silence of these limitless horizons terrifies me'.

Yet Boylesve, in *L'Ermitage*, reproached Lévy-Dhurmer for his borrowings from Botticelli and Memling, his success with the snobs and the excessively high prices of his paintings.

64. HUGO: *Justicia*. The visionary at the service of social justice. It is known that Victor Hugo, while in exile, carried out hundreds of drawings during spiritualist séances. This head of an executed man might easily come from the Beyond.

65. KHNOPFF: *Isolation*. Khnopff greatly admired Elizabeth of Austria, the 'Empress of Solitude'. He also admired Watts.

67. LEVY: *Oedipus going into exile*. Sketches by this academic painter are now often taken as works of Moreau.

68. MARTIN: *Muse*. This painting was an enormous success at the *Salon* of 1898 and the critics saw in it 'the symbol of a generous enthusiasm of the revitalizing genius'.

Henri Martin began by treating poetic subjects but in an academic style. In 1889 he adopted a Neo-Impressionist technique, but the key influence on his life was Puvis de Chavannes who looked upon the younger artist as his successor. When he does not mistake silliness for simplicity, Henri Martin is perhaps the best of the *Salon* Symbolists, with a palette which is much warmer than that of his fellow artists.

69. MARTIN: *Orpheus*. Probably the study for *Love* exhibited at the *Salon* of 1894. Alone in the desert, the poet invokes the name of his love in a final song: 'A sigh lost in an indifferent world.'

71. MAURIN: *Dawn of love*. Charles Maurin (1856–1914) studied at Le Puy and at the Ecole des Beaux-Arts. He exhibited at the *Salon*, with the *Indépendants* and at the *Salon de la Rose+Croix*, and knew a brief period of fame. This painting belongs to a triptych; the other two panels are entitled *Dawn of dreams* and *Dawn of work*. 'Full of talent but eccentric', declared Péladan. They are a curious mixture of eroticism, social aims and literary aspirations. This canvas is sub-titled 'Les Illuminations Arthur Rimbaud'. The poet to whom this painter comes closest is Verhaeren, and the painter with whom he can be linked is another Belgian, Frédéric. A gifted draughtsman but a deplorable painter, Charles Maurin merited this remark of Rémy de Gourmont: 'Leaving aside those dreary colourings, the painting well illustrates a humanity weary before it even starts to live.'

74. MAXENCE: *Spirit of the forest*. The career of Maxence (1871–1957) begins with him exhibiting regularly at the *Salon de la Rose+Croix*; it ends with him as a member of the Institute and sending a *Meditation* to the *Salon* of 1939 at the end of a series of *Serenities*, 'books of peace' and other images which were always treated to a full-page reproduction in *L'Illustration*.

His angels with their faces of aesthetic ladies and their clothes like chasubles have the look of participants in black masses, but are really closer to a Breton legend where religion mingles with the fantastic. This was one of the most noticed of the works by Moreau's pupils at the *Salon* of 1898.

77. LACOMBE: *Cliffs near Camaret*. Mme Geneviève Lacambre, while noting that the cliffs possess human profiles, indicates the connection with Gauguin's painting, *Above the abyss*, painted five years earlier in Brittany. Lacombe is also known for his forest landscapes and for his beautiful wood sculptures which bear a certain resemblance to those of the German, Barlach.

83. MINNE: *Weeping mother*. This sculptor from Ghent, greatly influenced by the Primitives, treated such themes several times. This drawing served as the cover for a book by Grégoire Le Roy, *Mon Cœur pleure d'autrefois* ('My heart weeps for former times'), published in 1889. Of all the Belgian Symbolists, Minne was the one who was most influenced by Toorop; the School of Laethem-Saint-Martin established itself round him.

84. MOREAU: *Evening and sorrow*. Robert de Montesquiou gave this watercolour its name, for it reminded him of these lines of Baudelaire:

> *Sois sage, ô ma douleur, et tiens-toi plus tranquille,*
> *Tu reclamais le soir; il descend, le voici.*

> (Be patient, O my sorrow, and keep even stiller,
> You craved for Evening; and look, it is falling now)
> (*Recueillement*, in *Les Fleurs du Mal*).

85. MOREAU: *Sappho flinging herself into the sea*. Following Chassériau, Moreau was fascinated by the myth of Sappho which, for him, represented the Beauty which was doomed to die; he treated the subject many times. 'One longs for the beauty of a land of art where statues line the tops of the cliffs (as in Moreau's *Sappho*)'—Proust.

86. MOREAU: *The mystic flower*. This symbol of an established religion, indifferent to the martyrs whose blood waters a monstrous lily, looks forward in spirit to his immense unfinished picture, *The Chimeras*.

87. MOREAU: *Venice*. This allegory of the capital of Deca-dence was very famous: Jean Lorrain praises it when writing of another 'Venice' by Aman-Jean; Lévy-Dhurmer painted the same subject, and there are these lines by Proust from his article on Ruskin, written during a visit to Venice in 1898:

'When one has seen the pictures by Gustave Moreau, one acquires a taste for sumptuous dress, for things diverted from their inherent charm and read as symbols; the tortoises become what the lyres used to be, the flowers encircling a forehead be-come the symbol of death . . . And one is content to see people as the mental means through which the poet—who alone is able to choose these things—moves, raising one thing onto the level of another, the flowers which encircle the statue become the statue itself, the statue becomes the goddess who passes by not far away, while the flowers of a corsage almost become jewels and materials.'

88. MOREAU: *Jason*. The influence of Mantegna is very notice-able in this painting which the critics thought unwholesome. The sorceress has just given the hero the elixir which will enable him to overpower the dragon.

'Two tender puberties brimful of energy unite their innocence and marry their triumph; the hero and the fairy have signed the pact . . . Impassive in body and soul, they ignore one another and the monster which their ivory feet trample into the ground does not make them tremble, for a subtle magic presides over their meeting . . . Memory turns back towards the androgynous attractions of a profane Sodom' (Ary Renan, *Gazette des Beaux-Arts*, 1899).

90. PUVIS DE CHAVANNES: *Inter artes et naturam*. A smaller version of the large decoration in the Musée de Rouen celebrat-ing the art of ceramics. It is the picture of an ideal society dedi-cated to Beauty. The influence of the Aesthetic Movement is certainly discernible. J-E. Blanche tells us how Puvis worked on one of these compositions: 'His method of work certainly turned the decorator into a very intellectual painter. He would reflect on a given subject for a long time and then suddenly a vision would come to him which he would note down in watercolour on paper. There were very few changes between this sketch and the finished work, but studies of architecture, numerous drawings from the model, then the enlargement after passing through a stage of making an oil sketch not much larger than the water-colour.' Puvis declared with regard to this composition: 'The cartoon is the libretto, the colour is the music.'

91. MOREAU: *The peri*. The peri, fairy of oriental tales, tames griffins and feeds off the scent of flowers. Moreau frequently treated this subject, using Persian miniatures as a source:

'In studying the Orient, Gustave Moreau follows back the course of the migration of myths; he finishes at the point where they burst into flower' (Ary Renan).

92. MOREAU: *The rape of Deianira*. This story, part of the Heracles cycle, was treated several times by Moreau: 'The strongly pronounced personality of this exceptional master, the mystery with which he shrouded his work which, from 1880 onwards, was only just known through old photographs, all this had contributed to his making a strong imprint upon the spirit of younger generations. Thus, for some six or seven years, we have watched the rejuvenated gods of hellenic Olympus and the

Shakespearian figures of Romanticism burst into flower among the coral' (Léonce Bénédite, *Salon of 1898*).

93. PUVIS DE CHAVANNES: *Girls by the sea shore*. One of the paintings which led to the conception of the large-scale decora-tion for the Sorbonne, of which Huysmans wrote in 1887 in the *Revue Indépendante*: 'Presumptuous gala made from old plush, slow and frozen, laborious and false cartoon, this is how his great machine destined for the amphitheatre of the Sorbonne struck me. This is the work of a conventional slyboots, skilful and naïve, but one has to admit that he shines next to the others; his attempt seems to give off a more elevated and less heavy bore-dom. . . '

Here is an idea of the programme for the decoration for the Sorbonne given by the master himself: 'The left-hand compart-ment is reserved for Philosophy and History, symbolized in the case of the former by a group of figures representing the struggle of spirituality in the face of death, spirituality being recognizable by a gesture of fervent aspiration towards the ideal, while the other shows a flower, the expression of terrestrial joys and of the successive transformations limited to matter. . . .'

94. PUVIS DE CHAVANNES: *Summer*. This had a great success at the *Salon*. It was in relation to this picture, so noticeably unpicturesque, that people started to define Symbolism in paint-ing.

'The inadequacies of his painting, accidental or intended, never hide anything, but highlight his first-class qualities. Today, nobody treats a subject in a generalized way, no one encompasses all its facets with such natural simplicity . . . The subdued light, harmonious, bluish, in which these happy visions live, sings to the eyes like a melody by Gluck . . . this is Summer in the eternal land in which the artist's soul lives' (Georges Lafenestre, *Gazette des Beaux-Arts*).

97. PUVIS DE CHAVANNES: *Hope*. The title is an allusion to the tentative hopes that followed the defeat of 1870 and the Commune of 1871. Gauguin pinned up a reproduction of it in his hut in Tahiti. The model, 'little Dobigny', also posed for Corot and Degas. The face is reminiscent of Burne-Jones. Ary Renan wrote of this painting: '(Puvis) is the most ingenuous and poetic painter that the French school has produced; his conception has the simplicity of the unconscious masterpieces of the art of the past and only resembles them in this spontaneous simplicity. His execution is solid, stripped of clever devices and mysteriously transparent.'

98. PUVIS DE CHAVANNES: *The shepherd's song*. This paint-ing is based on the large *Vision of the Antique* in London, and aroused Péladan's enthusiasm in his *Salon of 1890*. With this painting in mind, Maurice Denis drew this interesting com-parison: 'Despite fairly similar qualities, I note this profound difference between Puvis and Poussin: the latter hides, under decorative details borrowed from the rhetoric of his own period and through the charm of his sensibilities, the strict knowledge which he has of his medium; while the modern master leaves bare everything that is artificial and wilful in his work. We argue about whether Poussin was inspired by nature directly or whether he followed his poetic ideals; but we can clearly see that Cha-vannes employed a system, that he deliberately idealized nature' (*Ecrits sur l'Art*).

99. MONTALD: *The garden of Paradise*. Montald's over-riding ambition was to be a very great decorative artist in the manner of Puvis. He was particularly associated with Verhaeren and Delville, whose idealism he shared. He frequently treated this subject of a closed garden belonging to a poetic universe which rejects the external world.

100. MOREAU: *Orpheus*. This canvas was immensely successful at the Paris International Exhibition of 1867. Articles about it were numerous, starting with one by Chesnau, a champion of the Pre-Raphaelites, who were also shown in the same exhibition. The incident shown in the picture was invented by Moreau, and was the first idea for his later Salomes contemplating the head of John the Baptist, but devoid of cruelty.

101. MOREAU: *Galatea*. This painting is the most perfect example of Moreau's two principles: static Beauty and essential Richness. The curious vegetation heralds the work of Gallé and Lalique. 'His art attracts the eye and holds it as would a magician, dressed in a costume made of a fairy rainbow, who stands in the middle of a ball filled with black tail-coats' (A. Michel, *Gazette des Beaux-Arts*, 1889).

103. PUVIS DE CHAVANNES: *The Pigeon*. A reference to the carrier pigeons who carried news during the siege of Paris by the Germans, and thus a symbol of Hope. Very close to some Rossetti drawings.

106. POINT: *The Eternal Chimera*. Armand Point (1861–1932) was the most Pre-Raphaelite of the Symbolists. A trip to Italy in 1894 caused him to move from a sort of dreamy realism to a detailed idealism. With the help of his favourite model, Mme Paul Berthelot, he evolved a Leonardesque type of ideal woman who appears in all his work, although he dressed her like Botticelli's muses. In order to bring about an artistic revival, Point set up a studio of applied art at Haute Claire near Fontainebleau based on William Morris' principles. The products of this studio are much more Neo-Byzantine in style than *art nouveau*. He exhibited regularly at the *Salon de la Rose+Croix* and even designed the poster for the fifth *salon* together with the Dutch artist, Sarreluys. This poster showed the Ideal in the figure of Perseus brandishing the head of Zola.

107. REDON: *Pandora*. 'Odilon Redon transposes the romantic poetry of his beautiful charcoal drawings of the past into explosions of flowers which are much more real. Symbolism is no more; Redon survived it and his smiling wisdom now turns itself to translating the intoxicating charm of bouquets with the same skill and the same mystery' (Maurice Denis, *Le Salon d'Automne*, 1905).

109. REDON: *Woman in profile with wreathed head*. 'I have loved and I still love Leonardo's drawings: they are like an essence of life, a life expressed by the contours as much as by the reliefs. I feed from their spirit, refined, civilized, aristocratic; I feel the serious charm in them which lifts me towards the heights of mental delight' (*A Soi-Même*, 1902).

111. ROCHEGROSSE: *The Fine Arts*. A view of the Garden of Arts by this very prolific painter who exploited Symbolist ideas in a totally academic style. The poet in the pictures looks like Edmond Rostand. This detail shows what official art had absorbed from Symbolism. In his canvases depicting historical events or social symbolism, Rochegrosse is capable of achieving very bizarre results.

112. ROUSSEL: *The Virgin of the path*. One of the many forests of which the Symbolists were so fond and which almost all derive from Puvis de Chavannes' *Sacred Wood*. 'He will become a wonderful decorative artist'—Albert Aurier.

113. ROPS: *Death at the ball*. One of his very rare paintings in oil, and his most successful. Rops had been launched by Baudelaire:

Combien j'aime
Ce tant bizarre Monsieur Rops
Qui n'est pas un grand prix de Rome
Mais dont le talent est haut comme la pyramide de Chéops.

(. . . How I love
This strange Monsieur Rops,
Who is not going to win the Grand Prix de Rome,
But whose talent is as high as the pyramid of Cheops).

114. ROUAULT: *The meal*. One of the few works based upon a secular theme by this artist. The musician, the flowers, the half-light conjure up the vision of the Symbolists' ideal life.

115. ROUAULT: *Jesus among the doctors*. Here the favourite pupil of Moreau has recalled the setting and figure of Herod in the *Apparition*. There can also be seen the influence of Rembrandt, for whom Moreau, who went to Holland in 1885, also had a great admiration.

117. SEGUIN: *Les fleurs du mal*. The masterpiece of this admirer of Gauguin, who died very young after spending his entire artistic life at Pont-Aven. He was one of the best draughtsmen of the group, and did lithographs and etchings based on Baudelairian subjects.

118. SCHWABE: Study for *Spleen et Idéal*. This oil is a preparatory study for the coloured etchings done for the edition of Baudelaire's poems published by Meunier in 1897. Schwabe also illustrated the poems of Samain and *L'Effort* by Haraucourt, and he deserves to be regarded, at least as much as Mucha, as the master of *art nouveau* illustrators.

119. SCHWABE: *The Virgin of the lilies*. 'A very deep feeling for those things which add their voice to the solemn choir of Nature. Each one of these lilies has been understood with love' (Léonce Bénédite, *Art et Décoration*, 1898).

120. SERUSIER: *Tobias and the angel*. The angel is a young Botticellian girl and Tobias a young Breton fisherman. Sérusier met Gauguin at Pont-Aven in 1888 and it is through him that Gauguin had such a strong influence upon the *Nabis* (other than Vuillard). Becoming increasingly mystical, Sérusier developed a theory of art based on sacred numbers and worked in the Benedictine abbey of Beuron in Germany with another painter from Pont-Aven, Dom Verkade.

121. MOREAU: *The dead poet borne by a centaur*. One of the pictures in which Moreau unconsciously reveals his attraction to young men, guilty and therefore linked to death. For Ary Renan the figure of the poet which recurs so often in the work of Moreau represents the soul.

123. MOREAU: *Woman and panther*. One of his most stunning watercolours, it probably represents Circe. Here one finds, as in

many of Moreau's mythological portraits, the fruit of the judgement which the painter passed on Michelangelo's Sibyls: 'All these figures appeared to be frozen in the gesture of an ideal somnambulist. They are oblivious to movement to such an extent that they seem transported into other worlds.'

125. SPILLIAERT: *October evening.* 'Spilliaert, together with Ensor, is one of the basic links between Symbolism and Expressionism. He is also one of the principal precursors of Surrealism in Belgium' (Francine Legrand). René Huygue has compared him to the *Nabis* on the grounds that humour is seldom absent from his work. However, Spilliaert suffered from depressions; he wrote to a friend: 'I have always been afraid. Never bold. My life has been led alone and sad, with an enormous sense of chill all around me.'

126. SEON: *The fairy.* Ever since his childhood, Séon had been fascinated by fairy-tales and he became one of the key artists in the return to the fantastical, in the careful style of Puvis. In this style he illustrated Péladan's *Mélusine*. This drawing is a preliminary design for a *Septénaire des Fées* ('The Fairies' Septennial'), also by Péladan, which was never published.

127. SEON: *The despair of the chimera.* One of the most celebrated canvases of Symbolism, and the most thorough-going example of the theory of Chromoluminarism developed with his friend, Seurat. His ideas were elaborated by the critic Alphonse Germain: perspectival gradation of tone; the horizontal line means serenity, the vertical spiritual elevation. Orange means sorrow, purple melancholy. 'Scholar and logician, he believed in making his dream possible, and his winged feline "gymnocephalus" has been constructed according to the laws of anatomy, supernatural but plausible' (*La Plume*, 1895).

133. WEBER: *The puppets.* This painting, by the only caricaturist to have been influenced by Symbolism, was enormously successful at the *Salon* of 1900, for people saw in it a condemnation of Symbolism. In fact, the puppets who distract the artist from reality are dressed for a performance of a play by Maeterlinck.

134. BERNARD: *Portrait of my sister Madeleine.* The sitter came to Pont-Aven in 1888 at the invitation of her brother. Fascinated by Gauguin, she actually married the artist Charles Laval whom she followed to Cairo, where she died in 1895. Gauguin also painted her portrait (Musée de Grenoble). The background is the same as that found in his well-known *Madeleine in the Bois d'Amour.*

135. CARRIERE: *Rodin sculpting.* This apparition shows the sculptor as a demiurge making life out of matter, and clearly demonstrates the importance of Rodin in the artistic conscience of the *fin-de-siècle*. A parallel is often made between Rodin, the master of voluptuousness, and Carrière, the master of tenderness.

Moreau did not like Rodin's sensuality: 'Rodin—the dream of Michelangelo coursing through the soul and the brain of Gustave Doré, always, always coupled with sadism "à la Rops". . . .'

136. CARRIERE: *Portrait of Paul Verlaine.* Born of a German mother, Carrière was brought up in Strasbourg. He then entered Cabanel's studio at the Ecole des Beaux-Arts. In 1876 he visited London and in 1879 he exhibited his first *Motherhood*, but his style only became fully formed at the end of the 1880s under the influence of the Symbolists. It appears that Verlaine did not like this portrait very much, and yet it is the best one that there is of him. He sold it very soon after completion to the critic Jean Dolent and wrote these lines on the verso:

'. . . small malicious eyes . . .
Shining as if sticky with a varnish of tears,
Fundamentally true, the portrait of a little man
A slightly faded and flabby Socrates.'

137. DESBOUTIN: *Joséphin Péladan.* Desboutin (1823–1902) is primarily known as an engraver, and although he exhibited at the *Salon de la Rose+Croix* his work is almost all in a realist style. He was a great friend of Degas. The Sâr Péladan, enchanted with his portrait, compared it to Titian's *Young man with a glove*, and he gave him a title. One can see a certain resemblance between this figure and some sages of Hippie culture, but Péladan had sufficient character to brave the ridicule, and the frivolous *Vie Parisienne* admitted at the first *Salon*: 'What is even stranger about the *Salon de la Rose+Croix* is that we came to laugh and had to admire' (*Vie Parisienne*, 1 March 1892).

138. LA GANDARA: *Portrait of Jean Lorrain.* Jean Lorrain (1855–1906) was a brilliant chronicler of Parisian life, known as the Petronius of the *fin-de-siècle*, the author of poems and extraordinary short stories on the fringes of Symbolism. He did much for the reputation of black Symbolism.

139. LA GANDARA: *Portrait of Count Robert de Montesquiou.* Painted in the same year as the celebrated portrait by Whistler. The subject, who provided a model for both Huysmans and Proust, holds a scarab in his hand, the symbol of happiness. Through his articles and his collection, Montesquiou brought Gallé and the best *art nouveau* artists to the notice of the public. He also organized a Gustave Moreau exhibition.

140. LA GANDARA: *Portrait of a woman.* For a moment one might have thought that La Gandara would be the French Whistler, but his later portraits were closer in style to fashion plates.

142. GAUGUIN: *Nirvana.* Gauguin reflects the influence of Schopenhauer in this portrait of a Dutch painter who had settled in Pont-Aven, Meyer de Haan. One could almost see the sitter surrounded by ghosts as in a play by Strindberg, about which he had written: 'To catch sight of happiness, is that not a foretaste of Nirvana?'

144. DE GROUX: *Portrait of Rémy de Gourmont.* The famous critic of the *Mercure de France* and champion of the Symbolists. He discovered De Groux, Filiger, and Séguin. He gave one of the first definitions of Symbolism: 'Red coral, we have seen enough of it: would that it were blue!—Symbolism can be literally translated by the word liberty and for the men of violence by the word anarchy.' 'Symbolism will have to be considered as the free and personal development of the individual aesthetic within the group aesthetic.' He was a great writer but also very ugly, and had a passion for Nathalie Barney, a beautiful American lesbian to whom he wrote 'letters to the Amazon'. This portrait hung in Miss Barney's drawing-room until her death at the age of 95.

145. OSBERT: *Songs of the night.* Alphonse Osbert (1857–1939) is one of those artists who remained faithful to the Symbolist ideal throughout their lives. After spending some time at the

Ecole des Beaux-Arts, he was noticed by Puvis de Chavannes, whose influence upon his work continued from then onwards. At the same time, he was closely associated with Seurat and one can discern a certain similarity in their drawing styles. Osbert exhibited regularly at the *Rose+Croix*. His *Vision*, Joan of Arc according to some, St. Genevieve according to others, was enormously successful. A *Hymn to the Sea*, very close in style to this *Songs in the Night*, was described by one critic thus: 'The same atmosphere pervades this painting as the poems of Edgar Poe or certain landscapes described by Villiers de l'Isle Adam. The same gentleness, the same sense of infinity, the same penetration . . .' (Alphonse Germain, *L'Ermitage*, 1893).

Osbert received commissions for decorating provincial town halls and casinos with compositions which became increasingly mauve.

147. PUVIS DE CHAVANNES: *Saint Genevieve watching over Paris*. The most famous of all Symbolist paintings, and much influenced by the trends of the younger idealist painters. 'The contours are the most calm, the least complicated, tonalities reduced almost to those of a cameo, not a gesture, no interest other than the close tie which one senses exists between the saint and her city' (Léonce Bénédite, *Art et Décoration*, 1898).

One of the most gifted critics of Symbolism, Redon's friend Mellério, wrote in 1896: 'Puvis proceeds by synthesis and simplification; he finds generalizations of pose in Greek sculpture, he places everything at the service of the idea.'

150. LEVY-DHURMER: *Portrait of Georges Rodenbach*. The Belgian poet (1855–1893) settled in Paris in 1887, where he won great acclaim with his *Bruges-la-Morte*—whose monuments serve as the setting of this portrait—one of the most beautiful novels of Symbolism.

152. LAURENT: *Portrait of Georges Seurat*. This rather conventional painter made a number of studies of his friends for a large painting called *At the Concert Colonne*; these are valuable iconographic documents and aptly convey the musical fervour of the circle. The technique used is very close to that of Seurat.

153. POINT: *Portrait of Madame Berthelot*. The best example of a French Pre-Raphaelite. Mme Berthelot belonged to a family of scientists, politicians and bankers at the turn of the century.

156. SEURAT: *Portrait of Aman-Jean*. Aman-Jean became friendly with Seurat at the studio of Lehmann. Together they frequently visited Puvis de Chavannes. The young man was very influenced by Fantin-Latour's lithographs and created one of the feminine types of Symbolism. He knew success at an early age and was closely associated with Mallarmé, Péladan and Verlaine, whose portrait he painted.

157. MONTALD: *Portrait of Verhaeren*. To a much greater extent than Maeterlinck, Emile Verhaeren (1855–1917) was interested in painting and brought the Symbolists to public notice through a large number of articles. Odilon Redon provided lithographs for the frontispieces of his books, *Les Soirs* ('The evenings'), *Les Débâcles* ('The disasters'), *Les Flambeaux Noirs* ('The black firebrands') (1887–1890), works which were 'born in the deepest part of man's intimate being, in the fantastical *camera oscura* of daydreams and visions'. His best-known works were *Les Villes Tentaculaires* ('Octopus cities'), 1899, and *Le Multiple Splendeur* ('The many-splendoured thing'), 1906.

158. PUVIS DE CHAVANNES: *Portrait of his wife*. This Rumanian princess, whom he met in Chassériau's studio, was the only love of his life and had a great influence upon the direction of his philosophical thinking.

159. VAN RYSSELBERGHE: *The reading*. Verhaeren (second from left) is reading a poem to a group of well-known people connected with Symbolism, such as Stuart Merrill, Gide (second from right, his head in his hand), and Maeterlinck (leaning on Gide's chair), but one of them is openly hostile, Félix Fénéon who is leaning against the mantelpiece.

Van Rysselberghe attacked his friends from the *Salon des XX* who went to exhibit at the *Rose+Croix*: 'Nothing is as nauseating as Péladan's self-advertisement and that of his disgusting long-haired accomplices . . .' Van Rysselberghe's landscapes, executed in a *pointilliste* technique, do, however, bask in a Symbolist atmosphere.

160. AMAN-JEAN: *Perfume*, or *Woman with a rose*. This lithograph, published by *L'Artiste*, is witness to the revival of this art form under the impetus of Symbolism.

164. BERTHON: Poster for the *Salon des Cent*. 'Imagist' and lithographer at the end of the century, Berthon provided an archetype of Symbolist woman. The *Salon des Cent* was organized by the magazine *La Plume*.

165. BLANCHE: *Parsifal*. Although the friend of the Impressionists, J-E. Blanche was always interested in everything new and worked on the *Revue Wagnérienne*, a periodical which brought together artists and writers of the imaginary. This mediocre portrayal of the 'simple man of integrity' illustrates the influence of Symbolism on society artists.

166. BRESDIN: *The good Samaritan*. Théophile Gautier and Baudelaire were among the earliest admirers of Bresdin's rare lithographs. Huysmans made them famous by writing about them in *A Rebours*.

167. BOURDELLE: *The death of Tante Rose*. This sculptor, disciple of Rodin, exhibited small statues and drawings at many of the *Salons de la Rose+Croix*. In this gouache, the similarity between the angel's wing and the nuns' veils is highly symbolic.

171. DENIS: *The Blessed Damozel*. The translator of Rossetti's poems, Sarrazin, described this heroine as one of those beings 'who seem to look upon the earth as nothing but a state of temporary unearned exile and who seem to have no other native land but the sky. There they await the poet.' In this same year, 1893, Denis also illustrated the *Voyage d'Urien* by his friend André Gide, one of the most successful examples of Symbolist illustration.

172. SEURAT: *Landscape with Puvis' 'Poor Fisherman'*. Homage to Puvis de Chavannes. Gauguin had a reproduction of this painting in his bedroom, while Toulouse-Lautrec painted a parody of the *Sacred Wood*.

173. PUVIS DE CHAVANNES: *The Poor Fisherman*. Leaving Symbolism aside, the *Poor Fisherman* seems to be one of the most modern and most important paintings of the nineteenth century in France. The State bought this canvas in 1887 and hung it in the Musée du Luxembourg. Young painters immediately came to study it, while in the same museum the young poets preferred the splendours of Gustave Moreau.

Huysmans did not like it: 'This old fresco eaten up by moon-beams and washed away by rain. . . .'

180. ENSOR: *The devil leading Christ in Hell*. A drawing reproduced in a special number of *La Plume* dedicated to Ensor in 1898, in which the following commentary appeared: 'All the angels of light, cherubim of Harmony, thrones of light and shade, seraphim and the never-fading power of the rainbow have visited Ensor and, in the care of the devils Dzitts, Hihahax and Craon, he too had descended into Hell . . . His work sings in polyphony, at once angelic and ironic, like a strange and wonderful concert of pens of silk and velvet.'

183. GRASSET: Calendar for the *Belle Jardinière*, March. Grasset (1845–1917) came from Lausanne; two things he admired decided his vocation: Gustave Doré's illustrations and Viollet-le-Duc's books on medieval decoration. He was at once the pioneer of the renaissance of the illustrated book with his *Quatre Fils d'Aymon*, published in 1884, and one of the most fully committed artists of *art nouveau*, designing furniture, ceramics, stained-glass windows and posters. This group of prints marks a revival in commercial art. and reflects the influence of Walter Crane and Kate Greenaway.

185. DE FEURE: *Door of dreams*. (See also No. 44.) This triptych is the frontispiece for *La Porte des Rêves*, a collected edition of Marcel Schwob, an erudite writer of short stories and a great friend of Oscar Wilde. The critic Franz Jourdain saw a relationship here with Bosch's *Flagellation of Christ*; we are more readily reminded of a worried Snow White.

190. RENAN: *Sappho*. Ary Renan, the son of the historian of the early years of Christianity, was much more interested in the more disturbing myths of antiquity. A one-time pupil of Delaunay, he was most influenced by Gustave Moreau. He was one of the few close friends of the master and he wrote a very beautiful study of him, for he was also an excellent writer and poet. After travelling in the Near East, he spent much time in Brittany. The critic, Henri Bouchot, who saw this painting in the *Salon* of 1893, wrote in the *Gazette des Beaux-Arts*: 'The poetic deeps where the body of Sappho fell into her last sleep among the corals and the seaweed. Burne-Jones' siren never knew this intertwined forest of plants.'

192. REDON: *Closed eyes*. It is in this painting of a subject which he had already treated in black and white that Redon starts to use colour. It is perhaps inspired by one of Michelangelo's slaves, about which the artist wrote in 1888: 'What elevated mental activity under the closed eyes of his slave! He sleeps and the anxious dream which chases across his marble brow places our own (dream) in a moving, thoughtful world. The sleep of the slave awakens our dignity' (*A Soi-Même*).

197. SCHWABE: *Death and the grave-digger*. The critic of *Art et Décoration* compared Schwabe to Dürer and wrote: 'And in the reverberation of his faculties, all of which are excited at the same time, the reflections of tragic, bizarre and mysterious dreams are mixed under the artist's fingers, in which one deciphers the symbolic signs of confused destinies and, at the same time, infinitely touching refinements of feeling.'

204. REDON: *To Gustave Flaubert—Death: my irony surpasses all others!* This is one of the second series of lithographs inspired by the *Tentation de Saint-Antoine*. These lithographs had delighted Huysmans, who wrote in the *Révue Indépendante* of 1887: 'M. Redon exudes the strange smell of his wonderful talent, bizarre landscapes in charcoal, a profile of an attentive, rough woman, a ghastly cyclops with his skull eaten away by a sorrowful and staring eye, an idea embodied in the form of a demoniacal being with a mouth like pincers.'

207. ROUSSEL: *Noli me tangere*. Published in the *Revue Blanche*. Here this *Nabi* painter was as much influenced by Redon as he was by Carrière. But his paintings based on the theme of the *Afternoon of a Faun* exude a feeling of the joy of life which is far removed from Symbolism.

211. ROPS: Frontispiece to *Poésies* by Mallarmé, published by the *Révue Indépendante* in 1887. Rops seems to us today to be unworthy of Mallarmé, and one must re-read the remarks which were made about him at the time in order to understand his position as the leader of black Symbolism: 'The emotional meaning of the lines and the splendour of the ideas makes him the only contemporary artist who could be compared to the old Symbolist painters of Germany and Florence' (Théodore de Wyzéwa).

But Moreau could not stand 'sadism "à la Rops" and the decay of the modern spirit, a crazy mixture of mysticism, of the beer-hall, of boulevard pornography' ('A propos de Rodin').

List of Symbolist Painters

AMAN-JEAN, Edmond, 1860–1936: *the most charming of the French Symbolist painters, who exhibited poetic subjects, portraits and decorative panels regularly at the* Salon de la Rose+Croix.
BELLERY DESFONTAINES: *decorative designer and illustrator who combined Realism with the style of* art nouveau.
BERNARD, Emile, 1868–1941: *one of the most important artists of the School of Pont-Aven; he moved from a primitive style to one based upon the masters of Venetian painting.*
BESNARD, Albert, 1849–1934: *this very gifted artist acted as a link between Symbolism and academicism; he exhibited portraits and allegorical paintings with great success at the official salons; he also painted some very beautiful frescoes.*

BOURDELLE, Antoine, 1861–1929: *the creator of robust sculpture who exhibited at the* Salon de la Rose+Croix.
BRESDIN, Rodolphe, 1822–1882: *his extraordinary engravings had a great influence on the work of one of the masters of the Symbolist movement, Odilon Redon.*
BUSSIERE, Gaston, 1862–1958: *a disciple of Puvis de Chavannes, he exhibited Wagnerian subjects at the* Salon de la Rose+Croix *and illustrated books.*
CARRIERE, Eugène, 1849–1906: *painter of family scenes and humble people, he was much liked by the Symbolists, especially by the writers.*
CAZIN, Jean-Charles, 1841–1901: *his large biblical scenes with their straightforward representation of subject-matter and their muted colours were very popular with the Symbolists.*

CHABAS, Maurice, 1862–1947: *he exhibited mural decorational panels and imaginary landscapes at the Salon de la Rose+Croix.*

CHASSERIAU, Théodore, 1819–1856: *his frescoes exerted a great influence on both Puvis de Chavannes and Moreau.*

CLAIRIN, Georges: *Sarah Bernhardt's favourite painter who treated Symbolist themes in an academic manner.*

DEGOUVE DE NUNQUES, William, 1867–1935: *French by birth, he lived in Belgium and painted imaginary landscapes and designed stage sets for Maeterlinck's plays.*

DELVILLE, Jean, 1867–1953: *the master of the philosophical side of Symbolism, he was a disciple of Péladan and lived in Paris during the 1890s; he then became a teacher at Glasgow and at Brussels.*

DENIS, Maurice, 1870–1943: *the most gifted and thorough-going of Symbolist artists, he brought about a revival of religious art; he was also a decorative artist, book illustrator and excellent art critic.*

DESBOUTIN, Marcellin, 1823–1902: *an engraver and friend of Degas, he exhibited at the Salon de la Rose+Croix.*

DESVALLIERES, Georges, 1861–1950: *a pupil of Gustave Moreau, he was a decorative artist who founded the Studio of Sacred Art with Denis.*

DORE, Gustave, 1832–1883: *the last of the great draughtsmen of the Romantic period; his illustrations of the works of English poets had a great influence upon Symbolism.*

DOUDELET, Charles, 1861–1938: *he illustrated Maeterlinck with woodcuts in a medieval style.*

DULAC, Charles-Marie, 1865–1898: *a decorative artist who became a painter of mystical landscapes; he spent much of his life in Italy.*

ENSOR, James, 1860–1949: *far more wide-ranging than most Symbolist artists, he was one of the few caricaturists of the movement.*

FABRY, Emile, 1865–1966: *a Belgian painter of harrowing allegorical subjects; he was a follower of Delville and exhibited at the Salon de la Rose+ Croix.*

FANTIN-LATOUR, Henri, 1836–1904: *a friend of the Impressionists, his Wagnerian subjects and lithographs were of great importance to the Symbolists.*

FEURE, Georges de, 1869–1928: *Dutch by birth, he was one of the most elegant of Symbolist artists; he was also one of the creators of art nouveau.*

FILIGER, Charles, 1863–1928: *the most mystic of the painters of Pont-Aven, he exhibited at the Salon de la Rose+Croix and then was rapidly forgotten; he lived in Brittany.*

FREDERIC, Léon, 1856–1940: *coming to Symbolism from a very extreme form of Realism, he painted vast social subjects.*

GARDIER, Raoul du, 1871–?: *a pupil of Moreau, he exhibited at the Salon de la Rose+Croix.*

GAUGUIN, Paul, 1848–1903: *the most important artist to have been influenced by Symbolism.*

GRASSET, Eugène, 1841–1917: *born in Switzerland, he was one of the best illustrators in the art nouveau style; he had a great influence on the decorative arts.*

GROUX, Henry de, 1867–1930: *a Belgian artist who spent almost all his life in France; his paintings tended to be very violent and were appreciated more by writers than by fellow artists.*

JACQUEMIN, Jeanne: *a mysterious woman who dabbled in the occult and influenced Huysmans.*

KHNOPFF, Fernand, 1858–1921: *the greatest of Belgian Symbolist artists and the only one to achieve an international reputation.*

LACOMBE, Georges, 1868–1916: *a landscape painter who was much influenced by Gauguin and who later became a member of the Nabis.*

LA GANDARA, Antonio de, 1862–1917: *a society portraitist much influenced by Whistler; he knew a number of Symbolist writers.*

LAURENT, Ernest, 1859–1929: *a friend of Seurat, he was an academic painter with Symbolist leanings.*

LE SIDANER, Henri, 1862–1939: *a painter of landscapes and intimate subjects in an Impressionist style.*

LEVY, Léopold, 1840–1904: *a history painter who imitated Gustave Moreau in his mythological paintings.*

LEVY-DHURMER, Lucien, 1865–1953: *one of the most gifted and strangest*

of the Symbolists; *he was a fine pastellist and painter of the fantastic, of portraits and of some very beautiful Mediterranean landscapes.*

MAILLOL, Aristide, 1861–1944: *a sculptor and follower of Rodin: he was a painter during the early years of his artistic career, working in the style of Puvis de Chavannes.*

MARTIN, Henri, 1860–1943: *Puvis de Chavannes' favourite pupil; he exhibited at the Salon de la Rose+Croix and painted large decorative panels for Toulouse in a pointilliste style; he was the favourite of the Salon.*

MATISSE, Henri, 1869–1954: *as far as the Symbolist movement is concerned, he is important as a student of Moreau who also came under the influence of Puvis de Chavannes.*

MAURIN, Charles, 1856–1911: *a provincial painter with socialist leanings; he exhibited at the Salon de la Rose+Croix.*

MAXENCE, Edgar, 1871–1954: *pupil of Moreau; he exhibited at the Salon de la Rose+Croix; he later popularized the Symbolist ideal in his paintings exhibited at the Salons.*

MELLERY, Xavier, 1845–1921: *a painter of intimate subjects who longed to be a decorative artist on a large scale; he exhibited at Les XX.*

'MEROVAK': *otherwise known as the 'man of cathedrals', he produced designs for extraordinary architectural projects.*

MINNE, George, 1866–1941: *Belgian sculptor and draughtsman; he fell under the influence of Maeterlinck and exhibited at Les XX; he then retired to Laethem-Saint-Martin.*

MONTALD, Constant, 1862–1944: *Belgian landscape painter and decorator, he was a pupil at the Ecole des Beaux-Arts in Paris.*

MOREAU, Gustave, 1826–1898: *the greatest master of the Symbolist movement.*

MUCHA, Alphonse, 1860–1939: *a Czech decorative artist who was one of the founders of art nouveau; he vulgarized Symbolism in his posters of Sarah Bernhardt.*

OFFEL, Edmond van, 1871–?: *Flemish illustrator with a tendency towards mysticism.*

OSBERT, Alphonse, 1857–1939: *a friend of Seurat who expressed his debt to Puvis de Chavannes in his poetic landscapes and in his decorative paintings; he exhibited at the Salon de la Rose+Croix.*

POINT, Armand, 1861–1932: *the most Pre-Raphaelite of Symbolist artists, he exhibited at the Salon de la Rose+Croix and founded a studio; he was a gifted draughtsman.*

PUVIS DE CHAVANNES, Pierre, 1824–1898: *the most important decorative artist in France at the time; his influence was far greater than that of Moreau.*

RANSON, Paul Elie, 1862–1909: *one of the founder members of the Nabis, he was interested in the occult and in liturgical art.*

REDON, Odilon, 1840–1916: *the most important Symbolist artist.*

RENAN, Ary, 1858–1900: *a disciple of Gustave Moreau, he painted mythological subjects, exhibited at the Salon and was also an excellent art critic.*

RODIN, Auguste, 1840–1917: *the great sculptor, and one of the contemporary masters whom the Symbolists most admired.*

ROPS, Félicien, 1855–1898: *a Belgian illustrator in the spirit of Baudelaire who was much admired by Péladan; he spent most of his life in Paris.*

ROUAULT, Georges, 1871–1958: *one of Moreau's favourite pupils, he started his long artistic career by exhibiting at the Salon de la Rose+Croix.*

ROUSSEL, Ker-Xavier, 1867–1944: *one of the members of the Nabis; a contributor to the Revue Blanche.*

RYSSELBERGHE, Théo van, 1862–1926: *adviser to Les XX, a friend of Van de Velde, and influenced by Signac; he spent much of his life in France.*

SCHUFFENECKER, Emile, 1851–1934: *a friend of Gauguin; his delicate pastel landscapes stand halfway between Monet and Symbolism.*

SCHWABE, Carlos, 1866–1926: *born in Germany and brought up in Switzerland, he exhibited at the Salon de la Rose+Croix; he was one of the most bizarre of Symbolist illustrators.*

SEGUIN, Armand: *painter and engraver who worked at Pont-Aven.*

SELLIER, Charles, 1830–1882: *one of the precursors of Symbolism, he had an influence on the development of the School of Nancy.*

SEON, Alexandre, 1855–1917: *a decorative artist and illustrator who was one*

of *Puvis de Chavannes' most gifted pupils; he exhibited at the Salon de la Rose+Croix; his work was liked by Symbolist critics.*
SERUSIER, Paul, 1864–1927: *a disciple of Gauguin and a member of the Nabis; he was also a theoretician of the mystical side of Symbolism.*
SEURAT, Georges, 1859–1891: *the friend of several young Symbolist artists, his drawings display certain mystical tendencies.*

SIMONS, Pincus Marcius, 1867–1909: *an American who lived in Europe and exhibited Wagnerian subjects and amazing architectural designs at the Salon de la Rose+Croix.*
SPILLIAERT, Léon, 1881–1946: *a Flemish Symbolist who was influenced by Verhaeren; he acted as a link between Symbolism and Expressionism and his work is sometimes reminiscent of de Chirico.*

Index